Also by Robert Harbison

Eccentric Spaces (1977)

*This is a Borzoi Book
published by Alfred A. Knopf.*

DELIBERATE REGRESSION

ROBERT HARBISON

DELIBERATE
REGRESSION

 ALFRED A. KNOPF NEW YORK 1980

THIS IS A BORZOI BOOK
PUBLISHED BY ALFRED A. KNOPF, INC.

Copyright © 1980 by Robert Harbison
All rights reserved under International and Pan-American Copyright
Conventions. Published in the United States by Alfred A. Knopf,
Inc., New York, and simultaneously in Canada by Random House of
Canada Limited, Toronto. Distributed by Random House, Inc., New
York.

Library of Congress Cataloging in Publication Data

Harbison, Robert. Deliberate regression.
 Includes bibliographical references and index.
 1. Primitivism in art. 2. Art, Modern—Moral and religious as-
pects. 3. Aesthetics—History. I. Title.
N7432.5.P7H37 709 79-3466
ISBN 0-394-50799-1

Manufactured in the United States of America
First Edition

FOR MY PARENTS

CONTENTS

ILLUSTRATIONS

Grateful acknowledgment is made to
the John Simon Guggenheim Memorial Foundation
and the National Endowment for the Arts.
The author also wishes to thank E., the book's first reader.

This book tells a disastrous history, how man is willed a stranger to himself and dissolved till not recognizably human anymore. The sources of this process are only partly ascertainable in his despair at a world without God, and his continuing need for transcendence after the supernatural is gone. The furthest excess of Romantic individualism is to re-create a god in the self out of just those parts beyond one's conscious control, so the unconscious and ungovernable is elevated as the true beyond, the highest part of the individual no longer individual.

In this rearrangement of human nature, capacities which had always been despised, the least knowable instincts or libido shared with animals, are put first. Nineteenth-century subjectivism leads through personality to a depersonalized end. It is man betrayed by his imagination, by an irresponsible power of reconceiving himself and undoing his own development, but the extravagance of the reversal is explained in part by a prevailing sense that it will not work, that science will succeed at expelling the beast and the life from man. To the astonishment of many Romantics the destructive components of these two developments are brought together in the first half of the twentieth century, as if separation has made reason and imagination more heartlessly like each other than before their polarization.

Drawing a parallel between the liberties thinkers began to take with the boundaries of thought and those later taken by rulers with the integrity of persons, one need not find in it an explanation. Still, the coincidence must have a meaning, the fact that the destruction of man in art just preceded his extermination in fenced compounds. Emissions from decomposing religion infect politics with cult feeling, and energies which had for centuries been somewhat disengaged are harnessed to physical reality, art emotions converted to power, or the control of matter.

The story of how enthusiasm for the primitive and the belief that salvation lies in unlearning came to be a force in almost every field of thought is exceedingly strange, but I hope no reader will feel it at the end an aberration. Ideas which have made reality meet them on their own terms are no longer aberrations.

The book begins its examination of these undoings in a lull, meant as a contrast to the convulsions which follow. For the French Rococo, civilization is a garment worn easily by a man who lounges in the mother's lap enjoying the amphibian experiences of pastoral, picnics which hint regression to animal feeding, childish games. The style's moral instability is signaled by the curve which rules it, a style which dissolves as it progresses toward its most licentious member Fragonard, its nearest approach to religion, as pornography can seem almost mysticism.

In *La Nouvelle Héloïse* Rousseau, one of the great resisters of the Rococo, restores God in the form of society, and uses the unlikely weapon of the child to undermine the age's confidence, turning it from play to ideology. He replaces pastoralism with regionalism as if to divide the present into historical periods by depriving it of its center.

He is succeeded by still stricter scientists, indulgent Rococo clothing by abstemious neo-classical nudity, a banishment of metaphor and pulling in of peripheries to dungeons and paved temple precincts. This first of nineteenth-century historicisms reaches backward for a more primitive psychology, an inorganic vision of human nature which bestows a costly peace. David counters more and more the abrupt, discontinuous quality of his idea of heroism by reiterating its gestures like watchwords becoming catchwords. Thus the Revolutionary crowd can be a proliferating unity, like the small temple chambers in the Thorvaldsen museum each with its bleached god.

Now a ruler arrives to reconsolidate this crystalline dispersion, preaching heroic inertia and the esthetic of smoothness which is how authoritarian peace always looks. The most interesting later practitioners of neo-classicism diverge from explicitly political subjects, express anti-Napoleonic sympathies, but still present the organic as inorganic, so Runge's babies are ice patterns, and Friedrich's trees mechanisms not organisms, as if he sought beyond everything a container without a content.

Rising to combat classical history as coercive emptiness is Catholic medievalism carrying its full force only in Protestant countries and above all in England, whose industrial lead is attributed on the Continent to her ruthless rationality. The Gothic Revival plays with quaintness and obscurity, with the possibility that old crudities are really high symbolism, but essentially it uses medieval forms to embody a new disintegration of thought and is tempted in its open hostility to the present to succumb to principles of authority outside the realm of adult credence. In Ruskin allegory and derangement follow helplessly from each other and every example is in danger of becoming a symbol.

The later phase of the movement recognizes itself as a detour or, more majestically but no more hopefully, a decay. From a dogma style has degenerated to a tone, a fog of materials trying to bring an atrophied part of the soul back to life. The Aesthetic Movement is the pseudo-superstition of resurrecting man's capacity for belief by shocking the senses with gorgeousness, like Wagner in his silks and furs.

The course then doubles back from history to prehistory, from Gothic Revival to Ossian, to catch up a strain of historicism from which the anti-historical view will spring. Folk-collectors of the late eighteenth and early nineteenth centuries claim a further-back ancestry for themselves; wandering in mental mists, they begin to perceive history as an animism which might fill in for religion. But with the Grimms this fiction that is more than fiction begins to compel allegiance rather than belief, and the flaws in their understanding establish its authenticity. Poetry is redefined as an unpolished lump toward which the proper respect verges on fanaticism.

Later in the century myth becomes a preferred literary mode, dark old forms reasserting themselves in conscious art. New hermetic ideas of the pictorial and interfusion of the arts with each other are forecast prosaically by the Pre-Raphaelite conception of painting as illustration.

But the true psychologizer of archaisms is Burne-Jones, for whom the simplest experiences become abstract, flowers become fables, and nature sterilized hastens the flight into the psyche.

The conception of a world beyond subject matter, and myth as anonymous ambiguity, is met best by music which still bears traces of representation, operas of Wagner, early Strauss, and Debussy. Nietzsche can be seen as an intellectualized equivalent of Wagnerian dissolutions, a myth-enforcer exasperated by shop-soiled historical accuracy to construct his god of frightening dream images.

Anthropology actualizes Nietzsche's idiosyncratic perspective on his historical moment as experimental reality, and redefines culture by reference to something cruder. A science of superstition is only desired by a decadence which perhaps imagines itself nearing an extinction. It can be an excessively literal-minded counterweight to Europe, a more drastic folklore, or a poetry almost without relation.

Nietzsche had always seemed about to proclaim an anti-religion, but this system more passionate and tyrannical than other philosophers' never fully emerged in the daylight of delusion. The bedevilment of late Romanticism by religion has its final flowering in D. H. Lawrence's rediscovery of cult as the fullest reach of his inventive powers. He fashions his community of horrors from which it is ideologically a short step to the visionary politics of early Nazism, more a conscious derationalization than formation of a new magic, which improves Nietzsche's freedom without responsibility into obligation without responsibility, from which symbolic trappings fall away leaving pure order-fanaticism.

In early Soviet society forces are differently aligned. Jaded and inexperienced palates had been seen to overlap by purveyors of refined folk art, and a similar intuition lets Kandinsky forge of worn-out remnants of Romantic spiritualism a radical decharacterized art. Contrarily, the attempt at a transvaluing politicization of all thought leads, in its second stage, to stony conservatism in art and life, like a humorless folk style without the flair of either naïve or sophisticated variants. Like Nazism, Soviet Marxism had offered man an abstraction for belief, not blood but the proletariat, which is to say justice or a kind of equivalence between production and need.

History waited to begin, man remained undiscovered, and the energy let off by recognizing these simplicities was forecast in Trotsky, exhibiting the new functions of socialist man as if he were a lucid Constructiv-

ist club or library. But his demonstration is based on fantastic privilege, and in the next stage Stalin doesn't expose himself so frankly, the new man becomes an enigma and thereby resembles the good dumb brute he puts forward for emulation, a stage which marks a temporary halt in the story of man's oppression by God substitutes of his own invention, many of which, if not this last, have issued from places disturbingly close to the sources of poetry.

DELIBERATE REGRESSION

NATURE AS A CHILD

In the eighteenth century pastoral becomes a more serious or at least more literal form than it had ever been. But before Rousseau shows it particularizing to rusticity, coming down to roost in a cot which seems actual because simple, it passes through three slackening stages. Earlier its nature is determined by an inextricable tie to the feminine bedroom and boudoir, the most sheltered precincts of civilization felt as dens of naturalness. Watteau's interest in women's clothes had gravitated to their vaguest component, the skirt, and infused it with unforeseen melancholy, its wrinkles as of a pool into which something small has fallen suggesting those problems of aging the painting keeps anxiously at bay. Sometimes his women are scattered on the ground like cut flowers, or held against the sky like Gilles, a large silvery cloud. His sheens seem copied from nature, from the surfaces of feathers and wings, a faint gilding of reality which connects luxury and passage, like music, a narcosis favored by this painter.

The asceticism which lends Watteau's enthusiasm for the feminine its redeeming dissatisfaction was alien to the rest of the century, which first sank comfortably back into an indoor ideal less dreamlike and problematic. Though less the victim of devaluing imitation, Boucher is a more deeply conventional painter, who inventing new textures and new lewd-

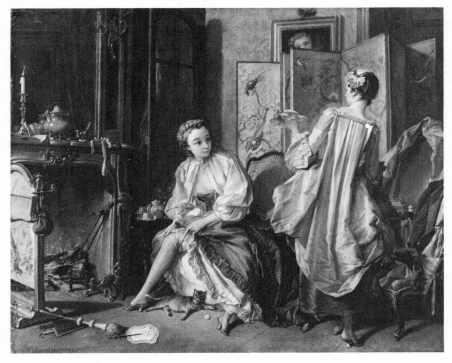

François Boucher, *La Toilette*. Thyssen-Bornemisza Collection, Lugano, Switzerland

ness converts them at once to conventions, cools them by immersing them in paraphernalia and desensitizing the human face as a carrier of meaning.

Watteau's pastoral restricts masculine entry, and Boucher's occasionally does away with it altogether, his final intimacy feminine, where two women admire each other, hand each other a bit of silk to provoke the next move in a dressing or undressing which is the central cultural act, for beyond all the barriers of curtain, ribbon, and lace is nudity, civilization's inmost recess, a secret granted in the form of a final simplicity. It is as if everyone carried in his mind's eye the vision of a naked Diana with one attendant cushioned on the foliage beside a bathing pool, as if dress were the obvious code for undress, as if the disorder of clothes, tumult of clashed materials and densities, conveyed sensual abandon better than the incommunicative flesh itself.

The excitement of the center increases as one retreats from it, and spies multiply at the periphery of the space sacred to woman, denatured

by literal intrusion. So the curtain has its hand on the door it has pushed lightly inward, and the painted portrait's eyes peer just over the screen from which inquisitive birds look down on the treasure passively displayed in the gaudy shrine which competes to outshine her. The fact that Boucher enjoys it more and understands it less, that the feminine becomes for him doctrine instead of feeling, has not prevented this linkage of sex and civilization from taking deep hold, till now it seems natural to feel woman the guardian in the same guise of both.

Watteau shows leisure raising itself to art in music, dance, and theatrical costume if not performance, for he lets art shade off into ordinary existence to fill a receding country vista without a boundary. Though grownup grace is a learned version of childish play it becomes automatic and appears to spring spontaneously in the backs of those inspecting the pictures on *Gersaint's Signboard,* for example, producing an idyll in a city street. He draws dancelike movements out of casual encounters, large Rococo curves from the departures of picnickers, but by Boucher's time the process has reversed itself, and starting from the porcelainized feminine closet he casts outward. Beginning in art he discovers nature, and the starting point distorts the result in a peculiar way, wildness the antithesis of art, disheveled, careless, like human things hastily assembled or coming undone, trees as tattered hangings. The landscape is thus a sophistication of the bedroom, a rumpled softness for whom halfdress is the natural state, a multitude of invitations—ragged banks, ragged windows, ragged doors with doves fluttering around them like vapor from body heat. In spite of such iconography the place is strangely cool in texture, and colorless through the graying or blueing of its greens.

In this mood idleness begins to seek play which looks like work instead of art, begins to build dairies and little mills instead of theaters, which Boucher's landscapes had already shown the charms of, more sleepy and less demanding than Watteau's parties. The manufactory of milk is especially easy to conceive as a feminine prerogative, cows and maids a reinforced benignity, immobilized at the service of growth.

So the boudoir grows up into the nursery, and the mistress into the mother, largely a symbolic change and not more than a flirtation with adult responsibility, for the woman becomes the child and identifies with infancy rather than serving it, so Marie Antoinette builds her village in order to feel a hundred leagues from the palace, not to force her way through into mundane existence. The transition from the boudoir to the

nursery in Fragonard redefines the ultimate feminine space as home and a comfort dedicated to the embryo or child, instead of mystery and a lure belonging to the woman's own will. It seems a more generous and sociable ideal, but it contains its further abdications, finds its greater naturalness in resurrecting children's games as the focus of grownup activity, the poplar which the stair coquettishly circles as it climbs to the porch of the Queen's House in the hameau as a living maypole, the landscape dotted with hiding places made not found.

The Queen left herself no activity but that of tourist at Versailles, climbing her lookout towers to view the world with a detachment rarely equaled, achieved through the laborious re-creation of the life of a child. She had realized more unhappily than others in her position its social nullity and acted out the idleness forced on her in the most diversified way. To remember that similar functionlessness can be found far afield in this historical moment one looks at the overdressed people in Tiepolo, whose costumes are last vestiges of lost functions, whose idleness weighs heavier because it is masculine and military, because it still signs with the signature of energy.

Of all Rococo painters Boucher is the only real believer in the sufficiency of the human which the whole style professes, and even in the sufficiency of human mediocrity, who solves the eighteenth-century problem of the loss of transcendent realities by inventing a comforting code. When he shows Madame de Pompadour outdoors, the outdoors is simply a convention of solitude, meaning one will not be disturbed, the little glade almost as well furnished as her apartment in the palace, rocks making a table, roses only waiting to form themselves into a chair under her, trees like drapery, for a woman who has come out—of all farfetched activities—to read, whose surroundings are always attentive, who feels such confidence in her civilizing power the woods become as safe as the boudoir.

Boucher's people stay young by inactivity and bad posture. The same sun that turns men the color of tree bark makes women into rose petals, all parts of the canvas uniformly robust and plump, an effect achieved by his visible brushstroke, like the weave of reality, as if it comes in a standard unit or stitch, forming a seamless tapestry. The pleasure arises from this evidence of everything's being produced by the same method, of its all being styled. In his landscapes dilapidation becomes a style, hardened into permanence, dovecotes, waterwheels and rickety wooden bridges, mock houses, mock work, mock transport, perforated by decay to the

verge of believability, where carelessness never endangers so repair is unnecessary. The landscape is dotted with these efforts at construction, lovable for their failure, as if it were safe to trust the world to ignorance.

Such paintings point to the hameau at Versailles, not a real hamlet moved here or meant to look it, buildings happily linked around a stagnant focal lake, which provides only reflections and puzzles of transport. The working village, with its dairy and its ballroom, constitutes scenery —a front and a back, a good side and an underside, whose actors didn't try to avoid going behind, for there the fiction was most delicious, because then you were inside the Boucher canvas looking out between the threads.

Like Versailles, a self-sufficient world which is neither rural nor urban, but more formal than either, combining the insularity of the former with the sophistication of the latter, Boucher's paintings fall between myth and pastoral, myth lowered by rusticity and pastoral distanced by ritualized sexuality, according to a color code followed more strictly in the shepherd subjects where men are red, women blue, and the background velvety green. The blue vegetation of the pure landscapes approaches still nearer the look of tapestry, the least human matter become a wall hanging, as lewd scenes were felt to be most appropriately represented in the frigid medium of porcelain.

Louis XV was driven by the irregularity of his habits to changes in the tapestry of bedroom ritual which the onlookers affected not to notice, though this knowledge undermined their participation. The King was put to bed every evening and waked each morning by a crowd of courtiers many of whom exercised brief functions like holding a candle while he read his devotions in a room already brightly lit, or handing him a small article of clothing. Like many of his contemporaries the King had tired of the large rooms of the earlier period, perhaps as much under the influence of new heating technology, which by improvements in chimneys made it possible to be comfortable in cold weather, but only in smaller areas than customary, as by a revulsion from grandeur. In any event the system which he devised was not to move the ceremony from the large bedroom of his predecessor, but to pretend to undress and to keep his clothes on under his nightgown so that when his visitors were shown out he could climb upstairs to Madame de Pompadour's apartment. In the morning he arrived a few minutes early and dozed in the unused bed before calling in the others. His predecessor had been punctual and thus put as little strain on the attendants as was consistent with

frequent small demands on their time, but Louis XV was less precisely bound by the schedule and exposed its arbitrariness more because it was inconvenient for him too.

It is a short step from his charade to Marie Antoinette's donning the costume of a shepherdess, not for a play or a ball or to have her portrait painted, not for a specific ritual function, but an ordinary afternoon, life itself, what is left of it. Yet a costume is more confining than the most inconvenient clothing and her willful excess the most illusory freedom.

Boucher shows more and more the conventionalized face which reality puts on, giving little clue what it is like underneath. His women wear a heart-shaped mask, vividly reddened in the two main lobes and unchanged even in profile where the noses make only a slight interruption. Watteau's poetry of dress dematerializes its object, but in Boucher flourishes and whimsies—knots, ribbons, bows—are glorified and ordinary experience poeticized not really transfigured, the boudoir, workshop of beauty, trumped into a shrine by showing it overflowing with feminine vestiges. Ribbons, though impractical, make one practical suggestion— they may be untied and their wearer undressed. In Boucher we feel the constant proximity of undressing or of the clothes loosening of their own accord. Where style has taken over, to step out of one's clothes and escape the tyranny of style will be the ultimate freedom. But after the rules are broken one finds under the style only a nondescript reality, and when Boucher's girls get their clothes off in his mythological pictures, the flesh appears atrophied from disuse, instead of heightened by suppression.

The other source of revitalizing energy is meddlesome childhood to which he turns over all the arts and sciences in the wall panels at the Frick. Real children, except for the King's, were banished from Versailles, but fat representations of them erupt in the painting and decoration of the period. In these Bouchers they keep infantile proportions— large heads, squat bodies—while assuming the knowing expressions of seven- or eight-year-olds and scaled-down grownup clothes. Fresh incongruities occur in each, stemming from the size or force of grownup implements, or the improbable deftness or concentration needed to wield a telescope or sculptor's chisel.

To turn the world over to children or monkeys is a confession of failure or wish for extinction. When we are amused by Cayot's *Cupid and Psyche* as two-year-olds in the postures of experienced lovers, we give in to cynicism and it does not matter who does what or how well it

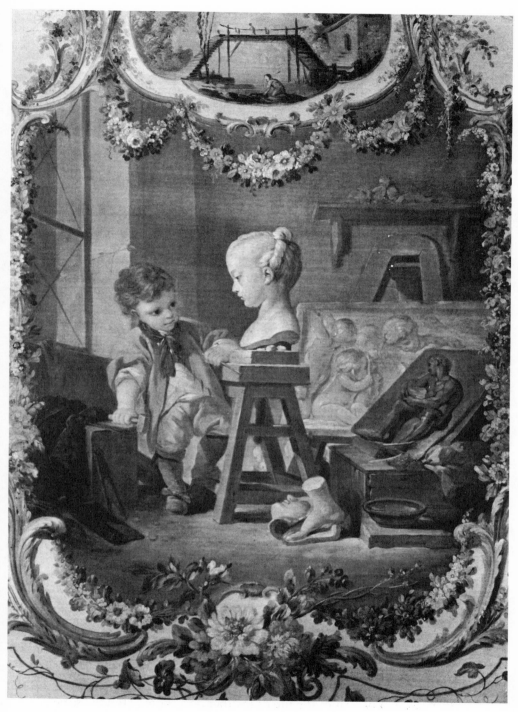

François Boucher, *Sculpture*. The Frick Collection, New York

is done; we will not interfere. All human effort, judged severely enough, is clumsy, but in these emblematic spaces the highest is tolerantly degraded. Boucher's nonchalance arises from an absence of feeling for consequences, which makes every subject pleasant, reading a letter or attempting a rape, punishing a child or paddling in shallows.

His people cannot take risks because the idea does not exist for him, but in Fragonard the idea of childhood is the idea of risk, an unstable state where everything is done in a hurry and the privacy sought is in danger of being broken in on, though the even younger spies are a lesser interruption of seclusion than adult jealousies or rivals. This pressure applied by learners more infantile still is Fragonard's way of signifying the evanescence of the Eden of youthfulness he depicts. His actors have a short time but they do not use it well, for however much a ride in a swing or climbing a ladder is a dream fulfillment it reduces one to a human ribbon or nosegay and withholds firm identity. But his frivolous surface incorporates a sublime understanding of impulse by seeing in the human actors bubbles carried aloft by a wave on which they form only slight abrasions, frivolity marking their place in the midst of something larger, young love put at the center to fix the highest reach of the accidental, whose intensity frightens one who knows its undependability.

The fluidity of his brush is itself a youthfulness careless of distinctions, piled clouds echoing boiling leafage, discarded clothes echoing fleshy reeds, drawn into dissolution which takes them back to undivided substance, a state before analysis or even names. Like this awareness without edges, the perfect happiness recalled by Rousseau in the *Rêveries* occurs in moments when he loses his adult grip, taken from him by a Great Dane running beside a carriage who knocks him down on a country road, or induced less accidentally by lying in the bottom of a rowboat drifting on the lake. When he wakes after colliding with the dog he lies on his back looking at the night sky and feels an access of pleasure at being unable to remember where he is or where he lives, at being unable to fix himself in space. As consciousness returns he watches the blood flowing from his wound with the contentment he would feel beside a country stream, and then picks himself up to walk home unaided, without a clear idea what he is doing, accomplishing useful work while enjoying the benefits of unconsciousness, briefly becoming a creature of instinct.

His nearest approach to the life of instinct on a more extended scale is the two months he spends on the small island from which the rowboat

set out, which he wishes had been two years, two centuries, or an eternity, two months during which he leaves his boxes of books and possessions unopened and decorates his room with hay and flowers collected on his walks. But these trophies gain their effect from being placed on the unopened boxes, and the island its charms from its manageable size: he divides it into squares and plans to follow the plants through the seasons in each. As he leaves, the idea occurs to him that this deserted place could house a colony of rabbits, a Crusoe-like plan to populate it with dumb but productive inhabitants.

He is caught by contradictions inherent in solitude turned into an ideal, or in the self attempting to subtract its various outside supports. In the end he can give his solitude a content only relatively uninfected by society, applying methods developed inside civilization to study objects outside it, though plant society has felt the hand of man even on this little and inefficiently farmed Swiss island. His happiness, which comes to him from non-human sources, is forgetting: only when, alone in the woods, he forgets his enemies can he imagine they forget him. It can be registered as happiness only when measured against distress, so the brevity which he regards as accidental is its essence. Looking through his plant collection he is entirely happy *in the most unhappy lot* anyone was ever burdened with. Rousseau the great de-imaginer of society is always writing about it in spite of himself, and his most successful doing without, in things not thoughts, is a suicidal prompting soon retracted, for having given up botany and sold his plants and books, he is smitten with the love of it again, and, now poor, has to recover his disowned knowledge by a more primitive method, borrowing the books and copying them out by hand.

The girl in Fragonard's *Swing* is also half-lying on her back, set adrift in mindless ecstasy through the simple machinery of the swing, which is suspended in a structure of voyeuristic gazes, her boy-lover looking up her skirt, another man—who controls the ropes which produce the monotonous pleasure—staring from behind, and statues on either side watching from lower and higher still. Like much garden sculpture in Fragonard, they dissolve the boundary between flesh and stone, art having forsaken its pedestal of permanence and responded fleetingly to the moment with whispers and smiles inappropriate at all other times in this place.

Children's games like swinging or blindman's buff have a more insistent purpose here than in Watteau, where they form part of his diffusion

of art into the wider spaces of life. Such ritual is more recognizable but more bizarre as a code for art in Fragonard because its extreme rigidity is seen as impulsive when it occurs in grownups, as if to propose that art should strive for mindlessness.

Like many Fragonards it has replaced a man- with a foliage-centered world, a fancy padded orifice which dwarfs the creatures venturing around its edges. In such a setting the lovers' union looks even flimsier, a message transmitted with delicate literalness by her ejaculated slipper, which has just begun to repeat more enthusiastically her controlled fall, and will land on the waiting lover to give their consummation-without-touching its little seal of truth.

Though obscene in the patron's inception the incident as seen by Fragonard achieves Rousseau's ideal of passion and innocence coexistent in the same heart, and manages to extend the preliminary stage of an infatuation more successfully than he did in *La Nouvelle Héloïse,* where it was also devotedly sought. By rhythmical heating and cooling like the motion of the swing Julie tries to keep their relation aloft without making the final concession, by granting and then drawing back from the favor, to maintain their motion by rebounds the reader is to feel are as natural and unplanned as laws of physics.

Checking time in its flight to make a stoppage like a statue or giving passion in its rationalized interstices, a series of letters like discontinuous stills, are Fragonard's and Rousseau's ways of suggesting a continuum by contraries. The jumble of disparate episodes in *Fête at St. Cloud,* like a child's narration beginning near the end and finishing near the beginning, gives a better sense of the democracy of moments than hierarchy would. When Fragonard becomes consecutive on a large scale, in the *Progress of Love* at the Frick, the progress is hard to detect. In four scenes love is shown as two feverish attempts to meet and two relaxed recording sessions fixing spent emotions. An intense perception of the present takes paradoxical form as anticipations of a future for which this intensity can imagine no definite content, and therefore fears, and recollection of something so quickly receding it exists now only in reading or drawing.

The first of the vertical panels, dominated by their green backgrounds and thus making a dim confusion like tapestries, naturalistic not woven, shows four figures like two in a garden like a jungle, seated on or falling from a low wall which separates the front border from a turmoil of foliage. A lone male figure leans out from the left, obscured by a cubic

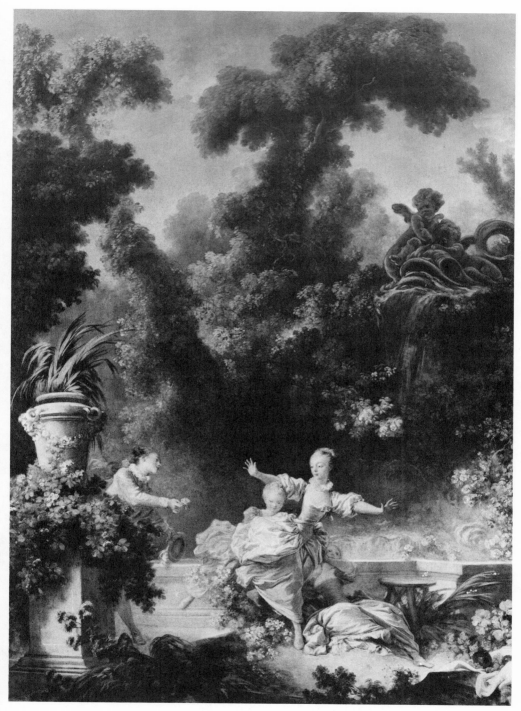

Jean-Honoré Fragonard, *The Pursuit*. The Frick Collection, New York

pedestal topped by a cylindrical urn, gushing soft leaves from the square and reeds from the round. He grows from the base like a herm and wears pale colors like a porcelain ghost, belying the force of his gesture, offering a rose to a girl spreading her arms wide in alarm, who grows together with her maids. Immense trees behind follow the people's actions like their shadows, enlarging and dispersing them but keeping faithful to details like the outstretched arms.

In the second panel the couple is alone, except for the extreme agitation of the surroundings, this time monolithic, a spout of tree rising over the spot where the boy erupts into the garden from the top of a ladder out of a lower world. Again a statue rears above them, its spurning motion connected with the girl's semaphore of spread and lowered arms stopping the boy as if she sees an intruder coming the other way, yet telling us it is a false alarm. Though he will in a moment be able to take the next step into the garden, like the postures on Keats's Grecian urn his arrest is defeat.

In the third scene they are again in company, their excitement past. Sketched by another boy in the foreground, the girl must be imagined holding her garland over the kneeling lover's head for a prolonged moment, never finally crowning him, a moment in which the guardian statue has fallen asleep.

The last scene is private, the lovers on a pedestal at the center, like a statue, she reading a letter, he lounging at her side, a parasol which might have shaded them displaced to a nearby statue, the background a triangular opening rather than an adventurous extension, tops of trees like hummocks that make a confusion about the level of the human action.

The same events are repeated twice, first in company and then alone, their achievement of privacy belying the disappointing socialization of the whole sequence. As they are for Rousseau the earlier stages are the best, and manage, as he does, to make a mystery of generality, and to use the assignation to portray human society as a vast unknown.

All four provide a mystification of the normal acts of lovers, assimilating the sexes to each other through the boyishness of the man, and getting thereby the blandness of cooing doves. Greater self-consciousness drives the last two on into parody-religion, for rituals must be made from the inessential parts of a process; and it is in the nature of the act Fragonard wants to record that peripheries should be given the greatest expansion. Rousseau's lovers wax most eloquent on dueling or the peasants of the Haute-Savoie, subjects accidentally turned

up by the hard probe of their passion. Only by the disorder of the rela-
tively clear-headed foreplay and aftermath can the authenticity of the
central ecstasy be gauged. In *La Nouvelle Héloïse* the reflected intensity
takes the form of perverse assertions that all is over when it has hardly
begun, and in Fragonard the reality of the focal mystery is seen in the
undoing which is his relation to all that went before, corruption or free-
ing of the painting's surface to a liquid state.

The eighteenth-century interest in the letter as a kind of sociable
secrecy, a form both public and private, intimate and decorous, repre-
sents in Fragonard the first stirring of a contrary impetus to the life of
instinct. For no matter how passionate a love letter is, it formalizes the
lovers' disjunction in time and space, and introduces the possibility of
intellectualization, for the emotions he re-creates in the letter are not
exactly the ones he feels in the moment she is reading it, a detour even
more tantalizing when they look over each other's shoulder as in the last
stage of the *Progress*. *La Nouvelle Héloïse* keeps showing how divergent
the responses in the closest relation can become if you are not on the
spot to take the other's temperature into account in planning your
course, and have to form the whole discourse imagining her feelings.
The first word of the reply is enough to tell you you were wrong but
not at once how wrong. Part of the form's excitement for them lay in
how clearly it shows the role of separation in all communication: the
difference between people is the space given to words for maneuver.

Readers in paintings are usually feminine, and the viewer becomes a
violator, reading her thoughts without her knowledge reflected from the
page in her face. The flimsiness of the paper suggests the replaceability
of objects of feminine attention, and when "the friend" (the only name
he ever has) in *Héloïse* makes a production of recopying much-thumbed
letters into a sturdy album, increase in the thereness of the correspon-
dence is matched by a drop in its importance. Self-consciousness
brought on by letters causes shrinkage of the mind's span.

The absence of the lover in Fragonard's *Souvenir* prompts the girl to
draw the tree into her dissatisfaction and to write his name on it, revers-
ing the abstraction absence causes by embracing a stand-in while tattoo-
ing it with the old loyalty. When the friend in *Héloïse* is sent away for
coming too close he makes his way to a point on the opposite shore of
the lake and writes his letters to Julie in view of her village, and, helped
by a telescope, her house, on a rock table deposited by a glacier. Now it
is winter and he needs a fire to bear this solitude, but if he cannot be

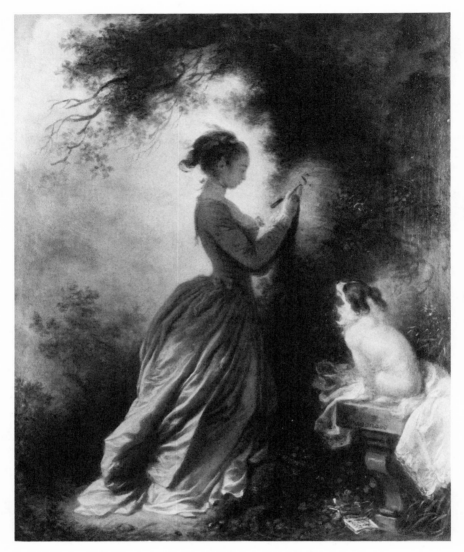

Jean-Honoré Fragonard, *The Souvenir*. The Wallace Collection, London

with her this is what he wants, deprivation which by clearing away his surroundings makes him feel more there. Such enjoyment of a bare world seems a forecast of the dead ends of neo-classicism, nudity and suicide, nudity as hardship without clothing, not luxury. The friend threatens suicide in the lake but leaves it to Julie to rescue that idea from theory into practice.

Drastic solutions are so greatly desired by Rousseau that if he cannot have one extreme he will take the other, if not passion then education, two sides of the same view of human nature expressed in the symmetrical pair of books he wrote at the same time, *Emile,* the treatise on education asking if regulation can be made free, and *La Nouvelle Héloïse* the sentimental novel asking if passion can be controlled.

Though it was very searching his interest in childhood began as a need to prove something. Born a few days before his mother's death he returned to origins for the rest of his life in an effort to believe he and man had been good at the beginning and their fault lay outside the fact of their existence. But when one has gotten out from under the curse at the beginning one is left with a more intractable problem of how things go wrong thereafter. In *La Nouvelle Héloïse* a good beginning invariably provokes retribution which lands the sufferer in a worse spot than before his happiness. In *Emile* the need to prepare the pupil for society requires one to make his life worse before it can be better. And in the *Second Discourse* all the beauties of the presocial state, which to imagine so purified of ingrained notions is Rousseau's great contribution, make justification of the life around us impossible.

Prehistory is often the favorite period of primitivists, but in Rousseau's case the ability or more accurately the desire to discard the achievements of civilization is so powerful that he cannot re-enter social life when the hypothesizing is over. Part of his effort is reminding man of origins he has forgotten and making him learn infancy again, pursuing prior stages like a child badgering its father with questions. The goal of this recession is to recover man alone, hence the source of his own ideas, his own begetter. But in the present, priority is only a fiction of not knowing what the result should look like—so he makes Emile laboriously reinvent the microscope and thus artificially reproduce the whole history of man.

Rousseau's education must always appear the first of its kind—hence his rule that every teacher can have only one student in his life: two students would unfocus the vision and undermine his authority. The falsehood is that Rousseau himself has been through it before and is now using the idea of a child to organize and perfect the history of his own development.

Now he begins education with birth, terrifying as a practical proposal, but creative as the reseeing of something irrecoverable. One can speculate about the educative effect of milk, swaddling, and children's play

when past, but to scrutinize them passing is to rebind the baby in definite intentions at every step. One of his most interesting experiments is the attempt to control the order in which ideas are learned, admitting them one at a time, tidying the subjective chaos of remembered initiations. But "What if I had come on things in another order?" is a different inquiry from wondering if he should teach Emile freedom or property first, opposite impressions of the same configuration.

In the end the arch-subjectivist becomes a behaviorist, instilling a predeciphered moral by manipulation devious like a nightmare, and continuing to preach that living example is less coercive than system. He shows Emile how to plant seeds and quietly rejoices with him over the growth of the bean plants, helping him water and weed them, until one day they come and the plants are gone, the teacher having arranged with the gardener to root them out on the pretext of needing the ground for something else. Thus the tearful child is *shown* the existence of prior rights, legal ownership against instinctive appreciation of a place. Rousseau's sense of the badness of the world causes him to opt always for toughening instead of shielding the child, and his liberation of education from the schoolroom leads to the unbearable condition of every room a schoolroom waiting with its lesson.

Finally Rousseau has escaped subjectivism in the retrospect provided by Emile. If proof were needed that he is more concerned to reconstruct his own development than invent a practical scheme of nurture we have it in his farming out his own children and limiting contact with actual children to bestowal of money, lottery tickets, and apples on strange ones met along the road. The schoolroom is a coercive environment in Rousseau because it has been his chance to systematize his ideas of intellectual development, but his own learning has consisted mostly of detours, and unraveling why he is taking the long way around on a walk—it is to avoid a beggar made dependent by his goodness—is the fulfillment of his quest. When his interest in the strange paths the mind takes leads him to lay out a complete set of routes, it is more like a geometrical garden than his random country walks.

Even in Fragonard the schoolroom is located on the same scale as the prison, though his *Schoolmistress* means no harm to her half-naked reciter, will perhaps butter him like a piece of bread sooner than she will beat him. But the brown cellar in which the lesson takes place makes the disproportion between them subliminally threatening. Fragonard's is a world without real parents because parents are children too, a world

without rules, but paintings like this one intimate dissatisfaction with Rococo refinement in the garden and the bedroom, intellect largely closed to it, until these feminine spaces come to seem cages and one dreams of escape into prison or genuinely hard surfaces.

As the pupil moves from childhood to adolescence she becomes the beloved, an uneasy marriage in *La Nouvelle Héloïse* between the politicized theme of authority and the old passional indulgence, which eventually forces a clear choice between the interfering sets of feelings. Similarly, another coercion, the idea of picturesque labor, seems to force a choice in the end. Both Hubert Robert and Fragonard are taken with the vision of washerwomen heating themselves up under a threatening sky or bridge, turning the fountain into a smoking sacrificial altar, their work an engrossing immolation greatly superior to idleness. Rousseau picks a trade for his well-to-do Emile in search of activity compelled rather than self-willed, and the most expensive entertainment ever given at the Trianon turned it to a country fair where the Queen and her

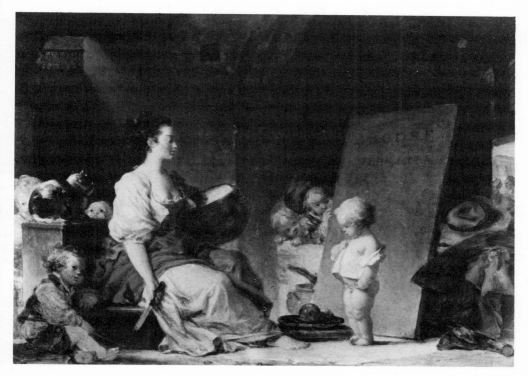

Jean-Honoré Fragonard, *The Schoolmistress*. The Wallace Collection, London

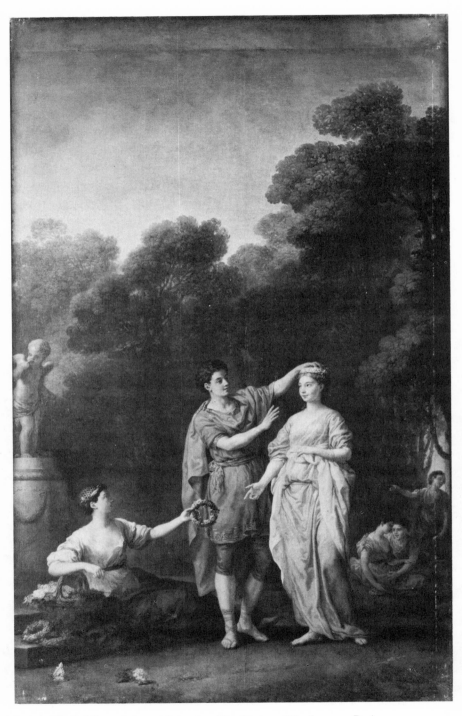

Joseph-Marie Vien, *A Lover Crowning His Mistress.* The Louvre, Paris

friends sold sweets and drinks from little booths. Like a child who wants a way, no matter how fictitious, to enter the world of money, the Queen's most imperious act was to insist she be paid for her lemonade.

The interest in work is an early sign of hankering for more coercive structure, for a life which will really make demands. Later when the altar first appears in scenes of love, looking much like a garden statue but differently regarded, it is the outside objectified, squared up, to which one dedicates one's formless self, the masculine about to assert itself over the feminine, and it is in this quasi-religious realm that the shift to neo-classicism is silently taking place. The feminine daydream of losing one's heart will turn to the masculine act of setting off for war, consecration at the orifice of death instead of the secret places of the genitals, a plan to depopulate, not people, the earth, to subtract not add, which feels contempt for the selfishness of creation and wants to make history with a destructive act of social use. In neo-classicism the Rococo problem of staying young is solved conclusively by dying young.

By reliquizing its stages in the *Progress* Fragonard had moved toward turning love into a cult. But if he solemnizes the subject by fixing it, Vien, who painted four replacements, institutes a pseudo-religion openly in *Two Greek Girls Swearing Never to Fall in Love, Two Greek Girls Meet Love, A Lover Crowning His Mistress,* and *Two Lovers United at the Temple of Hymen.*

The development seen in these cycles was happening in many places in the 1760s, at the end of *La Nouvelle Héloïse,* for example, where the dead Julie's virtues are turned into a cult, having been exemplified as self-defeating during a fever she catches while saving her drowning son, her death a suicide with redeeming social value. Julie's cousin treats her grave as a shrine, and she and the husband invite St. Prieux and his English friend to form a little community devoted to Julie's memory, which by its sexual makeup will be almost a monastery. So they invent an institution rather than making do with one they are given, even the family proving unstable, which from a distance the lover thought a perfect form.

This movement of *Héloïse* from passion to social conscience, from the cult of private impulses to the worship of standards found outside and prized for their alienation from oneself—represented by causing them to emanate from the rival—parallels the generic development from child to man and the stylistic one from Rococo to neo-classic. The Rococo could make anything decorative, thus even bookcases join, in the libraries of

Bavarian abbeys, the play of forms. The later period can make anything serious, so in Rousseau the innocent insignia of childhood spawns a doctrine. His obsession with milk, the authentic mother's milk not a nurse's, and milk as wholesome for grownups instead of alcohol, seems to him not a food fad but an encounter with society's broken relation to simplicity. This literal infantilism and symbolic innocence-ism are early signs of a sentimental cult of motherhood which gained momentum in the early nineteenth century, a premonition of strain on the family rather than its consolidation. To Rousseau the family formed part of a lost pastoral ideal, a feeling in which his experience had made him prophetic, for in the urbanizing nineteenth century the family came to represent for others as well a lost perfection.

The most blatant transitional figure between the old style and the new, Greuze, makes the pretty eighteenth-century subjects didactic by a slight shift. His *Votive Offering to Cupid* shows the kneeling figure so frequent in the art of the period, a veiled religious posture, whose disguise he begins to remove. This prayer-reverie appears variously in Greuze—women lament their dead husbands, their broken mirrors, and in the present example, their about-to-be-lost virginity as they contemplate their first affair. In spite of different paraphernalia there is only one event, loss of innocence, a condition invariably feminine, like breasts, Greuze's a mind in search of archetypes the spectator must peel off the superficies to find.

The girl in *Votive Offering* is offering herself to an ocherous little Cupid on a high pedestal carved with the rape of a nymph by a satyr. A pair of doves she has brought are lounging on roses at the base, floundering enfeebled and untied, even more exaggerated signs of helplessness, softness, and loyalty than she. Cupid's pose would be incomplete without her, for he holds a stone garland, his counter-offering, over her head, off-balance but forming a sculptural group with her. She is turning to stone—one of her ribbons has caught the ocher of the statue, and her dress is a strict classical costume—she will end petrified as part of the statue's lesson. By calculating the pose more carefully than Fragonard, by somberer colors and colder handling Greuze makes the spectator a voyeur at the lewd display of virtue.

He wrote demeaning explications of the moral benefits of his pictures which argue that they are simple and well-meaning. The main events of his life make him too a moral exemplum, who imitated the plot of *La Nouvelle Héloïse* as a young man in Rome, renouncing a girl he loved

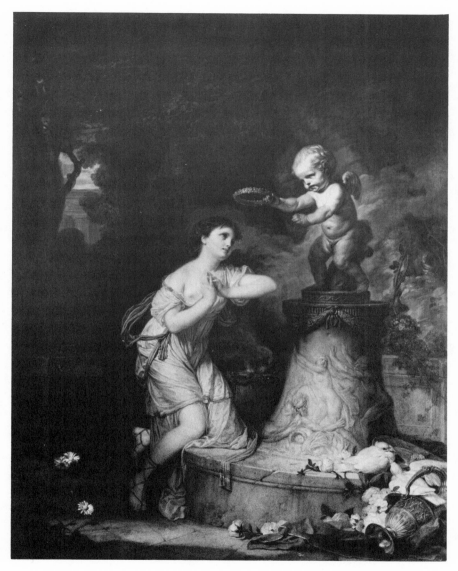

Jean-Baptiste Greuze, *Votive Offering to Cupid*. The Wallace Collection, London

because her birth was too high. His description of his later life as a husband does not convince one, though, that he found illumination easily in that. He could have extracted darker morals from his own weakness and the unfaithfulness of his wife than his paintings tell.

But his life suggests explanations for the way the Rococo garland be-

comes a prison chain and figures are bound together by looped series of outthrust arms, forcing a clear meaning from their multiplicity. In the *Votive Offering* the exchange is violently halted by being shared with a statue, resulting in an image safe as coitus interruptus is safe, in a private temple-place cloaked in sad purple.

The idea of the moral model or exemplary soul, so pervasive in Rousseau and Greuze, is thought more convincing the more inhuman and unnatural its virtue is, the more its behavior disobeys all ordinary desire. Julie keeps writing her lover long letters when committed to seeing him no more and Rousseau gets his most aggravating tension from this stasis. Frustration is all, love and desire derive from it, and thwarting provokes reaction. But in the succeeding style cold exaggeration of gesture can produce something near the feeling of unexpressiveness, of time slowed down and energy conserved by cold emotion.

Before long the impropriety in Greuze was noticed, incongruity between firm teaching and soft matter. Subjects more consonant with instruction were substituted for his pouts and pitiable sufferings. Pain and ceremonies of death, banished by the Rococo, make a triumphant return after a cleansing purge of pleasure carried out in art before it happens in social life.

THE CULT OF DEATH

Late-eighteenth-century archeology began to provide the impetus for artistic innovation, encouraging purity and simplicity, for the action of time made Greece and Rome look barer, more colorless, and built of harder materials than they had been in fact. Death made them ideal and many of the measurements Winckelmann devises of beauty are qualities of the tomb—muteness, smoothness, tranquillity—of the just-dead or the long-dead, neo-classicism concentrating on youth and old age and ignoring middle states, youth a fresh corpse on which nothing can now be written and age a parchment so covered with writing that separate lines cannot be unraveled.

Winckelmann's obsession with youth is not enthusiasm for life but a dream of perfection which will somehow continue to be physical without veins, creases, or disfiguring diseases (he imagines Greek appreciation of the body an effective charm against them), his scorn for modern particularity of detail not esthetic in the usual sense, but the key to his hopes from life and his way of making sensuality spiritual. Greek expression is as vivid in their muscles as their faces, he says, matter uniformly expressive, one of his virtuoso extractions being an intuition of the temperament of the Belvedere Torso from a study of its folds. For all his appreciation of breezelike motion, a tremor in the flesh at rest, the

qualities of the ideal sleeper are more dependable in stone, whose nakedness can be studied without embarrassment in a leisure safely endless now that one has stolen the body from its possessor. Simplicity is now sought at the other end of life, not children and foliage, but the most advanced level of civilization, death a reposeful organization preceding the great disorganization, marble sculpture fixing the moment of inertia before decay.

Winckelmann ends in the worshipful posture of Greuze's sufferer, placing his garlands reverently at the feet of his favorite statues because he doesn't dare to put them on their heads. The highest power to which the thing-centered universe can be raised is the point where all objects are felt as corpses, and living in a roomful of recoveries from which the accumulated dirt has been cleaned is living like a ghost in a tomb. The incommunicativeness of many neo-classical works, like Thorvaldsen's, plays on the inarticulacy of stone to increase our sense of a barrier between dead matter and ourselves, felt more strongly by Winckelmann because his understanding goes so far without being able to cross the last distance. Inspection of the body intent as his finally seems morbid because it springs from insufficiency, not just wanting to be near the sacred object but to become it, and not just to inhabit it but to exchange souls with it. Worship is inertia when its distance from its object is as great as this.

The circumstances in which classical remains had been found, buried in the ground, infected deeply the subjects of neo-classical art, which gravitated more often than Greek and Roman originals to prison and tomb, the darkest and saddest moments as the realest of all. Perhaps the gain sought in greater frequentation of death is a diminished fear of it, and certainly the physical toughening advocated by Winckelmann and others is, in the widest view, preparation for death, to make a life of which is perhaps the most serious but a hopeless system. To be so purposive, to look always toward the simplest because most final of moments, imposes a too passive unity on character. Perhaps it is truer to see the pieces left by the past as uncollectable, disjecta prophesying the disintegration of all things, or at least in their fragmentation a hint of revolutionary upheavals to come in human society. Winckelmann throws seals, coins, vases, and sections of frieze together comfortably because he still has faith in an essence none of them can perfectly represent, but if one loses this faith and sees the human past as the record of damage done, it ceases to hold an answer.

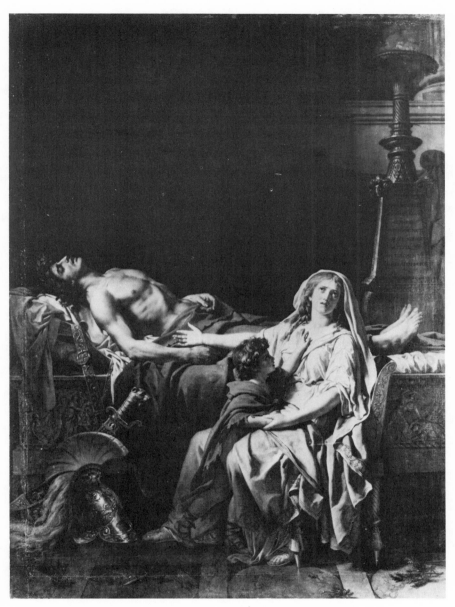

Jacques-Louis David, *Hector and Andromache*. École des Beaux-Arts, Paris

In Jacques-Louis David's first really archeological picture, metal appliances and a metal-green curtain like a patina numb the surface. Andromache's chair puts her below Hector's couch like a chair drawn up at

an altar, and the outflung gesture which calls oratorically for an action to complete its trajectory in many neo-classical works is here only deep frustration because both those successively called on by the zigzag of arms fail to respond, Hector because he is dead, she desensitized by grief.

This feeling of impediment makes the pathos of David's pictures tolerable, his mourners more serious than Greuze's because they wear a selection of archeological discoveries, because their hands and feet are more expressive than their faces, because the spread of the corpse is counteracted by an alert vertical format, because though pressed into commemorative frontality and sunk below ground level his people appear to resist it, because red and purple are sublimations of blood and violence, an energetic action which lies somewhere in the background. He became expert at presenting corpses as heroism, in the famous picture of Marat and various temporary displays of fallen heroes, which trusted more to eloquent nakedness but turned a horizontal event to vertical by elevation of the corpse and tall incense burners as in *Andromache*.

His great classical breakthrough was *Belisarius* of 1781, but beneath its stern colors and architectural intimidation is anecdotal pathos which forecasts many nineteenth-century pictures, likewise cleared of sexual passion to let the tears flow more readily and brought up to date to make their emotional demands more obvious. David's sufferer differs from Greuze's in being old and masculine rather than young and feminine, and enduring barriers in the middle and behind the feeling which make a long title necessary—*Belisarius Recognized by a Soldier Who Served Under Him at the Moment When a Woman Gives Him Alms*. Perhaps the overbearing stonework will kill him before the emotion in the reaching arms makes its way around the woman who is an obstacle to the exchange, which his blindness would interrupt anyway without her. Though the delay is artificial, it gains power from the feeling there is not much time left, and from the unyielding maleness of the wished-for union, granitic like this nicked and tilted floor just outside the city, which leaves little room for maneuver.

Military maneuvers are finished in the earlier Davids, but in *The Oath of the Horatii* a ceremonial stiffening is the prelude to violence and death. It sublimates battle into formal promises of aggression, avoiding the neo-classical theatricality of action stopped noticeably in its tracks, and instead becomes dumb show by portraying an event which is dumb

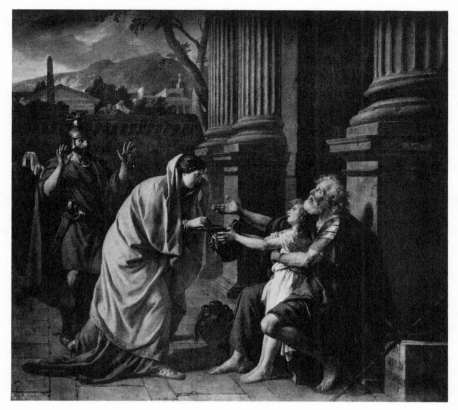

Jacques-Louis David, *Belisarius*. Palais des Beaux Arts, Lille, France

show in fact. Thus it is free to be stark as a poster, brandishing its antagonisms, showing a crisis in the family through figures whose arms and legs have turned to knives, whose salute is attack and whose priestly sponsorship is suicide.

Here David first makes us uneasy to find reiteration the essential test of truth, in outstretched arms mechanically generated from each other, duplication which leads through democratic crowds to totalitarian unison, kept tolerable in the *Horatii* by throwing the polarized groups off center against the graph paper of the background. Its mechanization of heroism, its hard lines, clear colors, and above all its perfected poses convince us of the inevitability of this particular development, but a subversive irony reminds us that the side of the picture which has slumped into grief like a sleep will spring to life and produce the last catastrophe

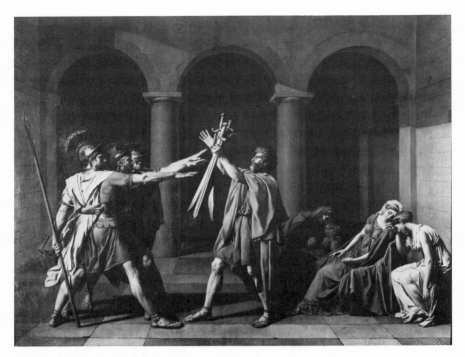

Jacques-Louis David, *The Oath of the Horatii.* The Louvre, Paris

when one of the women accuses the only male survivor on his triumphal return, blatant sexual-role differentiation lying in wait for the chance to reverse itself.

At this stage in his career David's pictures are landmarks, true icons, eternal propaganda, more memorable in the present case because the classical paraphernalia has been cleared away, the altar which would soften the feeling toward piety subtracted to leave them to their own resources. Perhaps the polished poses and their friezelike deployment owe something to sculpture, but neo-classical pictures generally make their indebtedness more obvious, Benjamin West's *Pylades Before Iphigenia,* for example, where priestess and captives view each other across a puny altar, her robe and their flesh white like marble, translating stone's inertia into sexual shyness.

Many neo-classical pictures of sacrifice at altars retrieve the pomp and awe of religion without the penalties. Onlookers leaning back in alarm or forward in pious anticipation express a dignified superstition and al-

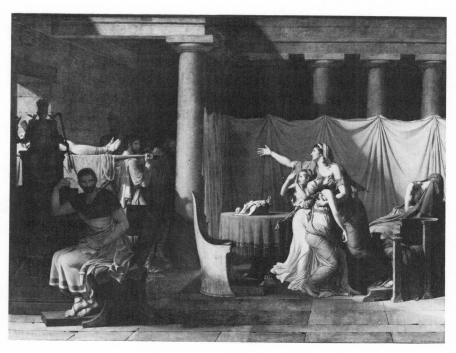

Jacques-Louis David, *Lictors Bringing the Bodies of His Dead Sons to Brutus.* The Louvre, Paris

low one to regard a religious event with irony. David is not content to evoke such mild emotions, however. In *Andromache* his altar has a corpse on it and carries a definite message unlike the smoking altars which need no interpreting. Things as hard-edged and clearly seen as the objects in *Andromache* seem at first unsuperstitious but the rationality of so much linear detail exercises in the end authoritarian force like an Assyrian relief, as if the power which organizes the surface might also be exerted on the spectator, as if a style of decoration could give foretaste of a political regime.

In a Greuze like *The Ungrateful Son* fragmentation of the family foretells the fragmentation of the state more volubly but less explicitly than David's *The Oath of the Horatii* or *Brutus,* a painting which one can easily take as a second tableau in the same sequence, though the deaths forecast there and presented here are not the same kind. The violence predicted in *Horatii* has been carried out and then turned back on the imaginer, abrupt heroism followed by introspective paralysis. The jerki-

ness of the brave action of *Horatii* is a sign of deep estrangement from the world, and war, the active version of death, which makes the conjunction with youth normal and not freakish, reverts to the passive version, archeology, as the clearing of *Horatii* thickens again and Brutus is shadowed by a primitive ghost of the mother country, as if having tried to banish superstition David had to confess his failure and readmit a pseudo-religion more debased than the kind dispensed with.

The impulse to strict control which brings him nearest to Winckelmann breaks up under external pressures, though after the Revolution it will be reimposed in a less vital form. Winckelmann's metaphors—the skin of a youth like the surface of the sea, Laocoön's muscles gathering themselves like hills, Venus a rose unfolding, or Venus a dawn which unfolds like a rose—depersonalize toward more featureless states, evacuate feeling to return to primitive repose—a similar impulse to that which creates the tensions in David. In Winckelmann a suppressed sensuality, in David a suppressed enthusiasm almost without object, a need to act quickly, drown calculation, and be done with ideas. So Winckelmann's ideal is an absence of tension where details slip into each other, the best art like the best water leaving the least taste behind, a remark David would have understood, not through answering blandness, but by reference to those intractable parts of his character he continued to struggle with, presenting a Laocoön who has briefly forgotten the serpents by an effort of imagination.

Though a less striking image than his depictions of public affairs impinging on the lives of families, David's *Tennis Court Oath* is an eruption from the restriction of the earlier subjects. Here the gestures of *The Oath of the Horatii* are multiplied by a hundred without the same effect of heroism, for although each pose is carefully studied individuals are lost in a mass of waving arms like a single head of hair, the crowd a simpler reality than an individual, largeness more featureless than smallness, a great emotional storm at the bottom of a well echoed outside by another, striking the palace with lightning and changing the curtains to banners far above the crowd. As David becomes heated he becomes mannered and crushes uncountable votes into this ballot box where magnificent poses make no impression and labors are unfeelingly submerged.

His enthusiasm for crowds alters his sense of proportion, seen in the repetitious processions he organized—a hundred women bearing olive branches matched by a hundred children of the same age as the martyr carrying torches, increasing the tragedy with the idea of all the families

sympathetically suffering. They stop briefly in appointed places, their muteness followed by an anonymous shout repeated three times as if in logic-defying trance. A procession that lasts all day and winds through numberless streets asserts mental sway and claims territory for ideas, allegiance a sign of virtue in no-longer-existent individuals. When obstacles keeping people apart in earlier Davids are dissolved and family bonds replaced with the simpler ones of the crowd, they resemble each other too nearly to make individual response. The rituals of liberty bring a new rigidity and propriety, uniformity with no end or beginning producing disorientation which will eventually lead into reaction.

Though it was never painted *The Tennis Court Oath* became a widespread icon in Jacobin clubs, multiplied like the crowd through engravings. Similarly, David's proposed depiction of the martyrdom of Barra, whose fête and the picture were prevented by Robespierre's overthrow and the painter's imprisonment, was to be obligatory equipment in French schools.

He had come to believe in the regeneration of public morals through art, not inconsistent with partisan use of inflammable materials, political opponents and not the martyrs themselves the real subject of canonizing funerals, Barra's pointless death tailored by Robespierre into an exemplum, and David's image of the invented event one of his most deeply felt. The subjects of neo-classical art are manipulated in life, now become a pantomime taken from painting. Empty ceremony is twisted around to the exertion of real force and primitive rite taken seriously as the polarizer of the tribe into loyal and dissenting elements. So a mass oath culminating in plantation of a Tree of Fraternity in the Place du Carrousel on January 7, 1793, could be used without incongruity as cover for a police raid on the favorite meeting place of Royalists, soldiers around the tree taken off in perfect order to surround opponents who were then arrested.

In spite of his powerful position David should be counted victim rather than beneficiary of the oath-taking mentality of which he supplied such memorable images. The pageant and its culminating oath, a momentary visual flurry, is a form in which he had long believed, though he never found a satisfactory way of making its alterations of reality permanent, since his Revolutionary costumes attracted scant support outside his own studio and the five stages of his greatest festival, though replayed for a few weeks in theaters, could not be afforded in durable materials. The first live reproduction of a David had been presented at

the end of a performance of Voltaire's *Brutus* in 1790 when the actors silently grouped themselves in the pattern of the painting, which perhaps gave him the idea of ending the *Festival of the Supreme Being* with Robespierre looking down from an artificial mountain on many groups dedicating themselves to the nation in the postures of the painter's *Horatii,* a painting become the source of a military formation, symbolic militarism or militarized politics being the form that David's interest in both war and social life repeatedly takes.

After the Revolution his conception of a major work has been permanently corrupted to Gargantuan size, but such a development had taken place before the Revolution and without the stimulus of such success in the architectural projects of Claude-Nicolas Ledoux. Even when they began to be built, as at Chaux, their huge scale expresses disillusion with man and discontent with anything buildable, so that they are better in plan, like diagrams of the relations between bodies of government, but not fulfilled in plan because their goal is to embarrass the senses through reason, creating spaces too big for any crowd to fill, and surfaces so featureless they look like something has been taken away.

David proposed a huge statue of the People on each of whose limbs the name of a suitable virtue would be carved. The crowd provokes the giant, not as a model of, but a counterweight to itself. The devalued individual feels need of the superhuman, a partial explanation of the easy transition from egalitarian feeling to emperor-worship. David's monster of the People is a misunderstanding of the craving for a powerful individual and shows him ready for Napoleon. The generality of his nearly verbal family of motifs—bay leaves, urns, banners, young trees, water, fasces, togas, sunrise—is more rootless than it knows. When imagery surfaces in Ledoux it is similarly generalized, but the stone water frozen as it issues from ceremonial openings at Chaux, or square sections frozen to round columns, signal the onset of winter, night, and death, and make us read the emptiness pessimistically, a classical portico as the mouth of hell, not the house of light, roughness inside the smooth front of the gatehouse at Chaux suggesting chaos within order. Like the underground garden and grotto wedged into the urban fabric at the Hôtel Thélusson this rough inside and smooth outside use classicism as the mysterious cloak for a Romantic psychology.

Flaxman's illustrations to Homer had just as surprisingly found their accuracy in negation, giving up curve, multiplicity, and color in pursuit of the origins of esthetic pleasure, bringing to its highest point a concep-

tion of art as an outline. This vacancy is a retreat from political complexity, outlines like the laws of society without conflict. It was a form which in his later disillusionment David was able to use, which allowed one a fundamental emptiness in the midst of accuracy. But before the Revolution he is an updater not an antiquarian, who never conveys the sense—one of Flaxman's achievements—that the represented lives are infinitely remote. Of the three main conventions for representing the ancient world the early David follows the middle one, somewhere between the dilapidated ruin of Hubert Robert and smooth replica of Flaxman, so the walls in *Brutus* have nicks at shoulder level, a mild quarrel with too perfect reconstruction. The scale from unintelligible ruin to flawless model is a historical development as well as a recital of possibilities, from the eighteenth century to the nineteenth. David's generation is the first to move beyond a fascination with ruins, which leaves the classical world in the state it found it, looking after years of burial like a decayed corpse. To restore the past to its original freshness is a scientific undertaking motivated by a feeling that it wasn't much like the present, and scorn for the particular partial state in which a remain turns up.

Flaxman looks untroubled but gives a less exact copy than he wants us to think. After all, he seems to say, a primitive world is one from which things are missing, and the further back you go the freer you feel of the complications of the nineteenth century. If the result is a world forlorn, bereft of the inhabitants we expect, the absence is beautiful and believable, for it is scientific to go from nothing to less to more in a mathematically testable way.

The vases, which he seems to resemble, because his most idiosyncratic motifs—blank shields hiding the bodies behind them, processions of monotonous regularity—occur there too, and they share his obsession with outline; these vases show light on dark or dark on light, but not as Flaxman does light on light, and his originality is the exploration of that minimality, giving up the main means of differentiating elements from each other, without intending to relinquish the discoveries of art since the Renaissance, but only to appear to, only to pretend he cannot show volume, recession, distant spaces.

Flaxman's illustrations look more like the Parthenon reliefs because they have no backgrounds, but this absence is a radical reseeing of classical art. The empty parts above the figures are not materialized like the black or red surface of the Greek vase, so he is always less crowded than Greek originals, and discreet shading makes our eyes travel endlessly

John Flaxman, illustrations to Homer's *Iliad*. Above: *Hector Chiding Paris.* Below: *Thetis Bringing Armour to Achilles*

back in the empty parts, which thereby become some of the furthest distances ever represented in art.

His other innovation is to make of nudity a kind of emptiness, to reinforce vacancy afar with blankness nearby. In painting, nudity is an inno-

vation of a second stage of neo-classicism, where it is reimported from sculpture. At first David isolates nudes and gives them circumstantial excuse: Hector is nude as a corpse and Paris as about to step into the bath, but in his first large allegory after the Revolution, as in Flaxman's Homer, nudity is justified not by the naked person's activity but by proportions of nude to clothed which play over the surface ignoring function and selecting figures at random to undress.

There is a nudity like clothes, and there is clothing and armor virtually identical with nudity. In fact Flaxman's happiest resting place is a shadow state in between which has no name but suggests undress and modesty at once, a skin improvised by the moment like the cloaking of Paris's arm in his meeting with Hector.

Much of his nudity is only the suggestion or anticipation of it, the half-naked figure dropping its head in self-absorption, flesh a phenomenon which creates a hush, realizing the Winckelmann ideal of sedate repose. Even the frankness inherent in profile and fullface is the unyielding frankness of positions unalterable like laws of physics. Blank areas fix the eyes hypnotically—the animal's empty flank in *Nestor's Sacrifice,* which hides a girl behind it—but it would be fruitless to struggle with these absconded parts, so after an initial resistance we accept the anesthetic. That much of the world is gone, and how little we regret it.

Flaxman continually reduces expressiveness without vacating entirely. The shields are empty, round bits of nothing held between us and bodies, but they are round, they are bounded. Thus the bolster under the dead Patroclus is featureless but has an edge, and although faces, which express only rage or frigid composure in Flaxman, are all turned away in mourning, they thus provoke a timid speculation about what they must look like. As neo-classicism becomes purer it turns in on itself, and its blandest works are inscrutable, its grossest nudities like the sculptures of Thorvaldsen let in the least daylight, images with the least distinct personality of any which ever stood out in this way.

Johann Martin von Wagner of Würzburg's most ambitious painting shows the naked heroes of the *Iliad* spread on the beach before Troy, many of them corpses, those taking part in the council distinguished by the fact they still wear helmets. It represents a minimal transposition of the academic nude from the studio to another functionless place, where to feel naturalistic is also to feel desolate, and to connect, as the *Iliad* makes it natural to do, nudity and death. Perhaps it explains the mourning hanging over many Flaxman subjects, where nudity is the prelude of

death, where whatever is beautiful is felt to be going away, which matches Winckelmann's sense of himself as the maiden on the shore from whom the classical world recedes in the form of her lover on shipboard. Flaxman's achievement as a classicist is to give the clear ghost of something, in which to be unattainable is precondition of the primal.

The difference between David's *Oath of the Horatii* and *Intervention of the Sabine Women* is death still untasted and death an event which has happened numbingly often. When reality overtakes him he outfaces disillusion with grandeur, instead of retreating enlarges the scale and at the same time smoothes the texture. The *Sabines,* conceived in prison and finished outside, shows what the earlier hopes come to when individual heroes are collected. The two sides are led by paralyzed nude figures, fore and aft, fixed in place by the big gold zeroes of their shields like holes at key points in the picture, unconfused but powerless, with women caught in a pincer movement between them. The result is squalor, physical force no longer clear in its effects, producing a confused antitype to his pageants and processions, whose elegant colorlessness owes something to Flaxman and to the crowded classical frieze perceived as a wasteland.

The signs of hardening here make the transition to Napoleonic pomp and insensitivity feel more inevitable. But even when he escapes Napoleonic subjects in *Leonidas at Thermopylae,* and for the first time opts to present all his figures nude, again the salutes which have survived from *The Oath of the Horatii* through *The Tennis Court Oath,* festivals, and Napoleonic pictures take up their disconnected perches, fragmentary groups of man-machines now plaited in front and behind each other like classical statues in a warehouse, a series of related acts each clearly seen and pathologically distinct, at the center of which is a figure taken from a classical seal reproduced by Winckelmann, turned passively toward the spectator, an image of abstracted, misunderstood, about-to-be-trampled heroism.

His most numerous descendants gradually work around to lurid treatment of classical subjects exemplified by Guérin's *Clytemnestra,* leading on to Géricault's *Raft,* but his truest takes the single figure as rigid icon to a more interesting dead end. From *Napoleon Enthroned* of 1806, the most effective deified emperor ever put forward, Ingres went on to a fantasized variant, *Jove Supplicated by Thetis,* which dramatizes the spectator's awe in the cringing supplication of Thetis.

Though both make frontality spellbinding, and though the question of

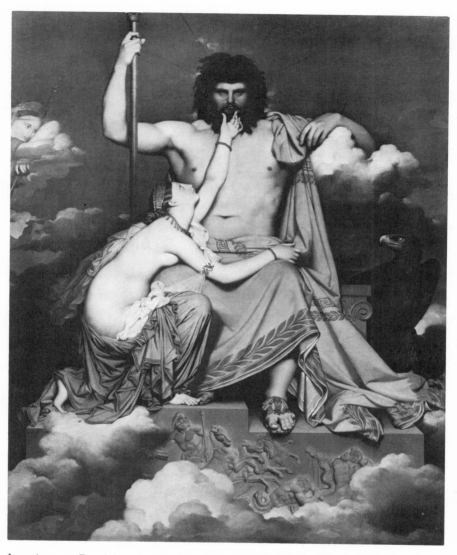

Jean Auguste Dominique Ingres, *Jove Supplicated by Thetis.* Musée Granet,
Aix-en-Provence, France

whether one likes Napoleon ends up under the feet of his power, the
images are too ingenious to be pure totalitarian propaganda, Napoleon a
sun formed of a half-circle of gilded chairback and a half of ermine bib,
lit in the middle by his severed head and shining outward in the rays of
the velvet robe.

Jove is also a queer composite, Thetis having given him her arms, symmetric to him but not to her, one of which propping his chin is his way of meditating while soullessly running her through with his scepter, the symbiosis of their postures allowing him to perform contradictory actions while expressing nothing. Even nudes in Ingres look official, their silky flesh a marble coating from which the introverting soul retreats. Jove's mindless power is the end to which narcissistic neo-classical nudity has led, power implying as always powerlessness, fulfilled in the anti-democratic throne settings for Napoleon by Percier and Fontaine, which construct an aura for one who resolves many, turning him into a huge fetish or crest at whom all can cluster, a queen bee who is her people. Ideology has come full circle to a kind of individualism again, a cult of the leader which has its classical warrant in imperial Rome, the rugged simplicity of camp life parodied in hangings heavy with gold which resemble tents.

At the end of his career David came to paint sad and empty icons in a depoliticized heaven, like *Mars Disarmed by Venus and the Graces,* in which myth is finally unpassionate and unmeaningful. This is the end of all his efforts to raise politics to art, making civic life an instructive festival, and to dedicate painting to the service of an authority outside itself, perhaps to make it an instrument of tyranny, perhaps to fall under a delusive spell of politics as theater. Heightened feelings of art's relevance give way to conviction of its irrelevance, for here among the clouds there can be no archeological accuracy, no tension, no life as David has conceived it, the pattern which had been the supple inscription on the hem of a garment now enlarged and run across the top of the picture, a last comment on the neo-classical search for a true code.

David wears out certain possibilities of linking art with power, so that initially Blake's effort to internalize the search appears more promising, but power psychologized also ends in inertia, and results perceived as cosmic by their author seem to most viewers private. In weak neo-classical beginnings he already gives signs of a radical plumbing of the personality in search of the main principles of matter and energy, and in later versions symmetry inherited from classicism still lends its support from underneath. At first he is more rigidly columnar than other neoclassicists but unplastic, and beginning to perceive disconcerting composites formed of identical figures growing next to each other, as if one sees the same thing twice, or more than twice, as if reality reduces to a single identity, Blake terrorizing matter with his instinct for uniformity.

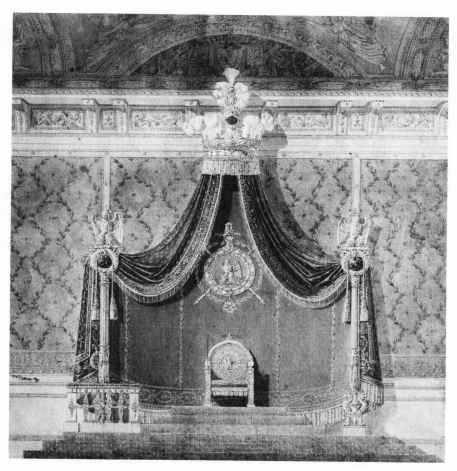

Percier and Fontaine, throne design for Napoleon at the Tuileries.
Collection Olivier le Fuel, Paris

In *The Body of Christ Borne to the Tomb* a funeral is perceived as a
temple, yet it seems an unconservative view because the architecture is
made of men, Christ's bearers the columns of a portico, and the slab he
rests on, the cornice, but a ruined porch for when he runs out the col-
umns continue in stiff women bearing no load. Such rigidity of sexual
roles is typical of Blake, the similarity of fluted robes more typical than
one might think: sexes look the same and behave differently.

This picture's greatest oddity is its least perceivable: a third bearer,
not matched in the row behind, is a dummy column walking at the
proper interval but occupying his hands with vials instead of the slab,

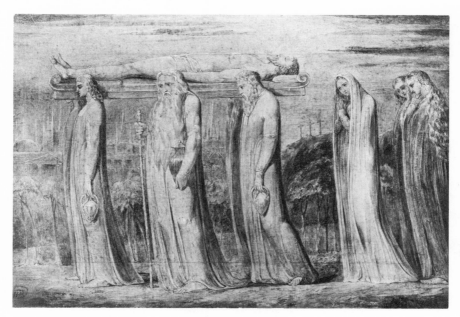

William Blake, *The Body of Christ Borne to the Tomb*. The Tate Gallery, London

making vivid the fact that the building could at any time come apart, a temporary memorial.

In spite of vinous Corinthian hair forming unclassical capitals which intersect the cornice, it is an example of classicized Scripture, for having replaced Hector with Adam, Blake interprets classical remains as echoes of Patriarchal ones from further east, and though debased our best guides to the original. His own older antiquity is thus a reinterpretation of stories and styles which have already come down, as the renamed ghosts in his night visitations have places in earlier reports.

His weirdest visions are his most symmetrical, in fact are visionary through excessive symmetry:

> The painter of this work asserts that all his imaginations appear to him infinitely more perfect and more minutely organized than any thing seen by his mortal eye. Spirits are organized men.
>
> (*Descriptive Catalogue*, 1809)

So the angels in *Christ in the Sepulchre* make a triangular shape like the cross section of a lily or three joined-up Gothic arches radiated from a

common center. In *Satan in His Original Glory* similar wing shapes are extroverted to make a force field around his body matched by robes flying out in spires beneath, a person swallowed by or diffused into his emanation, the tops of his wings echoing the points of his crown as if the conglomerate strives to be one large tulip bloom drastically violating the notions of size set by the figure.

Such subordinations held a hypnotic attractiveness for him, drawn into the organizing whirlpool of power he detested. Trying to present sweetness Blake makes a sickly pastoral, vague Gothick adorned with vegetable ringlets. His beauty is always more compelling when confused with terror, so his respectable old men are tyrants, God obscene in Oriental splendor, power felt as fear, like the impressive sentencing of Adam, in which God sits calmly convulsing others, ice in fire, whiteness reflected as redness where his robe meets the fiery whirlwind like an object and its double at the water's edge. The equal venerability of the two figures makes moral nonsense of the event: one Patriarch judges another, in the form of a nude body drastically simplified to a column of congruent bulges.

Flesh in Blake often seems more flayed than either naked or clothed, as if in stripping off he had gone on until he came to pain. Fuseli is less unconscious of the sadistic possibilities in exposure, and makes a nightmare of the neo-classical deathbed or turns it into a scene of torture where man is treated like a machine, twisted into barely conceivable distortions as if one part had been nailed in place and the rest moved to test possibilities. The light picks out parts like dismembered prey and produces a set of alienated proximities in artificial frenzy that supposes an observer relishing it all, a figure frequently included in the scene.

Blake might have given in to the tamperer who monitors his own acts in fascinated horror, if such lack of wholeness in himself hadn't disturbed him. He couldn't tolerate that disorder or relinquish the ambition to portray all of reality in each of his images. This organizing or cyclic quality of vision which causes him to move the neo-classical prison to eternity makes the most accidental of his ideas enveloping. Spiritual beings proliferate mechanically, the reiterated X's of a wallpaper pattern; vision, defined by its rigidity, is thus the deepest conservatism, an inability to imagine exits from one's ideas, and no development except return.

Even his greatest leaps are visions of order not disorder, like the monsters of madness, one of whom crawls past on its hands and knees with its head turned toward us in alienated horror. Like many Blake figures

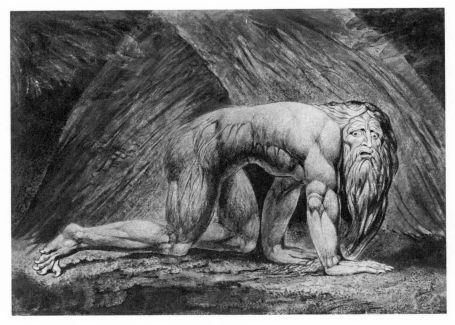

William Blake, *Nebuchadnezzar*. The Tate Gallery, London

this image of *Nebuchadnezzar* is not a human image. The relevant passage of the Book of Daniel reports a vision whose exaltation entails suffering, whose dreamer is a tree cut down to a stump and left to be wet by the dew until seven times have washed over him, seven days or seven years, because through the telescope power of the prophet mind a day can be an hour or a year, a power not controlled by the possessor. His hairs will become bird's feathers and his nails bird's claws, to signify that he will be lost in his power.

Blake's *Nebuchadnezzar* is not the familiar character from the Bible, yet faithful to it nonetheless, uncovering a secret, even longer history which was there all the time, inscrutable as the life of a root. His figures are not human because the level of experience he wants to describe is not recognizably human, though it happens to us. It is a more complete entry to an underworld than Fuseli's in spite of the stiffness of Blake's technique.

Nebuchadnezzar's muscles flow over him like a deluge, or cover him like tree bark, the flow pattern of his beard as much geological as fluid,

the conflicting arches behind solid as roots and flexible as rivers. The picture gives a series of metaphors, blurred together in the Scriptural text, a more stable shape whose parts must match and can be checked against each other. Thus the geometry of the figure as of a table and the clarity of its internal divisions, thus, for all the strangeness of his ideas of beauty, the feeling that Blake's world of proliferating and undifferentiated muscle tissue is close to neo-classicism after all.

The practiced viewer recognizes better and better the consistencies of Blake's style, becoming used to figures plunging upside down or fanning out concentrically from the bright middle of a vision, without understanding them. Though their principles can be explained, in some sense Blake's designs cannot be understood, because the clearer one becomes about their structure the less sense it makes, which places him in the class of authentic primitives whose language is spoken beneath the threshold of translatability. His relation to what David does is obscure, yet subject in Blake to intensification and sweeping distrust of traditional attitudes, a devotion to reality as simpler than previous depictions can be traced in both, a unicellular world in which the war of opposites reduces to an identity. Though they are in some sense opposites, not rational and irrational forms of the same madness, to see them together is to doubt if there is a finally rational motive or plan, not simply rational granted the desire to represent a ghost or a sacrifice, a desire, that is, to negate the prevailing reality and erect the prevailing unreality in its place.

Like Blake, Philipp Otto Runge is a student of energy in primal forms, in infants and vegetable growth instead of monsters and muscles, a representer of paradise instead of hell. He thought of his work as symbolic landscape, not an obvious description of his most eccentric project, worked out in 1803 as four drawings of *Times of Day* and foreseen as painted panels filling the walls of a room. The drawings are atingle with so many microscopically observed moments in the lives of plants there is no room left for the "view" which usually makes a landscape, and such a ceremonious conception of existence applied to such idle natural occurrences as *Morning, Evening, Midday, Night* makes at first an estrangement between man befuddled in his symbols and nature.

Each drawing consists of a vertical tableau surrounded by a narrow pictorial border, and varies the same small stock of materials: between ten and nineteen infants play or sleep symmetrically on huge flowers

supported by sagging stalks and depicted with visionary sharpness. All but *Morning* are organized around a female figure, a mother in *Day* who becomes a heavenly body in *Evening* and *Night*. Cramped into the narrowness of the borders more infants climb or stand among straighter-growing plants.

The designs resemble the classically derived grotesques of Robert Adam—Runge calls them his "large arabesques"—slightly brought to life by creatures more puckish than usual, but perhaps no more consequential than those in pictures of the English fairy vogue of the 1840s. Though he makes self-sufficient what is ornament in Adam he is still bound by the convention of perching figures among foliage at mechanical intervals. But he concentrates our whole attention on the vaguely agreeable stuff of classical decoration, the vertical stem as a series, a plant growing out of a vase into a further species, shifting to another vase, extended until the space to be filled has come to an end. In Runge this tower or fountain of images carries mystical ideas of the unity of life, so that even to disrupt the sequence by showing the pot sitting in the leaves of the plant whose stalk it carries is fervent expression of illogical growth. To show vegetable and human on the same scale by enlarging blooms to the size of faces creates a greater, more basic category, life. Turning anonymities of pattern to picture makes ornament into science, solemnized but still not individualized.

At the center of *Morning* is a large lily plant poking above the cloud cover of a planet whose edge forms a low horizon. Five blooms are supported by stems of exaggerated thinness like jets of water, one of which shoots up into a full flower, while the others curve back to earth like windows with half-circle tops, each kept in place by a putto sitting where the curve begins and by the weight of an unopened bud from which a stream of cut roses drops. The rigid central flower supports a pyramid of infant acrobats, six sitting on the petals, three dancing on the pistils.

Combining vegetable and human produces a figure mirroring itself in other forms, the lily's trumpet echoed by a mute formed of the nine putti, the flower's spread counteracted by a skeletal down-pushing lily whose base is the three putti heads and whose top is the five stems at the bottom of the picture. Growth turns back on itself, or proceeds in both directions at once, though at different speeds and intensities. This X-ray of spiritual reality shows it proliferant from a few simple bases, all things shadows of each other. Roses blooming from lilies taken separately are

Philipp Otto Runge, *Times of Day: Morning*. Kunsthalle, Hamburg

Philipp Otto Runge, *Times of Day: Midday*. Kunsthalle, Hamburg

an impossible repletion, a symbol choking on itself, until this motion is seen as the completion of the less visible idea-of-a-rose. And now the anonymous putti express the intermittencies of our perception or the nodes where our vision becomes clear, a nascent sketch of the unified world we are only beginning to understand.

This cosmic flower is a single expansion representing all growth, whose less forceful but larger shadow, down-pointing, transfers mental power over size and duration into physical reality, like similar dislocations in Blake. So a thought becomes a thing, discovered in the world before performed by the mind.

Later parts of the series leave a promise unfulfilled, by showing the putti still at the same age, only giving in to time by going to sleep. In one sense it is true that these lives need not grow old to convince us of the series' completeness, because they are only the animation of the leaves taking an easier form. But Runge is permanently fixed on the opening of buds, and the expanding lily is the best symbol for all his thought not just its earliest stages. There is only one moment, reiterated, and so we can feel his four times both lengthening and telescoping the day, showing an infinite but very resemblant variety of happenings, a crowd as one.

In a letter he says "We must become children to reach perfection," and expressing his own harmony with the world he describes himself prone in dewy grass, swallowed by plants and able to soar, which becomes, transmuted, the central event of the later versions of *Morning,* an infant on his back in the middle of a field. The strength of the child as an object and perhaps as an idea is its defenselessness; it cannot be argued, and resists translation to visual images so that we sense a tension between his verbal aspiration and his visible method, which is roughly that he sounds Romantic and looks classical. The strength of these conventionally naked children is not individual but a collective pattern beyond identities as a flower is beyond remembering its separate petals.

Like children, plants are interesting to Runge as natural objects *and* carriers of abstract meanings which may interfere with the naturalistic presentation of them. It is hard to decide whether the *Geometrically Constructed Cornflower* of 1808 is mainly a symbol or mainly a fact. It is shown as a fat disk on a bulb stalk, much enlarged, the circular top view pressing against the horizontal side view. Geometrical guidelines have been drawn in or left in, so that we cannot detach the flower from the rose-window frame in which circle turns to square. The bloom is seen

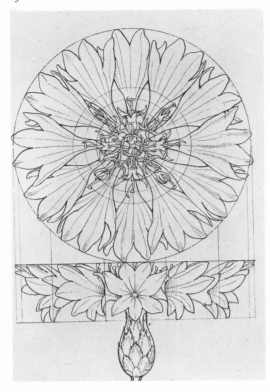

Philipp Otto Runge,
Geometric Cornflower.
Kunsthalle, Hamburg

with bewildering precision as a composite of twelve subsidiary lily-trumpets displaying vase-bulges wasteful when lavished on sub-blooms. Even without personality a multiple makes a set of individuals; seen from the right nearness parts of one flower make a crowd. Runge the botanist employs a shadowless line, yet the ragged outer edge thwarts our attention, more variety than we can digest bumping against the geometry. Flaxman clarity is used to lay out innumerable small deviations from the scheme, and the drawing's main events are thus some eccentric spaces between plotting lines and flower—toothed triangles left by the petals at the edge of the circle, large triangles left by the meeting of the top and side views, and jagged triangles left under the side view by the retreat of the outermost trumpets. Such spaces come into being when one tries to fit a bloom into a pre-ordained mathematical figure, yet show the effect of observation too, a strong desire to symbolize resisting itself and refusing to accept success. It is a miracle of mediation, one become many (conversely, *Morning* puts all in a single stalk), the two compared views,

like Blake's flea's ghost with mouth open then shut, looking like a scientific textbook but feeling like a crystal's refraction of one vision into two. Science can make the same thing look utterly different, or keep two divergent views before the eye at once. But in Runge bifurcation is not a comfortable power, and his symbolic strivings come from this wheel broken, defeated by the intensity of his vision; in spite of pattern-finding the result is confusion, a staring monster instead of the expression of love his theories lead him to expect.

The untoward results of such a plunge into natural notation can sometimes be more comfortably synthesized, as they seem in his paper cutouts of botanical specimens, a parlor game he practiced with dazzling effect. It is a mode familiar in other hands, though the usual subject is a human profile not the kinks of leaves and jitter of plant hairs.

All silhouettes and Runge's most of all straddle classic and Romantic, an art of outline like Flaxman's, still more radical in emptying detail from the center and concentrating nervous energy in the edge. Even though more featureless than Flaxman's, the area within the boundary is a solid not a void, a bag or box we cannot see into but know is not really empty, the silhouette prodding an allegorical imagination.

Runge was vulnerable to the idea that such concentration could yield unbounded results, like Blake thinking an unbalanced emphasis on aggression was truer, and to turn a whole picture to flame achieved a conclusive purity. The two of them are obverse and reverse, all flame and all flower, who by seeing only the one or the other assert a comprehensiveness which becomes an obscurity, that of substituting in good faith the part for the whole, mistaking a metaphor for a metaphysical system. Early in the *Times of Day* Runge applies classically derived patterns to the natural world as if to carry the forms of Ledoux into the fields or to fit the rose into the rose window. In the drawing for *Midday* unnaturally long leaves behind facelike iris blooms make circular architecture on a square base like barrel vaults. Iris leaves are right for girders because flat and stiff, and because their narrowing spear fades out as the angle of view steepens, but here we begin to suspect that Runge uses facts opportunistically, and acknowledges observation only when it fits, which gives such naturalism as remains a séance quality, as of plants which might speak or walk away.

The conflict between symbolism and naturalism is exacerbated in the borders of the first painted version of *Morning* because each impulse is more grossly embodied. They show in their fewer, more vivid forms a

hierarchical development from water lilies on chewed pads to red lilies with highly developed bulb and roots to white lilies without lower parts. The lowest of the three sets of babies inhabits prisons formed by the roots and supports large purple bulbs like crowns. After the leaf stage red lilies bend themselves to seated occupants like luxurious couches, in contrast to the higher white lilies carrying kneeling cherubs chastely, almost without touching. The bad lilies are more passionately observed especially in the Bosch underparts, an enthusiasm kept in check by the ranking. Color is moral, introducing complexity from which it is diffi-cult to return to the primitive uncolored state.

None of Runge's *Times* are narrative in the usual sense but convey meanings by structural devices like the flower-dealing baby growing from the back of the kneeling baby as the leaves grow out of the bulb in a parallel section of border, a comparison bearing on the main idea of flowering. His meaning is exhausted in these comparisons as it is not in narrative, even Blake's series involving more motion than Runge's which realign themselves in the same spot, working out variations in a single group of conditions, as if he were setting himself to design a series of snowflakes.

The conflict began to be healed in the center of the first painted *Morning,* where a more naturalistic baby is fused more with the idea of the flower, both radiated by sacred color as if to express all growth as light. He at last cuts himself free of the decorative tradition to which Robert Adam belongs and drops the border in the next *Morning,* labori-ously contriving a return to the autonomous picture most artists begin from. Here the movement toward naturalism and ineffability at once is carried further in an epiphany which looks as if it could happen in a real field. But the dismemberment of this picture into nine fragments per-haps shows that this emptier naturalism was most baffling of all to view-ers. Perhaps the precision of the abundant vegetation will not unite with and comes unstuck from the spiritualism of the huge sky-lily. Perhaps something as much like a landscape is more troubling in its ghastly col-ors, greenness in the flesh and purple in the grass suggesting chlorophyll in the one and blood in the other, than anomalies of the linear designs where odd junctures identify the points of strain.

In the *Times of Day* Runge calls spirits out, waking up a world which was asleep and feels decidedly pagan, but in the last *Morning* he begins to dissolve figures back into the setting, a process which would end with humanity more immanent than present, as it has become in pictures of

Philipp Otto Runge, *Morning*. Kunsthalle, Hamburg

Böcklin's like *Polyphemus* or *Hunt of Diana,* which unlike other contemporary landscapes need titles to be understood.

He straddles a crevasse between classicism and a new view of things not yet born, though he is often depicted as having crossed the divide. Transitional figures can be pushed back and forth across it at will, but

Caspar David Friedrich, *Graves of Slain Freedom Fighters*. Kunsthalle, Hamburg

in Runge's work the drag-elements, lingering phases of neo-classicism, claim attention, not because he disappoints Romantic expectation but because he is most original in his backward-looking impulses, which bear fruit as emotionalized geometry, a more primitive kind of thought.

The apparently impossible union of mysticism and excessive rationality is usual in other proto-Romantics like Caspar David Friedrich, who like Runge turn classical vocabularies to unclassical ends. His landscapes are based on elemental shapes like the hollow or mound, buried in particular detail until the skeleton is almost lost and the image wavers between something—a grave-hole—and nothing—a slice of rockface, dramatic in its granular sharpness, undramatic in many small foci—so that the grave may be an archetypal convergence or an accidental crease in the rock. He has found that the greatest enigmas are views of very little, a vacancy it takes acuteness to perceive, a simplicity only meetable by courageous intelligence.

Most of his figures are seen from behind trying to unravel the deep mystery presented by simple means of firs and mist. They may be understanders or simply loafers, or it may begin to be that the former must

become the latter, introversion the only heroism. His man on a crag is not the suicide or the tourist, not the lover of mists but the act of abstraction and shows us how to read the barer landscapes as mental functions, not to look but ponder Looking.

Those Friedrichs of women looking out windows from darkened rooms into a patch of cucumber-green glare are models of the instrument of looking, the Romantic eye which hatches a vision in a black box, his paradox that every something comes from almost nothing, for the world never concludes anything properly, never puts the roof on the dolmen of trees which surrounds the dolmen of stones or the abbey of stumps which surrounds and dwarfs the ruin. He delays the conclusion in hopes of a more embracing one as yet over the border of conceivability, or as if to say conclusions are man-made and therefore unpleasantly finite, man's own conceptions not man's highest goal. When Friedrich naturalizes Christ's suffering by placing it on an inaccessible peaklet hemmed in by observant pines, he stirs a doubt about all attributions—is it a crucifix or a crucifixion, an emblem or an event, and how natural can anything that happens, that needs a little slice of time for its enactment, be?

His paintings fall into two classes, "looking beyond" and "looking into." The second sees nature as an oracle or receptacle, the dark hole of a grave or a path into the forest. The larger first class suggests a featureless distance with a gate, a gate-form like a perforated ruin, or a figure with its back to us, which gives us something to look out through, or by a set of featureless horizontal zones which produce limitlessness in a small area.

Many Friedrichs have their complementary opposite, dark spire and columnar void, full mouth and empty, glimpse of light or glimpse of dark, to switch from one to the other of which is to fall into giddy doubt about the meaning of this alphabet of shapes and to feel that a church and a ship have the same zero value from far enough away. Forms in Friedrich are truly reversible, so fullness can in an instant become emptiness because skepticism which understands their geometry so well adds and subtracts them like children's blocks, having gone looking in nature with Romantic hopes and come home with expressionless classical rudiments, cones, cubes, and spheres.

The sign of the cross is reputed to be the answer Friedrich is looking for, and he employs it to give clear valency to an experience otherwise indefinite. But it seems questionable that it is a hopeful sign, that the

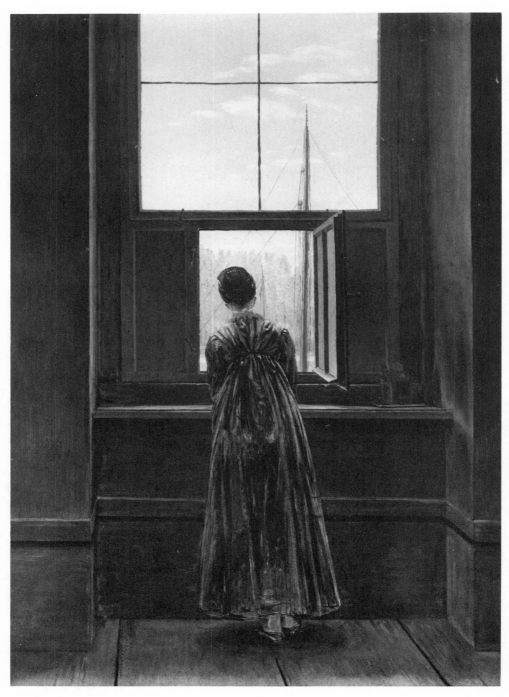

Caspar David Friedrich, *Woman at a Window*. Nationalgalerie, Berlin (West)

coppery spring issuing from under the *Cross in the Forest* could be a river of life in any unpolluted sense, or the evergreenness of the pines and the tufted Gothic church growing among them a cheerful life. For the cross still marks a grave, a concentric mouth of narrowing diagonals, and the looming trees are death-in-life, like the monks going underground in *The Abbey Graveyard Under Snow,* among domineering cross markers taller and more lopsidedly vital than the black walking corpses.

Friedrich was not mild and his paintings are not hopeful, presenting a vision so disabused that to find him a trustful Christian is one of the great distortions of criticism. He is un-German and un-Romantic in the understatement of his means and clarity of his response to a world he continued to see in the same bleak terms from almost the beginning to the end, with resignation and without joy.

His distinction arises from his desire to make his paintings lead some-where. Usually he frustrates the answer even as he forces the question, so even with as near a view as *Woman at a Window* who turns her back and becomes a tree to us, whose clothes exhibit parallel ridges like bark, we feel we are not near enough to recognize the species of things in Friedrich, and of course there are many in which the center is inconve-niently far off like the three figures on the rocks in *Moonrise over the Sea.*

He arranges that the possible causes of affect should stand out tiny from a neutral ground, so we seek relations among the three figures and two sailing ships as one tries to make a pattern from a few scattered dots. Ships are souls in flutter, glide-motion, silence, remoteness—and humps are like graves in thickness and darkness. The series matter-life-spirit moves up and to the left within a narrow range in both dimensions, the active area a fraction of the total canvas, meagerness reminding us of the unmendable gap between these weak things and our ideas, or our *idea,* which for the insistently goal-oriented must be the only subject, death, the end of all geometry.

He is one of the most monotonous and questing of painters because he is trying to tell us what death is like, and the culmination of neo-classical reduction. The development from Blake to Runge to Friedrich is a de-velopment from mythic history through mythic natural history to the solemn wonder of a demythologized world. Runge appears to teem with abstract humanity in super-real nature, whereas Friedrich invests all meaning in empty nature, making emptiness an idea with definite struc-

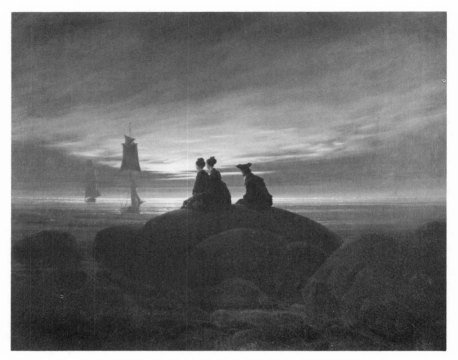

Caspar David Friedrich, *Moonrise Over the Sea*. Nationalgalerie, Berlin (West)

ture. He is a religious painter only in a peculiar and terminal sense of the word, in feeling awe before a world which is pure matter and nothing else, briefly able to see the meaninglessness as mysteriousness. His irregularities, which should be read as ironies, are his ways of showing the flimsiness of hopes that the cemetery gate leads to a world beyond, for the portal of eternity does not gape at the bottom, and metaphysical longings are not satisfied by a tilted head at the window. Though he is not without issue, his Danish descendants have never struck anyone as religious, because they calmly accept the reduced circumstances in which the phase through which Friedrich passes leaves them.

Painters like Eckersberg and Købke are experts of the featureless view, whose emptiness is measured by a solitary signpost near the center like the flagpole in *View of a Lake near Copenhagen* (1838). This shows two figures at the end of a dock built over the water, turned toward a distant rowboat, not far off but near the low horizon which makes the distance astronomical. The groups would look the same whether they

were approaching each other or drawing apart but in fact the boat is getting further away, as reality always seems to be spreading itself more thinly in Købke. Although it appears to be the slave of a dull environment, the painting endures its desert spaces like someone who can look into the heavens and see constellations on a single surface instead of unthinkable distances, calmed not frightened by the sight. He achieves the emotional emptiness denied to Friedrich because structure without content does not disturb him.

The most original development in Danish neo-classicism came in the application of principles learned in empty landscapes to the treatment of interiors. The spaciousness of these little rooms like Bendz's interior in the Amaliegade (1830) is carried over from outdoors and a dissecting glass held over the scene, separating its elements as if by mechanical means, so the coat stands out on the door, the cap on the wall, and the skull on the desk, as distinct pieces of matter, crystals left by chemical regression to more disorganized states of being.

Købke's portrait of the landscape painter Sødring (1832) isolates and

Christen Købke, *View of a Lake Near Copenhagen*. Statens Museum for Kunst, Copenhagen

Karl Friedrich Schinkel, *Staircase and Landing, Altes Museum.* Staatliche Museen
zu Berlin (East)

archipelagizes objects to a degree that only cubism allows a non-Dane to
appreciate, but keeps the dispersed matter from flying apart by one of
the weird but unobtrusive color harmonies which seem to thrive in the
Danish environment, monotonous and strange like Eckersberg's gray,
dull green, and rust, achieving perfection by mineralizing everything.

These Danes can give local subjects the hardness of monuments, so
nondescript barns of Denmark become as potent and inscrutable as
Greek temples or statues, in part because their relation to the past is un-
Romantic and they feel no particularizing allegiances. They make it ap-
pear that neo-classical vision works best in a place relatively empty of
history, or that the style's special gift is to clear it away.

But a nearby effort to materialize history in heavily classicized form
shows this style coming close to giving a new meaning to the local. Karl
Friedrich Schinkel sometimes paints a Gothic cathedral as part of a
grandiose architectural system, the material ready for the shift to Gothi-
cism but the viewpoint too comprehensive still, as if the subject must be
local *and* seen from close up, a localization of eyesight which Ruskin

among others will embody in a liberated form, or Pugin show in his preference for the small detail or ritual appliance. Schinkel already suggests the polarized, often nationalized view of the next phase, though in unheated form, treating history as an operation of consciousness, like a mental scene-change. He resembles mid-eighteenth-century eclectics in being able to entertain incompatible styles in succession, like Greek and Gothic, carried out with academic thoroughness new in a dilettante, and his buildings—bristling with rich details in unsympathetic materials, iron railings and painted borders—conceal an extreme subjectivity of approach. The stairs under the porch but outside the building at the Altes Museum in Berlin are one of his most scenographic details, like scaffolding left up so that one can experience the building as a series of incomplete stages as a workman might.

This view from the inside out is repeated in extravagant drawings: looking out from the museum at Orianda, where stumpy columns fill more than half the floor space, into the alien Crimean day; from the starry night of his Athenian palace into sunlight; from the roofless temple on a high acropolis onto all of Greece in the panoramic *View of Greece in Its Prime,* painted in 1825.

This painting shows the last stages in the construction of a large Greek temple, seen at the level of the frieze with tops of columns as yet lacking capitals underfoot, workmen lowering a section of carved pro-

Karl Friedrich Schinkel, *View of Greece in Its Prime.* The New York Public Library. The original painting was lost in the war.

cession into place with ropes, ladders, and wooden trestles. Through the oddity of its perspective it is both an inspiring vista and a glimpse behind the scenes, inhalation of unlabeled landscape and an inspection of clock-work, clever fusion of abstract heaven and the facts of engineering. Yet it impinges uncomfortably on the spectator, referring to spaces just over its borders like a painted backdrop, a horizontal slit missing its bottom half. The perspectival discovery of architecture molding the landscape, reimagining the Greek land, could be transposed, and one could resee one's own land not Greece, as Gothic not Greek. Schinkel's painting suggests the German artist might find inspiration in looking at his home-land, where a marriage between style and geography will make his products larger than life.

RELIGION AS ART

When Gothic first appears at the fringes of classicism, the motives seem frivolous. At the beginning the style is associated with the Romantic landscape based on a metamorphosed classicism which took shape around many Adam-style country houses from 1740 onward. In these compositions revived Gothic has a peripheral place, for in the woods no flavor dominates and many are felt appropriate, Chinese, Druid, Gothic, and—still predominant—classical. The later religious valency of the style does not hold, nor does the strong association with a place. These gardens were not whisking visitors across continents and cultures, so the styles had no influence on the surrounding vegetation though it would have been perfectly feasible to plant the Chinese in bamboo, or cultivate mistletoe near the Druid.

Dropping temples carelessly among the trees makes the exercise un-dogmatic, and only mildly dislocating, encouraging a pleasant sense that there are many creeds in the world. And the way Gothic is imitated by this early revival, appropriately spelled Gothick to express its ungainly and unhistorical character, reveals at once the narrowness of its aims. Pointed arches and finials appear everywhere, as surface decoration and spearheads on the skyline rather than structure, and chairbacks imitate window tracery without the glass, bare ruined choirs. Pugin makes the

best case against this phase from the vantage of historical rationalism, counting more finials in a mirror than in whole medieval buildings and reprehending the halving of tomb canopies to create mantelpieces. But he hadn't pointed out anything new, for Gothick was frankly exploitative, never attempting faith to its originals, taking what it needed to excite certain emotions and discarding the rest. Thus it could forget that the pointed arch had originally a structural function, could abstract and repeat it like so many jagged pines. The revival hadn't penetrated as far as building methods, so Gothic details were simply appliqués on existing or conventional fabrics, and sculptural details carved from stone in medieval originals turned up as best they could in wood or plaster.

Whatever its initial equality with Chinese, Gothick soon revealed greater capacities than its rivals, even classicism, to serve the purposes styles were now being asked to serve. Though important as formal punctuation, the classical temples in English gardens were most potent for the thoughts of vanished things they called up. As soon as someone of eclectic mind began to view buildings this way, as memory houses giving entry to a set of literary associations, it must have occurred to him that the local church was really more deeply rooted and required less work of the muser, who needn't read the Italian past into lumps in the ground but could dig his own right out of it.

And as soon as he had grasped the more natural relation between nature and history in Gothic we imagine the landscape garden eating away at the esthetic certainties of the Adam house beyond the trees until it transforms it to a castle. There is no evidence it happened this way except in some surprising houses built, not converted, with Gothic outsides and neo-classical interiors, like that of the theorist Richard Payne Knight who thought a castle harmonious with the landscape and Greek rooms comfortable to live in. Good sense pushes him to a contradiction which could not thrive as a model, treating the exterior as a picture and the inside as a house, letting it come apart into two things, one to look at, the other to live in, a dramatization of the problem inherent in the Gothick view, the tendency of esthetic considerations to come loose from the rest of experience.

From the beginning Gothick dabbled in "religious" emotions, awe treading on fear, reverence on superstition. Though sometimes as at Lee Priory it was painted in delicate porcelain colors, unlike the other remote styles entertained by the English eighteenth century as subter-

fuges for the Rococo, Gothick calls up a darker not a lighter world, announces a change in temperature and invitation to the irrational, which though trivially crazy in appearance springs from deep sources and leads to one of the great derangements of recent centuries. From this episode in the history of taste comes by a clear descent, which the key participants, Pugin and Ruskin, have tried to obscure, a revolution in historical consciousness, in ideas of recoverability, and in man's relation to the lost portions of himself.

In some sense there is no more important figure for understanding how the eighteenth century shades into the nineteenth than the crank William Beckford, who by building a house for himself which he called Fonthill Abbey pushed the connection between the revived style and religion to new heights. Though not a folly in scale it was one in permanence, so practically all that remains of this collapsed monument are pictures and descriptions, of both of which there is a large number. From outside, Fonthill led one, as Pugin complained, to suppose it was inhabited by a religious community, by exhibiting transepts and a crossing crowned by a huge central tower, an east end decorated with a cross, two western towers, and a cloister attached.

The result is not assorted reminiscences of medieval religious architecture, because in scale and completeness it makes a thorough appropriation, claims the qualities of a church for a dwelling as if they have worn themselves out in their customary place and lie there free for the taking. Well might Pugin rage against the way each part of the church serves specific everyday uses:

> The seemingly abbey-gate gate turns out a modern hall, with liveried footmen in lieu of a conventual porter; the apparent church nave is only a vestibule; the tower, a lantern staircase; the transepts are drawing-rooms; the cloisters, a furnished passage; the oratory, a lady's boudoir; the chapter-house, a dining-room; the *kitchens alone* are real; every thing else is a deception. . . . (*True Principles*, pp. 59–60)

Another appropriation begins around the same time: the incorporation of monastic ruins into landscape gardens, of which the most wonderful instance arises from the purchase of Fountains Abbey by the local squire in 1768, signaling a new appreciation of Gothic but paralyzing it in a web of paths crossing smooth lawns. Fountains is larger than any of

its ornamental companions and even more purely scenic, providing its owner with an esthetic object on the scale of the Roman Forum or the Colosseum.

Pugin's answer to such transfers of the old Christian architecture to non-sectarian existences is to build imaginary churches of his own with the difference that they are to be used for worship, of a kind which is itself an archeological reconstruction, unknown in England since medieval times, if then. Gothick had become embedded in sadistic novels and lords' pranks, so that its first applications to churches might have seemed faintly blasphemous, mock-religious architecture, the ragged equipment at Shobden for instance, like a jab at awkward superstition by a refined rector.

Pugin's program is fraught with dangers because it is hard to shake all suggestion of whimsy from the idea of reconstruction, no matter how painstaking. He could never have thought his innovations would fit with what religion was to most users of his appliances, but his work in cathedral libraries and Continental churches had given him a new conception of religion which he announced by turning Catholic.

He makes it hard to separate convention from innovation in his work because reassuring features may be protective color at a dangerous point in the argument, thus perhaps his evocation of the Mass in language of eighteenth-century taste, leaning heavily on the word "elegance." He feels himself so embattled that almost none of his theories can be taken at face value as explanation since they form part of an attack or a dogma, camouflaged attack. From this man who made conviction the basis of everything and cannot express doubts by which he might test his convictions, we only learn what he wanted to think he thought.

Helping to re-establish a connection between art and religion, and thereby appearing to undo a large stretch of history, is his main achievement, but he remains a descendant of the picturesque, the spidery quality of his designs recalling the previous age and justifying as Gothic itself does not the epithet "elegant." He bears the relation to his model that Robert Adam does to his, feminizing and attenuating it, while persuading contemporaries of his archeological accuracy.

Pugin's peculiar mixture shows up in some of his earliest works, the illuminated manuscripts made for his own amusement in the early 1830s, studies of imaginary buildings on a minute scale useless as plans and forming in jewel-like density a clinical equivalent of the medieval book of hours. The earliest, called *The Shrine*, exposes the mechanism

A. W. N. Pugin, page from his illuminated manuscript *St. Marie's College.*
The Victoria and Albert Museum, London

most blatantly. All his works are enshrinements, the one in this title St.
Edmund of Canterbury's, a hypothetical destruction of the iconoclasts
Pugin now un-destroys, beginning with two title pages and a perspec-
tive view of the shrine, each page set off by blank interleaves, an un-
medieval way of emphasizing their preciousness. Then an anatomy

begins, closing in on the central kernel—shrine from the east, plan, elevation, saint's effigy. So the kernel is a corpse, but where will Pugin go from here, for the book is less than half over? The next page is not decayed flesh but a more private table of contents: "The Holy Relics of Edmund," not pieces of him but his possessions—a reliquary he owned, a cross he wore, another one, his clothes, his beloved picture of the Virgin, then a retreat to the larger world of ceremony, and finally, beneath the depiction of a pontifical ring, Pugin's justification saying that although he has invented everything, because he has studied the style of the years after the saint's death he hopes he will be forgiven, science legitimizing a prowl around the corpse reminiscent of Gothic novels. As always Pugin gives machinery and no action, metal trimmings without the soft flesh.

We can use this project as a model to reinterpret less infected series on buildings, like *Le Chasteau* of the following year with texts and labels in imitation Renaissance French, or *St. Margaret's Chapel* and *St. Marie's College* of that year and the next.

Many architects have toyed with unbuildable buildings before they came to actual erections, but Pugin never threw off the early un-architectural mentality. Here section and plan are not functional but entertaining, as if one were a bird or could see through solids, and in these series one watches him become fixated on the conventions of architectural drawing until he prefers the miniature to the gross fact in stone. The narrative of forty-one views of the same thing, turning the chateau until all aspects have been exhausted, moving in closer and penetrating its smallest secret, is like an ascetic's inventory which displays the loot of the sacristy one item to a page, so it lasts and lasts. Although he managed to express this attitude to detail in the compartmentalization of walls and ceilings later on, Pugin never embodies his love of Gothic as fully in reality as he can in drawings.

Fanatical consistency, which his religion comes down to, is less attractive the larger its field. Outside a *Contrast* the primness and emotional emptiness in his Middle Ages is more evident without its over-legible rival above. The plan of *Contrasts*, Pugin's most popular book, is to juxtapose building types from widely separated centuries, the fourteenth and nineteenth, as if one were taking scientific measurement of the same thing at different times. But reality never exhibits comparisons this clearly even when centuries build next to each other, because the later won't normally duplicate the earlier functions.

THE SAME TOWN IN 1840

1. St Michaels Tower rebuilt in 1750. 2. New Parsonage House & Pleasure Grounds. 3. The New Jail. 4. Gas Works. 5. Lunatic Asylum. 6. Iron Works & Ruins of St Maries Abbey. 7. St Peters Chapel. 8. Baptist Chapel. 9. Unitarian Chapel. 10. New Church. 11. New Town Hall & Concert Room. 12. Wesleyan Centenary Chapel. 13. New Christian Society. 14. Quakers Meeting. 15. Socialist Hall of Science.

Catholic town in 1440.

1. St Michaels on the Hill. 2. Queens Cross. 3. St Thomas's Chapel. 4. St Maries Abbey. 5. All Saints. 6. St Johns. 7. St Peters. 8. St Albrowights. 9. St Maries. 10. St Edmunds. 11. Grey Friars. 12. St Cuthberts. 13. Guild hall. 14. Trinity. 15. St Olaves. 16. St Botolphs.

A. W. N. Pugin, plate from *Contrasts*

Pugin sees even the simplest types, like public pumps, as institutions. For him workhouses, bishops' palaces, market crosses, manors are entirely picturable, all life come to the surface. He enjoys the wrench from century to century more than he realizes and makes his drama, un-

medievally, from discontinuity. The Middle Ages is more exciting plunked down in the nineteenth-century city than when life was a single monotonous cloister, circling and circling its own consistency.

Though he felt the energy of the gap Pugin couldn't incorporate it. His buildings are empty coffers, spoiled the more usable they become, which fail to concede the intervening history as the works of Butterfield and Street very shortly are to do. Without his writings Pugin would be a less important figure, and they depend on a structure of antagonism predictably absent from his buildings, though one could imagine structures which incorporated his contrast between modern and ancient civilization in one educational fabric. Yet his preoccupation with the enemy separates Pugin the antiquary decisively from his eighteenth-century predecessors. Mrs. Radcliffe's novels are only by implication social acts; gentlemen's hobbies hidden in their parks may work occasional conversions but this is not their purpose. Pugin is the first writer on Gothic in which the romance is overbalanced by invective, whose Christianity proves itself by the strength of its hatred of the non-Christian.

The great enemy attacked so effectively in *Contrasts* is the rationalism and diversity of industrial civilization, which offends by showing its function, stripping human action to a skeleton (coffins which look like containers are carted and simply buried, not shrouded, ushered, lowered), giving signs of social fragmentation (shopfronts display contradictory, too-legible messages), and being populous, putting prisons and rows of houses where the medieval had walled gardens (which come off well in the bird's-eye view and less well trudging along outside the wall). Awkward joints in medieval structures signify unconscious vitality, and advertised function (in chimneys, hinges, stair turrets) is strength—an idea withdrawn from modern mills and smokestacks. The medieval world is tidy and permanent, flat courtyards without dunghills, no intermediate stage between well-built town and trim field, while the modern world is full of conversions and unsettled business, impossible to prefer because of cropping at the edge like badly framed photographs.

Pugin's unfairness has been taken as further sign of how deeply he believed what he was saying, and while it is true that an opponent who distorts his materials is more dangerous, he convinces even adherents that they cannot reach him rather than that his views are securely founded. Belief, as Pugin understands it, cuts one off, without joining one up to the other faction. So he proves his conversion by alienating the

group he used to belong to, but never turns away, and his real audience remains non-Catholic.

He is more effective because his hostility ranges so widely. It is not unheard of that a writer acquires a reputation for stringency by making people wonder where his anger will strike, or where in the end it will not strike, showing he finds little of existence acceptable. Pugin might have been expected to applaud the intentions and correct the lapses of Gothick, but he is unfailingly witty at its expense, never admitting shared impulse in the castellated grate and his reredos with pinnacles and curtains. The idea is shocking because true, and his contempt shows he suspected it.

Pugin's life is an attempt to deny his estheticism by freeing an interest in appearances from taste, for taste offers no solution to social problems until you translate it into belief and make emotions excited by your objects not so much pleasant as virtuous. Everyone needs to think he pursues what he does for important reasons, and few artists have ever accepted that their work was devoted to satisfying the senses. So in Pugin's case a superstructure came into being whereby the style was no longer valuable for itself but for the life it recalled, not by anything in its nature, though these supports were welcome when he found them, but through circumstantial association with the ages of faith. Like most revivalists he began by imitating Perpendicular, the most sophisticated stage of the style, but as his eye sharpened he came to prefer earlier moments and the reason had to be that the faith had elaborated itself along with the architecture, and that purer forms meant purer feelings.

In the late 1840s Second Pointed (now called Decorated) became fixed as the favored style, a uniformity which must be regarded as esthetic sectarianism, highly informative of the way the history of art had begun to order people's eyes and feelings. The idea that there were four stages of Gothic had appeared as early as 1763 in an essay on Spenser, and finer discrimination of the qualities of each, often accompanied by the feeling it must be possible to rank them, is an application of "science" to art fascinating to follow and treacherous, since one cannot withdraw at the end or avoid complacency as one sees them come closer to the right answer, like God watching Adam. Late in life, when given to reprehending his early incorrectness mixing features from the different Gothic periods with ones translated from later styles back into Gothic, Pugin expressed the despair of enthusiasm cooled by historical

discrimination, which bears even more heavily on us who cannot look at anything without trying to date it:

> As we gain knowledge conviction of failure is inevitable. It quite gets on my mind. I believe we know too much. Knowledge is power but it is misery. Dear me, a few years ago I felt quite satisfied with things we now look upon as abominable. Still I almost sigh for old simplicity when I thought all the old cathedral men fine fellows.
> (Pugin to John Hardman, 1851, quoted in P. Stanton, p. 194)

This tyranny of history, more compulsory than that of the classical orders, took strong hands to break, resulting in a style which had severed links with the past instead of finding a more comfortable relation than that provided by the scientific discrimination of styles, so demanding in the amount of context it requires every work to sit at the center of, and so profoundly tired of this history at the same time.

Pugin holds out against many things, commerce, progress and comfort, Gothick and classic, Protestant and pagan, while giving in to products of the right period unselectively. But he shows his ideal is not other people's Gothic by calling it always Christian or pointed architecture and shifting the onus of novelty and rudeness onto classical by calling it revived pagan. He will not admit the justice in other people's names or even in their letters, ancient (one of his favorite words) is always antient, and chasuble appears in the *Glossary of Ornament* in three archaic spellings besides the standard one. Pugin's Anglican rivals the Cambridge Camden Society went even further, and a list of their antique spellings is a map of the space they find for themselves between Catholic and Protestant: Catholick, lettern, pue, monial for mullion, crop for finial. One of the sweeping effects of the new style is its regressive influence on legibility—plates and plans labeled in and public inscriptions written in black letter, so called because in Gothic script letters are blacker, more forceful presences but less different from each other than in Roman. An adherence to the past which adopts literally obscuring features like this is perhaps superstition as much as esthetic revival, and the enthusiasm for decorative lettering ranging from lips of chalices to cornices and ceilings is far from an interest in clarity and explanation: it attempts to drag language back into a dark tangle of emblem and charm and inscrutable blob-shape.

When Pugin imagines medieval life in full, it is clearer why vest-

ments often seem his entire idea of life. The series of twenty-three drawings for the projected book *Church of Our Fathers* shows the ceremonies of the church at its most ritualistic with little variety of feeling, all religious acts as frozen processions, less specific and passionate than his depictions of the metal implements of those activities, the liveliest image a sacristy with its great cope chest held open by ropes and pulleys attached to the ceiling.

Like Gothic novels Pugin's world suffers from monotony of setting; he wishes life could be spent in a cloister, and one of his great evocations of community is a vision of the dead brother buried in its floor prayed over by monks who perambulate it. The other is the old English manor house as a representation of old English hospitality, when the rich entertained all classes, not other rich only, a caution against deriving attitudes too easily from buildings, since inhospitable owners replacing hospitable do not express it by walling up doors or reducing the size of halls, which do not mean as they increase in size merrier and merrier companies.

All visions of the past have less diversity in them than the quietest present, and in Pugin's Middle Ages everyone feels the same thing; the religious reformers destroy the emotional unity of the nation which he hopes to restore by starting history again at a point prior to the conflict, a clearer and in that narrow sense a more reasonable view of historical process than ones less solution-oriented. His rationality, which seems to some now his most progressive quality, is the kind which finds reasons for things too easily.

The great principle of making the useful a vehicle of the beautiful, employed to show the greater honesty of medieval designers, cannot be applied to produce unmuddled conclusions. Pugin's most curious examples are taken from medieval metalwork, extension of hinges in scroll patterns (as against modern concealment of hinges in the doorframe) and decoration of bulky locks, where the old craftsmen extract positive benefits from necessities which modern builders hide out of sight, weakening the hinge by curtailing it and making locks more not less mechanical. His ingenuity in preferring the awkwardness of the Middle Ages leads to calling disguise embellishment in the old case and deception in the new. The scrolls may achieve a partial confusion about where hinge ends and frill begins but the crudity of the lock as a machine is unevadable in retrospect. A consistently thought-out preference for the medieval would recognize crudity as good faith which could not be otherwise. When an Arts and Crafts designer forges clumsy hinges it is conscious

historicist choice, a freedom unavailable to the Middle Ages, but interpreted as equivalent to the old simplicity and freedom from rationalized alternatives.

The category of "functional beauty" which is sometimes seen as descendant from this attitude of Pugin's is beginning to be recognized as a mostly delusive construct, most of all in the buildings which seem most freakishly to embody it. The Pompidou Center in Paris masquerades as rational, but treats bolts and wires as decoration, making its greatest display on the underside (the back) which, as with a machine whose control panel has been taken off, the visitor feels he should not see. Such examples only show that functional too is only a way of thinking, largely under the control of the designer, not a necessity leading him by the nose through ugly ducts, and that it was still a decision, though for historical reasons unconscious, which made certain features of buildings necessary and unwanted at the same time.

Pugin's rationalism like that of functionalists since is a method of Puritanical exclusion. In *True Principles* he fulminates against wallpaper which gives an illusion of depth by shading, because as it is carried around the room it shows the light striking from opposite directions on facing walls, neither of which will often correspond with the sun outside. Early Victorian patterns could be remarkably overblown but Pugin has turned his dislike into a principle, making huge consequences follow from small abuses. This bit of theorizing pushed him further into the weightless linearism to which he was already inclined, and the Gradgrind hatred of illusion separating design so sharply from picture ended in Arts and Crafts interest in flat patterns of folk art, rational consistency prompting a retreat to primitivism.

The religious revival though setting itself against the bareness inherited from the Puritans represents a tightening rather than a loosening of rule, and the efflorescence of art it encourages is in these stages strictly regulated. Even Pugin's wit derives at bottom from inflexibility, so he says it is lucky for the projectors that climates are not imported with building styles, or Arabian deserts and northern forests would jostle uncomfortably, a principle which would have kept Gothic out of England if applied by medieval builders. He uses medieval hatred of the flesh where appropriate—to outlaw naked angels—and elsewhere classically derived ideas of decorum—to drive out the company of grotesques. For Pugin the heightened landscape of the believer is laid with traps and

snares, and while in a sense it solves all problems, his creed makes the world harder to live in.

A chapel in his house at Ramsgate puts its east end up against the west wall of St. Augustine's, his private church, without taking notice of it, in a way that reminds one of the frontispiece to his *Apology* where twenty-four of his churches are lined up like boxcars in a freight yard. The buildings at Ramsgate too are uncomfortably marshaled for an unarchitectural purpose, and his view of things remains disunified, chancel and chapel screens, a favorite device, acting as inflexible membranes or boundaries rather than enrichments of space.

St. Augustine's combines the utmost integrity in materials and detail with the utmost whimsicality of plan, a plan whose interior asymmetry suggests a glimpse of a more magnificent church, the corner of a cathedral. Although Pugin's detail is scrupulous the function of the building is still picturesque, an abbey built because he wanted one, housing services carried out according to an ideal conception of the liturgy.

Sir Francis Dashwood dressed and had himself painted as St. Francis because his god was self-realization and he enjoyed using the most potent materials. Pugin donned his own vestments and served as acolyte to make the service more acceptable to God. But the distance between the church and house at Ramsgate is perhaps not as crucial as he felt it, sufficient to divide Beckford's Abbey, a self-indulgent practical joke, from Pugin's, a piece of selfless devotion. On the contrary, it suggests the religion of the revival half-decayed from the beginning, and the movement a dissolution instead of resurrection. Refined in form, Pugin's designs are naïve about their own dependency. His development from the earlier dilettante is to lose perspective and self-irony and become embroiled in his hobby. It is as if his ideal were a medieval absence of personality, fanaticism stepping over individuality into a ritual space where life became one connected work of art like a procession, which avoided endings and thus preserved ignorance of the self intact.

Unlike Pugin, Ruskin is a confessional writer whose contribution to the revival is to establish a relation between the enthusiasm for history and one's feelings about one's own past. He had many ways of keeping time, observing it, lamenting it, losing it or possessing it, which we can share most completely in his *Diaries*, a form used by people who hope to turn their lives into histories, which become from time to time for Ruskin a mechanism for selective repetitions, for filtering and refiltering his

experience, tightening and loosening his grip on it as he rereads the entries of a year before and two years before, drawing their relation to the present year, expanding them with fuller notes on his meals or hotels, revising them by saying how his sense of that day has changed, or answering them with a cry that the unforgettable is forgotten. It is a process carried out too constantly in relation to the recentest past to be remarked often, except that he sometimes says mechanical entries are written just for reassurance the weeks aren't wasted. He believes in the day, the week, and the year, an intriguing and costly faith. A ruined day must be counteracted by its successor, a lost week is "a whole week and no good work done," and years shrink as he looks at them. In 1856 at the age of thirty-seven Ruskin calculates the "number of days which under perfect term of human life I might have to live . . . 11,795," and for about the next two years keeps a daily record of this balance, counting backward toward his death without further comment, perhaps a goad to achievement, perhaps a purposeful humiliation of pride, but certainly evidence of intense desire to record, to keep the shape of the whole constantly in view, which takes the form of meaninglessly detailed focus on it. Once more in his life Ruskin counted off in this way, waiting for Rose's majority in 1869 when he would have her without her parents' consent, carrying it on for at least a year, until uncomfortable with wanting the number to grow smaller he begins counting from two pleasant events in February 1866, so that the number increases each day, a calculation without the same interest and more quickly dropped.

In 1840 Ruskin divided his diaries, keeping two parallel sets, one for intellect, one for feeling which he called the Book of Pain and later destroyed and which was probably taken up at this time with his futile love for Adèle Domecq. It is a kind of symbolism to institute a difference so inflexibly, and it means that a large part of Ruskin has been subtracted from our view, but in the blanks and cryptic references which remain we can gather that every disappointment in the relation became an anniversary to be observed with increasing fervor at yearly intervals for the next six years. In one part of the year they crowd each other so closely it is like Passion Week without a resurrection at the end. The diary that remains says only that the black day was marked, not the nature of the celebration, but presumably in the missing volumes Ruskin refreshed his memory, meditating on the form of his loss, more tenacious of sorrows than joys.

His travels are organized similarly if not quite as rigidly—he is the

great revisiter, perusing a Bible of Europe whose canonical texts are established early in his life, some reappearing because they are stopping places on the way to Italy, some great anchorages on which he can never lavish enough attention, but all of them attracting affection because they are "old," which is to say he has been there often before, Abbeville, Rouen, Geneva, Chamonix, Pisa, Lucca, Florence, Verona, Venice, names which acquire for the reader of Ruskin a resonance like the great names in Proust, which often has very little in it of everyday associations: Florence not Renaissance and secular Florence but a lily bloom of quiet piety; Venice severe in her luxury, marrying visual opulence and primitive Christianity.

Proust has a stirring description of the relation of the names Ruskin mentions to the ones he doesn't mention, in which the apparent randomness of his few examples raises a hope of the other experiences which will never find their occasion, or may, according to laws so obscure no one can guess them. The *Diaries* show him selecting in his journeys as he does in his works, eliminating many of the stops included in his first trips with his parents and singling out Italy to a degree that his earliest writing does not show him aware he would do.

Days in gross lots are manipulated magically in attempts to control them. The anniversary—one of the great techniques of religion, ritual in its guise as a time-tool, dominating passage and punctuating the non-ritual outside world—is practiced so naturally by Ruskin that his invention of a private time-religion cannot be laid to the influence of early religious training. It is forced on him by something deeper than earliest learning, and likewise the attempt to make private symbols of Italian places by the pattern of his visits is less willed than readers are likely to think when confronted with elegant statements like "My work in that time was all in three places on three painters," "Three cities have been of supreme moment to me . . . Pisa, Geneva, Rouen."

He reduces the multiplicity of his experience by saying it is smaller than it is, but also by trying to make it smaller, returning in 1849 for one city alone, Venice, toward which at the end of his life he seems to have nursed a strange resentment, for taking so much of his time or associating itself so firmly with his name. He identifies a turning point in 1845 where if he had not been drawn aside to Venice his whole life had been different, *Seven Lamps* and *Stones of Venice* had not been written and time less intense and more productive had been devoted to more sensible projects. It is in the Epilogue of 1883 to the second volume of

Modern Painters that Ruskin tries to shock his readers with this specula-
tion, knowing it is heresy, but harmless, railing against a power too
great to withstand and a way of saying the dilettante's time was not his
own, his life a life of exacted service, the saint making a last feeble effort
to salvage his ego from his creed.

Some of the bizarrest numerology is contrived in the furthest retro-
spect but there are examples from close up, though Ruskin's first en-
counter with many of his favorite objects does not exist: in our earliest
meeting he is seeing Venice again. In spite of great lurches of newness
in his response we feel underneath something so old and fixed it is like
trying to reinterpret a parent, always a forced exercise, deliberate erring
after novelty. For the patterns from which he receives greatest satisfac-
tion are closed and will seem to some readers sterile allegories, but per-
haps like other allegories they are designed to lessen the need to work
for an interval afterward, and thus only point toward the rest which
they earn:

> It seemed to me, during a somewhat restless and sad interval of the
> night, as if my life, with its work and failing, were all looped and
> gathered in between St Cergues farewell to Mont Blanc in 1845 and
> St Cergues return in 1882. Thirty-seven years . . . Thirty-seven: take
> ten to learn what I had only then begun to learn, and they are but
> 3 x 9 for Art, Geology, and St George.
>
> (Diary entry for 5 September 1882)

St. George is political economy, its controversies here submerged in
the tranquillity of the childish sum, operating like the copying of its
creed in his own hand required of a new joiner of the guild of St.
George.

Ruskin's orders must be examined not for their intrinsic interest but
in consciousness of the disorder they put a stop to. His formula for re-
turning from the Continent, standardized as he gets older, is: "In my
old nursery again." Just as he returns to the same rooms in foreign ho-
tels he keeps the nursery in his parents' home at Denmark Hill as his
own up until his last lucid return in 1882. It causes him the greatest
consternation, not to liken himself covertly to an infant when well into
middle age, but to consider that a remembered strength of feeling and
indifference to time's passage is permanently lost. Perhaps he exagger-
ates his belief in this loss in letters home of 1845 detailing the change in

his mind from dreaming to workmanlike and commonplace, for he continues to inspect old haunts not entirely without hope of finding the old emotions. Thus three days after the analysis of decline mentioned above, which asserts the beauty of a child's absorption in time instead of outside it, Ruskin spends five hours tucked under a ledge on a mountainside watching the clouds.

The gulf he sometimes feels dividing him from his earlier self, of which the most eloquent and sustained expression are the Epilogues and Additional Notes to *Modern Painters*, across which he projects a heart-rending envy, is the curse of a man who lives by sensations, whose ideal is immersion in the moment or the detail, and who consequently accumulates a stock of uncommunicating and perishable intensities. It would have horrified Ruskin to hear his life described in this way, and a good deal of his fascination for us resides in the struggle to make himself feel things he doesn't feel or construct professions he doesn't believe. The blockage caused by religious belief in the easy expression of feeling seems a mostly creative force, but in one place refusal to ask what he felt proved costly. On the subject most critical for understanding him we don't know his opinion because he didn't allow himself one.

Most of his references to his parents are ritual expressions like prayers directed into the upper heavens, which he hopes will meet a willing ear in spite of being unsolicited. Even in his diary sparse references to them are of this impersonal and eternal character. Of course a large anthology could be collected of his pronouncements on duty and submission, all regarded by the writer as veiled references to his parents, but disastrously misjudged if meant as descriptions of his own work, than which nothing more willful and unteachable in its course can be imagined. If we still want to know, as he does not, what he thought on this subject, we are left interpreting his many dreams about them, excepting the ones he thought too awful to write down, and the formal tone of the letters always addressed to his father at his business address though intended for both parents. This device is a final confirmation that we are not meant to know about Ruskin and his mother, and reading the single exchange between them in this correspondence we are likely to acquiesce, facetious gallantry sitting so badly on the archetypally serious man.

Nonetheless his parents have a great deal to do with how Ruskin came to value the detail seen in close focus as it had rarely been valued before. The effect of this concentration, not its conscious intention, is to stop time while he ingests the object. It is distinguished from physical greed

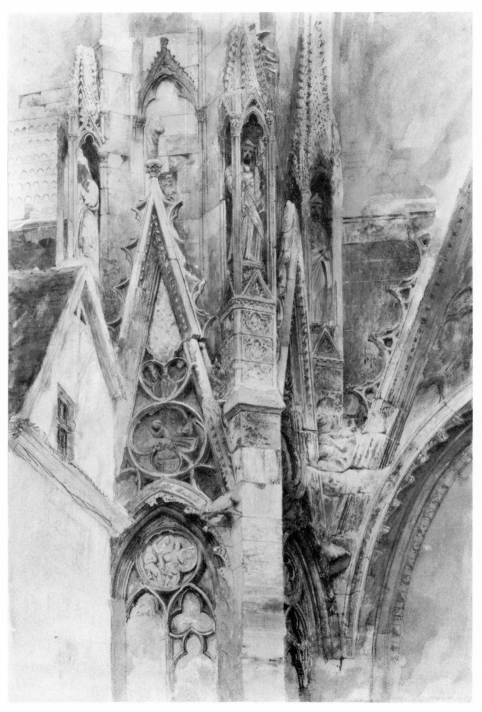

John Ruskin, *Rouen Cathedral Gables*. The Fitzwilliam Museum, Cambridge, England

by being internalized and more highly structured, but it is flattened and deadened by calling it as Ruskin does devotion. For him interpretation is a kind of ownership, and he becomes exorbitantly angry at an official or even a religious service which separates him however briefly from the object he has decided to fasten on. This is the meaning of drawing as he habitually uses it, a way of hanging on to the object until he knows it, of preserving the relation—sometimes for several weeks—while he duplicates the loved being, his most satisfactory drawings the near-lifesize details of architectural sculpture and his most painstaking the copies of fresco. Likewise photography pleases him as allowing one to carry the palace away, and he marvels that with a photograph by a fire in Switzerland he can put time back two weeks to his last day in Venice.

This continual search for undivided union with the world outside in the form of a representative token is an unusually strong survival of the unitary feeling of infancy in which oneness not plurality seems the natural condition of things. He does not seem to have regarded human relationships in the same way, though it may provide a partial explanation of why his most passionate object outside the family was a child, Rose la Touche. His relations for the most part would have taken the forms in which he always imagines character, when personifying trees or mountains or offering a metaphor at a turning point in an argument—as children and stately old men, God and a child, the most primitive bifurcation, little further on but fatally divided from the bliss of not remembering there are other beings in the world. He was strangely incapable of imagining most kinds of character and though he began as a poet could never have made a novelist.

Ruskin begins by seeking or finding the privileged relationship, into which all relations dissolve, among mountains, stately old men in a state of senile decay, who still wax from time to time deplorably fierce. One of the triumphs of his imagination is to derive all human greatness however elaborated from the savage blankness of the hills, and it is almost fair to say that for him everything of importance in the world has occurred in the shadow of the Alps, that Mont Blanc is the center of the universe. It is also a triumph that such an animistic throwback should have passed himself off as a moralist, but perhaps he makes a critic and not a poet for these dizzying faults in his mind, which call forth a healing labor of explanation.

He came down from Mont Blanc, turned from nature to architecture and painting, from one kind of stone to another, following as he saw it

an inevitable cooling and crumbling as the mind grew older, but also because art offered truly repeatable experiences. Mountains became cathedrals to him by dint of repetition, but even after many visits were hard to recognize and the wrong size for the patient study he tried to apply to them. The fourth volume of *Modern Painters* is the final document in Ruskin's involvement with mountains, and doubles back to parallel volume one, focusing attention on its own growth. From now on mountains enter at the ends of chapters in a rhetorical device of putting the subject beneath him, letting him show there are more and grander things than Titian in the world, a freedom of transcendence he needs because he can never resign himself to being just a writer on art.

Art seems the answer, then, to Ruskin's fear of change and sense of loss; when he finds in Italy the style and period he can feel as constituting the childhood of art he is given a better substitute for remembering his own or a means of arranging the memories. Though the age of faith, of Ruskin's remembered and dreamed faith, never lost this function for him, its survival was soon called in question. Already in 1840 Venice is not what it was, and by 1845 the alteration of memory has become unbearable, until he can hardly see it through his tears, is in time but just barely to catch it before it falls, feverishly sketching one side of a building while they knock down the other.

After Rose's death the light changed and black clouds filled the sky more and more for him, so in *Storm-Cloud of the Nineteenth Century* he argued the alteration of the English climate as in *Stones of Venice* he had preached the disappearance of Venice. Cosmic processes echo the pain of ending and the world now says goodbye to the better feelings he has lost. It is not a very different sense of the finality of the moment from that which produces loneliness or causes him to say "I now begin at last to understand aright in the sixtieth year of my age." It leads him to identify exactly things which cannot be identified, which are not in fact moments at all—the spot in Italy where his joy began, the best day for work in his life. It is the tragedy of well-meaning egoism, the belief that every thought has one understander, that even the Bible still waits its right reader, who may be John Ruskin.

Ruskin's history is a transposed version of his sense of personal time, perfect psychological base for a revivalist in attaching him so firmly to a past time, except that unlike the practicing revivalists he does not think he could be satisfied by the present. More at the mercy of time than most, Ruskin claims authority over a distant past, sure of Tintoretto if

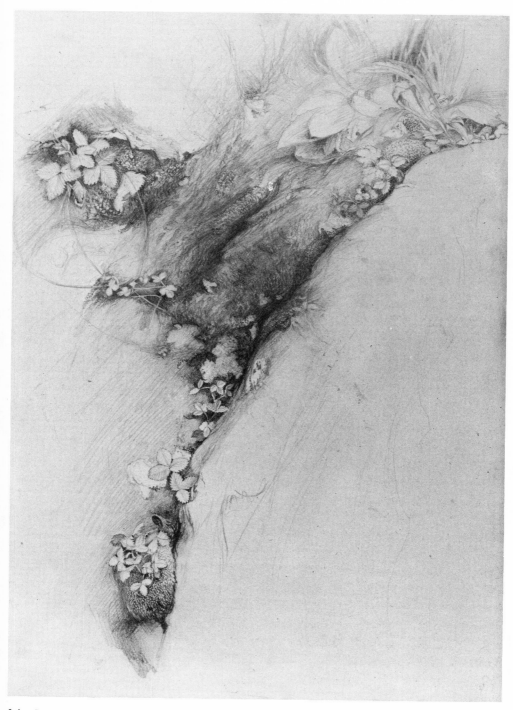

John Ruskin, *Moss and Wild Strawberries*. Ashmolean Museum, Oxford, England

not of himself. Like the human and geological history accelerated before his eyes, incorporating great surges, gulfs, and reversals, Ruskin's past is erratic and un-gradual, a time of heroes where ignorance lets him surround his three great men of the sixteenth century, one in the north and two in the south, with wide empty spaces. The hero's childhood jumps out at him, a rebuke to articulate knowledge and worldly renown, and lets him see even Titian as largely alone, a child in a walled garden, rich in experience but saved from knowledge.

Ruskin's undependable attempt to tell the general history of Gothic in *Stones of Venice* launches after two preposterous lists of the style's moral elements into contrasting evocations of the northern and southern landscapes, the south like a piece of Art Nouveau metal and enamel work, the north like a rude Norse carving, or rather the south art and the north nature, both expressed in climate. The irrelevancy of this procedure is left to us to find excuses for, and we do, for these terrains *are* the architects—cathedrals tear and heave themselves out of the moorland (where is this cathedral on a moor?) instinct with wolfish life, the aggravating slowness of their construction compressed not to a life or a year but an afternoon, his style animating the idea as he says the Gothic spirit animates the buildings, displaying many of the qualities it names and applauds.

It is high-handed notion of how things happen, unserious and amateur in its structural explanations, discarding them anyway to say that cusping of pointed arches, though strengthening in its effect, appeared as an expression of the principle of foliation, which is to say the love of vegetation as it can occur in stone. They are structures of desire, thrown up by love. The explanation is a psychic allegory, depiction of a hierarchy of motives, the highest products arising from highest, most distinterested motives.

Likewise his understanding of the changes which he calls downfalls is derived from his sense of the moral dangers confronting the individual, though it may be clothed obscurely in technicalities of construction. He finds two turning points in Gothic, the beginning of decline in the mid-fourteenth century, the death of the style in the fifteenth. Both times the cause is a new self-consciousness, first in window tracery, when, from dazzled at the star shapes in between the masonry, the builder first feels his attention drawn to the ribs and realizes they can be manipulated. It can be expressed as a shift from mass to line, which seems sufficiently technical, but withholds the clue to why the change is loaded with moral

consequence. The model is drinking in poison unawares and substitution of stone for stars an instance of replacing spiritual with sensual, linked to the doer's preferences, not chosen, but consciously developed thereafter. It may be an allegory of the loss of religious belief, or, in the changeover from delight in perception to complacent manipulation, of the corruption of the seer into the writer. Ruskin is not given to expressions of that particular self-disgust or plans to write no more, yet one must feel his laments at growing self-consciousness and its accompanying fatigue sprang in part from the sense of his own books crowded around him. So we would arrive at blaming his madness unscientifically on his writing, which made him increasingly aware of the inextricably egoistic nature of every act, but by its identification with the omnipotent master, work, could never be slacked, could only as things got worse accelerate, because he had mistaken the disease for its cure.

His patterns, moving in their simplicity, would be hampered by excessive historical or structural detail. The broad sweep of the history is told almost without specific examples, not of course because appropriate ones would not have suggested themselves but through a longing for monumental simplicity, for a really cleared space, so the cathedral is a distillation of them all perched on a high mount of the imagination. His map of the style's course owes its charm to a paradox: both Gothics, early and late, are most noble where they meet. This sounds more improbable than it is, causing the reader to visualize the figure, and to see that the shape of these four centuries of history is one pointed arch, Gothic showing its Gothicness by the figure it makes in time, so that catastrophe is strongly patterned.

Ruskin makes legends the way most people give excuses, but extraction of the self-contented skeleton traduces its effect in place. He pretends to be a lawgiver, and there are thirty-three rules laid down in the space of the eighty pages on the nature of Gothic alone. His rules are not galling because like Blake's they are always unruly, issuing from love of paradox so strong and generating such floods of contradiction they appeal first of all to the restiveness in any mind and most deeply to the most restive. His sense of history is made unencompassably various, like a dozen poems overlaid in the same place, in spite of ruthlessly clear outlines of the centuries, by Protean forces of contradiction constantly crossing the bounds of sense in alliteration verging on nonsense rhyme, in suggestion that birth is death, Gothic is Protestant, rich is humble, beauty is fallible, in the love which evades its object. His love of Gothic

is shown by his leaving it, turning the definition to a consideration of workmanship in general, picking qualities to describe it which most people will dislike: Savageness, Love of Change, Love of Nature, Disturbed Imagination, Obstinacy, Generosity, the second list which duplicates and interferes with, supersedes and complements the withdrawn first. This near-chaos is perhaps another simplification, but it works its spell, infects its readers with its love, of impropriety, risk, and waste, and raises them to its phantasmagoric heaven outside sequence.

Ruskin's history is memorable because deeply, helplessly symbolic, in singling out its examples, in perceiving its ideas as creatures, and above all in believing its own thoughts, feeling the reality even of single words to be hardly inferior and in places superior to that of objects. In some degree these are common to any imagination mainly literary, the degree of explicitness required, limit to abstraction tolerated, kind of connections valued, and especially the part loyalties play in its every act. But Ruskin had more difficulty shaking off this kind of thought or confining it to a special place, his work, than most of those vulnerable to it do, so that it exercises incapacitating influence on everyday dealings. Thus he is bedeviled by a passion for naming slightly connected to convenience or memory, the ordinary function of names being to make things easy to find by establishing their places, Ruskin's names often confusing the class to which an idea or object belongs. So he names his sketchbooks from the visit to Florence in 1874:

1. Etna book
2. Eve book
3. Pig book
4. Boss book
5. Fiesole book

a list which occurs inside the cover of the second one, now at Bembridge, where the only "Eve," a copy of a figure in a fresco, is the first drawing in the book. From this example one concludes as one had guessed that the names appropriate a partly false particularity, for the books are not all about their names, which only signify his inability to give up concreteness even when the object has no natural identity of that kind. His titles are a notorious instance, a code nearly as impenetrable to a practiced as to an unpracticed reader of Ruskin. Not many readers of *Seven Lamps* could give an exact explanation of the "Lamp" in the

title (delayed until the reader has stopped expecting it), and a reader coming to chapter 4 in the section on clouds of *Modern Painters* V, "The Angel of the Sea," will peel his eye in vain through several pages before learning that the title is a name for rain and being comforted with this name for a kind of sea cloud: "the robes of love of the angel of the sea," sounding dangerously like a theology. Names like these make his names for letters received (the "star-letter" from Rose takes its place with all the others in the gold case at his heart) or paths around Brantwood look easy. They remain opaque because the sense they make is not useful, and similarly when seeking terms to describe the permanent constituents of a long discussion to come he usually settles on deceptive ones, like the Surface and Linear Gothic of *Stones of Venice*, or the Tented Plants and Building Plants of *Modern Painters* V, those that rest and those that toil, the Arab nomads and the architects of more stable civilizations, which is to say non-woody and woody plants, the second of which falls into Builders with the Sword and Builders with the Shield, the one aggressive the other defensive—in other words evergreen and deciduous, a translation to ordinary discourse he omits to give.

The emblematic mind of the Middle Ages unaccountably revived, we may think, which embroiders even geology and botany till they become a wearable jewelry of sensation, invested with permanence by matching, triangular, pentagonal, or septagonal structure, his symbol systems assigning numerical values to whole groups of sensations which locate them in a new time outside earthly time, a sequence not imaginary like numbers because it is concrete, but not shifting like sensation because it is numbered. As finally worked out in his books, these five-part schemes of the climates of various continents and their symmetrical suitability for art provoke only wonder, but in the diaries we can watch how they come into being in his life, as he gives asymmetrical, ragged, but ringing names to different parts of days in order to bring them to heel:

A thousand things pushing each other like shoals of minnows. Note the finding brow-arch, the Ravenna lizard, and bringing in of the Gentle Bellini, all on Wednesday? Were they—find out? The brow-arch I know was; what I don't know, doesn't matter. Tuesday ended by my lying sleepless, in some pain, but happy, till 12; which ended the Red man's innings. I got up and took lady Castletown's medicine and slept, till the time of the wood fire; and its teaching.

(Diary entry for 29 December 1876)

The symbol system lurking here will never be perfected, because left as hazy intuition it suggests greater convergences than could finally be defined. But the next day he extracts more selectively:

Christmas. 25th. Little Bear's day. 26th. The Red man's day. 27th. Up, and shown the meaning, and recover arched eyebrows. 28th. The great sunrise. (Diary entry for 30 December 1876)

That is the rigidity of non-descriptive names again, misleading concreteness which reassures without summoning up, like baby talk which is palpable, clear, and meaningless even to Ruskin, which preserves the things without their associations, as perhaps, contrary to expectation, certain kinds of symbols do, freeing a bit of experience from some of the mud which usually clings to it.

The concreteness of the symbolic imagination is at all times selective, and his immersions in gross contemporary reality preserve the emblematic quality; thus he decides to have *one* intersection in London swept ideally clean, to show, he says, how they all should be, entering the jumble but dispensing with most of it, letting one stand for many, even *be* more vividly because it is only one, and surrounded by many.

As he picks one crossing so he picks one building, the best and most meaningful of all those he has seen, Giotto's tower, which is not a true or at least not a habitable building but a showy adjunct to one, and his favorite sculpture the effigy of Ilaria di Caretto at Lucca, which is a tomb. In 1845 he writes that every evening after watching the sun set from the ramparts he spends fifteen minutes watching the light fade across the prone maiden's face, followed by a saunter through streets where they are lighting up the shrines at the corners. It is one of his clearest substitutions of art for life, or deceptive manipulations of art to make us feel all life is gone. Like Pugin's *Shrine* it is an invented obligation, a theatrical faithfulness which he carries out unaided and undisturbed, the careful description of her posture as a piece of carving insinuating that she is recently dead and neglected, that only one person is not remiss in his duty to her.

However uncomfortable he makes us, he clarifies by the heavy demands he puts on it the process of symbolizing, which, however momentarily, lays out its object and crosses the hands of its image on her motionless chest, though turning right away from embalming to an inconsequential stroll. One asks of a symbol that it seem to talk about

something else, and tell one about It so that one doesn't recognize the subject. So Ruskin doesn't think "I can't have women," but feels the pressure lightened without being shown how. The incident comes as close as he willingly goes in waking life to the subject matter of his dreams, which are crowded with throttled expressions of desire and defacements of the body.

Though obscure in exact application, Ruskin's symbols are peculiar in making clearer reference to the inventor than symbols usually do, or perhaps in asserting less tactfully than they usually do the identity of one thing with another. In fact Ruskin on mountains makes us wonder if to symbolize is not to mistake an identity, to displace and reattribute feelings with more work performed the greater the inappropriateness of the surrogate. When he imagines himself at the summit it is "high above all sorrow," a compelling connection of their insensitivity to their height, nonsensical except if it makes a reference to the tree line and the leached sterility of the higher soils. He says "*they* are high above" but we read a wish, "Oh, if *I* were high above all sorrow, as I am above Zermatt. I can imagine best what I don't have, and when I do it, the word 'sorrow' becomes beautiful, becomes in fact my favorite. Then for a minute I love my tormentor, which puts me high above, etc."

"Its veins of flowing fountain weary the mountain heart as the crimson pulse does ours" (*Modern Painters* IV, xii) is another sentiment whose forces are falsely apportioned by the grammar. Everyone knows that streams erode mountains, but the idea our hearts destroy us is new, two economies hot and cold, red and white, alike only in steadiness, which he makes a beautiful outrage. A little later the idea is worked out as parallel to human choices rather than bodily procedures, though even the blood echoes the intentions of the soul it cohabits with, thus the heart above should perhaps be convicted of coldness:

The feeblest, most insensible oozings of the drops of dew among its dust were in reality arbiters of its eternal form; commissioned, with a touch more tender than that of a child's finger,—as silent and slight as the fall of a half-checked tear on a maiden's cheek,—to fix for ever the forms of peak and precipice, and hew those leagues of lifted granite into the shapes that were to divide the earth and its kingdoms. Once the little stone evaded,—once the dim furrow traced,—and the peak was for ever invested with its majesty, the ravine for ever doomed to its degradation. Thenceforward, day by day, the subtle habit gained

in power; the evaded stone was left with wider basement; the chosen
furrow deepened with swifter-sliding wave; repentance and arrest
were alike impossible, and hour after hour saw written in larger and
rockier characters upon the sky, the history of the choice that had
been directed by a drop of rain, and of the balance that had been
turned by a grain of sand. (*Modern Painters* IV, 220)

A certain amount of embroidery here of the idea once seized does not
damage the strangeness and sincerity of the equation, or rather spoils the
writer's anonymity without undermining the authenticity of the idea.
The effect of his insistence is oddly to make us think he is talking about
himself. Symbolism begins to seem over-interpretation precisely when it
deflects our attention onto its inventor. O reader it has been my un-
happy lot to follow the course of these eroding hills.

In the elaboration lie the glory and degradation of the passage, for as it
progresses the idea belongs more and more to Ruskin and less and less to
the landscape he found it in. His tendency to turn symbols into personal
accomplishments, pieces of virtuoso needlework, has a less conscious
mirror image in his feeling that the world is trying to teach him some-
thing, by leaving a certain significant flower at his door, or that it takes
an interest in the fact that the last lines of *Modern Painters* were penned
in the shadow of Mont Blanc, that ogre of whiteness and non-figuration
which inspired their flowered carpet. One thing redeems that work for
him when he reads it over—"that I did justice to the pine," a ludicrously
small, yet impossible, claim, as if the pine could in the least appreciate
the most munificent favors. At moments like this he appears to believe
his own conversions, as when he proposes to model the patterning of
walls on the surfaces of shells and flowers or a leopard's spots we cannot
be sure the building has not become a creature to him, the metaphor
asserted its sway over reality. Doubtless these insistences are sometimes
"development" internal to the text, but Ruskin's thoughts not seldom
reappear as laws of nature.

Without quite expressing it to himself he has reached the point where
symbols no longer look toward experience beyond themselves, but are as
they exist on the page the highest form available. The hopeful side of
this is a realization that the mind can reform its experience very satisfac-
torily within itself, and thus that many pleasures ordinarily called reli-
gious are accessible to the esthete, estheticism the path to a kind of
sainthood. But the freedom comes from diminishment: religion is a sym-

bolism, a way of organizing and giving authority to one's esthetic perceptions, and God is reduced to the principle of coherence in the work of art.

Ruskin's way of treating the Bible gives the clearest indication of how this comes about. No one will doubt that it is the source of his eloquence, his peculiar concreteness, his invective, his feeling of being at home in language. While he never contests and happily submits to its rhythms he is oddly dictatorial in what he will permit a Scriptural text to mean, as if one could both confess its sway and determine its content. Thus on a small scale his idea that one can substitute "helpful" everywhere the Bible says "holy" and have a more usable, human text, as if—which may have been a convention in the kind of Biblical exegesis he heard every Sunday—the needs of the user come first and it were assumed he will have to create his own significance to get much good of this old and irrelevant text, conversing with which is a one-sided process, as with an aged parent.

He devotes startling amounts of energy to deriving not only sense but moving sense, his kind of sense, from garbled shreds of Scriptural text, in the tradition of the preacher who could unfold to you the nature of heavenly love starting from a verse which was plainly an instruction for pasturing sheep. In the beginning, early in *Modern Painters*, the explanation seems to be that he has ideas about how nature functions but lacks the temerity to theorize on big subjects, and so attributes them to God. Thus the emblematic meanings he is able to fabricate for birds become "the sacred *function* of birds," and he ends claiming reverence for his own meaning, not God's work. He had perhaps found before ever writing a word that one could get a reputation for piety in this way, that the sleight of hand went unnoticed or that the method of securing mental novelties was appreciated as long as one gave the credit to the Ruler of all things.

More likely he fell into it unawares, feeling it a duty to make God interesting, to quicken Him. By the time he wrote the notes to *Modern Painters* he had recognized a pitfall in supposing that the meanings he managed to find in nature were God's main intentions, that his own thoughts were the world, but the way he expresses it is to say that he no longer believes the clouds exist for man's benefit, not that he'd been mistaken in giving his ideas a heavenly source, but, somewhat plaintively, that the world has discarded man.

If you applied the techniques of exegesis strenuously, and not simply

to manufacture sermons, if you tried to read the world as you were used to reading the Psalms, you found it didn't work, in the sense that you couldn't count in the same way on the meanings which exfoliated there just as plentifully. The other kind, which have more chance of holding than the attempt to make heroes of flowers and trees, are the comparisons of the hills to architecture, finding an intention in the world like that in a work of art, organizing minerals instead of moralizing vegetables, which shows a further drop of faith because it thinks God's work is dignified by being compared with man's, another step in the process of judging Him good insofar as He is human.

This comparison of mountains to architecture, as lower to higher, is not felt as blasphemy by Ruskin, but here he reveals most plainly where the qualities he values lie. One looks hopefully for them in the Alps; in front of the Doge's Palace one knows they are there: men are pious and we begin to doubt that God is. The same trick of elevating the world by comparing parts of it to works of art is familiar in James and Proust, where it has become an extravagance, a wistful hope that nature should be virtuous like pictures and poems, which seems to us the self-regard of the artist, but will seem less so when we know where it comes from, and that the technique only tries to reattribute once more qualities recently taken away.

Proust is correct to identify Ruskin as a proto-Symbolist, his progenitor, and also to feel that he has presented him with insoluble moral difficulties. Less understanding readers express impatience with Ruskin's persistent effort to make beauty moral and mock his efforts to like Fra Angelico's paintings more because he thinks their maker is good, or to like Salvator less because he thinks his paintings bad. Of course it is in some part an effort to identify greatness with himself, to attribute all beauty to qualities he hopes he possesses, and to this extent a narrow and centripetal view.

But if one remembers that his contribution to the dismantling of religion was to show that its pleasures, as they had become, were accessible to the esthete, which makes him the father of Joyce and Proust, one will at least no longer consider his Christianizing of art and intellectualizing of religion to have been a regressive and irrelevant pursuit or believe that a class of esthetic bigots who find one style virtuous and its competitors vicious are his main descendants. His air of reconstructing religion in another place, so that now one could worship best on mountains or in

front of paintings, made him more dangerous to its survival than out-right attackers. For Ruskin in the end the interpretation is issued in a more authoritative form than the original text, Scriptures are texts but true interpretations are laws, and his vision of early Italian art has re-written not simply resurrected its object.

ART AS RELIGION

Ruskin proceeds from inner deficiency to envy of qualities man formerly possessed, old art a source of faithfulness. Having asked originally that it lead him to God he ends by deifying this simple human product. When the role taken by nature for earlier Romantics is assumed by art, the world is replaced by an idealizable part of it, and Ruskin falls back into the self without knowing it, seeing in the nineteenth century's ignorance of his favorite paintings a sign of its not heeding him.

Following his lead, part of the revival turns inward, away from social consciousness and hence from history. Along with a loosened attitude toward authority goes an indulgent obsession with texture and the nature of materials. The architect and ecclesiastical designer William Burges conceals secularism in emblematic obscurity formerly excused only by high impersonal goals and uses monsterism as the cover for a new elevation of art, distracting us by unseriousness from the reassignment of reverence to man's storytelling power.

Medieval grotesques had already raised problems for revivalists, which Pugin had met with a distinction between licentious survivals deriving from pagan sources and admonitory pictures of the vices contained in right-minded schemes. His own work avoids deformities and

composite creatures, the metal lions on the doors at Cheadle his furthest venture in animal vividness.

As on other subjects Ruskin's mind was divided—while he could enjoy the enthusiasm grotesquery gave an earnest of, distortion didn't need to go far to seem dark thoughts from a diseased imagination. Looking at a whole cathedral he might value harsh details for the frank view of mental flaws in its builders but he would have reprehended Burges's deliberate raising of grotesque to new prominence and the freedom from metaphysical care it signals.

On a bedroom stand for his London castle-house Burges put a company of creatures with shaving implements in place of heads—brush, soap, razor, scissors, comb—like drolleries from a manuscript border blown up and welcomed into the room. With minimal alterations he creaturized old bottles or lumps of crystal, adding metal bird-feet, thick paws, or quizzical heads, so that his life might have had the proportions of a manuscript page, except that he didn't stop at discreetly dotted animation among an embracing foliage of rich stuffs and hangings. He saw faces everywhere and so he drew them in, like someone who cannot look at a stain without materializing a meaning.

Many of his most extreme designs for fountains, cupboards, or even castle towers take as their point of departure a whimsy in a manuscript, the architect making palpable what to the medieval illustrator remained an impractical freak. In large articles where there is no need to economize space he achieves the sense of enlargement by disproportion: on the painted wooden organ cover in the form of a castle for Lille cathedral, walls are cut away as in manuscripts to reveal rooms jammed with people absurdly large for their setting, not as in manuscripts for bare legibility but over-legibility, expansive comfort which equates growth with life.

He can also produce the sense of enlargement in small objects like decanters in which red glass, green stone, gems in indescribable shapes, and antique coins are united in a silver mount, where inert and hideous materials are prodded from luxurious rest into farfetched grotesquery of substance. On this scale he is often a Gaudi, dreaming of large monsters no one in England will commission and solving the unfeasibility by making the smallest idea feel as if it is expanding, more than filling its space. He leaves nothing un-narrated, and finds ways to narrate faucets, hinges, doors. He needs only motion and the possibility of surprise, not

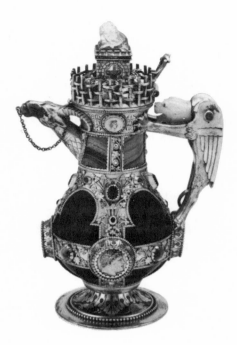

William Burges, decanter.
Victoria and Albert Museum,
London

always even animal life, not spirit, nor like Ruskin, assurance of benign rule, for he cannot imagine malign, and this absence of the sense of evil makes him able to tolerate happily a confused hubbub like Ruskin's madness.

In complete rooms like the series at Cardiff Castle, he seems more storyteller than architect because competing sets of images overlap, emblematic and anecdotal figures, botanical accuracy and mechanical stylization of plants, from which a loose end jumps out, a snail or snaggly root, that grasped and followed backward causes the series to unravel into individuals.

Though in the Chaucer Room at Cardiff there is something everywhere and no distinction between ornament and neutral surface, the chimneypiece is the ruling presence among the others, like structural sculpture when like this it shows the hood joining the wall at the top, but elsewhere entirely converted into a Castle of Love or Tower of Babel stormed by amorous knights or left behind by the parts of speech which go out to form the world's languages. Higher up here three works of Chaucer's are mingled in pairs of unhappy lovers, fowls in flowering trees, and medallions with printed tirades of famous women. Literature

has been dismembered and scrambled to form an order like an alphabet of single images, which is perhaps an architectural form of story because atemporal, rebeginnable, and skippable, suggesting its whole self adequately to a browser. Yet the wealth of picture predicts a depth of entry

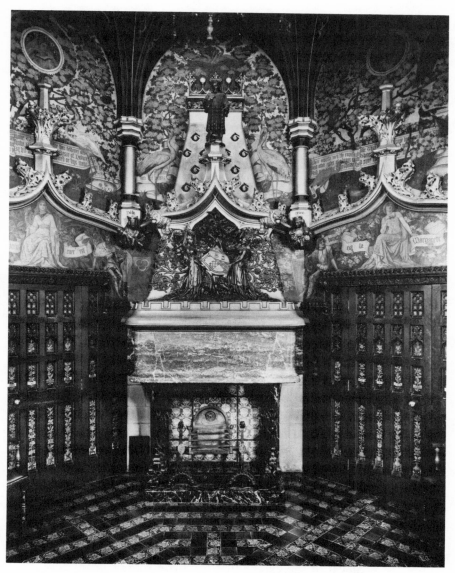

William Burges, chimneypiece in the Chaucer Room, Cardiff Castle

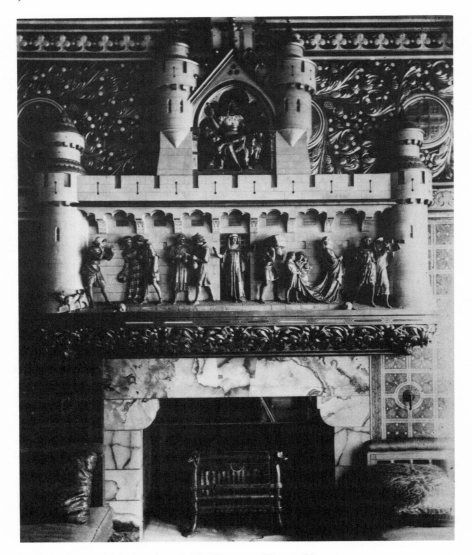

William Burges, chimneypiece in the library at Tower House

one never achieves, the pieces like playing cards without individuality, both too discrete and too many.

At first the reader thinks the decoration will be difficult, an allegory manufactured of large abstractions or tediously local references. And Burges is medieval to the extent that the main sets of images are often personified abstractions, not so much visualized as translated, like sur-

names in heraldry, by punning or literalizing a metaphor. The pleasantest shock comes in finding that the pompous personages are not always "Faith" or "Evil Counsel," but "Flax," "Wool," "Noun," "Verb," "Rum," "Beer," and thus that the tumult is the contest of convenience between clothing fabrics, or inebriating beverages, or a lesson in the construction of the sentence. The concepts materialized are material ideas already, which do not need to be symbolized to be portrayed or understood, so that doing it becomes an act of irresponsible imaging. Some of his most successful series, like the comic alphabet in the library at Tower House, are orders without subordinations or even meaningful relations between the parts, which are multitudinous, distinct, but carrying uncanny significance because we associate them with words. The fascination with lettering awakened by the Gothic revival is a non-moral enthusiasm for shapes masquerading as interest in meaning, hypocrisy which heralds an important shift. This stage of writing slogans on everything immediately precedes the courage to do without representation altogether. The fascination with inscription is an attack on the most meaningful shapes to make them too shapes, not meanings, and to give picture the upper hand over language.

His way of decorating a library is to anatomize language at a level of generality where grownup differences are buried. The chimneypiece shows Grammar dismissing eleven parts of speech and one piece of punctuation to go and regularize human language. As a theory it is appropriately childish: Verb is a queen preceded by two Pronouns blowing trumpets, her train upheld by little Articles, followed by Noun under a weight, doing the work of the sentence. On the other side of the central gate Adjective and Adverb plan expenditures, and two Conjunctions dawdle, outraging Interjection accompanied by Question Mark in the form of a dog with curled tail. They are not arranged to form a model sentence, but show language shredded and locked in its comical separate identities, concepts seen when personified as entirely provisional, participating awkwardly in a poem. Just beneath the strutting words is another system, a cornice of leaves which has snared all the letters of the alphabet in order, with a single exception. Because they are imagined as spoken by a Cockney, the H is dropped, or dropping, inlaid in the onyx below.

Letters are played against leaves, and both against figures and castle, formal proportions of hard and soft, juicy and abstract to which the meanings we have traced are subordinated but also function as interfer-

ence, the role given to the human figure in Burges's architecture, an obstacle to formal order asking more than its share of attention. To a considerable extent the confusion *is* the narrative, Burges relishing the dual natures of his elements, as in alabaster basins and bathtubs at Cardiff inlaid at the bottom with swimming fish and squirming eels in silver.

The walls of Lord Bute's bathroom are paneled with a collection of colored marbles set in rosy walnut framing, a play of liver, pistachio, purple gray. Burges's innovation is to inscribe its name in Gothic script on each stone, running with the grain, which sets the disfiguring information sliding in different directions. It is one of his least tasteful effects because it defaces without embellishing, and exasperates the split between beauty and instruction.

Though not a large-scale disturbance, it adds itself to interruptions like the insertion of one Moorish room among the Gothic at Cardiff and at Castell Coch, rationalized historically by the fanciful supposition the style was brought back from the Crusades, but thrust forward in a lump not spread through the whole. He lets elements interfere with each other, feeling obstruction as energy, in huge beams which cut through the light of windows or the decoration of chimneys in rooms too small for them. This hyperkineticism reaches its end in his castles, dominated by their towers, the purest, least obstructed architecture, yet vulnerable because not obviously useful in the nineteenth century. The castle is an inert idea, heavy armor he lightens not by diminishing its mass but by turning it to pure assertion of character. Fortification, even more than the church of high ritual with all its newly rediscovered parts, becomes an expression of the nineteenth century, and through it architecture gains the freedom painting finds in pattern, and moves toward sculpture.

Though most his, Castell Coch is Burges's simplest work, his monolith. It is not a building for lovers of the picturesque, which fades at sunset or becomes misty at the edges. Buried in a hillside, it equally thrusts itself out, not perched like the upper forms at Cardiff but implying like some trees the same amount below ground as above. He started with scanty remains of a medieval building, and his survey encouraged the belief it was an agglutinative structure extended from the home clump, matching every step outward with a link to the rear.

These balanced impulses solve the problem of how to be fat *and* high, three towers of different height and thickness, bunched together by the round enclosure looping out to their rear. From beneath, on the slope

where the huge cylinders rise out of even larger square buttress-solids, it is pure climb without opening, except for a peppering of holes—drains, vents, or anchors for scaffolding—inscrutable even when we have seen water coming from one of them. On the other side at the bottom of the moat the wall starts as an artificial mountain, a bulge of masonry only changed to vertical above our heads. Thus all this stone conveys impregnability growing from a root too large to be uprooted, an assertion not to be topped from having jutted up without thinking, as the highest tower at Cardiff seems to have done. The larger castle is the flimsier, a string of bizarre effects; but Coch is a unified discovery, with less Victorian or even Gothic feel to it, a whimsy which works.

He had set out to build a functioning castle, not in the middle of a modern town like Cardiff but in a spot which still seemed a likely place for one, resupplying the moving parts, especially drawbridge and portcullis, controlled from a windlass room which is a display of medieval technology in iron and wood, with a fireplace for heating liquids to pour down on attackers, and a simple wooden partition for warmth. The oak grille of the portcullis, clothed in strengthening strips of iron, is a further exhibition of medieval-industrial style, to reconstruct their heavy labor more idle than reimagining their leisure. Passing from dungeon to windlass room to arched drawing room gives one a quick synopsis of social conditions, for Burges is careful not to convert the obsolete parts of the war machine to current uses, fighting to preserve believable proportions between relaxation and defense. The authenticity of one's own dungeon or a bedroom at the top of an inconvenient spiral stair like Lord Bute's is that of history as discomfort, which corresponds to stripped and "efficient" forms, obsolete efficiency for obsolete uses preserving a ghost of its original power however superseded. Thus the simple gutters in the courtyard, V's in section formed of boards nailed at a right angle, give the satisfaction of any machine which reveals its purpose, and also that of anything more cumbersome as a fact while simpler as an idea, a dethinking of life's equipment William Morris would have appreciated if it had not so overshot the edge of the necessary.

The open passageway these drains run along is one of the castle's great exhibitions of function, continued around the perimeter at the height of a non-existent story above ground, expressing continuously the work of stairs and of raising successive floors. Its purpose medievally is to give access to loopholes in the battlements and its effect to show the room skeleton with its wall stripped off, a work structure which

preempts the idea of ornamental walkway. It is fashioned of plain members painted rusty red, according to the rule that the crazier the project the more sober its detailing should become. Like fountains, a favorite form of Burges's he wasn't often asked to execute, it functions as activity free from use, making a cycle in which the end joins the beginning, not a perfect circle in either case, the fountain sputtering and the gallery adjusting itself erratically to the roofs coming to meet it as it passes over the dwelled-in part and blurs house into defensive wall.

In spite of such variety the deliberately blinkered accuracy at Castell Coch reminds one of his habit of copying the Middle Ages even in their unhistorical view of earlier periods, presenting Paris and Helen, as Chaucer would have done, in medieval dress to show that one would rather be damned in partisanship than saved outside it. In spite of its coherence there is something self-defeatist about Castell Coch, for all the integrity in Burges's obsessive return to the tower idea whatever medium he chose, in the drawing of Simeon Stylites kept aloft by ingenious homemade bracing, secure above the dissected medieval city; in the many-tubed vases whose meaning is explained in the vellum sketchbook where he imagines growth from every projection as if the chimneys at Castell Coch had sprouted leaves, for the towers there break into smaller towers, chimneys buttressed by flared squarings like their parent towers and mediated by stair turrets, thrusts of a size between tower and chimney.

Because of such consistency and his contribution to the idea of architecture as expressive, as at its most extreme an almost recognizable living thing met before in life and now enlarged, it is Burges's distinction to fail as a practical builder and to fall outside the realm of useful architecture, not that his buildings weren't well built but that the ones he most wanted to build were not much use, and become to a degree rare in his practical profession independent works of art.

William Morris is usually played off against architecture-as-literature, a story to be heard, contemplated, and put away until one needs to re-read it. Now he is remembered for his part in bringing the Gothic revival up to date, even making historicism revolutionary, which he did by concentrating on contradictions present from the start in the idea of a modern historicist style. Asymmetry, one of the qualities most admired in Gothic buildings, was recognized as growing by accretion rather than designed in all at once, so an architect like Butterfield often exaggerates in mass-produced approximation to the quaintness of medieval buildings.

Though Morris was to follow another route from perverse exploitation of coarse industrial finishes his goal was similar, an effect of irregularity usually denied to the copyist. When Ruskin psychologized the formal properties of Gothic in the chapter Morris's press reprinted as a pamphlet, saying the fact it had been built by Gothic builders was what made a building Gothic, he may have hoped it would inspire readers to become craftsmen who recaptured manually virtues of faithfulness irrecoverable along intellectual routes.

The first step in Morris's conversion, before he became interested in the conditions in which all work was done (a subject broached by Ruskin), was to transform himself as a workman and redesign his environment. Like all styles Gothic as it gathered force had spilled from one medium into others, propelled in Pugin's theorizing by a more coercive ideology than other styles because it was regarded as the outward badge of a spiritual condition. Pugin's attachment to detail and obsession with the "use" of obscure pieces of church equipment led to a new emphasis on making and concentrations of work in small utensils. In Pugin's view the religious purpose validated the obsession, and Ruskin repeats the curious argument that here luxury is sacrifice because although the work of art remains in the church it belongs to God. Burges disentangles such pursuits from religion and makes a secular version of the chalice, an antichalice borrowing its pompous form from the equipment of the Mass.

Though Pugin asserted that only sincere faith produced pure art and the Cambridge Camden Society carefully described medieval methods of finish, Morris is the first to attempt to reproduce not only medieval workmanship but medieval work, the act and process of decorating Red House holding perhaps greater interest for him than the achieved result. This anti-intellectual method revives Gothic as a real vernacular which real people talk as they perform real work. The results bear out the hopes, and no one will feel at Red House that art is degraded into craft as before later Morris designs where the materialist bias seems weedy rather than sturdy.

Forms and colors are bolder at Red House than in the later designs, especially in the painted patterning on doors and ceilings which approaches peasant motifs in freehand repetition of simple pattern, abstract but impure enough to seem semi-pictorial like handprints or footprints. Here Morris's veneration of vegetable dyes bears fruit in uncanny blue, red, and yellow darkened by their connection to the earth, and the absence of highly finished detail encourages bold shapes: the

entrance arch, windows of odd outline plainly filled, and roofs in broad lumps.

But the historicist paradoxes which seem at first to be solved by the simplicity are hiding in it after all. The reason figure-painting looks incongruous in this house, looks in fact backward when it appears in the mural panels Burne-Jones began and did not finish in the main drawing room, is not purely formal, for the simpler kind of design it conflicts with is both advanced and archaic, and signifies to Morris, as his writings attest, intensified historical flavor, a stronger pre-pictorial time. Because life is to feel Viking or at least Romanesque, pictures in perspective seem sophisticated anachronisms. The best details at Red House hide their crudity in their convenience, like the beveling of the stair rail, which like Burges's wooden drains shows an inspired stripping-away to a pre-medieval bareness which lacking distinguishing features can jump over the centuries and feel under our hand like just what we need. By going only a little further back one discovers a style almost styleless which presents therefore ease of physical translation, but when one simulates the life attached to it one must disguise its pre-Christian savagery.

Red House was built before Morris discovered the Icelandic sagas, but not long before, and certain bold simplicities in the house show that he had already been pushed toward the prehistory of his Middle Ages before finding its richest literary sources. The world of the sagas embodied some of Morris's hopes for the Gothic revival, clarified and freed of the heavy hand of Christianity, the life of a unified folk whose social organization was an intensification of kinship, whose leaders were simply the most active members, whose opponents represented individual greed too clever to shake the idea of a certain prized object from its mind. They fought over things, not ideas, and though there was something in the world called wisdom, nearly as hard to define as possess, the greatest joy was riding out alone in search of adventure, before one had been shackled by the reward at the end. Although this course of decline was inevitable at least one was defeated by the consequences of one's own heroic acts; heroism led to treasure, or a civilizing experience, and treasure brought decay, obscurely realized as self-defeat following attainment.

Sigurd the Volsung of 1877, his most vigorous rendition of the pre-medieval world, is an escape from the complications of morality to a place where power and virtue are not quite joined because virtue in our

sense cannot exist, but where inhuman strength gives leisure for the first stirrings of conscience, where "goodness" is a sustained but finally failed imperviousness to the invitations of complexity, a unity in the self which makes it dense to temptation for a space, until it begins to listen in spite of itself. If experience is corrupting the most beautiful time is the earliest, and to tell a story is only to accumulate the causes of melancholy. Even the saga, which begins with such a clean slate, ends clogged with poisons of thought, its freshness worn down by the tread of the denizens of the castle following the paths of their needs.

Though his sense of history is extremely simple it is powerfully motivated, all of a piece, and gives the key to his simultaneous entertainment of purified medievalism and revolutionary socialism, for the brutal impious past and the heroic future are similar. Only a revolution could restore a true Gothic architecture, he said, and would, and art would again be the cooperative product of a whole society united like a Germanic tribe, no longer by race but by recognition of a larger sameness. Vistas of the socialist future require the same scale as the rush of generations in the epic, which blurs the savagery of existence and allows one to contemplate life as a succession of deaths.

The sagas exist in a past before religion where the responsibility to remember one's superstitions weighs lightly, and Morris can enjoy acting the quasi-believer, announcing magic transformations which are simply naïve interpretations. The socialist future comes after religion, his portrayals of empty churches, in *The Dream of John Ball* for example, signifying the Victorian end of faith, the fading of its spell, perhaps to be replaced by hero-worship appropriate to a school story, less sophisticated but less weighty as well, causing one to erect rough-hewn memorials to one's simple champions of labor, reincarnations of Sigurd.

Morris sees far enough to realize that the heroism he calls for, built on innocence, cannot last, and needs constant renewing if it is to continue, an ideal vision but not Utopian in the ordinary sense. Thus one is led to ask whether a millennium is the proper conclusion to his cycle of generations, and if it expresses world-weariness instead of hope.

In the work for which he will always be remembered best, the devising of flat repeating patterns to cover large interior spaces, a similar gloomy sense of inevitability can sometimes be detected. Most of his designs are retreats from pictorial complexity to the simplicity of a two-dimensional web. The most interesting are still marginally undecided between flat and round, the minimal recession conveyed by stylized

shading which exists to blur the large shapes as much as to suggest depth. The basic forms are always vegetable, perhaps slumbrous leaves filling the whole space, or more usually flowers contesting with leaves, rarely perched in by small animals, but never intruded on by human figures, a world set apart and purified to a system of vague shapes tied together underneath by a hidden net of tendrils. Walter Crane's insertion of small figures on a Morris tendril-base shows how protected from exact indications of scale Morris designs are, so their forms can loom to the nearest view nightmarishly large, his best designs often his most Victorian, robust, full, even crowded. Like archaic diction, strong repeating patterns have an anti-representational tendency, drawing us toward incomprehensibility, tranquilizing in a far view but faceless in a near, metamorphism more manageable in mirror designs peeling and splitting in orderly ceremony.

Even though these strong designs contain no straight lines or still passages, always twisting with a slight torque, their motion is deliberate rather than springy. His designs like his prose are often imitative of liveliness without being themselves lively; his jollity like Ruskin's piety, a quality he deeply wished for. The best designs, dark and sad, belie his efforts to resee the Middle as the Bright Ages, and their effects of hypnotic confusion are increased not lessened when as was intended various foliages are overlaid in wallpaper, curtains, rugs, and coverings to garb a whole environment in leaves, a stylized rurality more like a bower than a copse, where one feels lost in the absence of figures, tangles juxtaposed as in an Islamic maze.

Multiplication of faceless densities is also the principal feature of Morris tapestries and pages of print, not obliged by practical necessity to seek the anonymity of unending pattern, and possessing edges like paintings. The "Woodpecker" tapestry is one of the liveliest but its variety is confined to a narrow band of colors and forms. Individual objects can bulk larger than in repeating designs, but often come to no more than a large figure walking in front of a Morris wallpaper materialized as a garden, or in the "Woodpecker" simpler still—a tree trunk which divides the design in two, a fattened line which fades behind an ostrich plume of leafage swirling up from below like vegetable flames but remains essentially a divider, Morris converting even opportunities for picture into border, and surrounding border with border as on his dark pages of type. It is a duplication too senseless to have occurred to a machine, this arbor enclosing an arbor, leaves protected by cushions of

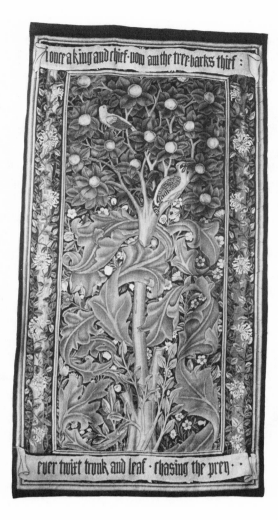

William Morris,
"Woodpecker" tapestry.
William Morris Gallery,
Walthamstow, London

leaves, looking onto vistas of leaves, a degree of self-containment remote from naturalism, however naïve in its ostensible subject matter.

His ideas of work bore fruit, if not in his own practice, where regressive devotion to "natural" techniques made many processes more monotonous for workmen than they need have been; his localizing of Ruskin's quarrel with modern civilization had its more measurable effect; but Morris's greater significance lies in his focusing of what design means, embedding words and pictures in regularized tangles till neither stands out and the recognizability of the image is nearly lost. One of the

distant sources of Kandinsky's innovations in painting lies in this coloni-
zation of the picture space by the border, a relinquishment of perspec-
tive and pictorial uniqueness in favor of anonymities of pattern,
propelled by an idea of history which hopes to reinstitute cohesions that
the patterns describe.

In *The Ring* Wagner reworked the Norse material Morris had ren-
dered in *Sigurd*, and the German's translation offended the Englishman
deeply, though one might have thought a fusion of arts in one sacrament
would attract him. His daughter quotes him as saying that the legend for
which the simplest language is not typical enough is an inappropriate
subject for the rococo conventions of grand opera. But perhaps the dis-
pute over truth to the sources trivializes the difference between the two
men, seen best in their relations to religion in the more primitive forms
it assumes in the legends.

Though Morris's interest in religion only began to detoxify itself into
an interest in the churches' qualities as architecture, and he described
savage rites like the cooking and eating of Fafnir's heart with grisly en-
thusiasm, he saw the sagas as offering a chance to escape from enthrall-
ment to the supernatural into the purely human, like release from a
weight. Wagner, a non-believer, constructed of old stories a new op-
pression, embodied in a flood of sound which asked submission, whose
seamlessness gave one the illusion of having no time to reflect, the sim-
pler religion converted to sensations of power with minimal statable
content fatally tied to non-individual sources of strength, like race, a
self-dispersal which had its necessary counterpart for Wagner outside
the operas in self-definition through traumatic separation from other
ethnic groups, copied from primitive tribesmen but assisted by tech-
niques of rationality belonging to later stages of social life, it never being
felt necessary to dress primitive impulses in matchingly primitive
sounds.

Of all Morris's Arts and Crafts descendants, the designer Henry
Wilson lacks obvious connection, for he signals a resurrection of the
exotic Venetian side of Ruskin to which Morris was immune, and an
intensified interest in esoteric symbolism more easily located in Morris's
romances than his designs. From *Sigurd* one could derive the idea of the
maker as a wizard not to be trusted, and the art he describes there fits a
later phase of style than his own, with a sense of materials like the luxu-
rious strain of Arts and Crafts.

Voysey seems a healthier derivative of Morris—free of involvement in

religion and picture still observable in Morris work—who solves the problem of an unforced historicism so well he may not look historicist at all, but the blurring may come from a kind of purism, newly self-conscious of its derivative quality and anxious to produce an archetype rather than a specific reference. While he cleans away detail Voysey emphasizes more than ever an organic lumpiness of outline, a marriage between functionalist textures and seven-dwarf shapes, takes his pictorial imagery from the nursery, doves and cherries, makes it vaguer and then gives it back to grownups. This progress feels only half-conscious and provides a good opportunity to follow the drift of late-nineteenth-century English design away from secure ideological and stylistic moorings until it takes a strong character to see where he is.

The drift exemplified by Wilson is more clearly marked but quite as obscure in its way, from recognizably Christian shapes and imagery to ambiguously derived and less communicative ones, Byzantine at their most comfortable but straying further, to Assyria and Babylon. He started like Morris and others looking for escapes from the straitjacket of Gothic, and found florid transformations which might be read as rationalizations, the west window of the church at Ealing filling the whole wall down to door level as in train sheds, its molten tracery and the overlaid buttress tracery outside making it hover between a large vegetable representation and a functional skeleton.

Wilson's organicism recalls Ruskin's concentration on single buds or petals and his way of seeing every flower fragment as a medium of light, lit up from inside by the glow of its own pigment, a world in which alabaster is the master substance. Ruskin's search for and magnification of certain general principles of growth, which animate all stems as abstract serpents, bring him nearer to the roots of Art Nouveau than the less transformative Morris.

Wilson has left few botanical studies, his vegetable forms less specific as he went on, but a study of embryonic leaves at the Victoria and Albert gives important clues about the relation of his natural imagery to nature itself. These fetal, stillborn forms are an Art Nouveau discovered pre-existent in the world, the plant distorting itself into flames or reptiles, a metamorphism characteristic of the edges of growth, pre-growth and post-growth, infancy and death.

In the chalice for St. Bartholomew's, Brighton, divergent natural substances are combined to make a monster, one nature represented in an alien one: grapevines in ivory, clashed against the rudeness of the discol-

Henry Wilson, *Embryonic Leaves*. Victoria and Albert Museum, London

ored enamel knop, a vigorous shape not smoothed out of its found condition, so only the crudest approximate to this conventional element of a chalice, but still looking ruined like the small reptile skull embedded in the carbonized St. George on Alfred Gilbert's centerpiece for Victoria's jubilee, the alchemy of gross substance into art, a transformation nearing its end, the likeliest reversal of decay being petrifaction. Extreme textural contrasts characteristic of Arts and Crafts even in more sober forms like Bainbridge Reynolds's conglomerates of copper, brass, and iron perhaps mean as they do in Mannerism a last phosphorescence in the materials before a final subsidence, a hectic speeding up of process, which is felt by Ruskin and Morris to be intrinsically a form of life. Fascination with decadent phases in nature corresponds to certain feel-

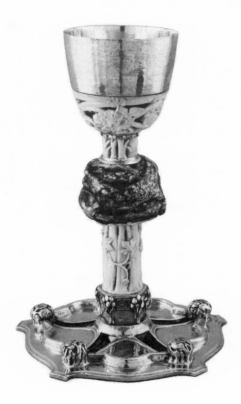

Henry Wilson, chalice.
St. Bartholomew's Church,
Brighton, England

ings about one's place in history. After Morris the sense of coming at
the end generates melancholy, of which the new interest in myth and
primitive religion is the most interesting, least functional form.

The way out of the impasse brought on by the decay of religion avail-
able to Wilson was an authorized version of Ruskin's symbolic corre-
spondence, authorized by duplicated evidence from the distant past
excavated by science, and institutionalized by the artist in specific forms,
like the Brighton chalice, also a calyx, a flower on its stem, attempting to
work a magic which would inhere in a thing not just in one's method for
contemplating it. It is both less and more ambitious than Ruskin's
schemes because it is content to seek its perfection in a bounded struc-
ture, the temple idea, whose floor is the sea, roof the dome of heaven,

central pillar the tree-of-the-world, dangling lamps promises of resurrection or the generation of more. It is ambitious because the architect invents the religion, which because unfamiliar to his clients will have to be imposed on them by furtive formal devices instead of the recognizable codes of Christianity.

W. R. Lethaby's *Architecture, Mysticism, and Myth* (1892), which influenced Wilson and was plagiarized by Mackintosh in the next year, is one of the most disturbing signs of the disintegrative nature of this historical moment, a disorderly world-bag of myths, the last hope of someone cast adrift who invites the terrors of history to roam through his head as random associations, blurring places and times because no single moment holds the answer, which may crystallize from the ragged synopsis of *all* thought and belief. The materialization of early- and prehistory has given Lethaby the idea he may find room there to hide from science and reason, from the earth as a sphere hurtling through space, and the building as an envelope without content. But he is too much a rationalist to fall under the provincial spell of any creed in particular, so he hopes that the residue of submission he can summon before many cults can be combined into a semi-stable belief.

This is not the stated aim of the book, which relinquishes terror, mystery, and splendor, and then makes its most impassioned evocation of the Egyptian temple awing the worshipper and crushing his imagination. That leaves Lethaby and Wilson fashioners of myths who have given up the fight, would-be worshippers who want to crush the imagination but cannot fully accept this purpose, and might therefore be happier in the safely barbaric realm of jewelry. The myth Lethaby discovers in buildings may feel in the end bland, the temple a scale model of the world and the architect a scaled-down god, meanings not historically appropriate to Christian churches but hard to place elsewhere, for if churches are not numinous enough private houses will thoroughly unmask the mythic hopes. Like religion the comparison associates man's work with something large and unlike religion with something believable, though the sensation of smallness, of the building as a feeble copy of its model, would perhaps no longer inspire awe because the reality it is modeled after is one from which faith has fled.

Wilson's most splendid project, the decoration of St. Bartholomew at Brighton, is built on an invisible iconography most visitors will not realize because it remains a unique case of such schemes to them. Whereas for Ruskin colored marbles and other luxurious stones are justified as

examples of nature's best workmanship, in Wilson they are formalized as the materials of the seven heavenly spheres in Arab and Kabalistic lore, exemplifying in their cloudy way seven colors, a non-figural, spiritual symbolism far from William Morris.

In spite of the nearly complete absence of detail, however, it is a pictorial use of materials, the black floor a flat sheet of water in which other details are stranded, alone in a wide sea, many anticipated dividers, like a complete altar rail, missing. In Lethaby's scheme the sea base is a stable idea but in Wilson's execution the spectator feels helpless to unite the huge and distant parts, swept out on a rich waste expressive of metaphysical loneliness. When one meets similar proportions on a small scale, in C. R. Mackintosh's oblong silver casket set with semi-precious stones which seem to emerge from the smooth surface, the unusual smoothness of the ground makes no attempt to hold the eye which slides on and on in an imaginary endlessness. Mackintosh's details like Wilson's look lonely, and his delicate colors have taken a fatal chill, aborted in the bud or before budding.

The black floor is reflective and the pink-and-green ciborium is absorptive, a structure forty-five feet high, the most stylized rendition of trees Wilson ever gave and his most impressive effort to crush the imagination, for in spite of the fact that the rich stones again deny their natures, soft now not wet, the cruel featurelessness of these forms creates an oppression more observable than an actual one grazing the spectator's head, for this is framed at a distance, a living picture of the relentlessness of gravity which bends upward, thrusts back again.

The smaller cylindrical candlestands echoing the square supports of that simple tent are the best realizations of a persistent dream of Wilson's, whose meaning is even plainer in the fantastic study of a building where two isolated columns again jut up far from any wall, reminiscent of the famous ones in Venice and sharing with Lethaby's phallic alcove drawing of 1888 the large snake writhing up toward the figures on the head of the column. Here the anti-religious frankness of the forms threatens most to break through, as perhaps also in the helmet turrets so favored by Wilson, Sedding, and other Arts and Crafts designers, where in spite of an apparent derivation from a Tudor feature (King's College chapel, Hatfield House) deep imaginings come from outside Christianity altogether.

The guiding principle of this decoration is not naturalism, or if so, ambivalent naturalism which associates forms equally with at least two

organic models, an impulse to which Gaudí is the proper end, who makes buildings so natural they are hardly credible, a church like bats hanging up into the air. Only convention lets us call Wilson's later web motifs trees, composed of arteries and decorated with leaves in the shape of hearts, as visceral as vegetable, and protected by an architectural canopy, the world turned inside out shielding its vegetable covering with its mineral core. In Burges the most esoteric symbolism is made somehow available, edible, hearts threatened by arrows, Rosicrucian alembics on the boil, all meanings made gross flesh. Lethaby speaks approvingly of Burges's barbaric strangeness but it takes a rare kind of imagination to accept symbols without believing them, to turn religious imagery into comic strip, innocence perhaps nearer its medieval originals than most revivalists think.

The cathedrals built or proposed by Wilson's generation seem reliably the last of such enterprises. Both Lutyens's projected Catholic and Scott's long-unfinished Anglican cathedral at Liverpool are impossibly large and enormously artificial at the same time, Lutyens's like the unwindowed ruin of a great Roman bath and Scott's the last large Gothic building. For a student of the revival this terminal has an overwhelming interest, the huge towers melted to a piece of Art Nouveau metal like the imaginary cities at the base of Wilson's chalices, details almost erased, huge, costly, and no longer there, a tomb whose corpse is so long flown it can no longer picture him, where the cross-shaped plan at last makes no particular sense, the style picturesque at the end as it was in the beginning, another Fonthill.

From absurdly literal claims the revival has retreated to ones so generalized they have almost no content, huge buildings hovering as almost-ideas, not-quite-relinquished hopes of transcendent coherence. Perhaps the proper drama for this setting is hard to guess because the Christian connection is no longer answerable to it, if it is a pagan eruption like the action of Strauss's *Salome*, ceremony turning to carnage, as the excitement in Wilson's organic forms may be their suggestion of cruelty, church decoration catching up belatedly with the sense of the world's indifference argued by Darwin.

ROMANTIC LOCALISM

Beginning as art in the service of religion, Gothic revival finally reaches an anti-religious conception of imagery. Another tradition had achieved a similar result much earlier by a more ruthless method, avoiding a direct encounter with Christianity by inventing unknowable eras prior to it. If James Macpherson had presented his Ossian as an imaginative reconstruction of primitive life like Rousseau's in the *Discourse on Inequality* the poems would be easier to appreciate as one of the most remarkable products of the eighteenth century. But enamored of the moral authority carried by the innocent voice he published his intuitions as literal translations of third-century Gaelic verse into English prose. If they had been viewed as guesses, or pastiches based on small acquaintance with slender remains, it would not have been possible to treat them with the reverent care the critic Hugh Blair did when he derived a whole society from hints dropped here and there by the poems. Though he helped them in the notes, Macpherson was shrewdest in leaving it to his readers to play the historian, piecing together the dumb evidence of the poet.

When literature is regarded as true record the reader becomes an archeologist, as Macpherson gave him specific ways of being and guaranteed he would find what he wanted most, a notion of the primitive which

fit pre-Romantic psychological ideals. The poems gratify the new taste for authentic obscurity, subjectivism on a historical base, like a cloudy jewel one can stare into without doubting its reality. How far the poet fell under the delusion he had hit on what it must have been like, and how far he congratulated himself in foisting his guesses on credulous Scotsmen and envious southerners alike, remains a mystery because most of the authentic records—his letters and journals—have disappeared.

We can now see *Fingal* and *Temora,* the longest Ossianic fragments, as unmistakably eighteenth-century poems, not in the simple fashion of his earlier *Highlander* reseeing northern history through Pope's Homer, requisitioning a conventional heroic vocabulary for local materials. Their derivation is more obscure and their participation in an exotic psychology more drastic, but as epics they are clearly post-Miltonic and their portrayal of man's place in nature is unthinkable before the generation of Rousseau.

The poems show primitive man's mind filled by, to the extent almost of consisting of, primordial natural images, cleared of social complexity —the indoors, cities, techniques, arts—so the mists and streams rush in. Nature in Homer is kept in its place by a sense of dependence on it, proportions lost by those economically detached from it like Japanese courtiers or eighteenth-century English travelers, for whom it becomes exotic, and who let it usurp the whole field by a magnanimous abdication. Specific rural activities disappear from Ossian because it happens prior to (or at a point in the social scale above) the division of labor, and its diffuse states might even be imagined preceding the settling of matter into its permanent forms.

Homer, both Blair and Macpherson agree, is unfortunate in the society he's born into, too complex for the noblest poetry, resulting in loquacity, his typical quality, the condition of having too many subjects and opinions, and speaking too particularly. This dissatisfaction with Homer solves itself for Ossian in a sophisticated deliteralization of the world, mental cleanliness like an educated person gone to live in a hut. Thus its monotonies are really novelties, with, if its historical authenticity is accepted, an inexplicable enthusiasm clinging to them. *Beowulf* is a fairer and nearer comparison than the epic models he cites, more Romantic than the classical ones through its interest in the edges of the human and its dwelling on fears in the night. But no reader finds in *Beowulf* the perverse preference of winter to spring Macpherson attrib-

utes to Ossian, marveling in a footnote at the vigor of imagination which loves unfriendly blasts, a foreigner's dream of a marriage between the countryman and his violent mistress, whose proper source is the breasts of those who experiment with walks in the rain.

Likewise darkness is an eighteenth-century preference thrust on the poem more often than genuine primitives would find agreeable. Homer had discovered the excitement in silent camps between which battle is suspended by fall of night, but in *Fingal* the interlude comes forward and ghosts appearing in the night to wakeful chiefs, councils held at night, as if fighting or threat of it left no other time for anything to happen, these motives make this a night poem to a surprising degree, as do, surreptitiously, figures taken from night weather introduced elsewhere, a secondary night.

The idea "outdoors" is not derivable from Homer, or the sagas, or any pre-eighteenth-century original, an idea projected from comfortable houses, till in Ossian existence is shown entirely outdoors, an impossibility, because such high conceptualization needs contrast and unfamiliarity. Some of the best excitements in the poems come from doing things outdoors which are no longer permitted there except by mischance, especially dying outdoors, a woman expiring from unsatisfied longing on her husband's tomb, melting together with the hill and the corpse.

Likewise the solitude which goes with it is fabricated within society, and as yet unknown in its literal Adamic form. A barer solitude first becomes a vocation in the eighteenth century, before which to be alone *with oneself* would have seemed spiritual emptiness to be overcome. From this point on, it becomes part of a myth of oneself and an effort to be individual to an extraordinary degree. In Rousseau, credited with the invention of solitude as of so much else, loneliness is sometimes seen as a fruit of solitude rather than evidence that the self is a fragment without meaning in isolation. Nietzsche, perhaps the most unrecallable of solitaries, planned a history of the idea, which might have begun with Ossian (anchorites and other self-tormentors disposed of), where it is still a mild escape which has not yet revealed its loopholes, protected by the general consent which surrounds acts in Ossian, where stirrings of dissolution feel like fresh currents of air.

Life in the poems seems remote, yet one could approach it more nearly in the present, as one could not the earliest life in Rousseau's *Inequality*, which has no "family" because it lacks dwellings, couples, and recognition of children by their mothers after weaning, Rousseau an

undefended thinker accumulating negations of normal certainties like the classical model-builder, not the enthusiast.

Macpherson's radicalism is psychological not ideological, and his heroic ideal, solitary life outdoors governed by sentiment scarcely hampered by religious belief, is found in the next generation in Dorothy Wordsworth's *Journal*. The life of her little band of solitaries differs in important respects from Ossian's warriors', but the epic's ferocity and bloodshed are lesser stumbling blocks than one might suppose. A favorite sentiment in the poems is compassion for defeated enemies, and at the end of *Fingal* the hero, saddened by success, expresses the withdrawal which so moved the poem's early readers. Heroism of action has receded into the past, and the heroes who survive are prisoners of memories which though sources of beauty are always painful. Macpherson transmutes raw experience into history by showing memory the poet's chief faculty, in Ossian who feels his age in the stories he tells, which finally express themselves as tombs in the landscape. In a similar way fields of daffodils or favorite copses become for Dorothy memorials to be visited for their power to resummon, and thus to tell her her age.

The poem enlarges its characters and their feelings to natural catastrophes, a hero as a hillside or a hurricane, but Macpherson has an amusing note scorning the vulgar supposition (in medieval Scotland) that Fingal and the others are literal giants. Seen to be great, they have been thought big, a childish confusion he says, yet one of the effects he most labored at, so that when Runge came to portray them he caught the Ossianic bombast in spare Flaxman forms which loom over the treetops.

It is cowardly to call Ossian bombast though; once shown the way to subjective heroism we pull back. The flaw and the inspired extension of the poems is identified by Blair when he says they show manners rude but sentiments refined. They are essentially sophistications, like all pastoral, giving the eighteenth-century reader the shell of heroic action with the insect pulp of hatred sucked out, the adrenaline of heroism without the coercion of it, so it becomes an exercise not a function. The innovation in a heroism of sentiment is that one's greatness is measured by the sweep of one's magnanimity, and that in this perspective victories and deaths become minutiae which the subjective hero hopes to rise above.

Runge's drawings are able to show a partial dislocation of perspective and interchangeability of modes (men and rocks), but in the poem the loosening of boundaries goes further than it could in pictures. Acts are

Philipp Otto Runge, *Ossian*. Kunsthalle, Hamburg

dismembered and characters dematerialized into images, giving the sensation of hallucinatory speed to the most prosaic parts of the poem, a kind of thought the reader will never catch up with, foretelling both Blake, who systematizes the psychology and hypothecates further the action of a passage like this from *Fingal,* until it could not be mistaken for history but feels a fresh theology:

> "But I will retire," replied the youth, "with the sword of Trenmor; and exult in the sound of my fame. The virgins shall gather with smiles, around him who conquered mighty Trenmor. They shall sigh with the sighs of love, and admire the length of thy spear; when I shall carry it among thousands; when I lift the glittering point to the sun."
>
> (*Fingal,* Book VI)

and Shelley, the freedom of imagery prefiguring how far above everyday claims his phantasmagoric pursuit of the image will rise.

Thus though presented as a contribution to local history Ossian was calculated to appeal to readers across national boundaries, one of the least restrictive works ever written, a placeless storm turned loose on the reader to try the firmness of his coordinates. Tears, battles, and streams, analogous processes, are rolled together and the exteriority of the world broken down until objects cease to carry a prose sense and become names lost in the text. It is estheticism masquerading as savagery, manipulating abstract and concrete nouns in the same way, which can read as Dick-and-Jane-ish simplicity, or a complete cloudification in which especially the commonest objects become mysteries. In unheard-of collocations, like "light of the oak" for fire, words lose much of their reference, left unexplained as if it were preferable the reader should miss the practical point, as if converting it to something which could happen in our world were a diminishment of power.

When the reader is finally dissuaded from a literal reading of Ossian, perhaps as much by its treading rhythm, a dance to which he is compelled before he feels ready, as by more observable habits of linking actors with the wrong kind of action (Fingal rises on Mora, as if he is a sun and Mora an island, Gaul pours as if a torrent), at the moment of leaving the literal behind he is swamped by a rush of disparate presences. The arguments prefixed to each book of *Fingal* and *Temora* are thus less appropriate than similar aids in other epics, for insofar as they work as intended, these poems destroy narrative and preserve no more "action"

in "sequence" than Blake, successive sentences, even successive phrases occurring in different places with new sets of objects, reality reborn from each minute to the next, which deliberately makes a nightmare of ideas like past and present, and present and absent:

> On Mora stands the king in arms. Mist flies round his buckler abroad: as, aloft, it hung on a bough, on Cormul's mossy rock. In silence I stood by Fingal, and turned my eyes on Cromla's wood: lest I should behold the host, and rush amid my swelling soul. My foot is forward on the heath. I glittered, tall, in steel; like the falling stream of Tromlo, which nightly winds bind over with ice. The boy sees it, on high, gleaming to the early beam: toward it he turns his ear, and wonders why it is so silent!
>
> Nor bent over a stream is Cathmor, like a youth in a peaceful field. Wide he drew forward the war, a dark and troubled wave. But when he beheld Fingal on Mora, his generous pride arose; "Shall the chief of Atha fight, and no king in the field? Foldath, lead my people forth. Thou art a beam of fire."
>
> Forth issues Foldath of Mona, like a cloud, the robe of ghosts. He drew his sword, a flame, from his side. He bade the battle move. The tribes, like ridgy waves, dark pour their strength around. Haughty is his stride before them. His red eye rolls in wrath. He calls Cormul chief of Dunratho; and his words were heard;
>
> "Cormul, thou beholdest that path. It winds green behind the foe. Place thy people there, lest Selma should escape from my sword. Bards of green-vallied Erin, let no voice of yours arise. The sons of Morven must fall without song. They are the foes of Cairbar. Hereafter shall the traveller meet their dark thick mist on Lena, where it wanders, with their ghosts, beside the reedy lake. Never shall they rise, without song, to the dwelling of winds."
>
> Cormul darkened, as he went. Behind him rushed his tribe. They sunk beyond the rock. Gaul spoke to Fillan of Selma; as his eye pursued the course of the dark-eyed chief of Dunratho. "Thou beholdest the steps of Cormul! Let thine arm be strong! When he is low, son of Fingal, remember Gaul in war. Here I fall forward into battle, amid the ridge of shields."
>
> The sign of death ascends; the dreadful sound of Morni's shield. Gaul pours his voice between. Fingal rises on Mora. He saw them, from wing to wing, bending at once in strife. Gleaming, on his own

dark hill, stood Cathmor of streamy Atha. The kings were like two spirits of heaven, standing each on his gloomy cloud; when they pour abroad the winds, and lift the roaring seas. The blue-tumbling of waves is before them, marked with the paths of whales. They themselves are calm and bright. The gale lifts slowly their locks of mist!

(*Temora*, Book III)

It seems necessary to take this large a sample in order to present him properly, because as in other eighteenth-century art its molten core is hard to locate under the professions of respectability. Notes appended by Macpherson are reminders of detachment, but even without contrary tendencies in the composite made by poem and notes, one might doubt that any work could have such a dissolute result, art's wildness carefully planned if it is properly to stun, though one can, caught up, forget the route one has traveled. When the ecstasy is carried on long enough one decides in an estimate of psychic economy to allow oneself this freedom, or not, after which art becomes consciously a mechanism, a discharger. Ossian remains, after all, as does even Nietzsche, an imitation of demonic possession, the poems an instance of the eighteenth-century fad of seeming to take leave of one's senses, which has as its goal the containment of unreason, a classical desire for completeness evident even in Blake's proverbs ("The road of excess leads to the palace of wisdom," but excess in the usual meaning does not travel by roads or believe in palaces). The example of Nietzsche cautions us however from claiming that writing is always a sign of mastery, for there the mechanism of daring oneself to go further and sending oneself to the edge is largely conscious, yet the undermining contradictions show expression producing heat by its inherent suppressions and helping precipitate an explosion in his case final, not a style of recovery.

In the chapter on Odin in *Heroes and Hero Worship* Carlyle reconstructs for primitive northerners a life of continuous wonder in which frost and flame, now subjects of lectures, are regarded with religious awe, an opposed theory of the outcome of intimacy to Rousseau's, for whom this union between man and his surroundings is wordless, thoughtless, unhaunted. Blair and Macpherson fall somewhere between. The striking absence of religion from Ossian reflects their feeling that the grandeur of experience is trivialized by doctrine, while their view of the origin of language is less sober than Rousseau's. Blair argues that poetry is primitive and primitive thought poetic, ordinary speech among

savages more daring than European poeticizing. At the same time he recognizes in Ossian exquisite individual sensibility, an overload of well-springs combining modern and primitive as the poem does, silently justifying itself as richer than the monophonic relics.

The piety of the poems, their substitute for religion, is a modern import, focused on the tombs with which the landscape is prominently dotted, a fixation on posterity. It might seem logical that earliest history should devote itself to this form of remembrance (one of Rousseau's innovations is to push back to a state before death is grasped as an idea), and many anthropological visions have shown rude cultures given over to the service of death, but in Ossian tombs are beautiful remote mechanisms of history not death, savored by the survivors yet not foreseen by the departers, the alignment one finds in authentic remains like *Beowulf*. In Ossian a certain kind of history is put in the place of religion, memory replacing prophecy.

It seems inconsistent while lamenting them to envy these former deaths, but oddly enough it works this way in Ossian, who makes us feel that the heroes are before us in both, closer to the beginning and the end of life, like all past lives conflating opposed highlights, and by inhabiting such peaks obliging us to measure our unheroism. The least communicative pair of moments in our lives is joined in these, because they happened so long ago, terrors of time dissolved by plunging in against its current. Like religion the contemplation of history devalues the present, and, weakening our place, reconciles us to having one.

Writers like Macpherson and Rousseau had banished Christianity from their considerations of early history, so that Chateaubriand in *Atala* sees himself as its reintroducer, who grafts it onto a fashionable vision of the nature prior to it. As a literary missionary taking Christianity to the New World, he is justifying faith not redeeming the wilds, by blending the two flavors gaining a Rousseauist authenticity for religion, primitivizing it after the fact by showing its adaptability to this recent idea of naturalness and human origins.

He needs all his imperturbability in the face of cultural oddity for this enterprise to seem plausible. But the stately gaze which never flinches or hurries is perhaps an agent of disbelief, suggesting that no faith but his could withstand these shocks. In the wilderness the practices of Christianity have only their beauty to recommend them, stripped of the cultural inevitability they carry in Europe. Here they are anthropologized and given a vaguer basis in sentiment instead of tradition, which though

more universal feels less stable. Chateaubriand bears so heavily on the beauty of religion that one feels if it ceased to be beautiful his interest would end. But such is his power that he civilizes all he touches, making it the right subject for a worldly observer, and can seem the civilizer of religion as well as Indian customs.

His characters use cultural loneliness to study Scripture and he looks in the Judaean hills for the imagination at work in the Psalms, consistently localizing the religious impulse, forcing it in the first case to express a personality and in the second subordinating it to his itinerary, for it will be better understood by the public after his visit. His own awareness of this problem does not ease it; no amount of submissive profession will make us believe religion guides Chateaubriand instead of his leading it. Perhaps travel is prideful more often than not, but his trip to Jerusalem, which carries Christianity to its source to form a symmetry with his journey west to another origin, is egregiously creative, the traveler grasping a hitherto concealed configuration in the world as if to give it for the first time a purpose. Chateaubriand discovers in the Crusades a foretaste of his own journey, a grand confrontation of East and West whose drama becomes its morality, but it is doubtful whether any medieval Christian could invite another culture to qualify his faith. This adventure of putting oneself deliberately under the influence of alien ways only becomes tolerable when constant converse with alien societies makes cultural relativism intermittently necessary.

Though the later proto-Romantic voyage to the Middle East is more pregnant with future possibility, the American travels guided by dreams of the previous century are undertaken by a less rigid Chateaubriand, though at its most exploratory his is a carefully composed mind which converts being-at-a-loss to an effect. In Chateaubriand both the wild and the natural feel like art, and his travels evince an unusual need for fresh disorder to subdue, so that the circumstantial prompting to the American trip, the search for a Northwest Passage, or escape from Revolutionary terror, do not explain, except by not ruling out, the kind of travel he pursued.

His fictions of travel are always stories of displacement and estrangement, even without a clear surrogate for himself as a tourist, which the American cycle includes. At the beginning of *The Natchez* the European arrives in an Indian village with his guides and soon finds himself, seated under a flowering catalpa lit by torches held by boys in its branches, asked by the Sachem, old and ruined by lightning like the tree, to tell his

story. René is young and says he has no story, a claim his preoccupation and the name he goes by, "the brother of Amelia," belie. Though the catalpa and the customs which surround him have intimated Chactas's tale, it still seems odd that we should trek into the wilds of the new continent to have our curiosity roused about a European narrative. Besides, Chateaubriand feels unreticent in the extreme, but volubility is perhaps a form of indirection.

René will find Europe tangled with America from long before he comes, though as in Faulkner this past cannot be fully possessed until he passes an initiation costing most of a lifetime. Chactas, the representative of Indian culture, the last great man of his race, has a Spanish adopted father whom he barely remembers. He is united with the brother of Amelia in having loved his "sister," before he knows of the relation, burying her when he learns it, assisted by the priest who represents the bond of white blood between them. On the mysterious naturalness of incest death supervenes, but the passions have already begun to transform themselves into the ornament of religious observance. Religion in the form of the priest or one's inhibitions is the natural mediator between passions and the world, and in Chateaubriand religion is only a seemly word for articulation, his case an unforced example of the Rousseauist belief that language is a proof of man's fall, an entanglement in the vines of complex desire which teaches that to love Atala one must first please the priest. Girodet's famous picture of the most often represented incident in Chateaubriand, the burial of Atala, insists on the morbid role of faith in pointing the way from love to death.

The priest has let the Indians keep their arrangement for the cemetery, or Groves of Death, consecrating it with a cross, a plot reminiscent of Eden, watered by its Stream of Peace with a tree in each family square the only gravestone, mute translation of the familiar record. While it is a Rousseauist hope that this service could be discharged thus gently, the elegant formality is not Rousseau-like, and infuses also the outdoor sacrament with hermit dressed in bark for celebrant. The priest thriftily uses what he finds in the woods, yet his jumble of nature and art is only a step removed from seventeenth-century masque, as his habit of engraving words of "an old poet named Job" on trees is from a Renaissance game. When he elevates the host it is lit by the rising sun, like the transformation scene which unfolds by known but unfathomed connivance; God is the true god who makes theater in the wilderness.

Chateaubriand must seek the truth in artifice and find his revela-

Anne-Louis Girodet, *The Burial of Atala*. The Louvre, Paris

tions in disguise, but with practice one learns to distinguish the true
Chateaubriand in motifs like Christianized Ossian, wandering across the
woods at night carrying one's cumbrous relics. He returns so often in
life and art to the periphery, moving from outpost to outpost, skirting
the center, that the motion must contain a main principle of his character
beneath the historical experience of the émigré. The geographical edge
in Chateaubriand, though difficult to achieve, is also the most superficial
and least impinging condition. Though never at loss for a meaning, he
travels in search of meaninglessness, or in long flirtation with it, trying
to put his cultivation at risk.

The reader may have less enthusiasm than Chateaubriand for the de-
sert or wilderness (the same word in French, with or without the trees),
because to him it is the most moving landscape, an experience of bottom-
less profundity. America is a desert, the East is one, Alexandria is sur-
rounded by three—sea, sand, and a city of tombs bigger than the active
quarters; his eye sweeps across these continents he has emptied and he
wonders, "Will it swallow even me?" The desert in Chateaubriand is

the most gigantic of tombs and his peregrination the equivalent of the blind Ossian stumbling toward the mound where Fingal is buried, mourning prolonged enough to wonder what effect it is making, but showing an authentic vocation for desolation.

In Ossian letting oneself go is heroism, and in Chateaubriand tourism is, but only the most extended sort, not for its moderate dangers but for being more lonely. The content of heroism is perhaps simply to be on one's own and to return to society as one left it, without succumbing to the other roles that present themselves, which he likes to imagine obscure and unliterary, the famous mainspring of the present work a nameless inhabitant of polar seas.

Like Ossian, Chateaubriand was susceptible to seeing very different things as much the same, or as either opposite or the same, both of which constructions blur particular qualities, so a European becoming savage and a savage Europeanized (René and Chactas as characterized by the latter) are confusing flips of the same coin, the residue of an eighteenth-century human essence. The Indian and the Arab are barbarism not yet risen to civilization and civilization fallen into barbarism, history always harking to a model outside the tarnishing current. High contrast and no contrast are two kinds of desert, approximations to a stasis or mental glare in which all is endlessly one. As examiners of primitive societies Rousseau, Chateaubriand, and Claude Lévi-Strauss are alike in their preference for a complex route to a simple goal, a taste for the power of logic to put an end to a difference, as Lévi-Strauss sees it do when he finds cannibalism and prison "symmetrical," one ingesting, the other ejecting its prey. That things impossible to be compared might be not only compared but seen afterward, following a mental flash, to have changed places is the most ambitious dream of such lovers of pattern thinking up spells.

Near the beginning of *Atala* we can watch one of Chateaubriand's symmetrical patterns coming into existence instead of tossed off glibly as it sometimes seems they are. The process moves by stages which partly cancel their predecessors. Chactas and Atala are fleeing at night through unfamiliar woods between his first and second captures when they see someone moving ahead of them with a torch, uttering peculiar cries. It is an Indian traveling in suspense toward the cabin of the girl he loves, who will extinguish his torch if she favors him, causing the desired darkness to fall, or she will let him burn. Next by the side of the road a memorial to a dead child appears, where young women hoping to be mothers loiter

on the chance of being chosen as the next habitation of his ghost, while the original mother wets the grave with tears.

Fortified by these two images, of love and of maternity, the text informs us, the hopeless lovers continue a journey longer than the suitor's and more thoughtful than the orphaned mother's grief. The first image is their undoctored desire and the second their embryonic foreboding, or desire piously qualified by alarm. Only their general concern with Love and Maternity is called on to explain their interest in such scenes, and something irresponsible and bizarre in the initial imagining is regulated by the safe names he finds for observation-become-images, or rather tableaux, for they are resting places though the desperate progress is said to continue as they move by.

Even in their initial weirdness the scenes are talismans, and could more easily be extended into a necklace of similar stones than snapped off after two like this. Chateaubriand recognizes after all the danger of surfeit and the demand for variation, but his alternation of flight with bouts of society—when, recaptured, they enter the glare and noise of another village—may simply string beads of greater size than individual pictures. Only at two moments in all his writings about the New World does one catch him without the defenses of poetry. They are his first glimpses of Frenchmen and Indians in the wilderness, recounted in the *Voyage en Amérique* and the *Memoirs*.

In the French dancing master with Indian pupils and in the brave pulling his wife on a horse we find grotesque contradiction and eloquent blankness barred from the novels. Never again does an impression so threaten his sense of fitness, the function of such shocks taken up hereafter by interruptions which vary the pace by stopping. Scenery interposes itself and we find ourselves halted in a wide-awake swoon which gives its reasons, not carried so far away that it forgets the plant and bird species. Such partitions divide a drama which veers naturally into an unbroken current, like a river which makes one stop paddling by its slowness.

One of the best examples of drowsy alternation in Chateaubriand is Atala's nightly reappearance to the bound Chactas, like Blake's dream, which happens so often he wonders if it happens at all. So Celuta appears to René in *The Natchez,* and both heroes are freed and tended, guarded as by a crueler kind of nursing, penned in buildings and then set loose to be lost on a marshy surface without markers, as if in the gentle nightmare of one who has fallen asleep over the *Discourse on Inequality.*

At his best he is like sleep, and unlike Ossian turns prose into poetry by constant braking, slowing it to the languor of an eternal present in which it is not masochism for Chactas to tolerate the delay of his execution by the festival which fills the day after he arrives. Reprieved so gracefully even a martyr becomes a spectator, and his heroes are more plausibly martyrs to time—that is to boredom—than victims of society which always releases them into that freedom where they will feel defects in desire the last barrier.

A Moorish half-caste who plays an insignificant part in *The Natchez* is called "the denizen of a third continent" (Africa to the French Europe and Indian America), a casual phrase which makes a realignment or explication of the other relations. Chateaubriand collects cultures, crosses frontiers, locates the great fulcrums of civilization in order to be everywhere, not just to have been. The ladies of Smyrna poised between the debris of Athens and the ruins of Jerusalem are nowhere and everywhere. Their city is Paris, or rather their fashionable life is a Paris which has freed itself from constraint by travel, like love in the wilderness, or an unseen flower. Chateaubriand the tourist is also the transporter, the idea of Paris so much his fabrication it can be moved, or found elsewhere. He imposes himself by relocating familiar scenes and rearranging geography: the old idea successfully detached will flower more gorgeously in the wilderness.

Chactas's greatest intimacy with Atala comes in carrying her fresh corpse through the flowery woods, stopping for the old priest to catch his breath. Years later he returns to find a swamp where the grave was, memory corroded by water. Through a process of brooding he discovers the relocated bones of the maid, to which have been added those of the priest, and sets off again carrying this reduction of both. Finally it occurs to René that the mysterious bones wrapped in skins which accompany the remnants of the Natchez on their last journey are this very residue, with Chactas's bones stirred in. Beside Niagara, an even waterier landscape, he prostrates himself before the rusty relics of the story, all its personages now tokens.

In *Atala* primitive existence is reverie and bones only become real as they are moved about and silted over by thought. It is a picture of building a memory, history a pile which grows richer without increasing in size. In spite of its palpability the process is essentially subjective and hence problematic, for memory, the key function, resolves itself to a tenuous chain of individuals, and the extermination of a race is simply an

overstrained figure for the final rupture of the single consciousness by death.

When Jacob and Wilhelm Grimm began collecting what appeared first in 1812 as the *Kinder- und Hausmärchen* they saw themselves recovering bits of the national or racial memory strewn about within easy reach but uncared for, not visionaries like Chateaubriand but compilers, or at most naturalists gifted with a sharper eye for the disappearing species hidden in the hedgerows. They present their collection as the first truly scientific in German, meaning that variants have been carefully compared, that the source is often verbal, transcribed in the dialect of the speaker not affected-naïve diction concocted by themselves, and that the apparent crudities of the original are not smoothed away. Such abdication before qualities sensed in folk products is revolutionary for its investment in uncorrected spontaneity, but it wasn't as easy to escape one's educated self as the Grimms believed. Collection is an anti-instinctive and critical procedure, even without their unformulated rules for what makes one story better than others, because a proximity not usual in nature allows comparison of stories after their selection. Fixing on a printed form traduces oral tradition further by putting a stop to the succession of versions in which a story is never the same twice, but always improving and decaying, until suddenly immobilized into literature.

Besides this they exercised more conscious influence by conflation, whereby incidents from different versions were combined if they did not conflict and duplications relegated to notes, resulting in a richer growth than occurred in nature, an approximation of the density of conscious art. An earlier generation could prefer Ossian and Gothick to the real thing or scrupulous recoveries, because they were more elegant and less gross, more obviously emotive and to an eighteenth-century sense coherent, than medieval or pre-medieval works themselves. In spite of their preference for the authentic fragment over the imposed continuity the Grimms overlaid the nostalgia which offended them in Ossian on their versions of the fairy tales, supplying an equivalent of the mists of time or haze of distance prominent in Macpherson and Chateaubriand and absent from true folk products.

One of the best of the tales, *Brüderchen und Schwesterchen,* which inspired the comforting mythic frontispiece to the first volume of the 1819 edition, only comes into its own because it symbolizes what for us fairy tales are about. The brother and sister leave home like many other pairs and enter in the forest a life of deepening strangeness, whose pull the

boy is less able to resist, finally drinking from the third of the brooks which warn her in whispers while calling to his thirst. This disaster initiates one of the Grimms' most beautiful idylls, for to hold the deer he has turned into she binds him with her belt and finds them a house in the woods, where life continues till disrupted by his enthusiasm for the hunters' horns. It is a visionary union of rude vigor and domesticity, of reassimilation to wild origins, return to childhood and sympathy with animals.

Because it matches Romantic notions of life in the woods so well one suspects that much of the feeling is interpolated by the Grimms, but the closest one can come to verifying their sources is to summon a Russian parallel, where the brother drinks from the hoofprints of the beasts he is successively threatened with becoming, and stumbles into the king's garden without passing through a house in the woods, the great pivot on which the Grimms' version turns.

The pattern is the same, its meaning different, but fairy tales disconcert us most by how little they care about their meaning in our sense of the word, discarding or retaining it by chance. That this story is "about" wildness and civilization, a welcome idea to us, seems finally illicit, and perhaps precious because alien to the circumstances in which we find it. Such fondness for its own settings, as in spite of its spareness the Grimms' language often conveys, jars with the most inalienable formal principles of the tales, the old geometry of threes and the familiar unraveling which retraces the same steps in reverse order, like a series of gates one must pass through both coming and going in order to gain credit. Left to itself a fairy tale never feels the burden of its past but returns to former haunts as a train passes through stations, fulfilling obligations and impervious to sentiment on hearing names long familiar, the romance of such journeys an imagination of those who see the names as surprises prepared for them by the night, who like the characters have the power of forgetting instantly what the kind old man has said.

Chateaubriand's superficial magic inheres in his attitude toward his material, while the surface of the fairy tales is misleadingly resistant and hard at the edge. As Wilhelm observed, they represent the most innocuous survival of an old mode of thought, myth. His way of describing it is to say that bits of myth lie distributed in them like shattered jewels among grass and flowers, bits whose significance has long been lost but goes on informing the stories like an unseizable soul.

This notion signals a critical transition from religious faith (Christian-

ity now presented as the killer of belief, stifler of imagination, disrupter of the bond between man and nature) to a surreptitious adoration of myth, seen as more fresh, deep, and terrible than its predecessor mainly because it is not grown over with morality. As a religion substitute, myth avoids art's disadvantage of issuing from too clear a source and feeling thereby an artificial choice. Credulity before myth is not worship of a mind like one's own but of an entity remote and non-individual, the mind of the folk which by mysterious accords throws up its monstrous dreams.

Interest in folk art is an attempt to evade self-consciousness which, beginning from an arch-subjectivism like Chateaubriand's, escapes the self by going further into it, to deeper more featureless parts, like a fall into a pit. Thus can the matter of fairy tales feel unshared as it is experienced, though common to all. The end of Romantic individualism is a retreat to unanalyzable clarities which though derived from an articulate product are themselves incommunicable, everyone's first article of faith about fairy tales being that their secret cannot be told. Despite its logical impossibility this idea of the discussable Unknowable has exercised a powerful hold on those who have given up the idea of an answer which resolves all, but still cling to the imminence of it.

Folklore study is a new branch of archeology, an examination of remains largely inarticulate because untutored, prehistoric artifacts surviving in the present, whose position outside history is indicated by their freedom, like other folk art, from the cycle of styles, strong in their anonymity, which appeals to the Romantic sense that the self is anonymous deep down, differently from the way the eighteenth century felt it.

Structuralist ideas of information and redundancy provide the most plausible explanation of how folk products survive extended illiterate transmission without denaturing or modernization, without losing their character or entering history. Information in this special use is contradiction or differentiation, a process of separating oneself off which has the best chance of transmission if haphazardly distributed through the text so that its location cannot be clearly identified by the transmitter. Edmund Leach, speculating on how the Bible became the sort of text it is, shows that the effect of a succession of editors, or sufficient multiplication of intentions, might be to approach anonymity again, amendments contributing to an unintentional coherence.

New ideas of individuality and coherence are needed to cope with the situations presented by fairy tales, which conceive the person so loosely

Ludwig Richter, frontispiece to
Ludwig Bechstein's *Deutsches
Märchenbuch*

or generally it becomes no more than a bounded territory which wants
to bring more inside itself. Our ability to engage passionately with such
levels of generality suggests that abstraction comes more naturally and
gratifyingly to human beings than is commonly supposed.

One's unthinking allegiance as a spectator at a game where one hardly
knows the sides illuminates the "morality" of the tales, which is more
cellular than moral, a kind of thrust like that which pushes a plant to the
surface. *Hansel and Gretel* is about food, an undeniably primal subject,
but if its participants are hardly human why does it assign dialect names
to them? Can this be simply disguise of its ruthlessness, as if a beast were
to wear the friendly face of an old woman? Certainly when illustrators
of the tales like Richter and Schwind concentrate on woods and chil-
dren, giving foliage the ruffly look of bows tied everywhere and making
the dozy grandparent relation crucial, we feel them simple-minded. Al-
ternatively, modern illustrators have seen the actors and motifs as mad,
not a view the tales want to encourage, but in a sophisticated translation
how they might come out, as they do in Lewis Carroll.

Such a translation is like the dreaming of someone who has been tipped off by Freud. One cannot make a simple response to a request for unedited material; trying to keep one's hands off produces results like madness, an overcompensatory excess. All the new sciences of unconscious products—folklore, anthropology, and psychoanalysis—face the danger of obliterating not just contaminating their data by observing them. When you ask someone to recite a dream or a tale so you can copy it down, the innocence which was its main virtue has been compromised. So the better system of roads at the end of the eighteenth century which simplified the collection of folk material was seen as a fatal incursion on it, as if after Freud's inroads on consciousness dreaming were to dry up. The Grimms like to depict the old fragments they publish in their folk-nationalist periodical as unvisited islands on which sun shines and flowers bloom in vain, but how can being unvisited not be a perishable quality if one is talking about a real and not a fictional place? Fortunately for psychic experience, however, the idea has reliable content, so a public experience can remain secret, and in the midst of busy streets inaccessible.

Thus Hansel's and Gretel's behavior is simple but obscure, not especially intricate though highly patterned, and like something one might do though not very like: laying a path of stone pellets from a stone house into the woods, laying a path of bread pellets which disappear and wandering till one finds a bread house, which one begins to eat, only to be shut up and forced to eat in order to be eaten, until finally one is able to shut the big eater up where cooking is done, so she is cooked but left uneaten, and one flees the place where all is food, returning to scarcity, the stone house.

Though powerful, this nightmare does not feel educational unless one is to learn that man's susceptibilities play into the hands of the world, that he is designed exactly right for his own destruction, that his chances of success are small, a moral Freud could have endorsed. Though he found it in pursuit of truth and the tale in pursuit of success perhaps at the level they are carried out it comes to the same, a failure to synchronize man with something outside larger.

Their views of the family feel similar though their ways of expressing them bear small resemblance, because both Freud and the tales disbelieve all moral profession and find real functions at a different level from that. If the knowledge of the tales became conscious they might make children ironists, but would never make them cynics, because they present a

presocial world of selfish atoms and hang tenaciously despite its unlikelihood to an intoxicating vision of success.

The fairy tale's forgetfulness, leaving on a second and a third journey as if setting off for the first time, is a sign of its central self-centeredness, not a casual structural defect. Its lack of baggage, or of a highly developed sense of responsibility, gives its resilience but suggests that overindulgence in the tales (contra Bettelheim) far from socializing a child will probably desocialize him. The freedom without responsibility Nietzsche strove so elaborately for is the fairy tale's by primal right, and the sophistication of a narrative might almost be defined by the prominence of the function of memory in it, by the depth to which preceding actions are engraved on its face. The Grimms' thirst for history led them to forms lacking all temporal depth, but what they still feel as historical sense is already shifting toward something else.

Romantic obsession with the coherence of "ontogeny recapitulates philogeny," the history of all life as the model for the individual's and vice versa—our particular instance of it being the equivalence between childhood and the fairy tale—has anti-historical consequences. Such preoccupation with roots and such search for unity between past and present leads to a cyclic view, joins the actor to sources of strength outside his own efforts but dooms him to a series of repetitions.

Certain organic metaphors for the processes of art and culture give the clearest indication of its historically revolutionary function for the Grimms. The great innovation of their generation was to identify culture with a specific national language and finally with race, so that one had the illusion of deriving highly contrived products from involuntary genetic process. This form of localism, which politicized language, culture, and race by linking them so closely to self-realization, by making them in fact surrogates for the self, saying these grand words and meaning me and mine, was able to look large and not pinched because it described itself in generalized language of growth. Therefore the politicization of language and culture to which the Grimms made a not very calculated contribution can be approached best through the apparently innocuous figures of the fountain and the flower.

Viewed in the coldest light, the flowing spring of the nation's poetry and the river of tribal migration are not organic metaphors at all, yet this indefinite image of continuous change is fallen into more often by organicist writers than the comparatively precise and limited one of the developing plant. The power of this image of movement to persuade early

folklorists will hardly be believed by one who finds in it mainly a suggestive blur, the idea of unspecifiable source and unending continuance, a disdain in other words of definite content, which vegetable ideas and even the fastest-growing most impermanent plant seem inevitably to admit more of.

The favoritism shown this figure is explained in part by its resemblance to another, and by the odd linkage long established between blood and race, blood imagined as flowing from one generation to the next in a continuous if invisible river. Thus the gravitation to underground springs as expressing the progress of races, not because you lose their path on the map but because it reminds you of the way blood asserts itself, issuing suddenly from a particular point on the body, a mysterious motion one would like to contain or pass on.

It is a subject at which one naturally takes fright, and so if a writer really means to evoke rivers of blood crossing Europe, he is not free to say so. Nonetheless it is an easy regression from one flow to the other, and in the vicinity of springs we are never far from discussion of the integrity of racial groups, but because of its evident harmlessness the idea of the river of folk can be deployed irresponsibly by a variety of writers.

The frontispiece to volume two of the 1819 edition shows one of the Grimms' old female informants pressing a small assortment of wildflowers against the tabletop in front of her. The shock of novelty when this was offered as a picture of the poet is now lost to us, an ordinary peasant woman drawing her inspiration from nature as it is casually gathered along the field's edge. Opposite the old grandmother clutching her shreds of story, a garland of woodland flowers forms a soft cushion around the words of the title, the Grimms' favorite figure for their collection to call it blooms they have formed into a rustic bouquet. The small fragment is congenial to them, sometimes as the scientist's instance, sometimes the poet's flash, their works frail single blossoms not oak trees, most passive and least distinct life, which might be trampled or mown, delicate not insistent, qualities few readers associate with the tales. In another connection, in their journal *Old German Forests,* Wilhelm describes the men of times when fairy tales were created as nonindividual, like lilies, because they followed their fathers' paths without new thought, an echo of the reverse personification found in the tales instead of the moralizing positive kind. A girl becomes a plant, to be

Ludwig Emil Grimm, frontispiece and title page to J. & W. Grimm's
Kinder- und Hausmärchen, Vol. II

redeemed not injured when a piece is broken off, losing her distinctness
toward an equilibrium in which all things are uniformly alive and none
extraordinarily so. It is a similar de-individualizing amelioration when
after an uneasy pregnancy a woman bears a sprig of myrtle, with which
a prince immediately falls in love—like most transformations in fairy
tales, boys to ravens, princes to frogs, one in which people lose character
instead of the reverse familiar in the rationalized magic of allegory.

Perhaps this difference is less important than the fact of transforma-
tion, and the fact of quest more important than the feather or bride or
cup from which God drank that is its goal. "Extremes meet" was a fa-
vorite Romantic proverb, satisfied so much more obviously by Blake's
transmogrifications than by anything in earlier literature one begins to
wonder if it is a valid intuition or an imposed dogma, but it is suggestive
to find the great de-poeticizer of the tales, Vladimir Propp, who calls his
analysis functional and reduces them all to a single type, saying that ma-
levolent and benevolent agency are the same, indistinguishably propul-
sive in sending the hero forth to what is alternately imagined as his doom
or good fortune, or that for something to be stolen by a villain or lacked
by a poor household has the same dynamic result.

Metaphors aside, if one asks in what way literature is firmly and not fancifully organic, ignoring such extremes as Blake's senseless vegetative cycles, one is reduced to saying that it feels right but doesn't look logical, that it defeats explanation and seems to be obeying a higher principle than reason, or at least another one. We offer our failure as proof of our theories. In other people's explanations it is easier to see that the main effect of invoking organic metaphors for literature is to save a larger place for the irrational, and keep open the possibility that art embodies an ultimate power whose source is beyond us, perhaps just because we must have something beyond us inviting us on, the world's mystery its greatest solicitude for man, the last explanation signaling the last moment of time for which there is any use.

Wilhelm said tales were just as essential to life as common household utensils, spoons, cups, and towels, and were found entwined with them except where links with the past had been broken by the noise of machines. To imagine the stories as things, simple handmade artifacts, pleases him, but because he does not want a continuum between humble technique and large-scale manufacture, he erects his barrier of difference between one machine and another. The tales have not perceived a crevasse here, and much of their dreaming is technological, speed and efficiency for its own sake past apparent use, shoeing a moving horse, swinging a sword through rain without wetting it, which may have lost some of its freshness for us but shows this kind of thought not really alienated as modern divorcers of technology and imagination have proposed.

When the impostor who has stumbled on the abandoned dragon's corpse hauls it to court and claims the reward, the hero is able to step forward with the animal's tongue he has cut out, the key to the whole monster which establishes his right. If we were not heavily disposed against such a description we might see here the symbol as a labor-saving machine, the literalist doing the sweaty transport for nothing, the symbolist possessing that infuriating elegance which arises from leaving out steps, and finding an unnaturally short route, based to be sure on work done earlier in another place.

When the fairy tale substitutes one bride for another or sends a girl along the side of a stream after a rolling ball of wool, the faceless dynamism is deeply true to its nature. In spite of this, in spite too of the way motifs appear in dozens of parallel manifestations in an area stretching

from India to France, in spite of many tendencies to an abstract polyvalent view of reality, the earliest connoisseurs of the tales chose to regard them as entirely local products, and emphasized their narrowness not their universality.

But when people begin to lay claim to myth as a possession and culture as national property to be safeguarded, they create unsolvable problems, for ownership of these categories and even of one's nationality is difficult to establish beyond doubt. Germanness is only satisfying if it is yours without question, and at the moment it becomes a conscious subject the worry arises that an enemy might be able to deprive you of it, so you contest it even without attacks upon it.

The Grimms traced Germanness to ultimate roots in the German language, most irreducible sign of national difference, and preached a linguistic conservatism which would have astounded a German of the Enlightenment. They preferred to find the tales in dialect because they were truer, more gnarled, more like objects, which is to make a positive of narrowness, to hold up language as a means of non-communication and exclusion of foreignness narrowly defined.

A principal difficulty for any ideologist of language or race is that both in their present states are confused and fragmented, and the usual solution is to posit and envy a time when linguistic and racial unity was more sweeping, when a small but distinct Nordic race inhabited the whole north and spoke an honest Gothic tongue. And in fact the Grimms' great linguistic achievements were devoted to the service of such dreams, a desire to believe that one had once been more perfect than one was now, not in the form of one's diverse literal ancestors, a throng of atoms unmanageably increasing as one traveled back, but in one's race-ancestors, to whom one could assign what qualities one liked, first of which would be a passionate awareness of belonging to a certain blood group, as yet insignificant but destined for hugeness. The company of German speakers was large in the present and unified in the past, and one could easily imagine that large and unified was its proper condition.

The Grimms took the hints of folk belief and custom scattered in various sources, prominent among which were the tales, to be intimations of once-undivided consciousness, and so grouped and rationalized them into a great Teutonic mythology, the kind of artificial synthesis which ancient Greeks and Hebrews had more or less made of them-

selves, which the ancient Germans were too deeply imbued with, perhaps, to require in externalized form, absence as evidence of what one is superior to.

When Jacob recalls drinking customs or the history of German cakes, they are not programs for revivals, because his mode is not action but nostalgia. In his love of pockets of backwardness and praise for communities which have let history flow past them unaware, he seems most distant from political participation, for localism is the enemy of history and change, and difficult to preserve from contamination. The professor of the creed of localism cannot be authentically provincial himself, since to recognize what is Hessian or Saxon he must have been infected mentally by foreignness, perhaps even threatened by it. The unthinking jingoist with an instinctive loathing of aliens only becomes dangerous when allied with a theorist of differences who has systematized his idea of Germanness and begins to legislate contamination, seeing all mixture and alteration of boundaries as disease rather than growth.

We read such sinister meanings in the Grimms' appreciations of folk culture only in retrospect, and find vogues for smallest units of Germanness—names, proverbs, *Sagen* (legendary explanations of strictly local phenomena like deep caves, islands stranded in rivers, or greetings among mountain people)—portents of things to come. In Ossian there appears to be an extreme nationalism of personal and geographical names, much of the distinctiveness of his world inhering in these baffling syllables, Inibaca, Selma, Cormack, which lie thick enough on the ground to become a subject in themselves and not an invisible convenience. In a sense they are all obsolete, since the same places and similar people still exist differently referred to, the names an inexpensive guarantee of the poem's authenticity. Gaelic names are distorted toward an ideal of primitive speech as mellifluous, thus their resemblance to early transcriptions of American Indian words. In this stage at least, nationalism can be a form of exoticism in which one pretends that the weirdness of the resurrected names feels immemorially right, and that only outsiders would balk at calling their children Urgot, Yvain, or Melisark.

The geography of Ossian and of true folk literature is foggy but the addiction to certain characteristic species—birches, pines, wolves, squirrels—may be seen as a geography with nationalist overtones. On a much later building like the National Museum in Helsinki owls, elk, and pine trees with drooping branches and interlaced roots have been elaborated into expressions of the local soil and hence the national character, a mod-

ern variety of totemism, in which one identifies oneself obscurely with lower forms of life, adopts them as badges not décor, roundabout forms of defiance.

The Germans even manage to lay claim to night and bad weather, Italy having spoken already for sun and clear skies. The *Nachtwachen von Bonaventura,* Novalis, and Wagner are seen in retrospect good German patriots of night. Once it is undertaken every coordinate of life can be polarized and even one's geographical position made an absolute. If to be northern is to possess a certain strong unattractive character, if it carries certain privileges, it is also something in which one can be out-flanked, Danes, Swedes, Laplanders all more northern than oneself, until one hits on the division of the world into north and south so there is no boundary between oneself and Scandinavia but between oneself and the Latins.

A similar manipulation makes workable Ruskin's link between geography and creativity. All our strength comes from the hills, and if English universities could be relocated in the mountains a great upsurge of productive energy would result. The fact that the cities like Venice which have produced what Ruskin values are not perched among mountains, and that mountain populations are in his experience degraded, is explained by the power of hills to act across distance and their powerlessness against bad habits deeply enough engrained.

For some reason the patriotism of geography and climate concentrates on the awkward facts of its situation, its isolation or discomfort, and encapsulates envy in the form "Evil, be thou my good." But the feeling one must endorse everything in sight for the reason above all that it is one's own will drive anyone of rational inclination to desperation, so it seems likely German defensiveness arises from being more in two minds about themselves than most people. An acute appreciation of the other side leads to polarizing what they want, until it is impossible to have even half of it.

One of the most encouraging facts about Elias Lönnrot, who in compiling the epic he called *Kalevala* made the greatest single contribution to Finnish national consciousness, is that he could never be provoked to anti-Swedish feeling. Lönnrot was a doctor who began to collect fragments of Finnish oral poetry on vacations and tours of medical inspection in rural Finland, without at first the idea of forming them into a whole. After his first publication, *The Harp* (1829–31), two skilled singers in an eastern district gave him a new conception of the songs'

homogeneity, though the possibility of putting together a Finnish Ossian had been broached much earlier in an ethnic newspaper.

As he went on Lönnrot not only collected but embodied the folk tradition, becoming a singer who like peasant ones could recite from memory and improvise links and elaborations as he sang. He differed from peasant singers in using transcription to learn the songs, which helped him build a larger repertoire than any of them, while his knowledge of literary models like Homer undoubtedly influenced the way he exercised the singer's right to arrange his material, to reassign actions to different of the stock characters who recur through the poems. But if he is a more radical social type than the Grimms, a case of deep mimicry, he feels correspondingly less ideological commitment to folk literature, casualness in his relation which makes him less important than they in the history of ideas.

Like Runge whose transcription of *The Fisherman's Wife* in the language of fisherfolk fired the Grimms at an early stage in their research, Lönnrot cultivated unscientific closeness to his sources, entering a two-way relation with the informants from which the Grimms kept aloof. His doctoral dissertation had been about magic medicine and he became a popular instructor through medical and agricultural manuals for simple readers, giving them something in return for what he got and even contracting their diseases like typhus. As he lacks, in spite of various linguistic compilations including a Finnish grammar and dictionary, the Grimms' scholarly rigor, so he does the crusading ideology of immersion in a lower class one might expect of a Russian, though he cultivated simplicity and retirement—peasant clothes, a pipe, work at an ingenious desk he had invented, exercise, singing.

The Grimms' materials remain detectably on the scale they naturally occur, though massed differently. Lönnrot while scrupulous in preserving the specificity of his fragments—charms for catching bears hold up the narrative for four hundred lines—imposes on them a principle of coherence borrowed from another culture. Trying to make an epic from these desultory pieces he forges an unachieved Ossian, flat and centerless because he refuses to falsify the indigenous attitude toward his actors into heroism, and preserves even the genre of the components, including recognizable bits from south Finland which are more balladic because in that region singers are women. After the addition of an equal amount of new material in 1849 the *Kalevala* became even more a treasure trove or national display case which contained every single bit of information

about the life of the early Finns Lönnrot could turn up. He was at pains to safeguard it from obsolescence with the claim that no new material was likely to appear because he and his assistants had scoured Finland and the songs were dying anyway from exposure to the air of national publicity. He is also concerned to show that odd usages in the poems like impossible tasks set for a suitor, a familiar motif in fairy tales, correspond to customs among the early Finns. He finds ingenious rationalizations of mythic beliefs, like that churches in Finland were built by giants and wrecked at night by demons, rationalizations which depend on the Finns taking their history from the downtrodden Lapps and then overlaying it with bits of their own contrary perspective. Thus giants are Finns as seen by Lapps, and demons Lapps seen by Finns.

A certain lack of the grandeur which the imported notion of epic demands prompted bizarre mythic interpretations Lönnrot confutes by noting prosaic inconsistencies—the character who represents the spirit of fire is afraid of it and gets burned, the spirit of the air is as much at the mercy of contrary winds as others. To imagine a slanging match early in the poem as a contest between water and snow, a pivot between winter and summer, or the voyage to steal back a prized grain mill, simply because the geography is uncertain, as occurring in the blue seas of heaven with the lynchpin of the universe as its goal, are efforts to enlarge the poems to match the scale of one's own biggest feelings. The characters are so obviously petty in themselves that somewhat on the model of Ossian one turns to the circumambient environment for intimations of something larger.

Lönnrot was immune to this need for transcendence which converted the poem's evident responsiveness to nature into an embracing nature cult. He argued instead that early beliefs were close to his own, founded on a single unspecific god. And he was content to lack a transforming vision, to collect pieces of shattered pots and to form them into a pattern but not to see it as the world-tree when he had finished.

The metric form of the original materials is also relaxed and uncomplex, consisting of paired lines, the second of which varies the language but repeats closely the matter of the first. Although the singing depicted in the poem does not take this form, as collected by Lönnrot it was usually sung by two, a lead and a support, one of whom directed its course, leaving the alternate line to be completed by his partner while he prepared the one to follow. They sang clasping each other's hands and rocking back and forth. As it comes through translation the motion of

the verse is powerfully physical, and the particular proportions of sound and thought would probably feel much the same in any language, like heaving and then resting on the oars, except that the repeat is not dead calm but an effortless exertion.

Thus the larger motion of the poem no matter how long it dwells on a simple action never becomes involute or intricate but a continuous grooming or polishing. Even the eyes sift the page like shaking a basket of stones, motion which acts as a filter keeping back some of the sense. In formal procedure it is an extreme example, but perhaps typical of anonymous products seeking out the kind of action which is rolled up then comes unrolled, and thus largely performs itself, like the house that Jack built or the hiding of successive kernels in each other and then in successive fish which are then chased and successively cut open to find fire at the end again. Admittedly Wolfram von Eschenbach's *Parzival,* though rude in its way and peculiar for its author's claims of illiteracy, is an extreme example of an authored poem, of a certain intricacy going with inexperience like a literary equivalent of Scandinavian or Celtic interlaced ornament. The professions of ignorance may be ironic adoptions of local coloration from the naïve hero, or licenses for eccentricity, for it is a poem which allows language to become contorted in following grotesque actions, but perhaps it only proves that any action is susceptible of gnarling as each one in Lönnrot is of smoothing. The comparison with Wolfram shows that there are certain kinds of wit and obscurity deeply individual and literary, however much he may pretend to be an oral poet, which could not be passed on by a group product like *Kalevala,* though the thought may feel animistic or mythical, so Wolfram conceives a battle as the struggle between the heraldic emblems on knights' shields instead of the knights themselves, between griffins and ostriches, on whose side a troop of anchors intervenes just as the conceit has begun to feel comfortable. Once he even splits one of these tribal totems between two groups, an army marked with the front halves of griffins joining a detachment identified by the rear halves.

Surprises on such a scale, of which Wolfram prepares large quantities, are impossible in an orally transmitted work like *Kalevala* with its liking for self-perpetuating chains such as the progress of Vainamoinen's tears in thirteen stages over various parts of his body, clothes, and possessions, running on to reach the lake and settle at its bottom from which they must be retrieved. Even a less automated example like the inquiry into the origin of iron touched off by Vainamoinen's wounding himself with

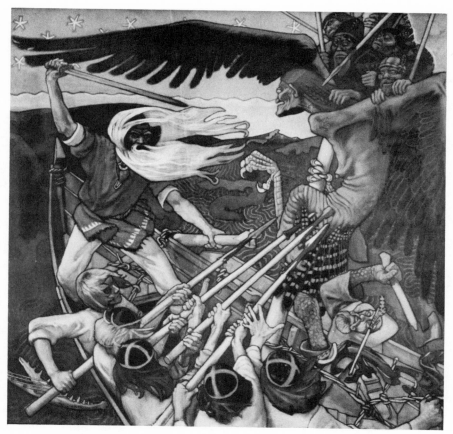

Axel Gallen-Kallela, *Defense of the Sampo*. Turku Art Museum, Finland

an ax and needing to know how iron came to be, and especially how it came to be "bitter," or able to hurt its maker, in order to staunch the flow of blood—even this historical investigation is self-completing, burgeoning irresponsibly at the expense of the narrative which is always losing its way because it is a purposefulness largely imposed by Lönnrot. Nothing reveals better the difference between the efficiency of the fairy tales and the exiguous spinning-out of the songs than the idle quality of magic in the *Kalevala,* which has become a reflex to be elaborated, whereas in the tale it escapes conscious inspection.

Home feeling not magic runs deepest in the *Kalevala,* local sentiment tied not to geography but to certain usages, mostly connected with the husbanding of things or with cleanliness. This unadventurous meaning

of local is well expressed in Gallen-Kallela's peasant interiors of dark wood painted in the 1890s, and more abstractly by his *Kalevala* illustrations which look hewn from wood, a moderate heroism of work. Some of the most poignant moments of the poem are the most obviously interpolated and substitutable, general instructions to brides on how to clean stoves, spoons not forgetting the handles, tables not forgetting the legs, with none of the Homeric feeling that a ritual significance still graces the act.

A nearer example than Homer of a naïvely materialistic world, the *Nibelungenlied,* lays over bare possession and maintenance a powerful mythology of waste. Expenditure is heroism there, sign of a craving within the limited confines for largeness. The *Kalevala* is remarkable for its sober contentment with cleanliness as a measure of civilization and for concentrating on its dark corner without pretending to prefer it to sitting by the window. Though an example of the higher Romantic valuation of custom and usage as concrete history, the sort of thing the eighteenth century had tried to call prejudice, the *Kalevala* is truly extraordinary in how little it presses the claim of its own uniqueness.

From the belief that the only reality is local, uniqueness not sameness being the irreplaceable value in experience, it is more usual to progress to extravagant claims for one's habits. Having split the world into atoms one asserts that each or one of them contains an unfathomable wisdom and finds oneself again sitting atop something large, the eighteenth-century infinite reached this time through a paradoxical introversion.

Macpherson, Chateaubriand, the Grimms, and Lönnrot share a mythology of setting out to collect authentic folk materials. The first two know so well in advance what they want to find that we cannot be sure whether they think they have found it or made it up. The nobility is at odds with the localism in Ossian, but they need each other. In spite of their queer names his characters are more ourselves than we are, yet the really telling thing is their historical inaccessibility which proves like a skeleton planted in an archeological dig that there has been no evolution —no progress, but likewise no regress to speak of since we can still conceive this purified humanity. It takes the weirdest particular circumstances to show that human life is a way of thinking not a set of physical conditions, archival research as a way of proving locality inessential.

To go everywhere weakens the power of place on oneself, uses up the world's capacity for the not-me. Travel has for Chateaubriand a more drastic significance and he is not simply a stronger enforcement of the

non-local moral of Ossian, because of the difference his personality makes, as the medium through which all boundlessness will have to pass. He travels far in search of a reality which can keep a step or so ahead of him, and if his antagonist is not quite equal to this, at least Chateaubriand proceeds on an assumption like the Grimms' that one will only ever be able to understand by discovering differences, differences so extreme one is tortured into questioning the familiar.

The American stories are more authentic anthropological fictions than the style will let us believe, as we can see in the retrospect of later experience like Malinowski's *Diary,* which suggests that Chateaubriand renders shrewdly the psychological effect of extended festivity which wraps away the individual lives of the tribe, and which remains after his much greater dose of that life Malinowski's best way of distinguishing primitive existence from ours. Chateaubriand gives it so well because it is what he is looking for, and could not be sure—until he finally found it— that he could not fully possess.

Macpherson and Chateaubriand are remarkably uninterested in specific paraphernalia of primitive life, or at least subordinate the interest to their general visions of man at home, as we are not, respectively in weather and the infinite, rather than in a place. The Grimms' narrowing and specifying finally comes down to language, an extremely sophisticated equivalent for the local in their detailed conception of it.

In the process of thought they stand at an early stage of, the local as unshared became the crucial arbiter of value. Making extravagant claims for the despised could best be achieved by finding other objects to despise and later to hate. The juxtaposition of nineteenth-century renewal of interest in folk tale and the appearance of the morality of folk tale as practical politics in Germany a hundred years later makes one want to outsmart history by finding not the seed only but the whole plant in the earlier time, perhaps by making out that adoption of fairy tales as part of one's adult cultural inheritance signals an as yet dim need to give evil a larger place in life, to welcome emotions long suppressed, rage, revenge, cruelty, with articulate endorsement they had never had before, as if one were telling a brave new truth.

TURNING AGAINST HISTORY

Like the Nazarenes in Germany, the Pre-Raphaelites are aggressive provincials in painting, reseeing old stories so radically that their best pictures look mainly awkward. The English movement is less reminiscent of specific archaic styles and a less literal mimicry of the medieval guild; its early purity undresses the past as much as dresses it, but achieves even in this starker phase a new mystification of story and appliance.

Because the historical suggestion of their name is not appropriate except in calling up unfashionable simplicity, their first great defender, Ruskin, twists it around to link them with van Eyck and Dürer not Italy, to make them a monastic order, Protestant not Catholic, mounting a Reformation in art to primitive vision and primitive Christianity.

The literariness which seems to us their salient characteristic didn't strike viewers then, distracted by a new harshness in the way they render "nature," or inanimate and vegetable objects, which assume thrusting prominence in their earliest pictures. Like that of the Nazarenes, it is a strongly linear art but, perhaps for lack of a graphic tradition, more bewitched by surface texture. Even more than the Nazarenes, therefore, the Pre-Raphaelites separate reality into distinct

parts and thus it is that faith to nature produces what is above all a school of illustrators. Thus also are fanatical devotion to texture, illustration, and picture purified of obvious representation linked in series. The Pre-Raphaelite microscope is a destructive instrument, and their meticulousness more revolutionary than dutiful.

The early Millais is the least literary of the main Pre-Raphaelites. *Christ in the House of His Parents* achieves an impression of startling accuracy by stripping away accreted historical flavor to get down to a multitude of sharp things, wood that is woody but not old, costumes which have sloughed the theatricality of *Lorenzo and Isabella* to become flavorless primitive like David's, neither Palestinian, medieval, nor contemporary but an unspecific amalgam. Though the composition remains angular, it comes together with greater ease than *Lorenzo and Isabella,* whose sudden stares and kicks are the most authentic things Millais ever captured, as of reality startled by a loud noise.

The clothes may be, but the faces are not Italian, not types, because too particular, and formed unnaturally into a gallery like a series of snapshots taken in a railroad station but mounted in an album. Only in modern times, we may think, has there been such cramming of human diversity, or perhaps we mean such perception of individual difference.

As no one has ever thought these people looked Italian, no one has asked if the stream in Millais' *Ophelia* is Danish, a less purposeful contradiction than the former, to show it as evidently English, deriving its power from our sense it was studied yesterday nearby. The way to imagine literature, Millais seems to say, is to put it in the place you know best, not a place of the mind or geographically or historically recondite ones, but the landscape equivalent of local modern dress. The contradiction in this procedure is not expected to disappear, so when Dyce sets young Titian in a recognizably English churchyard it means that Titian, like Ophelia, for all his historical far-offness enjoyed summer afternoons and sat on squeaking leather chairs. So as Ophelia floats downstream she catches a real chill, and is hidden from historical view by a tangle of identifiable waterside plants. This thick backdrop dominated by the upturned emblematic willow is one of the tours-de-force of Pre-Raphaelite painting but a confusing mess as well, a virtuoso display of textures muddy to incomprehensibility in its spatial relations.

Because of its minuteness Pre-Raphaelite study of nature tends to preciousness just when most faithful in its observances, a paradox

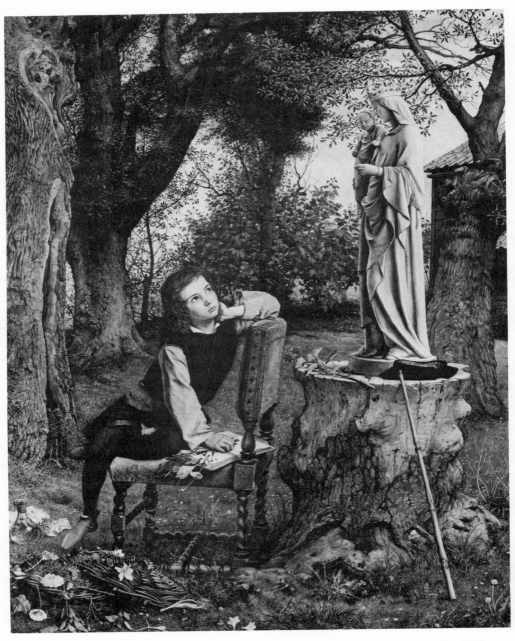

William Dyce, *Titian's First Essay in Colour*. Aberdeen Art Gallery and Museums, Scotland

Charles A. Collins, *Convent Thoughts*. Ashmolean Museum, Oxford, England

Ruskin applauded when he compared the rural bank in a later Millais to a Byzantine enamel. Hunt's *Light of the World* shows an even more bejeweled surface purporting to be a corner of England at a definite time of day, and Collins's *Convent Thoughts* gives a more rigid instance of the outdoors beginning to feel like the indoors by the overlabored method of its representation. It shows a nun in a convent garden behind a high wall, pondering a daisy while her other hand holds open an illuminated missal in such a way its pages come right-side-up for us, a miniature reflection of the flowers around her which have parted from her like the pages of a book, or stepped away like tactful personages who give thoughts fuller head within these confines.

She is a pressed flower whose color has faded, a process which has earned her a truer luxury, her vocation a figure for the analysis of sensation instead of its thoughtless experience. Pulling a daisy apart in this quiet walled space is an act of concentrated refinement like artistic creation, which can be dismemberment if by that one understands the multiplication of parts. The convent garden becomes thus a transitional Palace of Art, a conception which exerted unusual force on the Pre-Raphaelites, surprising only if one accepts them as devotees to nature in the rawest states.

Every illustration is a partly unwilling confirmation of the power of one art to compel another, a tutelage under which many illustrators grow restless, which alternatively sends others spiraling inward to locate art's sources in itself, to make a more hermetic and non-communicating image, a convent within a convent, like the island in the garden Collins's nun is standing on.

Whatever it is in Tennyson's poem, Mariana's entrapment in Millais's painting is the devotee's enclosure in art, which has crucified the body by throwing it out of use. But the power of its patterns is not felt to be simple in the painting, a power which has changed the seasons, autumn outside the window and summer in her embroidery, as often in the Pre-Raphaelites a surrogate for less domestic arts. Natural light is twisted by art to produce colored pictures in stained glass one must allow to usurp the windows to appreciate.

Here the chamber is a beautiful prison, disturbingly churchlike. Houses were churches in those days and there was no escape, ideas accepted enthusiastically by other painters but giving little pleasure to Millais. His career is the most disappointing of them all because from the most vital he develops quickly to the deadest, a decline already complete

J. E. Millais, *Mariana*. Makins Collection

in 1853 with *The Order of Release,* accompanied by less exotic subjects and greater certainty of handling, as if through the removal of contradictions imposed on his prosaic character by the incense of a more remote history he had been compelled for a few years to inhale.

The claustrophobia induced by art is the very sensation Dante Gabriel Rossetti pursues most energetically. His five illustrations to Moxon's Tennyson of 1857 are among his best works partly because crammed

into the awkward compass of the page and hence full of tensions in spite of illustrating undramatic moments in the poems. His devotion to literature cannot be questioned because so much of his energy was spent interpreting it, and yet his view is clearly idiosyncratic, a vision, which exaggerates the hieratic qualities of romance to make it a parody religion, a continuous ceremony carrying clearer sexual and historical overtones than are permitted to religion proper. Thus in *Galahad Receiving the Sanc Grael,* a version of Communion in which sexual roles are stressed, the knights form a garland in front and the angels a fence behind, guarding the prostrate figure of Perceval's sister as if the gilt background of an early Florentine painting had exercised its patterning influence on the whole scene. In some of the Tennyson illustrations, especially *The Lady of Shalott* and *Mariana in the South,* the sense of entrapment is more aggravated still, as if the figures were pushed from behind toward a small opening or pressed against a window. Here his awkwardness as a draftsman conveys passionate collision and his plagiarisms from early German prints are assimilated to new uses, the background of *Mariana* from Dürer seen in vertiginous perspective like a shrunken tunnel in *Alice in Wonderland.* Its writhings and truncated forms are exceptional even among these heated illustrations and so is the resulting impression that they are only small windows onto Rossetti's sense of the text, so details which take the whole side in Dürer are given only a corner here, and if he had more time he would have more to tell. He is the best though perhaps not the most faithful Pre-Raphaelite illustrator because, to Ruskin's dismay, he divides himself evenly between literature and painting, so that his involvement in the text makes him fit too much in the space allotted without allowing details to become independent of each other.

The author who corresponds best or can be coerced to fit Rossetti's conception is Dante. This conception imagines itself to be a sacramental view of existence, yet feels comfortable only in secular settings and halts frequently in passionate inspection of art, thus his Dante dreams of a sleeping figure or draws an angel, illustration contemplating the act of illustration, the process of representation itself as the final authentication of primary reality. Music plays the role more often than drawing or dreaming, perhaps because more easily disguised as an activity rather than an art, and more readily associated with women. Stringed instruments and hair, portable organs and passionate kisses seem almost neces-

Dante Gabriel Rossetti,
illustration to Tennyson's poem
"Mariana in the South"

sary linkages in Rossetti's mind, as if music always worked like Paolo
and Francesca's reading.

In *Tune of the Seven Towers* the three are brought clearly together—
cabinets of art in which women are shut up like porcelain, the esthete
herself an item in a collection; music as an enthralling rigor; and sexual
consummation bringing life to a standstill. It shows the enchantress
seated in a music-making device like a set of stocks which binds hands,
feet, and waist, and thus conceives art as a song without spontaneity and
a form of sealing oneself off. It belongs to a class of life-denying experi-
ence in which Rossetti includes sexuality and is able to show so actively
because he feels the contradiction in any passionate devotion, which al-
ways closes itself up to enjoy a sameness.

In Ford Madox Brown's *Chaucer Reading at the Court of Edward the
Third* the effect of teeming enclosure is achieved by building the compo-
sition upward as well as sideways, making a pattern in which motifs are
standing on each other's heads. It shows too full a range of age and occu-
pation, too garish a variety of costume, the manufacture of which is too
observable. But Brown's *Work* has a similar feel of having been added to

Ford Madox Brown, *Lear and Cordelia*. The Tate Gallery, London

endlessly, unlikely dogs stuck in at the last minute, the interpreters at right a late improvement, but some of the most extraneous accessories, like the party of ragged children, included from the start.

When Brown becomes historical the contradiction is less troublesome between the disarray of the world and coolness of the handling, and a crowd presented vertically in mural style easily forms smug pockets which feel as if they can get along on their own, a surprising feature also of much illustration unhindered by the practical difficulties made here by a vertical space full of creatures most of whose physical relations are necessarily conducted on horizontal axes. Of course in *Chaucer Reading* the format is not forced on Brown by a wall space, but part of a deliberate search for atomization.

From the start his illustrations had shown a willingness to disrupt the main emotion to make the scene feel more like a picture, as in the far view of Dover cliffs which comes between Cordelia and the sleeping Lear to frame the Britishness of the history and quicken us to the miracle

of telescopic historical vision. Appliances like the King's weird couch are a deep infection of poetry by ingenious science, systematized in later illustrations like *Elijah with the Widow's Son* or *The Coat of Many Colors* so that we feel everything has its place, cut off from others as if they took place in other rooms, as if to fit many rooms in one. It is smug also because the appliances all remind us of art and forethought, the carefulness of the life shown a commentary on the art which shows it.

In illustration such lack of fusion can be a positive spur to inquiry, such inability of the artist to think in wholes an aid to the spectator's learning, who will need to find the reason for many of the strange objects he sees. Much illustration, instead of a more slavish and unthinking branch of art, is a too-thinking one, trying to give the reader over-distinct and over-numerous ideas about the text, approaching a large mystery with many small clues, so that in the end one knows more about the houses of ancient Palestine than the feelings of Elijah, and has become a tourist not the prophet.

William Holman Hunt is the only Pre-Raphaelite who felt obliged, in order to paint Biblical subjects, to travel to the Holy Land, struck by the incongruity of Christ knocking at the grown-over door of an English cottage though clothed in Oriental splendor. It is detail not conceptions one becomes a literal Nazarene to seek, yet, like Rossetti, he exerts transforming force on the bits he magpie-like collects. Partly he does it by believing that the literal becomes symbolic by having odd thought secreted in it, partly by denaturalizing his details through cramming. Hunt found a way to give the hoariest narratives of the Bible the accidental feel of illustration, so that his picture of a theme as already plumbed as Christ among the doctors would need a long explanation appended to it. His *Key* to *The Finding of the Saviour in the Temple* is a hoax, though, illuminating inessential machines and leaving the far-fetched human types and encounters uninterpreted. But the investigator of this picture irritated by Hunt's footnotes seemingly intent on preserving every scrap of his research, his Egyptian, Assyrian, Palestinian, and British Museum adventures, may miss the *Key*'s clue to the painting.

Like *The Awakening Conscience* or the idolatry of motherhood perpetrated by and for Victoria at Osborne, it is full of Victorian duplicity, trying to sneak its wishes past by calling them symbols, or giving greed the face of moral improvement. Thus Hunt manages to read *St. Agnes' Eve* as a temperance tract, and Victoria to require before the sensuality of breast-feeding a hushed reverence. We know, or think we know, that

Ford Madox Brown, *Elijah with the Widow's Son.* Victoria and Albert Museum, London

William Holman Hunt, *The Finding of the Saviour in the Temple.* Birmingham Museums and Art Gallery, England

the love nest recorded in *Awakening Conscience* is an everyday world, but it feels undeniably weird. Palestine has not given Hunt his exotic flavor; he had learned before his journey how to avoid the ordinary while deep in the literal, to be fantastic without provable untruthfulness. So the move to Palestine was partly protective cover for the mind which bred luxurious exoticism wherever it was employed and elicited revealing inadvertencies from Ruskin, showing him, too, fatally charmed by indulgence dressed as teaching.

Like most of Hunt's paintings, *The Finding of the Saviour in the Temple* raises Messianic hopes, but a millennium of gold and colored glass, heaven a Turkish harem. Illustrating so much, it fails as an illustration, its drama stalled by feeling studied in every inch. Hunt's is an unnatural realism, a nightmare sharpness of vision which became more hallucinatory as the contradiction bore in on him between his literalism and his spiritual pretensions, his efforts to make peacock iridescences represent God.

The largest camel he ever gave his admirers to swallow was the so-

William Holman Hunt, *The Scapegoat.* City of Manchester Art Galleries, England

called *Triumph of the Innocents,* in the form of the Flight into Egypt
with the event of the title in far-off Bethlehem bubbling to the surface in
super-real emanations, madder than the madness of Dadd or Blake be-
cause of the "accuracy" of its formulation. A less intricate, more gro-
tesque camel is the *Scapegoat,* showing what excesses of ingenuity were
required to keep Hunt's technique from petrifying like that of the other
Pre-Raphaelites. The lurid Palestinian hills in the background and the
goat's footprints in the snow or sand are so freshly painted they subvert
momentarily Hunt's insistence that we understand this as an emblem of
human sacrifice. He proposes that medieval arbitrariness of symbolic
equivalence should go together with modern arbitrariness of mechanical
reproduction. The result is superior to a photograph not in the way it
looks but the way it means, as empty as reality and as deliberate as alle-
gory. There should be a liberation in this—to show painstaking detail
and then to humble it before the primacy of the idea, but it has the old
separated feeling of bad illustration which fails to keep the detail in sus-
pension and by some jolting motion allows it to precipitate out. Thus

one is left with a world which falls apart into appearance and meaning, where one cannot turn, as medieval artists could, to an image which means better for not looking like what one sees.

Although his early awkwardness and medievalism make him look Pre-Raphaelite, and although to paint the wings of angels he studies those of birds, Burne-Jones never makes the Pre-Raphaelite submission to nature and bears a relation to the earlier movement like Henry Wilson's to the Gothic Revival, decadence or phosphorescence if descendance at all. From an early stage he is a metaphysical painter, a title Hunt may covet but few would grant him, which means most simply that Burne-Jones's equipment stands in for something else, that when he shows a procession of women walking downstairs it is to express a feeling about time and repetition, all of them dressed in shades of neutral white to mean the endless sameness of experience which nonetheless changes its shape. Thought is like music, says *The Golden Stairs,* like it in vagueness, un-seizability, non-individuality.

If it is right to think of him as a history painter, he belongs in a region remote from the historical peephole represented by Dyce and Millais, *Titian's First Essay in Color, The Boyhood of Raleigh,* pretentious titles to which are appended pictures dignifying an ordinary scene with a great man's name. Time's mysteries inhere in those too, but the essential point about the later-to-be-significant is that only words can tip one off to it, and to force it into an image brings home a sentimental falsity in the whole conception. Of course there are things which are unknown before they happen, and to know them before makes human creativity a subject of the same order as monetary inheritance.

Burne-Jones's history is ideal and would survive without its titles, but its reliance on nostalgia is no less deep for being unspecific. It too is built on the desire to have another place in time, and more seductive for not requesting one in the known past. The past he makes us want resembles the known past, or rather resembles a number of them, the Middle Ages, the Renaissance, and classical times all at once. Costumes in *The Mill* are technically classical, their presentation decidedly Gothic, the result an ambiguous twilight they can never be coaxed completely out of.

He seeks a past without the trivial and reachable individuality of a year attached to it, like an address one could go to. Thus the ghostly gray which predominates more as he develops, a natural color for armor

but employed to make it translucent like glass or crystal, or soft like a succulent root. The significance of armor is psychological not functional in Burne-Jones, for whom, as for Tennyson, the most brutal medieval meanings, battles, wounds, lengthy convalescence, have lost their immediate relevance and become metaphors. His knights do not need armor for fighting but for bleeding inside of, to signify suppressed passion, or as the body's grotesque mask, to magnify its repulsive beauty, as of a serpent, an insect, an artichoke, a lily, each of which Burne-Jones's armor variously becomes, its stiffness one of the main avenues for metamorphosis in his world. Like other clothes in his pictures, it is freed to be more cartilaginous, streamlined, and voluptuous than its medieval originals, an irresponsible fantasia on organic themes.

This is how the co-presence of spirituality—the flutter of wings—and sexuality—columns and passages—can be explained. It is a metaphysic of both, sexuality only an aspect of non-individuality, angelhood a cold-blooded grounding for all strivings beyond the body, an end to religion, not a door left open for it. Both sex and aspiration are strongly inhibited in Burne-Jones, in clothes striated by tension until they look like brittle muscles or a pattern of knots more a kind of strapwork than clothes, invention become fetishism and lists of restrictions. Wings are heavy and oversized, their palpability contradicting their purpose, their beauty humiliating, a joke on flight. Their expressions show that his characters feel beauty to be limiting, carrying large penalties of self-consciousness. The mood is thus monotonous in the faces, but diversified in the laying out of the ensnaring plot.

He is enamored of fences, which he frequently shows thigh-high, an impossible height which could be stepped over in reality but traps the legs in appearance, like wet clothing or a self-imposed bar, from behind which the woman stares out sadly over an emptiness like her inability to imagine life outside the wall. Battlements are a favored variation on this theme in the illustrations to Chaucer, at the same unusable height, as if the lonely figure inhabits a manuscript-scale architecture, an archaism expressing as usual in Burne-Jones a mental condition, that of living in a place starved in its near proportions yet vast in its peripheral vacancy. Sometimes the battlement is the frill of the building, sometimes a row of savage teeth, an irresponsibility or a Gargantuan violence showing reality the plaything of thought, which is in turn the toy of something more obscure and further down, exciting in its guessed location and paralyzing in its monotonous slavery.

Edward Burne-Jones, *Perseus Slaying the Serpent*. Southampton Art Gallery, England

In his sketchbooks Burne-Jones often culls off a background detail from a manuscript page or early Netherlandish painting, so that a little closet or canopy or cupboard is brought forward to form a whole visual field as if one could, not retreat into a corner, but make a corner fill all space. His architectural settings often feel like collections or concentrations of these corners, rooms made of narrow passages, walls filled with barred or closing doors. Most of his spaces are high and narrow, but they may be low and narrow, horizontal slots the body is straitened into, like *Dorigen of Bretagne*'s room, an exposition of the idea of the door, open but not wide enough to pass through, or open and about to close. Here every projection of view, every possibility of vision has a flap or lid on it which could close it off, though for the moment they all hang

crookedly open, as in a mental confusion which is a set of variations on the same theme, as forgetfulness might be seen as a consistency if reliably recurrent.

Dorigen is looking at the grisly rocks through a window slit aligned with the picture space, beneath which are an opened and a closed book cupboard built into the wall, to the right of which is a portable organ with doors lying in different stages of openness, beside which are scattered books laid cumbrously open like doors. In Chaucer's story she is the prisoner of her thoughts, and here the multiplication of outlet, coolly considered, is mostly a mockery, but somehow lack of opportunity is a welcome development. Vertical walls are converted ingeniously to horizontal resting places, which seems the meaning also of a feature which recurs in the Kelmscott illustrations—the bed alcove, a reduced, more secretive extension of the room rather than an exposed piece of furniture. This ledge or slot occasions the many renditions of a waker played

Edward Burne-Jones, *Dorigen of Bretagne*. Victoria and Albert Museum, London

against a sleeper, a sentinel figure who by one kind of rigidity brings out the force of the other. The *Briar Rose* cycle is a greater example of this idea, overbalanced toward collapsed postures and thus making in the end an overwhelming effect of dissolution.

The consistency of these motifs—fences, fencing corridors, stricter and tighter openings—makes us feel the need or possibility of a conclusive interpretation, but to say that these configurations are reminiscences of womb experience is perhaps simply to recognize that the model when we find it must be deep, powerful without being local, and that therefore we should push as far back as possible. The angularity of Burne-Jones's architecture militates against this or any other organic interpretation, however, though it is true that in the Chaucer pictures rooms with ceilings curved like ovens are common, and that part of the stiffness derives from the technique of wood engraving. Perhaps the angularity is simply to focus on the difficulties and pangs of birth, on even the most natural home as not entirely comfortable. But more likely is the chance we have confused two forms of deep, that as our prenatal memories are, so Burne-Jones's suggestions here are deep, and to express them fully we must call on birth or death, the ends or final resting places of meaning.

It is a triumph of his power of suggestion that he makes us cast equally in the direction of origins and of repose and infuses us with a contented sense whichever way we turn that life is pain, and that pain has a beauty of its own. Burne-Jones, the student of pain, puts his pilgrim in an architecture of briars, one of the plants which interests him most for its way of varying graceful linear outline with a sharp punctuation, an allegory of the relation between form and meaning in his pictures, which hide engines of torment among roses. The elongated proportions of his figures, usually seen as a kind of elegance, and sometimes it is true conveying the indifferent blunt growth of independent narcissi, give more often the impression of desiccated sticks easily snapped, their length their weakness dead principles in a dead world. At its most intense his nature is sterile, trees woven into a tangle almost a wall, which now exhibit only a token growth, or the *Arbor Tristis,* a leafless ramification held by wedges in a circular stone platform resembling masonry against a city combatting the twilight with tiny lights at wide intervals. The devotee derives his sustenance from these desolations, immediately steps around the decorative railing of dancers in *The Mill* to examine the mon-

Edward Burne-Jones, *Arbor Tristis*. The British Museum, London

ochrome background, another extended twilight transitional between
ordinary existence and the heightened but featureless obscurity of
dreams.

Like its name and all myth, the *Arbor Tristis* is a man-made growth,
mysterious like the world but offering surer hope for a cure; lonely, it
could end loneliness if only it would explain. Pictures like this differ
essentially from true myth by their hypersensitivity to setting and re-
duction of the figures to frozen verticals in which only a sensitized tip of
growth remains. Burne-Jones's myth is myth without the actors, though
they may survive in sleepwalking replicas. Mythic trappings without
commensurate acts issue a call more desperate than the easier visions of a
comfortably allegorical age. Even Bronzino and Michelangelo are less

achingly enigmatic, less the prisoners of their work than Burne-Jones, at his best despairing of finding out what he means, unable to put his call for a new system of belief into fully intelligible form, his angels, for example, the proof of his remoteness from Christian iconography, shut out just as clearly as Blake and able to combat the exclusion less energetically.

His attempt at an active cycle to set against the inertial *Briar Rose,* ten scenes from the story of Perseus, is a history of monsters and murders, another late-nineteenth-century declassicizing of classic themes like Moreau's, Böcklin's, Nietzsche's, Strauss's, which makes a monotony of excitement and a prison of heroism. Another classic theme, the triumphal progress, is presented in one of his last unfinished projects, the huge and crushing *Car of Love,* like a machine of war traveling through a narrow Siennese street made a paved vesicle by stone struts passing overhead, the space engorged by the bulky engine which looks as if it will damage itself against the sides or tear a hole in them, but has just cleared a sharp bend. The chariot is surmounted by Cupid with huge gray wings and heavy drapery in imitation of a canopy over his chair, on which it stretches like strained flesh.

The living-unliving car is pulled by nude figures fancifully bound in regular rows and chased downhill by the runaway car or caught up in internal struggles which coincide far enough to congest a definite segment of the street. In another curved procession like *The Golden Stairs,* this machine is chasing the actors who should propel it, perpetual motion fruitless through dissociation from its sources. When it most resembles myth, experience becomes in Burne-Jones a treadmill of repetitions, fluid coursing down its huge channel powered by inertia.

Like Burne-Jones, Wagner found his way to a kind of larger work like a repetitive cycle, Burne-Jones in series of monochrome paintings which make violent narratives look motionless, Wagner in dramatic music which takes hours to unfold. Both of them discover the Jungian archetype before its time, a vehicle of myth which combines generality and obscurity. The flight from lucidity makes music the natural carrier of myth, with greater capacity for presenting anti-heroism as sublime than the other arts.

At the very moment when Nietzsche, the best destructive critic of nineteenth-century culture, identified it as the time when all the arts become literature, Wagner was showing how all the arts, literature as well, could stop being literature, a rare instance of music dictating struc-

tural ideas to the others. If in the mid-nineteenth century all creation is tinged with literariness, the early twentieth is infected by the desire to capture certain properties of music in other mediums, a general transmigration in the arts whose origin lies largely in Wagner's persuasive innovations.

Some progressions feel destructive as much as creative, and after all this lapse of time it is still easiest to see Wagner's method as decomposition and dissolution of traditional coordinates, by their nature more susceptible to embodiment in a temporal art like music than a spatial one like painting. His sense of experience as non-progressive recurrence is, like Burne-Jones's paintings, essentially anti-historical in spite of arriving like them, in *Tristan,* its most powerful embodiment, with strongly archaic if not exactly historical flavor. History or myth carry for Wagner at this stage no clear doctrinal instructions; in *Tristan* myth means no more than a world in which an unnameable power is felt outside individuals, a loose substitute for the supernatural which lets the composer pretend that the unconscious lies outside men. As in Burne-Jones legendary setting is a license for symbols to assume a prominence which makes enigmatic causal connections seem reasonable.

Tristan opens on a ship at sea, which is to say nowhere, on a featureless fluid like the slippery surface of the music, which extends itself in phrases too long to seem complete melodies, instilling only a Gargantuan pulsation like seasickness. This becalmed boat suggests another, drifting out of control somewhere with a wounded man on board, whose wound was traded for the ache Isolde feels now, so that she regrets healing instead of killing her victim. Images are presented first in detached and ambivalent potency before being anchored at named characters—drifting, somewhere else, and pain, before Tristan's past and Tristan's pain. Experience coming loose from its moorings this way, like the music from tonality, makes characters interchangeable in spite of bombastic exaggerations in the heavy tradition of opera, stalwart Kurwenal, imperious Isolde. And the often-remarked drowning of the voice by the orchestra, a lack of coordination between the real climaxes and the vocal climaxes most evident in the *Liebestod,* is only the sensorily most coercive destruction of individuality, refusing to admit it to the real profundities of existence.

In the last act the scene has shifted to the shore and again someone is waiting for a ship, Tristan for Isolde's, who has been promised another journey to another strange land, Tristan's this time not Mark's, to which

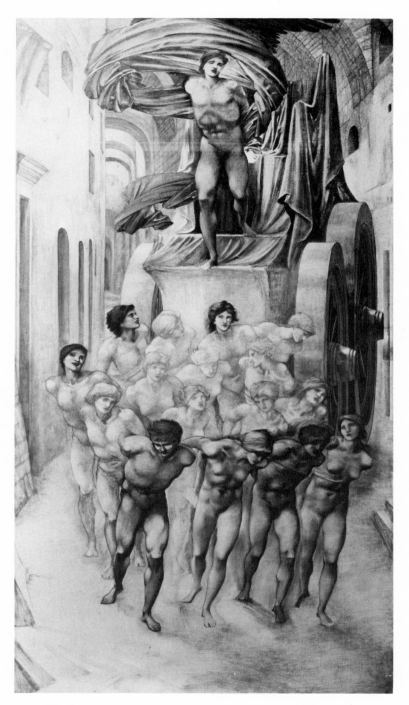

Edward Burne-Jones, *The Car of Love*. Victoria and Albert Museum, London

he can invite but not lead her, for although it continues to be perceived comfortably by Kurwenal as Tristan's homeland, this land is death, and this journey a transcendent confutation of the earlier one.

Such recurrence produces a blurring of structure because the compositional labor it represents is perceived at the moment of occurrence as fortuitous, as a bewildering sameness in the course of events, which thereby ceases to seem a proper course but a maze instead, in which one is lost without realizing it until one chances on a spot recognized from an earlier passage. In one sense any coherence is a longed-for confirmation, but in a more immediate one Wagner's are baffling re-beginnings and disorientations, for familiar motives re-met going the other direction can only unsettle the listener's sense of place.

Some of the most interesting musical precedents occur in non-German composers of dramatic music, in Berlioz's numbing repetitions, put in smaller compass than Wagner's, but giving a glimpse of how actively annihilating a sameness could be, and in Bellini's heartless extension of the melody to tire resistance in the listener and compel submission, to sustain him through a long fall in which he wonders if he has lost consciousness for an instant. Bellini stretches the basic unit past a breaking point where rational control wears out. Berlioz by contrary means makes us wonder *which* of a series of like sounds we have got to at any point, by continuing a repetition deranges our sense of place. These two hints of how moorings could be cut were developed systematically by Wagner, incorporated into a world-view as they had not been by his predecessors, and for all their impalpability enforced more persuasively in opera than they could have been on the apparently more receptive ground of the symphony.

Of all his works *Tristan* has found the most hypnotic doctrine to match the formal discoveries, argued in passages of philosophical disputation between the lovers, who work out in hymns to night which are mutants of death-wish that the highest consummation is death. Though it may be only a taste for profundity which drives them to this pass, the conclusion artificially reached carries real consequences. From saying that the impossibilities of love imply death, they come to the starker conclusion love *is* death, underscored physically in the two potions of joy and death which are finally assimilated to each other and shown to be one, not opposites as first supposed. A chosen death is a high positive which lords it over all more trivial-minded experience, entertainment of suicide based on a more sweeping categorization, never argued, but the

single belief which makes sense of the story, an idea of election: large spirits are subject to larger convulsions the world must bow to without understanding.

Wagner puts his most wonderful realization of endlessness, the *Liebestod,* at the service of these ideas, a long crescendo carried forward in waves without full relaxation, explicit in his verses as surges of heavenly fluid in which Isolde suffers death by drowning. The listener reeling under this assault may forget to wonder how a healthy person wishes herself into coma and cessation of breath so efficiently, for he has undergone something similar, a derangement of timing which feels like a death-sleep, a weakening of his resiliency of response which causes everything to reach him a second late.

Nietzsche in his fad of physiologizing decided that Wagner's characters were all sufferers from hysteria, a hint taken up in Thomas Mann's *Tristan,* the rehearsal for *Magic Mountain,* in which Nietzsche's hospital ward has become a sanatorium and Isolde's sudden ecstasy a pulmonary hemorrhage. Wagner seems to need debunking because of the way he perverts his gift, casting specialized psychological insights as ultimate truths, and forging his local dissolutions into numbing wholes contradicted at every step by effects which at their best are withdrawn not expansive. So his descendants are able to realize his promise better than he ever does himself.

Debussy's *Pelléas* takes a triangular subject like *Tristan's* and instead of a world-drama moving from kingdom to kingdom and abstraction to abstraction presents it as an action so private it eludes even its participants. Dropping the first scene of Maeterlinck's play, it opens by a pool in a forest, a condensed sea surrounded by ignorance, a jewel of water. The characters are introduced as lost, or interrupted not introduced, for the stable sense of beginning is erased to show how problematic all knowledge has become.

Its characters are not talkative, nor is the music, nor are the symbols. Debussy's Middle Ages are minimal without thinking, window, cave, harbor, forest, members of a finite series too plain to feel exactly like symbols, disappointing at first by their lack of ornateness, but suggesting a surrounding void, apparent flimsiness really the trailing off of sounds lost in immensity.

An inconsequential surface continually suggests sinister depths without the music's ever becoming heavy. Though it seems to escape, quickly dispersing, rather than to proceed, it conceals—like Bresson's *Lancelot,*

a later derivative—an earnest search, all its images figures for knowledge: water and darkness forms of burial or occlusion, everyone leaning over the edge looking in, or heaving a sigh when sighting a break in the trees.

The most inscrutable of them, Mélisande, whose leitmotiv is that she loses her identifying marks, that her crown, her ring, her doves, even almost her hair desert her, raises the theme of unplumbability to self-parody on her neurasthete's deathbed, saying, "I don't understand what I say. I don't know what I know." Even the answers one can give are not fully one's own, because anything statable has come loose from its preverbal source. The route between cellar depths and daylight is not just forgetfulness but alteration of being. The person who emerges above ground is not the one who suffered the hurt below, and this identity too if brooded on will disappear like a reflection in the water.

Her and the opera's way of talking about something else, of saying "It grows cold, the sun goes down" when she means "I am sinking," is disingenuous, not really anti-symbolic and diversionary. The man in Proust's parody of *Pelléas* who, having lost his hat, feels the cold as the onset of the final winter of the world, makes the linkage between incommensurate realities in a no more absurd form than the opera, except that he is in modern dress and a cloakroom instead of a forest. The whole of *Pelléas* has been displaced or lost into an unpopulated realm whose supreme elegance is its amnesia, its sense of having a past but being ignorant of it.

Such ecstasies of discontinuity as follow from malfunctioning memory in Debussy are realized less monotonously and more lightly still by Strauss's *Elektra*. One is ready to forgive Wagner a great deal for the sake of these works which have found the right scales and tones and above all plausible psychologies for Wagnerian dissolutions. *Elektra* is the most momentary and uneven, the least automatic and predictable music there had yet been, full of memorable snatches, but no melodies, its time scale so immediate it feels like speech, as if each word were separately set, so sensitive to an influence outside the music that there are no internal completions. Thus lightness and intellectual complexity are found together, but perhaps the initial impression of astringency is not dependable, such variety making richness, not soothing of course but barbaric, including a welter of textures which would not have been considered music previously and introducing lush episodes for pressing local reasons not as in later Strauss simply for purposes of seduction.

As Debussy is the perfection of Wagnerian ghostliness, Strauss is the

perfection of Wagnerian grotesque, of raucous raptures and thundering swoons, marrying hairiness and ideality as Böcklin wants to do. As Debussy is Wagner with impurities removed, as many Wagnerites manage to perceive Wagner himself, early Strauss is Wagner with the vulgarity refined into a positive stimulus by speeding it up and reducing its proportions so that it can continue to stun and thus to seem a prompting of life.

Wagner's *Magic Flute*, his sublime old age, instead of climbing down from philosophical pretensions, regresses to a ritual paralysis of them. Since finally he is above arguing and will simply intone them, he leaves the onlooker at *Parsifal* a simple choice: to become a communicant, accepting the music gratefully, or to leave the building shamed to set up his Klingsor's castle elsewhere. In the nineteenth century, as art took itself more seriously, more religiously, it assumed longer forms, most notably in the symphony and the novel, the apotheosis of which tendency is the temporal demand made by the *Ring,* like holy days of obligation. In *Parsifal* he sets out even more consciously to borrow the requirements of religion, and make his listeners take something on faith.

Although it adopts a protective Christian coloration the sacrament of *Parsifal* is really self-ordination, the proclamation of a new king and promulgation of a new creed manufactured by Wagner himself. Chastity elevated as the heart of the doctrine may seem at odds with the overmastering welter of *Tristan,* but this is only upholstery, and the central core is an objectification of the earlier passional tyranny which can now be confessed as inhering in the art process itself.

The listener to *Parsifal* cannot have just the music, or will remain fatigued and baffled if he tries to forego the communion which feels intolerably slow to a non-believer, telling a story seen as guarding a mystery, in language simple but imprecise, losing spears and gaining cups, like the childish pictures on playing cards. Its consummations are acts of kneeling, submissions instead of deaths, and the most unclean of all, like Jung's semi-secular improvements of religious events, is the double washing and anointing of Parsifal's feet and head by Kundry and Gurnemanz, a servant and a priest, ceremony diluted when multiplied to four until it seems a parody of getting dressed with help.

If the dramatic teeth have been pulled, the onlooker is not deprived of impossibilities to believe, magical ideas of defilement and paradoxes like healing with weapons or seducing with grief, which exercise his ability to unthink his rationality. But the most disturbing achievement of *Parsi-*

fal is its restoration of the gory side of Christian symbolism, its attempt
to bring blood-sacrifice into currency again, and literalize the suffering
intrinsic to any sacrificial act. To make meals into church services and
communion truly nourishing it connects bleeding and eating. The
knights can feed on Amfortas or on Christ, the goal of the action being
to divert the flow from one to the other, to close Amfortas's wound and
throw Christ's open again by outwitting the clever outsider whose envy
has fouled this mechanism. Piety and purity must not shrink from open
coffins or open sores. They acknowledge in fact a holy duty to gratify
their appetite for such extremity, the intellectual freedom to concoct
one's own beliefs taken as an opportunity to institute a slavery which
harks back to the world of the old German martyr paintings.

Wagner treats the naïvetés and crudities of such stories with rever-
ence; Nietzsche finds corresponding grossness in the behavior on which
man prides himself most, performing a destruction in the world of dis-
cursive thought like Wagner's on esthetic form. But the anti-cult would
like to become a cult, blurred categories making a kind of poetry, Nietz-
sche ordaining an end to the greatest of all works of art, intelligible his-
tory. There is a skeptical view of this skeptic, as a psychologist and
clever reader, an interpreter of symptoms, and there is an inflated, vatic
view as a Heroic Utterer, an Antichrist of thought. The great reduction-
ist for whom heroism comes down to digestion and God to grammar is
always defining in opposition, a reactive genius whose terms are dictated
by the enemy. His destructions are reactive but their recurrence shows
them obsessional, less effective than they might have been for disclosing
their roots in hatred not system, weakened by their authenticity.

Regarded coolly as they were not meant to be, some of his most mon-
strous assertions are simply exercises in turning upside down, seeking a
tactic strong enough to kill the offending idea, the size of whose threat
we gauge from the magnitude of his response. Because he exemplifies, as
he recognized, the decadence he diagnosed as the nineteenth-century
disease he becomes a murderous healer. The great divide in Nietzsche's
thought between reflection and action, sickness and health, is an exter-
nalized version of a private attempt to deny the largest part of his nature.
He is a disturbing thinker because there is so little of himself he wants to
salvage, determined to root out so much, regardless what takes its place
or whether its place is taken at all.

Like Ruskin he is much occupied with defining greatness, and he too
associates it with lonely heights, the same Alps, greatness a pressing sub-

ject in the depleted world where the self must become a replacement for
God, a Teacher, a Prophet, a man who thinks out of doors, which is the
way Nietzsche can see his own activity as heroism, to make it physical
and express breaking off as coming down from the mountaintop and re-
entering the flatland or Germany of everyday life. Like Ruskin he apes
the Bible, the book which smells, yet gives him his ideas of excess and of
fire, points the way to the self-magnifications which will make reduced
spiritual circumstances bearable. Never before has a philosopher so made
himself the object of his inquiry or the reader's attitude to them a subject
of his books. When he says Wagner one should read Nietzsche, or de-
picts the devilish Christian subversion one finds an anatomy of his own
method. Even accusing Paul of inventing Christianity, Nietzsche reveals
a wish of his own, an estheticized view of belief which sees creeds as
works of art and the grandest success to perpetrate a new one.

He tries viewing sickness as a badge of greatness, says his sickness
gave him the right to change (coerced his change?), and boasts that he
was never happier than when sickest. Like Freud finding truth in the
refuse of psychic life Nietzsche cannot let his body's errors rest. Though
sometimes his vision of the new man is that he will appear unannounced,
his more interesting theory is that he will spring from his opposite, real
greatness the ability to give oneself to sickness and turn it to health, for
the greatest strength is that which has overcome most. Thus to say that
health and sickness are essentially the same is not a simple contradiction,
nor only to say they are transformations of the same materials, but an
expression of the perversity some will find in drastic engagement: for
Nietzsche, health must get itself dirty.

A gap opens between the psychic truth that one must become infected
to cure or be cured, a modern subjectivized rendering of contagious
magic, and striking claims about the whole world, that here everyone is
invalid and nurse, which seduce partly because they must be untrue, and
because such perfect community, even of pain, cannot exist. We may
thank him for making us think what prevents this class of statement from
telling even partial truth, but next we translate it to narrower form to
make it true about Nietzsche at least: everyone suffers my weakness, but
does it less well because without feeling it. To be ill and feel oneself well
is the most degraded state, which I properly scorn.

His agon is perhaps a transformation of day-to-day worries about his
body like those Ruskin expresses continually in the *Diaries*. Certainly his
strangest insights arise from tormented intimacy with it, reading in Soc-

rates the hypnotism of ugliness, degeneracy put forward as a cure, or suggesting one could measure loss of energy in the presence of ugliness, a negative rendition of the power of art. In most hands it would be philistinism, in Nietzsche's something worse, because engrossening and bringing low the argument he poeticizes it, achieves a harmony we mistake for justice, a clarity for truth.

Like Freud's explanations Nietzsche's physiologizing often seems a breakthrough to another range of comprehension, yet one begins to wonder if one's ignorance is not simply relocated against a different barrier. The psyche penetrable and penetrated, the body becomes opaque and a mystery. It is a question of where one wants one's mysteries—not a trivial one, for it is as much as to say one's numinosities, one's religion.

Convinced that decadence is debility and that disintegration hastens outside all effort to end it, one comes to a point where willed destruction is the only healthy action. Sickness and violence are passive and active forms of one process, and if an underlying pessimism persuades one disintegration is inevitable, one opts for the form over which one can exercise some control. Thus Nietzsche characterizes strong races as ones which in wantonness and overreaching destroy themselves, and weak as those which ignominiously survive, a partial inversion of the usual meaning of strong and weak indicating the ambivalence met before.

Late-nineteenth-century calls for an end or reversal of history and revolutionary ardor depend on such hopelessness more often than is realized. Philosophizing with a hammer, with the sharp tap of an aphorism, can be an energetic, even elegant procedure, but beautiful blows are still intended to injure, the best weapon exhilarating as it kills.

He wanted to see himself as a catastrophe, a chasm, a historical divide like Christ, not only violent in his difference from what went before but violent in his violence. Historicism, he felt, made hostility difficult, and his way around the tolerant understanding which places the historian at the service of his period was an antithetical reading of history, a militarized partisanship. In part this is outraged solicitude for the fullness of past life. Like the most awful of his inversions, replacing classical clarity with Dionysian orgy as the essential spirit of Greece, most of his revisions energize an old confrontation grown feeble through long intellectualization.

Yet brutalizing is a kind of ideality too, and the blond beast (how impossible it is to introduce his terms into ordinary discourse) is also a fantastic construction, an emptied container indebted to the hated Rous-

seau, with whom he would have found more coincidence than he thought. Nietzsche differed most from Freud in crediting the possibility of permanent relief from the pain of self-consciousness, for which he credulously expanded the intermittent glimpses he had had to make a complete imaginary self of them.

At his worst Nietzsche invents an impossible history propelled by the thrill of error, by jokes which insist on getting things wrong—Christianity responsible for the French Revolution, the Jews a castrated people lacking warrior and peasant castes, the atmosphere of the Gospels that of a Russian novel—history as slander whose crudity is disguised by wit and projected forward in such unscrupulous borrowing from religion as the inverted Messianism of his expectation of a new race of barbarians. One does Nietzsche no honor discounting his excesses, which are his main lesson, in the sense he intended and in the further sense we are obliged to give them. But it is fair before decrying him to recall his virtues as a practitioner of intuitive history.

Even more than Rousseau, Nietzsche the historian buries his research, or gravitates toward those processes too early or dark to leave record, which for that reason have previously seemed transparent or undiscussable, like the building of man's first rudimentary memory, or the feelings of sea creatures at their emergence on land. His explanations of both follow the same pattern: a psychological reconstruction applied to a group as if it were one, resulting in a simple outline of events. The day of emergence from the sea, heaviest sadness the world has ever known, is one of his most revealing depictions because, though not like any experience lizards could have had, it is convincing, for it is an experience Nietzsche has had, and its false ring of truth is the same phenomenon as other historians' successes, by analogy with a familiar event to bring a distant one near. His "psychological subtlety," carrying such lived conviction, is his acceptance of the antithetical nature of consciousness, the mind's history its rage against itself, consciousness always created *in opposition*, the main feature of his own thought serving as model for these critical moments in the dimmest past.

His much-vaunted seriousness is really to take his own metaphors seriously, to press them hard and hold them long. But if we seek what went wrong, as even without hindsight of how misreadable his admirers found him we would need to do, we come to his falling, like Ruskin, too much in love with the terms of his own thought, worshiping "war," like Ruskin, because it is a necessary category of thought, and forgetting that

most readers' attachment of the word to killing will be less intermittent than his own. At first it seems that Nietzsche's error was not taking ideas seriously enough, regarding them as irresponsible play; but, like Ruskin, he took them in some sense too seriously, cut them loose too happily from what grosser understandings were likely to make of them. His crime was: not to take them literally enough, to scorn the prose sense of his statements about Jews and think the damage could be undone by showing his contempt for anti-Semites. Perhaps even this lets him off too easily, for how could he not have felt that "Jew" meant living Jews, and that if one wanted to stay in the past one needed to say "ancient Hebrews"? The power of these statements is the kind in which he was most practiced, the power of metaphor to create larger wholes by unstated fusions. The statements are only exciting insofar as they achieve this a-chronic conflation of two things the same for the deep, unarguable reason that language makes them sound the same.

It must be admitted that much of Nietzsche was left out by Nazi admirers, and one supposes he would have found them insufferably coarse. Should one then hold the stupidities of a writer's readers against him, or should Böcklin be blamed because Hitler could only see Florence as an interpreter of *him*, and not he a bad one of *her?* Stupid interpretations correspond more or less well with their model; they can be shrewd in their blindness. Nietzsche's perverters were the readers he had requested, not other Zarathustras, but those who in his contempt he had seen as prisoners of goodness, who surprised pessimists most of all by how effortlessly they threw it off. There were tighter short circuits in history almost than Nietzsche could imagine, let alone foresee.

Nietzsche's crime is an art crime, a mechanism in the realm of thought with awful consequences outside it. He is the most extravagant case of the late nineteenth century's captivity in symbolism, its adoration of the mechanism of art, in which craven self-flattery is passed over because its object appears supra-individual. When he introduces Christ in *The Antichrist* as a symbolist par excellence who can speak only on condition nothing he says is taken literally, for whom all of reality, nature, language possesses only the value of a sign, he intends it as an antithesis to his own method. Yet as the reader of *Zarathustra* knows, the halves of an antithesis have a way of looking like each other, extreme symbolism and extreme literalism both varieties of insane frankness viewed from the center. Being literal, being gross, means in Nietzsche finding physical poetry in abstract process: criminals are the refuse of a society which

forgets how to excrete, this malfunctioning body not a parody of Christ as the world's but an intensification of its poignancy, a symbol which could die.

And being literal does not mean one's meanings are fixed: elsewhere criminals are the strong when buried among the weak, when circumstances are unfavorable and the powerless overpower. This contrast shows that meaning itself is symbolic, and the more extravagantly reseen an action is the more obvious this becomes. Being literal is Nietzsche at his oddest, childishly exact, whose metaphors come up and lick his hands. And being brave is forcing opposites from each other, making play yield cruelty as in the Kafkan circus scene of *Zarathustra* where death is an entertainment. He is so infatuated with the discovery he exceeds the proportion of paradox past which language shows its fatigue, hardly usable, so he goes on calling things by what have become the wrong names in order to coin dazzling absurdities from them. His readers grow punchy from paradox and see ones which aren't there, master the technique of turning things on their head until Nietzsche can no longer command his meanings.

He is the greatest warning of the dangers of figuration, the power of parable to exasperate the oddity of a thought past the point of usability, so that, as he wished, readers learn him by heart without knowing what they have learned, the camel, lion, and child perhaps rationalizable as the dialectic of submission and aggression to a new synthesis but not rationalized, an idiocy of figuration which makes one a child again.

In one part of himself this is what Nietzsche wanted to do, to give up the acquirements of adulthood and collapse or levitate in laughter. His unbelief is the old desire to believe which has suffered a check, and he does not believe but wishes to believe his formulations, for how beautiful life would be if something were simply true. In the absence of a meaning one can have a structure, perhaps make a meaning of a shell, by abject prostration before one's own symbolizing power, praying that it come down and carry one off.

TRIBE AND RACE

To view anthropology as a situation someone is in, living among the natives, leads one to wonder why home is ever traded for immersion in a life one only manages to endure. As an archeologist does not feel sympathy with the stones which bear the inscriptions, so someone like Malinowski is not especially fond of the natives, obstacles obscuring the truth he is after. Living among alien customs is more impinging than among untranslated carvings, however, and tribal unison aggravates the visitor's sense of being outside. Like other scientific anthropologists', his genius lay in recognizing how remote the savages' minds were from his, seeing that their knowledge is not continuously present like an inscription or even a memory. He found they did not have stable memories which could be drawn on when one pleased, but needed to be jarred into reminiscence and comparison by the force of occurrences he could only wait for, not prepare. So he stayed a long time because of the evanescence of his objects of study, which existed unwritten, unsaid, even unknown to their owners and inventors, and which therefore needed to be taken by surprise.

The ideology of his two extended stays among the Trobriand Islanders in 1915–18 is to live cut off from white men so that he is forced to enter native life to cure loneliness and pass the time. In practice it proves

unattainable in spite of his charming picture of waking in the morning with a day like the savage's stretching ahead, eager for gossip and counting forward to a festival. The *Diary* summons up from time to time a world of traders, missionaries, and passionate discussion of French literature surprisingly close to Conrad's fictions, but these lapses can be left aside, for European culture was more dependably present in less personal form.

Frequently Malinowski mentions a novel he is reading, only to castigate himself for what he experiences as an addiction. Many of the books are pulp now barely remembered, or idealized wilderness like Fenimore Cooper's and Conrad's—for Malinowski nearer at hand—or super-civilized like *Vanity Fair,* but they all function as the most vivid reminders he has of the world he has left, and more generalized than the mail he is sent.

Romantic fiction is Malinowski's magic, for in this setting even the cheapest European trash feels metaphysical for representing known realities become impossible. He despises the habit because it is the clearest sign of dissatisfaction with the life of scientific inquiry, and failure to abide by an idea of the self as rational, content with the way things are and not the victim of unfillable wants. They feed the side of himself he finds magnified in Chateaubriand, wishfulness which flies in the face of truth.

Reading Frazer's *Golden Bough* during a convalescence had first drawn him to anthropology, and later when he put his response to Frazer in polished form it described his hopes from his profession. He saw Frazer's work as imaginative or esthetic in a wide sense, marrying classical scholarship and folklore, infusing marble refinement with rude vigor, bringing statues of old learning to life. This formulation suggests one might look for the formative effect of primitive life on him as well as the explanatory effect of his ideas on it. Anthropology may thus provide a rationalized cover for interest in instinct, a way of coping with one's natural mysticism by meeting it halfway.

When we begin to look we find a strong mystical strain in Malinowski the scientist, expressed in the vision of two lives confronting him: either he can marry, beget children, write books, and die, or pursue cosmic ambitions: "To possess the sea and the stars and the universe—or at least to encompass them in one's thoughts." From this intimation of his travels as Wordsworthian quests it is a long way to kinship charts, but intense feeling for sea and sky is one of the motifs of the *Diary.*

Malinowski's official attitude toward religion is that unbelievers of his generation are once more in a calm and sympathetic relation to it, the storms of freeing oneself seen in dogmatists like Huxley now over. But this Olympian tolerance is not consistently maintained in encounters with missionaries, for example, one of the tests of an anthropologist, who perhaps feels unpleasant closeness to the other class with an interest in the savage mind, settled for an even longer stay. His unfavorable opinion stops short of Lévi-Strauss's brief for their Indian murderers but he cannot treat them as just another kind of European.

Alienated definitions of religion as "a high degree of cohesion in the assurance of metaphysical privilege" suggest that the battle to free himself is unfinished, while in other places he recognizes that calling beliefs illusions may be ineffective against them. He appears more than usually resourceful in dealing with superstition, however; thus when walking down a dark path and imagining malevolent eyes staring at him he decides to give them existence as goblins, but of insignificant rank and dismissable. His struggles with superstition form one of the sub-themes of the *Diary,* along with the bigger war against dirty thoughts, lack of enthusiasm for work, and worry over bodily symptoms. Though it links him with savages it feels less distressful than the others, to which he cannot make the partial unmeaningful surrender he does to the demons on the path.

Like other anthropologists, Malinowski operates at highest pitch in his theories of the function of magic and myth in native thought, which can be seen secondarily as efforts to control his own thoughts, and exercise the legal power over himself of which the *Diary* shows unremitting pursuit. In his time it was a subject particularly in flux, as the focus of a variety of religious discourse, an undeclared mutant of theology. Malinowski's version of the relation of magic to myth was as practice to history or theory, and his interpretation of myth consisted of casting out certain ranges of meaning in favor of others with the result, in his view, of refreshing dead notions, by stripping them of their main previous source of power. If we did not know him better, his denial that myth was intellectual explanation or artistic imagery might seem philistine. But perhaps only one who felt their influence would have the negative energy to deprive myth of those, in order to see it as a "a hard-worked practical force," to physicalize it to a kind of crude science, as had earlier been done with other categories of knowledge. Alternatively, his work might be seen as salvage, as Freud may have found a materialist's

way to keep the soul alive. It makes this branch of savage thought match ours better than convention holds, their relation to reality more businesslike. At their apparent strangest they are most near, so he understands them by inverting the easiest suppositions, their freedom and simplicity for example a set of duties which makes court life at Versailles seem unregulated.

His science acts like poetry which roughens the familiar and smooths the strange. Even the admonition that complete lists or tables of every permutation of custom should be kept instead of the dilettante's selection of "interesting" ones is not a fetish of thoroughness, but delicate epistomological scruple that truth is so fugitive it will not be recognized at first, and one must therefore delay formulation to let hidden lines of force come out. It is diametrically opposed to Lévi-Strauss's totalizing approach, storming the main lines in hope that the details will fall into submission, less scrupulous perhaps but apt for one who must exploit bursts of energy, for whom if things are not quickly aligned they will not be aligned at all, whose thought is a seizure which cannot be reasoned with afterward.

In *Argonauts of the Western Pacific* Malinowski announces an unscientific-sounding final goal: to realize the substance of the natives' happiness, perhaps not so discordant with his results in its existential bias as in its optimism. Like all serious anthropologists he makes us feel the meaning of his work will be found in its widest relations and perhaps in a far distant place. If he had said that the examination of the kula, sacrificial giving disguised as commerce, an investigation which filled exactly the time of the First World War at the remotest point on the earth from it, had as its goal the detailed grasp of human futility it would have sounded truer.

The lesson of this volatile, derangeable personality, who misses the culminating part of a four-day ceremony because he is out of sorts, is surely to show for how little man's constant efforts at self-control count. Unlike Lévi-Strauss, he insisted on strict boundaries between magic and science, and magic and religion, between primitive and non-primitive habits of mind, but in spite of his confessing at one moment that native existence meant no more to him than the life of a dog and elsewhere that colonial atrocities were fully comprehensible, in spite of such confessions which the Frenchman's self-esteem will never relax to, Malinowski embodies better than that other life the principle Lévi-Strauss says is the ground of true anthropology: to find the self in the other, and see one's

own frailty and betrayals more unconfusedly in the distorting mirror of totemism, taboo, and savage kingship. Without the ideological pretense that native life is better than European Malinowski is able to take from it a new sense of his weakness—his equal powerlessness before death, his greater mental inconsistency—failures inadequately glossed by sustained work in the periods of remission.

Before he shows himself setting foot on American soil Lévi-Strauss steps aside to speculate about which decade in the last four hundred years would have been the best time to visit the new continent, and concludes it is an unsolvable riddle. With every ten-year retreat one recovers whole sets of vanished rites, stories, usages, but at the same time loses the techniques for understanding them. This fanciful speculation, treated as if it will yield solid results, gives a number of characteristic signs: the exertion of great ingenuity to return to the starting place, the flouting of time and rejoicing in that enemy's traps, the strong mental emphasis—anthropology as a radicalizer of thought and a perspective experiment instead of social actuality—and finally the implication of the knower in the knowing.

Anthropology is a way for him of avoiding triviality. His globalism is a hatred of the normal limitations of thought, which hopes to pass in an initial leap beyond them and then for good measure tangles their feet in paradox. Thus his resentment of civilization is not quite believable, but a theoretical construct, the end of a search for the hugest reason one could have for studying primitive tribes, result of an effort to perfect one's thought. If it would be naïve to take his passions too literally—for who holding such views would be content with one trip to Brazil, never staying more than a few weeks with any tribe, followed by a long afterlife in the corrupting civilization he despises?—they are still a source of knowledge about him. Like his progenitors Rousseau and Chateaubriand he invests diversionary energy in appearing to be what he is not, in this case a moralist, such egocentric and cerebral emphasis as comes naturally to him offending a prized notion about himself and prodding him to impersonate, like other extreme cases, his opposite.

As a conspector of cultures Lévi-Strauss sentimentalizes huge questions, the wrong scale for the partisanship he brings, perhaps to offset his more significant role as the abstractifier and dehumanizer of the most intimate ones, like man's relation to his food, where he is shown a more manipulative animal than anyone has thought, a geometrician in his sim-

plest acts. Perhaps this momentous transformation forces on Lévi-Strauss a retreat to the old morality it puts at risk.

Thus thought is tough but cultures are weak, wild plants formerly allowed to flourish in the little plot of the world, now plowed over in a passion for mono-culture, one civilization eating the rest, and with them the anthropologist's material, not because it is the best but the most vain-glorious. This observation subsists on a presumed likeness to the extinction of natural species, but as the beauty of diverse vegetation cannot be seen from inside a plant, so the advantages of many cultures cannot be felt from inside one of them.

The self-transcender like Lévi-Strauss who manages to pop up for a minute outside his own space of origin puts in a plea for neolithic simplicity before returning to less impossible discourse, assuming for the moment that a culture's projection of itself is more conscious than in most connections he could believe, and that cultural differential—which like many others he calls imperialism—is the willed product of one of them which has designed itself toward their meeting. The argument for preserving cultures, which is necessarily just an argument since there can be no effective plan for achieving it, except various forms of staying at home and suppressing anthropological urges, is that they have things to teach each other; but though his general claims are large, when he produces an example of what we could learn, it is that Eskimo methods would keep us warm best if we lived where they do, a specialized technology which could take its small place in Western lore as it does its central one in Eskimo.

His model of cultural meeting in the real world is not fertilization but corruption; thus the presence of "cheap" metal spoons alongside polished stone mortars in certain Indian cultures is infection, his theory of culture an ethno-centrifugal inversion of racism, coming to the same destination from a contrary moral direction. The cheapness of these spoons is a culture- and even taste-bound view. Like the roughest vanguard of civilization in the Brazilian jungle, scruffy pioneer families, prospectors, speculators, the spoons benefit from a lot of Western experience with which their own connection is remote, and in some sense carry that culture better than a Sèvres dinner service or the paraphernalia of the best French cooking.

To the native they represent a degree of manual skill which must seem superhuman, and who is to say that the fact it is less immediately

manual than the native supposes, and debased from its costly model as he will never learn to perceive since it is a difference only significant in the nearest proximity, makes it less and not more miraculous? The spoon in the jungle like the refuse on the moon might have given a different observer from Lévi-Strauss a new appreciation of the humanness of manufacture.

At a more important level his partisanship disappears, and after all how can one take seriously a force or an author dependent for its survival on the support even of Lévi-Strauss? Thus his adulation of Rousseau does the supposed mentor no credit, who is praised for virtues he doesn't have—as Stalin was called Our Wise Teacher—an exercise in believing the impossible, or perhaps only in putting over the impossible, flexing one's originality. But the irritations masquerading as history—apparently pristine jungle as the crucible in which our civilization was forged—go by a similar propellant to the staggering transformations his theory of specific symbolism has worked. On the one scale and the other he rejects apparent meanings for a deep unobvious view, but the paradox which trivializes at the larger magnitudes regenerates at the smaller.

The three sources of his development he identifies are all deep explanation: geology, Freud, Marx—fancy names for rocks, the mind, society, all geologizing reality by uncovering sub-strata, and only non-metaphysical because they quarry down instead of building up. Still, another universe beneath the ordinary surface, with its own rules, even its own language, constitutes for all its concreteness, transcendental relief. When he talks about his own development he is driven to the same kind of poetic structure which he posits as the basis of primitive thought, tangible algebra starting from clear equations whose goal is to confuse qualities from different axes into an inexpressible fusion.

Because the algebraic comparison will not really accommodate Lévi-Strauss's deepest ideas of form—in fact he calls his use of mathematical notation pseudo-mathematical though he projects as a goal beyond his own work the complete logico-mathematical analysis of myth—he is led to concentrate on the space between categories, to find all meaning in mediation, and the deepest reality of objects in their shadows. Thus the beautiful name for honey and tobacco, "the penumbra of cooking," an outline it casts which illumines its dense center. The rigidity of his thought miraculously gives way for new formal categories like this one of the outskirts or the "just outside," formal ideas which are the stuff of art.

Algebraic presentation is neither an obstacle nor a disguise, then, but

a means of depersonalizing ideas in danger of seeming the furthest reaches of subjectivism. Thus also his concentration on the human beings most remote from himself, and myth, the product which combines anonymity and elaborate structure. Thus his struggle to have the thought without the thinker; his book will show, not how men think in myths, but how myths think themselves in man. Finally one will not be sure whether the book is thought by Lévi-Strauss about them, or by Indians about him.

At this point the comparison between myth, music, and the shape of his book is brought into play. Music carries special charges for him, which though not universal he can expect will be tolerated by most readers, glad of accesses of meaning even if they cannot take possession themselves. But besides these he establishes it as the art above others which is realized in the listener, "plays itself in them," confusing the sensations of maker, performer, and receiver. Likewise myth passes through individuals on a journey in which they play no real part, and tells the intelligible by means of the sensible, obliterating the distinction of object from subject. Yet there is a non-synchronization in the comparison. A single myth is not like a musical composition, but the body of myth forms one piece of music which remains to be played exactly right, a score difficult to assemble because pieces are missing and the order unspecified.

The structure of Lévi-Strauss's book tries to redeem these indecisions. In the "Overture" to the first volume of *Mythologiques* he projects a form which will eventually include an indeterminate number of volumes as yet unwritten, which will begin at the center, move toward the edge, spiral back, recrossing the "same" distances along different coordinates, and plotting patterns composed of different points. Like music and like Proust it will not declare its end until it nears it, and though endlessly long will deny its own duration, perhaps in a form like Proust's, who ends his book with the decision to write it, a moment of projection in which everything behind falls into place, plotting the future by concluding the past, an archetype of the triumph of art. Perhaps Lévi-Strauss has in mind a kind of objectified Proust, the most subjective order distanced by locating it in the mind of the primitive or rather the order of art detached even from the primitive maker and posited as the basis of reality.

But in a different way from Proust's his book is only an earnest of this intention, the chapter titles taken from specific musical forms an imper-

fect rendition of his hopes. Instead of a single consciousness he places at the center a single myth, no more inevitable than Marcel, the starting place given to Proust, though Lévi-Strauss could if he had wanted have invented a more plausible necessity for his.

The key myth can be told in two pages, in something approaching the clipped form myths always take. A thousand pages which follow have as their goal its explication or rather its completion, its conversion to intelligibility, which will be attempted at first not by what we recognize as interpretation but by associating with it other myths which momentarily resemble it or differ from it or have been found near it and therefore might be expected to light it.

The goal is to recognize the whole body of myth, whose unattainability is welcomed into the structure, which will not ever know if it is complete, first of all because the boundaries of myth do not exist. Unlike art, myth is satisfying in the corpus and not in the particular story, but the suspicion arises that Lévi-Strauss's tantalizing Proustian idea of the structure of myth is only demonstrated by his own treatment, his great discovery being a kind of associationism between stories superficially different, links which are the ordering of art but make themselves out as accident. Thus the doubt returns which was buried under the confusion about who thinks the book: at what level and in what way is Lévi-Strauss's complexity being attributed to savages?

Wagner, he says, was the first to undertake the structural analysis of myth, and he did it in music, which, the arrangement of Lévi-Strauss's great work now seems to claim, is the only place it could be adequately done. In this comparison are high dreams, and ominous prospects for intelligibility, for what began in Wagner as fluid breakdown ended as mystification, as he moved from innovation to ritual rigidity without needing to revise his principles.

Superficially incoherent myths, even schizophrenically disconnected ones seem to suit Lévi-Strauss's purpose best by making his deep logic more welcome and supporting his contention that meaningful links always subsist at a level beneath content. He seems more interested in problems of transmission than in messages transmitted, which are sometimes relegated to the position of filling the space which necessarily exists between the surface and the deep pattern. By ignoring problems of motivation or converting anomalies in personal relations to explications of social role, explaining the interesting snags of feeling as not having to do with feeling at all, he achieves the transformation of his motifs into

goods to think with, as food becomes primarily thought and not eating, so feeling becomes mainly pattern and not energy. His pseudo-mathematical equations are important in enforcing this growing sense of system, and the model for thought, his basic unit, is a path of connected lines, a bit of wiring.

To make sure the links dominate the names or categories, he finds implausible names. One of the most important categorizations of male characters, wife-giver—applied to brothers whose sisters have never been seen unmarried in the course of the myth, and to incestuous sons, the brothers-in-law of their fathers to whom they refuse to give up the woman, their mother—perhaps has such an essential place because unlike the more enduring mother-son relation, theirs is transformative, expressive of commerce and a model of communication, the trade in meaning. And as always in Lévi-Strauss it is not sexual barter as the ancestor of speech, but sex as a sublimation of language.

Two kinds of wild pig difficult to distinguish in the jungle take up symmetrically opposed positions in the mind, one representing untamable bad temper reverting to nature, and the other docility which is a kind of instruction in cooking and hence culture. As the vacancies in this grid of relations begin to fill up, as the set of nature-culture begins to look complete, our attention is drawn further from particular stories by still-distant detonations like "However, the dividing line between culture and nature is not identical, as used to be thought, with any of the lines of demarcation between human and animal nature," the conclusion of a discussion of birdsong, and a glimpse of what it might mean to know the whole code we are still apprentices of.

Like motifs in Wagner and folktale his categories are the kind of meaning which can only assume its full value with deep familiarity, so that relatively long intervals are needed between its recurrences, and wife-giver (brother-in-law) will only seem a true category and not an artificial distinction when met as if by chance in many situations. Thus the jaguar in the key myth is not announced as a replacement brother-in-law when he first appears, but much later, after a series of human brothers-in-law have turned into pigs and birds to show him the way. There can be no doubt that the resurrection and straitening of the original myth into this carefully ordained shape is an achievement of Lévi-Strauss's art, that the "body" is his work, which like all makers he tries to locate outside his mind and credit with the largest possible existence, while retaining a generalized link with mental process, and thus creating

the paradox of the unbegotten thought, adrift in the world since the first days of man.

One of the key steps in the dissociation is to suggest that in myth chronological sequence is irrelevant, not by disrupting all causal connection—though he likes to pretend he can show examples of every action in reverse direction—but by laying special emphasis on such scramblings of order as frequently occur—like the wedding and then the gift, or the punishment and then the theft, always introduced after a repeated dose of the usual sequence and therefore stunning the reader as with an artistic innovation. To read these as the same actions in a different sequence allows one to assimilate foreign-seeming cases to one's growing set and energizes the class by dissonance.

Such disordering also bears an important function in making the morality of the story less comfortable. Trying to feel grateful and later being shown the reason weakens the logic of feeling. When enough myths have been assembled and their alignments and divergences plotted, he has succeeded in alienating morality further from feeling than we ever felt it in fairy tale, until it becomes a mathematical function like + and − , and at last we concede that myth, the form which above all others feels as if it is digging up what is already there rather than transferring new matter, this old knowing is only an algebra.

All previous primitivisms regress to a past which is in some sense the observer's own. Then, looking at primitive tribes, early anthropologists see space as time and realize there are things in the present more archaic than anything recorded or accidentally preserved in the European past, and thus achieve a complication in the sense of history which violates sequence utterly. The next step (an ideological not temporal sequence) in discrediting linear history is taken by artists who don't want to understand far cultures but simply to start over, who sense that primitive artifacts have their greatest effect when, instead of trying to place them, one rejoices in their placelessness.

In 1904 African sculpture was discovered, first in a bistro and then in ethnographic museums, and the taste for collecting it spread in the next few years among a group of artists in Paris. African and Oceanic objects had been on public display throughout the preceding half-century, but the art had always been treated as technology exhibiting the mechanical skill of savages. Because this secondary discovery, paralleling the explorers', was made by artists not scientists, primitive works were first appreciated as art in complete detachment from social and historical context.

Thus Picasso amused the dealer from whom he bought the pieces in his collection with his disregard of provenance.

Its lack of attendant ties was prized by these escapees from history for allowing them to see African art as more secular—that is, more formal—than their own, floating freer of the constraints of the nineteenth century. When Roger Fry calls African sculpture the greatest of all for its pursuit of pure sculptural values he is praising his own detached view of it. The most important idea for subsequent painting, the freeing of formal values from associations, was given a crucial push by appreciation of an art whose local meaning they felt safely ignorant of. They could now tack primitive art on the end of nineteenth-century realism as the necessary stage beyond it, in part because logical continuations could not be imagined.

Later Picasso claimed that the reasonableness of primitive art had attracted him, not a claim one can imagine Matisse making, in whose work of the same years it makes a less brazen and detectable entry. To the degree that he is not being paradoxical, Picasso signals that, lacking certain kinds of understanding, he cerebralized what he saw and imagined the awkward disjunctions in African objects into a process of thought. Thus we can explain his preference for poor examples without the signs of mastery because the analysis of form he projects into primitive sculpture would in that case have proceeded further in decomposing the simpler image hypothesized behind it.

As myth was later to do for Lévi-Strauss, the African figures aided Picasso in a process of abstraction. Though painting can never be essentially abstract, he exhibits in these years strong impulses in that direction, which draw inspiration, like Lévi-Strauss's more comprehensive depersonalizations, from the products of non-European primitives, seen as extreme logical purifications, remote even in their violence from the turmoil of animal impulse, reasonable at their most destructive.

Picasso's first negroizing works are portrait studies of 1906, including an easily recognizable self-portrait, showing that the non-individual nature of African thought has not influenced his choice of subject though it may secondarily undermine the personality of the sitter. Negroizing consists of breaking forms into large or concave planes, a cold arbitrariness which hacks and gouges the space.

Les Demoiselles d'Avignon, largest of the negro pictures, tolerates astonishing inconsistencies, for only some of its figures are African, and only in part. African is the most corrosive of the residues which contest

the space, but it is false to the picture's spirit to lay out the provinces of its archaisms exactly, Egyptian, Etruscan, Cézannesque, if indeed one can be sure of one's identifications. While reminding one of lots of old orders, it denies the order of art, so that the problems for conscious making it raises still haven't been and cannot be conclusively solved.

By late 1908 obvious African references have disappeared from Picasso's paintings, but the new concentration on volume remains, along with angularized decomposition. He has decisively shaken off resemblance to the textures of objects, even when the original disruptive impulses retreat to work themselves out in tranquillity. In the portraits of 1910–11 fragmentation into smaller refracting crystals feels approachably hesitant, nearer the human processes we are used to in art, but these pictures are the hardest to remember of any he ever produced, an indication of how complete the destruction has been. Music without melody, narrative without character, painting without images seem part of a world which has finished with man, conclusions impossible to live with. In intellectual boldness his subsequent painting is sensibly a reversion, but the short infatuation with African forms which pushed him to find radical equivalents for natural objects had already produced the main watershed in art since Giotto.

Dada's assault on Europe was more ideological than Picasso's and its use of primitive art consequently more psychological than formal, juxtaposing an African head and a speechless flywheel or drawing of a dredging pump to suggest that the European approximation of primitive feeling is the soulless magic of technology. Haussmann's huge mechanical heads, Duchamp's urinal-icons, Schamberg's sink-trap god are all expressions of this equivalence, art as a robot, an exchange between the qualities of god and machine in which the superhuman is defined by unresponsiveness. They start with jokes about the magic power of art but under the irony is a stifled boast.

Later surrealists like Dali welcome the black meanings of the primitive, and find objects nearer at hand which correspond to totems, devils, and charms. They conflate the schizophrenic and the tribal, two untrodden areas of the psyche, advertise for bad dreams, relish the suggestion in manipulative primitive works of life lived deep in a pit.

An extreme manifestation of such voodoo is Dali's *Buste de femme rétrospectif,* a garish mannequin severed at the diaphragm, draped with corncobs, crawled over by painted ants, crowned with a loaf of bread in which a gilded pen-set representing Millet's *Angelus* is stuck. The ants

and maggots molesting the bright pink flesh are an effort to make the cult-object reflexive, to suggest tactile pleasure in the intimate attentions one would be paid as this kind of goddess, a split between jeering at and succumbing to unspeakable fears so wide it verges on schizophrenia.

D. H. Lawrence's contribution is to make such imaginings more real by suggesting that we act out savage art. The novel is a strange medium for the exposition of a cult, but when Lawrence writes his novel about Mexico he ends up reinstituting not simply retelling the Aztec superstition. In part it is a genuine prompting, not to study the old life but become it, yet in spite of his fetish that he must write it in Mexico—he leaves the unfinished manuscript behind when he returns briefly to England—this piece of authentic field anthropology turns more and more to a liturgical handbook. Here the prophet of wordlessness and sightlessness works out rites and usages more natural than ordinary life, which will institute the rhythm of the blood. *The Plumed Serpent* pushes its utter contradiction, the feeling that one needs to ordain one's heartbeat, further than other Lawrence, but to expose the split at its most maiming helps explain how he is always so good and so bad.

It begins with one of the most irritable sequences in this irritable author, a dose of negativity called forth by the anti-rite of the bullfight, squalid costumed killing, *someone else's* passion and immersion. Skeptical here to the point of nihilism Lawrence later shows himself credulous to the point of superstition, and the two moods are obverse and reverse not separate personalities. Mocking and sanctimonious follow so close on each other's heels that the practiced reader anticipates the one in the other, as the listener to Hitler's speeches must have become dependent on having ridicule followed by calls for sacrifice.

At the beginning ritual gestures break through the wrappings of city life to be masked again by mechanism. Thus Cipriano ceremoniously passes Kate his cape and before she can savor this relation the taxi has whisked her off. It is the way myth exists in modern consciousness, aborted after a sudden entry, leaving one hungry for more. In spite of the cross-grained vividness in it, he makes one feel such disunity cannot be all, the world's variety as perceived practically insupportable. Strong intellectual defenses come in the wake of undefended vision and make likes and dislikes into a system. So his revulsion from the smell of Mexican pulque prompts a chart of the world's peoples and their drinks as revealing their natures. Momentary sensations become metaphysical boundaries, so missing Frieda turns into "the spirit of the lake is fled,"

and a fight with a hotel porter to "you can feel the evil of this town in your feet."

One feels crass asking Lawrence to give back the prose sense of things all the time, but if all extravagances are equal as mental transformations some are less permissible in their social effect. He tries to put observations in forms which cannot be checked: the mountains in Mexico purr a purr too deep for the ear, audible on the blood, a memorable fancy which if accepted is like a great grant of power to say things, a grant which drives him to claim instant comprehension when just as baffled by oddity as anyone, and thus to moments of utter wrongness, like this on Kate's Indian servants:

> At times they were merry, seated round on the ground in groups, like Arabian nights, and laughing away. Then suddenly resisting even merriment in themselves, relapsing into the numb gloom. When they were busily working, suddenly, for no reason, throwing away the tool, as if resenting having given themselves. Careless in their morals, always changing their loves, the men at least resisted all the time any real giving of themselves.

Then the reader regrets having thought what Lawrence imagines—the world-union of consciousness in the prehistoric past, for example—more beautiful than any fact ever verified, and perhaps notices that prehistory is the period Lawrence knows best. At last one wants soberly to ask what he knows about Mexico, and whether the idea that America is the continent of negation might after all be a mistake.

His fetish of arriving at opinions all at once without visible reflection precludes recognizing or correcting mistakes of course. All one can do is persist in them until one has hounded them home. The continent of negation is a logical and linguistic possibility without practical use, and perhaps one should be more swayed by the fact that he did not often act on his superstitions, that his literal life was not a path of avoidances and inconvenient homage to the notions he preached. *The Plumed Serpent* shows that one can only tolerably let someone think he knows best when he interprets this brief narrowly, holds himself to claiming less than he is entitled to, and, if he sees the same moral demonstrated everywhere as Lawrence likes to do, shows it as his own desire for completeness or enlargement and not a fact of geography.

But in *The Woman Who Rode Away* the continent of negation is re-

ally there, and looks a lot like Mexico, not passed off as *the* Mexico, but an afterworld of one writer's imagining. There as in Kafka scrupulosity over details makes its contribution to an abstract pattern, confessedly private, like a sober passageway to a great strangeness.

Even more than Kafka's, Lawrence's sense of things by this stage is answered better by brief forms than the novel, his need of stark pattern, the binary grid of allegory, and the flippancy which contains more and more of his sense of growth. It is too late to ask that *The Plumed Serpent* be a lyric; in part it is an ominous demonstration that Lawrence's best subjects are ones he knows something about, Italy or American literature, where he brings history to bear on roadside vegetation, his learning so well absorbed he forgets its presence and fails to miss it when he gets to Mexico. Of course it would never do for him to admit he loves the earth for the classics under it. Of course he reads many books about Mexico he cannot let on he knows, but in the end he fakes its classic culture.

At one level the elaboration of ritual in *The Plumed Serpent* is harmless play, redesigning the furniture of existence with an Arts and Crafts belief in its influence on one's life thereafter, like Lawrence and Bynner drawing serape patterns they then get woven. It takes the trivial form of the exotic names of Mexican gods as more "alive" than Christ's, and naming hours after animals instead of numbers as making time fluid. The rationale is that we accept ours readymade, these organic and mobile, but this is less authentic than Ossian because if they are real for the Mexican they are readymade, and even for English outsiders, their novelty will not last. But when you need one badly enough, any answer will do, and Lawrence's worst solutions give sign of where the trouble was greatest.

Designing flags, natural in children, is a danger signal in grown men or movements, because it turns symbolism into rivalry, so that in the end it is addressed to one's enemies, thus the threats in Nazi formulas for peaceful school flag-raisings, and the beginnings of heraldry in war and needing to declare whose side one is on. The banners of the new cult described with such unnatural precision are among the first uses in the book of symbolism as terror, yet one cannot easily account for the ability of a sky-blue flag with a yellow sun crossed by four black rays to intimidate, as the swastika does not seem intrinsically wicked geometry. Colors are given strict interpretations in traffic lights, after all, which are not totalitarian abuses of the senses, because they are instrumental, not

subjects for meditation. How far the color-slogans of *The Plumed Serpent* are from Lawrence's haphazard use of colors in earlier books, which perhaps were moving because torn loose from a scale and seeking to return to their hierarchic home.

The change is simple. In *Twilight in Italy* a man goes out a *door* in seeking a meaning, and though he may manage to climb up a hierarchy he keeps a foot in the street, the seeking as real as the finding, abstract relations between high, low, and neutral lodged with experiences in different registers, a space which will not form itself into a grid. Like the woman who rides away he is alone, so the unisons have less to command and are less staunchly believed. In *The Plumed Serpent* finding is over, the only sense of process imparted by waiting for the solution to be disclosed.

The dance has long been an uncomfortable obsession for Lawrence, as an explosion of touching in ordinary life. The cult shows itself publicly first in throbbing drums and stamping men who form a hypnotically rotating nucleus, geometry as a soulless creature, the all-male death of many into one. One can imagine a whole society as a mighty orgasm only by a totalitarian triumph of art over life in the name of pure act.

But there is a weakness in this self-contained figure seen by Kate lurking with another woman at the edge. If one's life is a ceremony one must perform it for someone, and if a secret ceremony, for a voyeur. The model for Lawrence's ritual is exhibitionism, to have a woman spy on your nakedness, maximum exposure and minimum contact. He ritualizes nakedness in recognition of its terrors, and however seldom he brings it up feels embarrassingly often because he cares more about it than he finds thinkable to say.

Exposition of a leader lets one intellectualize this display. Lawrence uses the crutch of the church for two of the main culminations of the book, but tries to change it as much as possible, casting out the old images before installing his own. Such anti-rites play surprisingly long-lived roles in the institution of cults, and his weak grasp on the psychology of belief is shown in how easily he imagines Christianity overthrown. Both Nazi and Soviet ceremony continue long after consolidation of power to repeat the combustion of old beliefs as if it were the safest fuel.

He requires a temple for his affirmations, darkness, and a big statue of the leader, like many nineteenth-century national colossi, Arminius standing for the German people, his hugeness representing them and

obedience too, for no one can struggle against such might, submission at home, aggression abroad. But worst of all Lawrence's infusions of physicality into his religion is having the god actually present, to look from the terrible image to the man and give up one's qualities to him—to inspect him, think and feed on him, and cede one's own as exchange for the privilege.

The fulfillment of the ceremony is primitive medicine like a diagram of the leader's body, liquids held to his head, breast, waist, and loins, which are bound with white, red, yellow, and black to signify the usableness of the four quadrants of his soul and its four mystic secretions, mixed and tossed on the flames, a physical sacrifice which leaves him capable afterward of reciting a lengthy poem.

These festivities are seasoned with a death, which comes too late to make a meal of. At this high moment Don Ramón's wife slithers to the feet of the new snake-god, representing the do-good opposition, struck down by a fit as it is trying to get out its accusation, and lingering on to have its well-deserved death agony orchestrated by the drums of Quetzalcoatl's homecoming dance.

This is the first, and the second of a crescendo of theatrical deaths that closes the book is a private parallel to the binding and cupping of Quetzalcoatl-Ramón, which he carries out on Huitzilopochtli-Cipriano. Starting at the head and moving with tortuous slowness down the body he blindfolds the main regions or spheres with strips of fur. Sight is first of the divisive awarenesses to go, followed by the heartbeat, the head, articulate speech, and finally consciousness when the top of the ladder is arrived at with the binding of the ankles and pressing of the feet into the responsive stomach of the questioner.

It is another portrayal of the Death of the Will, and with it individuality, a subject which preoccupied Lawrence, realized better in the sober sacrament constituted by the whole of *The Woman Who Rode Away,* equally a barren union, to a cosmos in which no sensual satisfaction can be taken. Giving the formalized sexual union a religious interpretation is like saying, as Lawrence does, that the stiff-arm salute works spiritual transfiguration of its performer, which is not what it is really there for, as everyone knows. The aggressive salute is a submissive renewal of the contract of obedience, transfiguring a man to not-a-man.

All the symbolism in *The Plumed Serpent* leads to an anti-symbolism of death and night, positives prepare the way for negatives, and true community is fulfilled in horrors because it accepts everything without

doubting itself. Cipriano is dead and a god, and proves it to Kate by the cool extermination of prisoners, distinguished into species by colorful insignia for different degrees of guilt and compared unfavorably to various animals in the poetry with which he greets them.

Killing has already been tested by Ramón as a source of virginal innocence, and Lawrence's most powerful statements in the past have often been negations, like the other evocation of a religion of blood and death in "Crucifix Across the Mountains," an impulse so pervasive it seems willful to attribute it to the world in which he found himself. One dwells on one's hatreds by choice; if one needs exorcisms it is because one is inhabited by demons. But this time he has chosen the form Satan took in Eden for his god, and has welcomed the last wickedness of this regression as the goal to which everything points. The bleeding wooden flowers in "Crucifix" seem quintessentially natural beside prisoners with necks snapped and chests cut by Huitzilopochtli's thugs in fancy dress.

Setting murder to poetry has not dignified murder but brought imagination into disrepute. One is pleased to hate poetry if poetry means disguising to oneself the meaning of one's acts considered from outside one's mind, if it means entire ease in loving the ideas which are one's own. But we need to remember at this point that Lawrence did not execute anyone and that Hitler wrote no coherent books. If the writer's most shameful venture alarms one with how near the creative and the anti-social can come, it has not dissolved the boundary.

Dictatorship appears first in twentieth-century Europe sponsored by a poet, in d'Annunzio's brief government of Fiume from 1919 to 1920. Politics becomes ritual again, confused with religion, and society appears to take on the coherence of a work of art, at least while the crowd is assembled listening to the leader who is its ruling principle, its wholeness. This is no sterile estheticism but the poetry of act, the people not simply spectators but the artist's material, to be formed into his monument like the readers of pornography.

The culmination in one sense of ideas of organic leadership, power whose sources and extent are romantically cloaked in illegality, is a failed artist who had made an unalterable decision at eleven to be a painter, was redirected to architecture by the city which ever after made him gloomy, until finally he arrived at the art superior in immediacy to the others, the magic medium of oratory he framed in Speer's flimsy architecture of light, anti-aircraft beams forming endless columns while they waited for the new Berlin to be built.

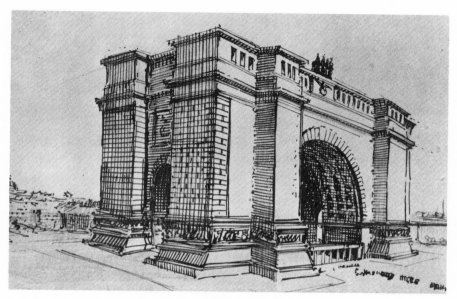

Adolf Hitler, *Triumphal Arch*. Speer-Archiv, Heidelberg

Hitler's relation to culture is troubled, a blind spot which arouses strong feeling. His own results do not stand up as art, corrupted by use, like the impressive decoration of every place he would appear, to set him off as "the Will expected by the Time to carry out the Task History has imposed," a super-effective pawn, the instrument of a higher power for which his best name is a hollow tomb-echo, Fate. Though the intention is corrupt, one cannot feel only contempt for the use of purplish old Nürnberg, the town of Dürer, to draw marchers up its narrow streets into ignorance again. His symbols are crude but they work even on those who see through them, because they have found the physical power to be as blatant as they please and are not waiting to see if the best judges want them.

As a student in Vienna he had been a great watcher of parades like those he later assembled, and susceptible to the symbolism they embody. His greatest project included a parade route, the triumphal avenue of the new Berlin which matched first one landmark and then another in its outstanding dimension, the Eiffel Tower in height, St. Peter's in dome, Nero's golden house in length, Versailles in continuity without variety. Much of his satisfaction in architecture seems to have come from inspecting models of his plans with Speer, one of which was over a hun-

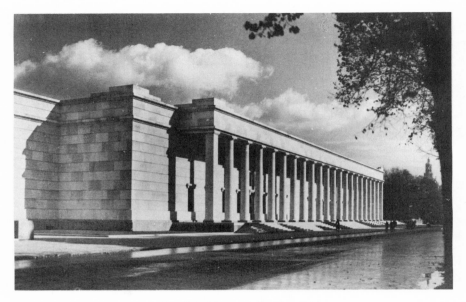

Haus der Deutschen Kunst, Munich. Photographed in 1934

dred feet long, as perhaps his passion for uniting Germany and Austria had something to do with another reduced version, how it would look on the map. Speer portrays him absorbed in bending down to simulate a humble visitor's entry into the new Berlin, reliving his old awe at Vienna.

His favorite buildings were mountains like the Palace of Justice in Brussels or overconfidence like the Paris Opéra, which could be read as insignias, Hitler the Romantic overimpressed by the apparent correspondence of the shell with what filled it, so that the modest Austrian Parliament building prepared him for cowardice within. The buildings he favored as a patron are inert not dynamic, however, risking bathos of scale and not of ornament, expressing Romantic nationalism in severest neo-classic dress. They engorge the ends of streets with oversized porticos, or multiply simple units to form an endless row like a modern crowd, which would stretch ideally, as the Haus der Deutschen Kunst in Munich only begins to do, as far as one could see. But by realizing his ideas of scale and dumbness better than Hitler's own projects the governmental part of Washington warns one against too eager a detection of the spirit in the face.

Hitler's degradation of Romantic love of heights, so that he planned a tower for Linz with his tomb in the basement which could be surveyed

from his retirement atop a neighboring hill, is the secondhand vehicle of a man who studies the newspapers instead of Nietzsche and Ruskin. If it is not trivial-minded to place him for a moment in the history of ideas, his interest as a culmination unworthy of his sources is extreme, turning enthusiasm for chasms to sponsorship of mountain pictures which are arguments for war. These show flags planted on peaks, swastikas infiltrating the most inaccessible high passes of the German border and thus by implication saturating the whole country. The intrusion of this emblem into painting is a recurrent feature of the period, painting in uniform, paying its contribution to the large effort by making an insignia the point of an image. Art suffers similarly when reduced to recording a marvel of central planning—the construction of a bridge on the Autobahn or a ministry in Berlin. The projector of the Autobahns saw them as allegories of straight-aiming German will, but these paintings, topical like newspapers, interrupt bridges in the act of crossing chasms and make their heroism drudgery.

Hitler's speeches are wild and the paintings and buildings he permitted tame, for official art is more likely to dampen than rouse. After their talk of spiritual awakening the Nazis in power clamped down on apocalyptic suggestion in the day-to-day work of artists, saving it for their own dark festivals, except one sinister genre, images of youth in veiled death paintings—marching soldiers looking dreamily to heaven, naked boys lifting heavy flags, toys and Christmas trees as forebodings of weapons and an outdoor end. The apparently healthy enthusiasm for children in totalitarian society is based on the calculation there is more to be got out of them; like signs of humanity shown to farmyard animals, it wants its victims fat.

Hitler's revenge on art is remembered better in its negative components, because he was more effective in discouraging than fostering, as anti-Semitism went ahead faster than German pride. So art in Germany became "the art-struggle of our day," polarized like race and to a degree *by* race, war the model for other activities. So anti-exhibitions are the best-remembered cultural events of the era, degenerate art unceremoniously displayed outdoors, books treated like criminals who feel pain as they go up in flames.

Without needing or being able to give examples, Hitler, Rosenberg, and Goebbels had long condemned art they did not like as the stammer of untalented children, no better than the productions of an African tribe, art-Bolshevism which contradicted the rhythm of German blood.

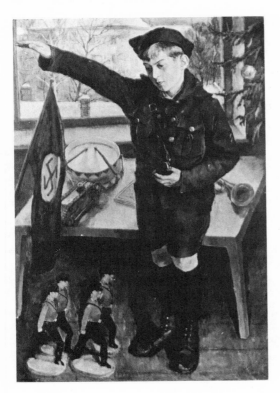

Emil Dielmann, *A Hitler Youth.*
Zentralinstitut für
Kunstgeschichte, Munich

Because his own ambitions had centered on visual forms Hitler's incomprehension and outrage settled there, where something more like a revolution with contending groups and manifestos had taken place. If there was contention he would end it, stop offensive production, round up existing works, sell some abroad, burn the rest, and leave a more homogeneous art to match a more homogeneous race. In the two European countries where it has been revered most doggedly art has proved most vulnerable to political interference, though the spread of ideology and the consequent politicization of art have not been limited to Germany and Russia, who have nonetheless instructed the world in the means of control.

The new attitude to art was glossed as a desecularization: it became the sacred concern of the German people, whose leader demanded in their name that it express what millions felt. Here a contradiction ap-

pears between Romantic ideas of self and society professed by the Nazis. To call a society organic seems just another word for totalitarian, individuals as cells of the body who must all be incorporated and act in sympathy with a single goal. Yet the Nazi world-view is said (by Rosenberg) to give form to the inner strivings of its members, which provides a base for the citizen's obligation to produce enthusiasm on demand.

In fact the idea of the inspired individual, the leader as an artist suffering a tumultuous inner life, is complementary to the idea of the racially consistent society like a single undivided soul. These unreasonable dreams of social coherence, turning qualities one might almost expect to find in a single village out onto the whole world, a grandiose localism, were the product of men torn by tensions, like Hitler, who presented himself in *Mein Kampf* as the Byronic wanderer most fitted to lead an organization by the heat and depth of his unsatisfied passion to see peoples united.

Goebbels in his novel *Michael: A German Fate* dressed the hero's prejudices as intuitions, appearing less definite and more numinous than they were in fact, but Hitler presents his as carefully researched, laid on granite foundations. Never has a political leader "studied" so many things, or "learned" so thoroughly and well, so that time has only deepened his convictions, sunk them further out of reason's reach, without altering them at all.

But this unchanging firmness adheres to feelings which are elsewhere depicted as Tristan longings, secure mainly because primordial, belonging to him from before he can remember, from his acquirement of language and the almost contemporary awareness it was German and not something else. The self which feels itself to be more than one sinks gratefully to rest in a society which is pure accord, and the vividest apprehension of this is a collective subjectivism whose lack of content becomes its profundity, as in the conclusion of a speech at the 1936 Party Day in Nürnberg:

Once you heard the voice of a man, and it struck deep and awakened you and you followed this voice. Year after year you went after it, though him who'd spoken you never even saw. When we meet each other here the wonder of our coming together thus fills us all. Not every one of you sees me; I don't see every one of you. But I feel you

and you feel me, we are together, we are with him and he is with us, and we are now Germany. (*Speeches*, I, 207)

In anti-visual emphasis and attempting a cosmic identity for the individual this bit of metaphysics is a scene from Lawrence. It raises the question of how completely carried away the movement was, answered when one matches moments of demonic possession like this with the cynicism which balances them. Hitler's dictum that one must never show the masses more than one enemy at once, reveals him as a manager of his own hatreds, for he had more than one, and almost succeeded at keeping some offstage while he dispatched the others. Besides, there was a corollary which unclogged the impasse, that genius was often revealed in making far-distant enemies seem the same.

Hitler, Rosenberg, and the others perverted Romantic principles if it suited another purpose to do so, or because inconsistency was a higher positive than any they could violate. When one has followed Rosenberg into his version of history and art as race, sifting it all from an interested perspective, consistency and inconsistency have merged. By the interpretation he gives to a localist saying of Herder's—that every race has its principle *within,* as every body its center of gravity—he puts himself in the position of being able to ordain a truth wherever he wants one.

In this world everything works together for good, the small Nordic band everywhere like the sea, and all achievement ours. Egyptian boats are Viking and their noblest kings blue-eyed, Christ Nordic, and Dante German, for the nearer home we get the more like us the ones we like become. To make hay of the profile of Augustus or Bismarck, race guaranteed as easily by nobility as vice versa, and to turn cosmic light and dark into commentary on skin color, is to adopt Nietzsche's particularity without understanding his purpose, flat instead of sharp, a self-gratification so witless it is not thinking at all, though useful as a caution against the tendency of all thought to become rationalization and excuse-making.

Hitler thought he could plan a World War and a World's Fair for Berlin in 1950 simultaneously, building and destruction. If signs are sought that war did not just mean victory to him, Speer's preparing for a world in ruins by building death into his buildings is one, a method of construction to leave them tidy after bombing, without loose ends of girders. Hitler's hatreds begin as part of a structure, an order not a

chaos, even an order-fanaticism like the need for art, expressing the rigidity of mind which is his leading trait.

The Jews are the other side of the Germans, foreignness in one's midst which cannot be separated without violence, seducer-betrayers of the innocent self, their homelessness matching one's own rootedness, a symmetrical part of a symbolism. His account of the dawn of anti-Semitism in himself and its progress from reasoned opposition to hatred is one of his most convoluted and artful creations, summed up at the end as the great spiritual crisis of his life. Perhaps it gives a structure to something which did not have one, but what a peculiar and unnecessary structure it is, the process initiated by his inspection of theater posters and deduction of the baleful Jewish effect on art, which modulates to their control of prostitution, and only emerges after this in public affairs. Perhaps it is true that Hitler's trouble began in art, that his fear of Jews is the uncreative in himself turning against creativity, for even though he had some basis he exaggerates their importance in art, and by the time he comes to the other exploitation of the senses, commercial sex, he has left reality behind. Rosenberg castigates Jews as uncreative, blaming them for all the discoveries they haven't made, performers not composers of music, a participation in the national property which before long was forbidden. Doubtless these men feel unsafe in their ownership; vituperation is more often than not a self-portrait. Few minds have been as full of plague and poison, mad dogs, paralysis, and howling as Hitler's, and it is not surprising he sought an external source which was putting them there.

His vision was always hard pressed to conceal its negativity; large assertions carry denials in their train: Germany will be a great power or she will cease to exist—he knows that everyone will be more shaken by the prospect of an empty earth than he. In the end Hitler's positives turn to negatives, his contempt for the Germans surfaces in a belief that rude Slavs of the steppes are stronger, and he accepts easily the idea of pulling them all down the black hole in his heart: after this there can be no more Germany. The great ideal of sacrifice, millions ready to die, for the Nazis the final justification of a strong society, should be called cruelty instead. Here all meanings are reversed—reward is pain, and opposites meet when Götterdämmerung is hailed as the new dawn.

MILLENNIUM

In Russian painting as in Russian society regressive beginnings had the most radical end, and traditional folk material became in Kandinsky an agency of destructive revolution. As he made his discoveries in Munich Russians in Paris were turning the sensation of being behind to advantage by adapting peasant motifs to rarified theater design. Bakst absorbs Matisse and cubism only to make folk material more elegant, less alien, and fit for civilized adults.

Russian illustrators of children's books had already achieved the same effect, screwing up both naïveté and refinement to a high pitch, surrounding precious scenes like gloomy enamels with borders taken from textiles or carvings and showing their origins by the calculated roughness with which they guard the treasure. The relation to folk is partly delusive, for the artist never relinquishes facility or minuteness, and Ivan Bilibin's borders are only relatively more authentic than his scenes from Russian fairy tales, the frogs which fill them bigger than the princesses below, but just as elegant, and only childish in the juxtaposing.

Oversized elements seem particularly child's errors, which is the effect sought by Bakst when he covers garments with flowers too big for them or Matisse in the amplitude of his last works. Patterns or creatures huge though inert in a Bilibin border are shown *taking place* in a scene,

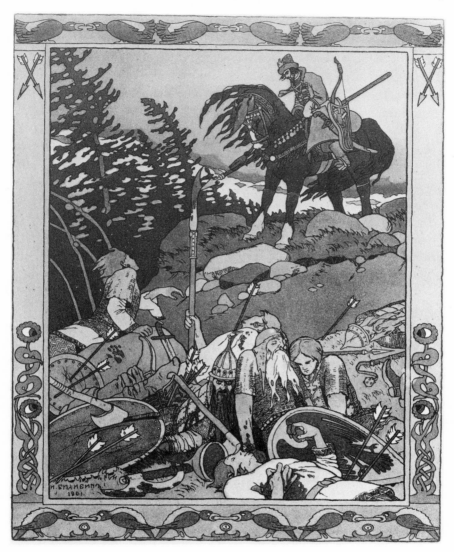

Ivan Bilibin, *Rider and Dead Heroes.* Illustration to *Marya Morevna*

the same design bent to cuff or hem, at a smallness which assigns reality a back seat, or a migration of the border animal along the cornice of a building, echoed by a line of ships trooping off across the sea, multiplied rows like totemic representations of the anonymous Folk.

One of his goals is to marry anonymity and extreme eccentricity, in

flat foliage shapes like beautiful stains or clouds like marbling. He congeals shadows or waves or beards into forms arbitrary yet permanent, sea spray falling apart into a woven pattern of maidens holding hands. These ambiguities are an animism, wandering in which we almost forget the contrivance, but rigidity seems the final message even of ones most like ink blots, facility the surest prison.

To look at awkward copies, sophisticated products interpreted by naïve hands, like Henri Rousseau or Finnish firwood rococo, embodying a relation between maker and material opposite to Bilibin's, gives the clue to his safe pleasures. He has kept within a boundary and borrowed from primitive only to make his story more decorative. An antithetical response finding itself in a world overloaded with knowledge selects from folk art just what Bilibin suppresses, its ignorance, not as formal innovation, which we have seen him pervert to elegance, but engulfing psychology.

The medieval and old Russian pictures Kandinsky produces around 1902 look like Bilibin, though traced by a more wobbly line. Kandinsky's temperament dawned slowly on him, but he had laid down long before the base which would drive him far from this simple romance like a feeble impression of Maeterlinck. Though recollected after his conversion to non-material painting, his visit to a peasant house deep in Russia, covered with carved and painted scenes, is a premonitory entrance into one of his later works. He barely notices that the subject matter is the riders, saints, and battles obscurely skirted in his own of 1910–14, and feels surrounded and penetrated so fully he is living and moving in picture, guarded from harmful documentary interest in primitive material by his strong inclination to hidden meanings. Natural objects in folk art are not themselves but hieroglyphs we have become insensitive to the spiritual valency of, so that we are not afraid to have dragons in our dining rooms.

Earlier, art experiences had suggested to him how mythic or tale material might make non-narrative images, though the knowledge had not immediately integrated itself, partly because the best demonstration was given in the non-visual form of Wagner's *Lohengrin,* characters preceded by a phrase which they seemed to radiate, their bodiless body, accompanied in his mind's eye by play of colors, and lines wild almost to insanity. Less radical in its reconstitution of his reality, perhaps just because nearer his own materials—Kandinsky a painter who would learn most from arts other than painting—was the painful experience of a Mo-

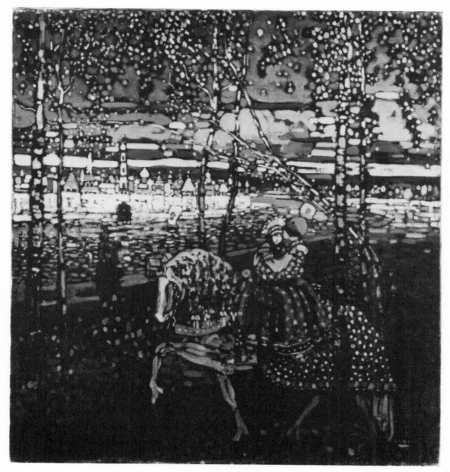

Wassily Kandinsky, *Pair of Riders*. Städtische Galerie im Lenbachhaus, Munich

net haystack, whose subject he thought missing because he could not recognize it. Important events in Kandinsky's life are often first defined negatively like this, like the news of the crumbling of the atom, paradoxically described as the removal of a great impediment to his pursuit of art because it made other disciplines tremble and fall. With such an appetite for unity he was extremely receptive to disruptive impressions, inclined to grant their truth, but then to find a way of organizing without misrepresenting them.

Years later the experience of the *Haystack* repeated itself accidentally

in his studio, a non-recognition more important than any vision he had ever had, his own product become his best teacher. After struggling with an outdoor subject he returned at dusk to find he had already done the work he strove at elsewhere.

It lay on its side lit up by an impossible glow, and the marvel of Kandinsky's receptiveness is that he did not return to a knowing view of this painting when he saw it again as it had been, but kept trying to recover the unrecognizable form, an unregarded magic lying deep in himself. He let it call up the hard questions of what one replaced the missing subject with, so that one did not disturb the deep drama of oneself, which had given him torturing glimpses before and suddenly appeared now in almost perfect form, receding as the vehicle righted itself. From this moment, which can be closely dated though he doesn't locate it, his pictures look more essentially folk-inspired, though to him it seemed he had no model and had struck out across a psychic wilderness.

When he tries to express his ineffable goal, the results are gnomic but suggestive. More than once he identifies a certain repeated impression of Moscow as the spring of all his later work, an hour or a moment when the setting sun turns a whole city to a single color sensation, a red spot. Monet renders it partially, but Wagner, who has never been there, rescues this Moscow entirely from inarticulacy. First a complex emotion becomes a visual sign, which is then converted to another, less graspable sense. It is called Moscow to remind you of where it began and of how far feelings can go and still feel tied to, even identical with, their source. Finally the art is about a journey, invisibly traverses a distance, reaching beyond time by omitting the mention of it.

Thus when he arrives in Munich it speaks to Kandinsky of German fairy tales from his childhood, blue trams as fairy breezes lifting one as they pass down the streets, yellow mailboxes as canaries, a vision which finds the past in the machinery of adult lives, not in its antique forms, which has thereby harmonized inner and outer and evaded the childish return of picking up its old toys. To locate oneself precisely in time and space, in childhood and old Moscow, Kandinsky perceives as a great limitation of one's power, materialism which music and memory freed from time show him how to escape.

He had found the structures later embodied in his paintings first in experiences like seeing Rembrandt at the Hermitage. Though he eventually sought to systematize it and it appeared late in his paintings it was

a mode of vision in some way natural to him, transcending the senses by their means.

Thus Rembrandt's twilit tones are sounded on Wagner's trumpets, like the trumpets frequent in Kandinsky's paintings, at last loosened from angel trumpeters and become gesture, a shape as an action. In the end it is a sign language of sensation detached from natural occurrence, so to distinguish the inner and outer meanings of forms he uses the example of a letter in a line of type, whose practical function is detachable from its happy or sad lines and curves. It is an unconvincing case, not usable in painting, like his overstress on a clinical freak, the patient who insisted his food "tasted blue." But perhaps he is unable to produce convincing inner meanings and translations from one sense to another because his important meanings are private.

The horse is a potent sign to Kandinsky for old reasons, and occurs in two of the four color impressions with which conscious memory first unfolds to him. He says the green, white, carmine, black, and yellow ocher have come free of material objects, but goes on to recount how green and white are connected with a symbol-toy of childhood, a thin branch made into a horse for "riding" by removing a spiral of bark, a dance of grownup action he still remembers with passion. The ocher is tied to another horse he has ridden only in imagination, taking turns with his aunt moving their favorite of yellow lead around the board, whose exact hue is resurrected by a horse he finds pulling a dust sprinkler in Munich and follows down the street.

They are detached from their surroundings but not their objects, like the levitating triangle of spiritual progress with geniuses at the apex, which flies through the air but keeps a definite shape, like the Virgins who hover above the stricken violence in Bavarian votive paintings he grows so fond of. The memories of horses are two images of play, an action which is not an action, which does not tire or conclude, like lifting a weight which does not need to be lifted. Later he finds confirmations of horse and rider as heroic images and perhaps recalls Plato when he sees the artist guiding his talent like a rider. But however overlaid it becomes, however near to a motion without a shape, it is not more abstract than the first stick-horse nor has it outpaced that passion.

Kandinsky never stopped trying to systematize such responses, to make all yellows the same yellow, all horses the same horse, to claim that the sharp aggression of yellow was ideally matched by the triangle, and

the snail-like inward turn of blue by the circle, to chart the correspondence between colors and sounds and to hope painting could learn from music—rhythm in color, repeated notes of color, colors set in motion. His results are important not as general decoding of the hieroglyphics of the senses but as the basis of his painting, though they show him dissatisfied with the possibilities of that or any other medium.

He wrote dramas with colors and noises in the titles, in which one might hope to find the fulfillment of his ideas of intertwined senses, like three-dimensional versions of his paintings set to voices and orchestra. They give the sharpest proof he sought the unattainable, blending the slow forward movement of five giants "as yellow as possible" with the rapid cross-flight of vague red creatures "somewhat like" birds, masking a large hill, which deepens and fades in time to the flutter of a man-sized flower on a pillar, with a crowd in long shapeless robes of different colors moving in unison and babbling discordantly.

The climax comes as confusion reaches the highest pitch, incoherence made conclusive as if by anti-art. It feels quintessentially made up, not dictated by necessity, and the effects of depth, changing colors, and eccentrically varied motion not easily and never literally captured in painting he did not for that reason cease to seek, and found better on canvas than the stage, whose physical limitations—gravity, the distinctness of bodies—weighed heavier on this hater of anatomy and drawing from models than the temporal ones of painting.

When the transformation of Kandinsky's pictures begins in 1909 the forms gradually lose their shapes like stewed fruit, but keep the deep rich colors which divide them into large soft patches. Soon after the change the three generic names for pictures appear—Impression, Improvisation, Composition—which identify three methods of construction—specific recollection of a moment in nature, largely unconscious inspiration, and elaborately plotted results presented as spontaneity. In practice the categories interfuse and as time goes on the first two categories assimilate to the next class, Impressions look more like Improvisations and Improvisations more like Compositions, suggesting that the divisions are a progression and that he might end up painting nothing but Compositions.

These categories roughly correspond to three phases he passes through by 1914, the first one fitting his description of paintings that are no longer the non-natural narrative he calls fable, but incomplete fairy tales that correspond to the cinema, suggesting mechanical flicker of the

image, in-between, unfocused. Forms in this phase even look translated back toward intelligibility, as if it would be easier for them to be more abstract. But as he develops, objects fly apart further, and depart from the Roman logic of circle, triangle, square to a darker geometry of parabolic solids, ellipsoid smudges, toothed lines, wiggles. In the second phase, though not weighty, the forms remain solid, guns fire clouds not bullets, which distend to comic-strip balloons, and waves beat up in series like comic-book explosions.

The third phase is emptier and faster. Matter which has been drifting slowly away from the bottom of the picture now rushes toward the top, completing the destruction of weight. Now the canvas looks like the collision of worlds he says it derives from, created like the cosmos from a series of mental catastrophes. These are sky-pictures whose forms disperse to fog or glow, colors no longer matching bodies but wandering outside them and provoking the appearance of heavy black lines to assert the forms which are no longer really there, and so, instead of lopsided hills with little cities on them, become large hairpins wheeling among smaller debris. In many of these paintings the flat plane of vantage is lost, skewing with absolute propulsion as its goal, wagging tails without animals, comets, and standing figures violently swayed by the breeze of thought.

Though much has fallen away, he keeps faith with some of his earliest inspiration, the thrill of fresh paint oozing from the tube, like words released from meaning, a roughness and presence which will soon disappear, soft violence which will become hard, jostling rows not individuals, which will be regularized to series, teeth or bristles which will cease to have private lives and be combed into submission.

In 1914 Kandinsky returns to Russia and the frenzy reaches a higher pitch before a sudden cooling. It would be good to know his responses to events on which he has been silent, but one sees physical signs like the gap between the Revolutionary November 1917 and July 1919 when he produced no paintings, appearing as one might expect changed after the interval, to a new cerebrality which may be reaction by contraries to the disorder around him or a partial accommodation with Constructivism. The hard-edged forms conforming to more usual geometry have been called monumental, and it is true his odd ideas of monumental encroachment of the arts on each other seemed for a time likely to guide Soviet reforms of art education, but the change is also a sign of withdrawing ambition and an instance of a sense around this time that painting was

becoming less necessary or possible, seen in a painter as unlike Kandinsky as Malevich.

Both Kandinsky and Malevich develop from varieties of peasant style toward different ideas of the bedrock of reality, one hard and technological, the other soft and superstitious. Both are radical reseeings and though opposed within it fall into the same sector of thought where a non-image seems more primitive than an image, simpler though not more natural because it is profoundly unexpected. And Malevich's diagram of the universe showing matter at a higher or lower level than ordinary eyesight is after all pseudo-science, an intuition trying to look factual. Even if they seem to embody the opposition of dark country and stark town which was vexing Russians at this time they both inhabit the same moment, one of those in which everything is called in question and unlikely types begin to think apocalyptically.

Malevich had already gone as far as he could go in finding a new world without any vestige of the old when the Revolution came to suggest he had not gone far enough. From two distinct peasant styles, the first of cloth, the second of metal, through a brief cubist phase, he exits around 1915 to a place where the building blocks have come apart, starved nearly into lines, to float in non-natural emptiness. He calls it playfully Suprematism because so far above breathable air, and contrasts it with the "little corners of reality" of representational painting, earthbound and crammed with material. He has "transformed himself in the zero of form and emerged from nothing to something," an entirely new world, becoming new by the elimination of the old, for which he finds no replacement. Like Kandinsky's these paintings are about motion and emptiness, and present the negatives directly, a purity Kandinsky thought would spawn only decorative designs.

Though Malevich continued after the Revolution to talk about them as if they made no reference outside the world of pure form it is impossible not to see his paintings as anticipations of the Utopian scientism which was the most powerful intellectual trend of the early Revolution, to which newness was so attractive that most of the determining features of reality could be jettisoned, the difference between city and country, between mental and physical labor, between art and industry. The over-coherence of the Marxist interpretation of reality, with its primitive goal of social decomplication after the end of conflict, inspires at this stage a hyper-dynamism directed toward that final stilling of all life.

Clear-seeming categorization like Malevich's decision that paintings

may contain form or emptiness is applied to every question: the world may have chaos or communism, and one is producer or user, primary or secondary, coercive moralization in the guise of the rational which drives even Malevich, the apostle of useless art, to turn his paintings into architecture by a few deft additions which make them read as axonometric solids. But this seems a joke on the constructive practicality of the early Soviet era, its preference of action to thought, its demand that paintings provide living space for workers. So he says people can live in these now-three-dimensional diagrams "if they want to" though that is not why he drew them, perhaps a jab at the tabletop size in which big Constructivist dreams of new structures end, or a gnomic invitation to treat them as the habitation he had always viewed art as offering.

So he designs a pilot's house in the barely disguised form of a two-engine biplane with the nose at the bottom, a practical joke on floating architecture as new life transcending the constraints of the old. But there is a meaning he did not admit in the ease of these adaptations. He wanted his work to be the sacred kind which could not be touched or employed, but got his power from introducing machine parts into the museum,

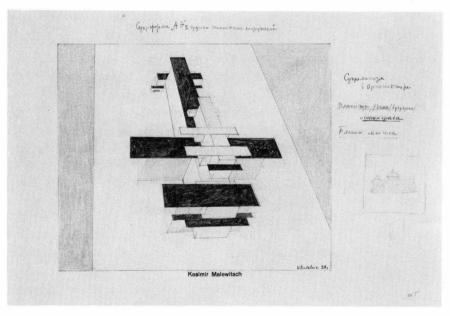

Kasimir Malevich, *Suprematist Architectural Drawing*, 1924.
The Museum of Modern Art, New York

which the Constructivists from whom he battled to distinguish himself realized, and moved them out again, thankful for the aura gadgets had acquired but pretending to ignore it.

El Lissitsky's embracing dynamism is mainly the energy of this transfer, of art transformed to industry and vice versa, an exchange the more vivid because obliged to exhaust itself in verbal forms, a workers' club as a palace of labor for the new collective rulers, or better yet the factory as a palace of labor, labor as a luxury and culture brought to the scene of real production in plays during lunch breaks. Now it has a place there because it has been converted to "re-creation which stores energy for further production." Or the factory as the true university of socialist man, or the machine as a brush which paints the canvas of the world a healthy red.

The sense of power which accompanies these conversions feels nothing can stop it—farms will be wheat factories, large cooking laboratories will replace little kitchens, Tatlin will vindicate youth erecting his tower without technical training, Lissitsky's Skyhooks will express the mystique of traffic and commotion by marking the nodes of interchange in Moscow's radial grid. The flaw in the enthusiasm is visible when he derives the Constructivist principles of mass production, standardization, and usability from rural log cabins, a novel updating of folk anonymity. The vision is ultimately dependent, and when it sinks to flattery of proletarian virtues, it has seen for a moment that it is being rushed helplessly along by something larger, and has wondered what if it fell off.

In Trotsky early Soviet dynamism appears as the haste and wit of brief treatments of large subjects, like a whole range of cultural questions in *Literature and Revolution,* qualities which dispose him to sweeping dismissals and acceptances, a certain graspability, and, compared to Kandinsky and many artists, a low tolerance of uncertainty. Yet if his style is energetic it is not truly popular (like the note now appended to a statement which had provoked naïve orthodox complaint: "Attention! This is irony!"), and among his Revolutionary comrades he appears a thinker and outsider, whose intense interest in art must have made them wonder, highly conservative as most of them were in such matters.

His concern with the future projected itself further and at the same time more concretely than anyone else's, and his version of the present moment as camp life, a bivouac between two battles, Russian and world revolution, is dynamism on the verge of millennial consummation ex-

pressed with compression suspiciously like that of apocalyptic novelists like Boris Pilnyak. He understood too well what Romantics meant, so that if he took issue with Pilnyak on the Revolution as a fairy tale invented by the folk, fabulous hunger, death, and truth, or St. Petersburg as lichen on the bark of Russia, superficial, sub-organic, parasitic, he had already been inside such thoughts, and his comrades hadn't.

The ideological source of Trotsky's energy is the privileged relation to reality which Marxism grants, allowing one to project if not to build a different earth, pushing on to the redesigning of man himself, the ultimate Constructivism applied to breathing, circulation, and unconscious desires (we have not stopped cringing before God, kings, and capitalists to fall at the feet of biological urges). On current construction he takes a sophisticated Utilitarian position, seizes immediately the jugular of nineteenth-century technology, the Eiffel Tower, exciting skill combined with disturbing aimlessness, which he says would have obeyed internal necessity better if originally designed as the radio station it has become. It leads him to a determinist treatment of Tatlin's unbuilt tower, deciding that since its meeting halls and offices do not need to be raised and rotated the skeleton which makes the height and motion possible is like the wooden temple inside a beer bottle which fooled him as a boy. Tatlin has turned it inside out and placed the container inside the web, but solved an equally airless problem. Trotsky is quick and reductive on sculpture too: it must give up its supposed independence, which has left it sitting unused in museums, and become a search for ideal form in objects like penknives, another deflating and synthesizing example—all human activities part of one life.

The poignancy of Trotsky's book is that the complexity of mind he mocks while appreciating in artists defeated him in the contest with Stalin. At the very moment he projected a replacement of dynamic political struggle by global "parties" of art contesting questions of style in the classless future, the inertia of the aging Revolution was brought to bear against him. He found no permanent safety in understanding things so well, his faith in ideas misplaced, the crude methods he despised in Stalin ensuring success. Trotsky's prescience gave way before showing him that the Revolution had had its fill of irony and refinement and would now shake off the vestiges he represented.

Trotsky imitates coarseness, but in the contest to avoid an individual stamp another art than literature would win. Film musters crowds who then watch crowds, raw images of themselves which create an illusion of

unison in an unprivate medium that holds out the ideal of all thought taking place in the conditions of a public meeting. Ordinariness becomes coercive as a positive when its content is manipulated to simple cohesion or uniformity, the party as image of the proletariat as image of the whole society, true mass-expression as prelude to homogeneity.

Vertov seems least artful of the Soviet directors because he acknowledges the mechanism of the medium, raising the succession of images film is made of to conscious awareness by jumping rapidly back and forth between two different worlds, a careening church tower and a face thrown back in laughter, superficially related as the same kind of motion, deeply polarized by politics. Our perception of large realities like the city or the crowd is discontinuous before it is harmonious, so Vertov's alternation of a woman waking with awnings going up, washing her face with hosing down lamp standards, emerging in the street with buses leaving the depot, is fast enough to seem the natural flutter of vision, stripped of the usual lubrication, forcing one to think back and forth between individual and mass and to exchange their qualities.

The crowd in Eisenstein's *Strike* five years earlier is always seen in motion, as if at rest it ceases to be itself, whereas in *The End of St. Petersburg* Pudovkin alternates near with far views, a face or two wrenched from the whole, against the crowd seen from above like filings as a magnet passes under the paper they lie on. Mediation is omitted to suggest the size of the mind's difficulty in seeking to understand history as human but non-individual.

In both these films empty buildings like anti-crowds, the deserted factory in *Strike,* the Winter Palace in *The End of St. Petersburg,* portray the vacuum left when the individual confronts the world with crowd-consciousness subtracted. This vertigo of full and empty is played against fat industrialists as clockwork toys flying apart, but in the end can only be stabilized by finding anonymous heroes, ice floes like the others in the thaw, who possess special properties. To avoid building on peculiarities too peculiar, one could form heroism of carrying a flag, which wrapped and unwrapped the hero's profile, or of repetitive work as in Vertov's *Enthusiasm,* where avant-garde speeding and overlay of the image makes tyranny, the assembly line through the collusion of this tireless medium as an invitation to become an industrious machine.

Another mass art, the poster, raises less troublesome questions, presenting a group member in multiple images across a city or even a country so that one feels solidarity with the others viewing it at the same

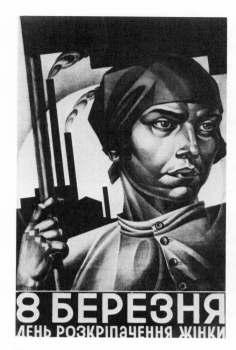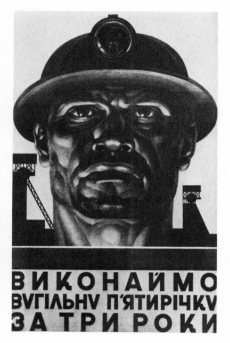

Two posters by A. Strakhov. Left: *8 March: Women's Liberation Day,* 1920.
Right: *Let's Complete the Five-Year Coal Production Plan in Three Years,* 1931.

time, but posters too underwent a change toward gigantism like that in
Soviet architecture and sculpture. A Strakhov poster of 1920 equates a
flagstaff with factory chimneys in the background similarly canted, and
the flag with their banners of smoke, ideology and action in accord. Af-
ter 1928 the face of the miner seen from underneath gets larger, the
background of foundry or dam gets further away, for the granite visage
which still pretends to lead a heroic charge has appeared like all giants to
silence the will.

Soviet sculpture dominates Soviet painting in the thirties because it is
a more suitable medium for expressing physical power. Vera Mukhina,
who conceived the most memorable of these intimidations, the great *Fac-
tory Worker and Collective Farm Woman* in stainless steel for the Paris
Exhibition of 1937, began as a quasi-cubist sculptor in the twenties. Her
V. M. Zagorsky of 1921 is a convincing icon of the uniform, the bulgy
pockets in the flying suit strongly plastic yet hard at work holding
things. The later hero and heroine of steel represent a real idea too, a

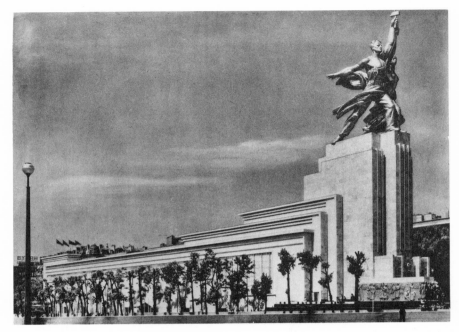

Vera Mukhina's sculpture, *Factory Worker and Collective Farm Laborer,* on top of the Soviet Pavilion at the Paris Exposition, 1937

statue of liberty as teamwork, holding aloft in their enthusiasm tools which accidentally form the national emblem. In Paris it appeared on the prow of the Soviet pavilion which became its oversized pedestal, an awful genre often thought of, if less often built in these years, architecture as a display stand bigger than its artwork. Or it could be sculpture itself, so massive and erect, like the main university building in Moscow, that use cannot measure up to the expression which holds it.

Zhdanov's opening speech at the First Soviet Writers' Congress in 1934 abounds in fantasies of size—millions are listening, thousands attending, other thousands writing in advice and encouragement. In no other country are writers so loved or so loyal, and the army of them rallies around Soviet power, engineers of human souls (a responsibility granted them by Stalin) wielding their weapons of technique. At the same Congress two of the most interesting Soviet writers made speeches explaining why they found it impossible to write in the new age, Babel to say he was still looking for the right language, and Olesha, more openly, that he had been beggared and cast out by doctrinaire response

("We are not afraid to call ourselves tendentious," Zhdanov had said), convinced that the colors of his childhood were false ("We turn away from the old Romanticism of a non-existent life," said Zhdanov), but unable to replace them with Magnitogorsk and the successes of socialist construction ("Our heroes are active builders of a new life," Zhdanov said).

Olesha had lived through attempts to work out a five-year plan for literature, with public pledges to fill quotas of words in specified periods, collective visits to industrial sites, and shock tactics to overcome obstacles in the path of socialist literary construction. Even in 1928 he had had to camouflage the poet in a fat crank who sought to lead a last parade of the feelings that Soviet reality left no room for, envy, vanity, jealousy, pity. His best stories are about telling his subjects goodbye—he is like the grandmother who remembers the wheat field as a landowner's park, who sees what is no longer there, and whose memories are drawn out in a series of distinct misunderstandings.

Olesha, the poet of the backs of hands, of the small letters which cluster around everyone, on pencils, forks, buttons, spectacles, a scattered army of ants fighting for survival, must define poetry as seeing what isn't there, or by implication, the Soviet era as a world which isn't there, in which the past is not permitted and delicate feelings are useless or counter-productive. He is the spokesman for lonely perception, a tramp registering the light in a pharmacy vestibule, or a dying man cataloguing peripheries as death takes them away. It was a gift precarious by nature, and given his partial desire to remake it, he did not have to be absolutely forbidden for it to forsake him, though eventually for good measure he was.

The best literature of Stalin's years cannot be read because it could not be written. Its history is more explanations of silence. Five years after the Congress Babel, Pilnyak, Mandelstam, and many others had been arrested, jailed, shot by their good teacher's henchmen, Mandelstam for committing a poem about Stalin to the memory of friends, Pilnyak for submissions and self-abasements so grotesque they read like parody. Despite heroic effort since, it remains a buried history.

Remembering Mandelstam one unreasonably resents those who manage to keep writing, though it seems permissible to invent a limbo outside literature for plagiarists like Sholokov, lackeys like Alexei Tolstoy, xenophobes like Simonov. There are more honorable compromises like Katayev's, whose Five-Year-Plan novel *Time, Forward!* preserves a

surprising quotient of imagination by externalizing it in technical proc-
ess, concrete mixers, trains dividing conversations in half, traveling
forms and papers, banging doors, words transmitted long distance by
telephone, where poetic perception of disorder is ingeniously harnessed
to socialist boasts, for the mess is the outward sign of heroic feats. In
later Soviet novels one is glad for whatever one gets, so relieved if the
feeling toward foreigners, shirkers, wreckers, and survivals is not mur-
derous, that one is liable to say it is enough. Katayev salvages what he
does by a duplicity: private reality is the weapon of those who intend to
betray society, the book says, yet it owes its own liveliness to private
perception projected out onto machinery with the link to the perceiver
afterward destroyed; it is only good through what it tells its readers they
are not allowed.

At its best Soviet fiction of the forties and fifties tells how people pre-
serve themselves, Vera Panova's *Kruzhilikha*, 1948 (English version,
Looking Ahead), a cocoon for quiescent humanity biding its time, whis-
pering below audibility that production figures and working on into the
night are not the true ends of life. It is the gray world just outside the
movies, of the first minute when one has gotten free of art, and it no
longer gives the Western reader the thrill of seeing how close he can
come to the trap without springing it, which is his craven pleasure in the
earlier years of Stalinism. It is Trotsky's camp life as a permanent
fixture, an engrained dishevelment hanging on in a new hotel with dirty
windows.

The moment came when the cocoon could risk falling away, and
Solzhenitsyn began to appear at a point which under normal conditions
would have been the middle of his career. But it was risked too soon, and
now in Soviet homes one can hear him called by animal names and
threatened with worse punishments than he got. For those who can read
him, which does not include those who if they knew it would want to
most, his heroic archeology has closed Stalin's time-warp, and healed
forty years late the fault in Soviet reality, now reconnected to the other
Russia of prisons and camps, the real life of those times, still anonymous
after Solzhenitsyn, like an inward and spiritual truth.

For many the worst events of the twentieth century seem final, mo-
ments from which no one can recover. It is not always easy to separate
an authentic sense of doom from desire for personal importance of one

kind or another, like the wish to live at the end of time. Those who draw the most sweeping conclusions are usually speculators like the present writer trying to round off their thought, but in spite of grandest endings these terrors will continue to be redeemed by those who think on them, as they have been in another way by those who knew them.

Primitivism is an objectification of the Romantic view of human nature which sees reason and imagination at war. Reason, the accountability of one's ideas to outside measurement, which the greatest poetic products have always incorporated, separating itself and racing ahead in the form of eighteenth-century science, provokes the counter-monster of untrammeled imagination, desocialized (as reason becomes desensualized), amorphous, suicidal.

The path we have traced is a thread of the self-destructiveness prominent in Romanticism, markable in the single psyche—one's own history —as well as the larger process. How far will the modes of poetry work in daily life is the question Romantics dare not ask themselves, imposing their associationism regardless of cost, using crude symbolic structures to overcome rationality (blood-red flags the first course in a diet of blood), finding in ignorance a reunion of all fields of knowledge, swallowing smaller distinctions in the last one, me and not-me.

To elevate intuition beyond visible check leads one on to dogmatic intuition, not content with saying, needing to bring to pass. So the ritual of art becomes a formalist substitute for doctrine, and the sanctified imagination reaches greedily for physical power, prods its adherents for proofs of their allegiance, and at last feels itself real.

Whether invented myths stay largely "spiritual" and (it must be admitted) unintelligible like Kandinsky's, or pretend to require conversion to fact like Lawrence's or Jung's, they are inevitably insincere. Hypocrisy may be incident to all religion, but it certainly enters those one remembers attending the concoction of. These practitioners never give themselves entirely to beliefs they watched themselves make up.

Getting control over religion in the nineteenth century, understanding its historical and psychological roots, seems at first one of man's great conquests. But he has only found partial liberty to determine the content of belief, not to do without it. Our theme has shown how often this means the restoration of naïve and outworn modes, carrying bizarre suggestions of boldness because the seeker has gone so far afield for them, to Catholicism, Italy, or Polynesian tribes, returning to a Middle Ages in which body and soul have changed places, body a mystery, soul

a husk. Man becomes his own oppressor in a newly witting way, and Pugin's, Ruskin's, and Morris's dream of a unified existence infused by piety comes true in Hitler and Stalin. When the idealist view takes over in life till even subways and bridges express ideology, till every particle of matter is animated by the same idea, the notion of art becomes nonsensical. Morris sees the Middle Ages as the time when all was art, and this idea ushers in the time when nothing is. Then life is ordered by those who (as Pugin and Ruskin had projected) permit no neutrality, having ceased to believe it can occur, for whom fanaticism is more true than tolerance, as it has often been in the world before.

The situation in art since Picasso has been comparable to a revolutionary aftermath in politics, disorder prolonged indefinitely as it cannot be where the connection with physical power is clearer, or even in an art like literature whose medium must be used by everyone every day. The exciting aimlessness of current art makes everyone hanker once in a while to see an official style reimposed, and explains the widespread envy of Soviet Russia in the 1930s. They at least, under a leader whose name meant steel, followed a definite direction, and if the featureless goal tortured the eyes and ears with slogans before it actually racked the body, it was writing its reality on the senses like the first delicate stabs at Kafka's prisoner. When those who seek transcendence in politics find it makes for barrenness after barrenness, that is all right too, because it is real, a rock bottom which is their disguise for God.

NOTES

INDEX

page 3. Rococo. F. Kimball, *Le Style Louis XV,* Paris, 1949 (an expanded version of *The Creation of the Rococo,* Philadelphia, 1943), is the most painstaking account of the style's evolution in interior design. Many lost Watteaus can be guessed from the engravings collected in E. Dacier and A. Vuaflart, *Jean et Julienne et les graveurs de Watteau au XVIIIe siècle,* Paris, 1922–9.

Gilles, Louvre, a man in the costume of Italian comedy whom some have tried to identify as one of Watteau's friends.

page 5. *Gersaint's Signboard,* now Schloss Charlottenberg, West Berlin. It hung as a shop sign for only fifteen days; story of its rapid execution and speculation about how it was displayed in E. Camesasca, *The Complete Paintings of Watteau,* London, 1971 (trans. from Italian of 1968).

page 6. Hameau, Versailles. Nine of the original eleven buildings remain, conceived by a painter, Hubert Robert, and carried out by Mique, who also designed a theater and garden buildings for Marie Antoinette. In the dairy with walls and tables of marble the Queen and her friends made butter and cheese. See L. Rey, *Le Petit Trianon et le hameau de Marie-Antoinette,* Paris, 1936. On other dairies, of which Rambouillet is the most elaborate, J. Langner, "Architecture pastorale sous Louis XVI," *Art de France* III (1963), 170–86.

Boucher. See A. Ananoff (with D. Wildenstein), *François Boucher,* 2 vols., Lausanne, 1976.

Boucher painted Mme. de Pompadour many times, standing outdoors (example in Wallace Collection), seated outdoors—the type referred to in the text

(Victoria and Albert Museum), reclining indoors (Munich Alte Pinakothek), standing indoors (Portland Art Museum).

page 7. Louis XV's habits. J. Levron, *Daily Life at Versailles in the Seventeenth and Eighteenth Centuries,* London, 1968 (from French of 1965).

Heating technology. F. Braudel, *Capitalism and Material Life 1400–1800,* London, 1973 (French ed. 1967), chapter 4: "Superfluity and Sufficiency."

page 8. Eight Boucher panels in Frick, each infantilizing two sciences, arts, or activities.

Cayot's *Cupid and Psyche,* Wallace Collection, marble sculpture signed and dated 1706, a precocious work foreshadowing later fashions.

page 11. Fragonard, *The Swing,* Wallace Collection. The garden sculpture in the foreground is taken from Falconet's *L'Amour menaçant* of 1754.

page 12. Fragonard's patron. The idea of *The Swing* did not originate with Fragonard. For the story of how the Baron de St. Julien shocked the first artist to whom he proposed it, see Wallace Collection *Catalogue of Pictures and Drawings,* London, 1968.

Fragonard, *Fête at St. Cloud,* Banque de France, Paris.

page 15. Letters. Reliable regular posts were first established in the eighteenth century. More or less fictitious works in the form of letters, especially descriptions of foreign travel and works of moral instruction, enjoyed a vogue in the last half of the century. Beginning with Richardson's *Pamela* (Part I, 1741), novels in the form of letters exchanged by the characters were popular throughout Europe. Rousseau, Smollett, Goethe, Laclos, Kotzebue, Scott, and Mary Shelley produced notable examples. See F. G. Black, *The Epistolary Novel in the Late Eighteenth Century,* Eugene, Oreg., 1940; A. D. McKillop, "Epistolary Technique in Richardson's Novels," in J. Carroll ed., *Samuel Richardson: A Collection of Critical Essays,* Englewood Cliffs, N.J., 1969; H. Anderson, P. Daghlian, I. Ehrenpreis eds., *The Familiar Letter in the Eighteenth Century,* Lawrence, Kans., 1966.

St. Prieux is not the real name of the hero of *La Nouvelle Héloïse,* but a pseudonym invented by her cousin so that he can meet Julie's husband. After that the deception must be maintained and the result is that no one knows the name of Rousseau's character.

page 17. Rousseau began *La Nouvelle Héloïse* in 1756 with a few disconnected letters. He said the first two parts were written more or less spontaneously without forethought. The full title is *Julie, ou La Nouvelle Héloïse, Lettres de deux amans, habitans d'une petite ville au pied des Alpes, recueillies et publiées par J. J. Rousseau.* When it appeared in 1761 it was an immediate success. *Emile, ou de l'Education* was composed in 1758–60, first intended as a straightforward treatise, the form loosening as it proceeded. When it appeared in 1762 the outcry sent him off on five years of wandering; it was the great disruption of his life.

"Second" Discourse because the second he had submitted on topics proposed by the Academy of Dijon (the first on "Has the restoration of the arts and sciences

tended to purify morals?" won a prize; the second was not so favorably received). *A Discourse on the Origin and Foundations of Inequality Among Men,* Amsterdam, 1755.

page 18. Fragonard, *The Schoolmistress,* Wallace Collection. Related subjects include stables, peasant dwellings, and laundries.

page 21. Vien's series is illustrated in D. Posner, "The True Path of Fragonard's *Progress of Love,*" *Burlington Magazine,* August 1972.

page 22. Greuze's life is recounted by E. and J. de Goncourt in *L'Art du XVIIIe siècle,* Paris, 1880–2, in whose terms the century has been seen ever since (a selection including Watteau, Boucher, Fragonard, and Greuze in *French Eighteenth Century Painters,* London, 1948).

page 24. Looped arms in Greuze. Many examples in exhibition catalogue *Jean-Baptiste Greuze 1725–1805,* Hartford, 1976, but especially *Paternal Curse: The Ungrateful Son* and *The Son Punished, Mme. Greuze Embracing Her Son After Twenty Years of Separation,* and *The Drunkard at Home.*

page 25. Winckelmann's first work on Greek art, translated by Fuseli as *Reflections on the Painting and Sculpture of the Greeks,* was written in Dresden before he had been to Rome or seen any but small works in the original (published 1755, translated 1765). His large *History of Ancient Art,* 1764, was partially rendered in English in 1849. The first and excerpts of the second are included in D. Irwin ed., *Winckelmann: Writings on Art,* London, 1967.

page 26. Winckelmann's conglomerates. The equalizing effect of engraved presentation on works in different scales and mediums is illustrated in Winckelmann, *Monumenti Antichi Inediti,* Rome, 1767 (facsimile 1967).

page 27. David, *Hector and Andromache,* 1783, Ecole des Beaux-Arts, Paris (loaned to Louvre). See entry in exhibition catalogue *French Painting 1774–1830: The Age of Revolution,* Detroit, 1975.

page 28. David, *The Dead Marat,* 1793, Musées Royaux des Beaux-Arts, Brussels. See entry in exhibition catalogue *The Age of Neoclassicism,* London, 1972.
 Funerals. The first public festival for which David designed the props was the transferral of Voltaire's remains to the Pantheon in 1791. Three funerals were carried out in 1793: Le Peletier's, Lazowski's, Marat's, the last culminating in night burial under trees by torchlight because putrefaction of the body prohibited further delay. The double ceremony for Barra and Viala projected in 1794 and twice postponed was in the end not carried out. This and later references to David's public celebrations are based on D. Dowd, *Pageant Master of the Republic: Jacques-Louis David and the French Revolution,* Lincoln, Nebr., 1948.
 David, *The Oath of the Horatii,* 1784, Louvre, Paris, see entry in *The Age of Neoclassicism.* The war between Rome and Alba Longa was to be decided by single combat between two sets of three brothers, the Horatii and Curiatii, born on the same day to mothers who were sisters. Two of the Horatii were slain first, but by a ruse the third triumphed. When he returned wearing a cloak of one of the Curiatii, his sister

who had made it for her lover cursed him, whereupon he slew her. He was condemned but spared on appeal. A large wash sketch by David of the triumphant return of the hero dated 1781 exists in Albertina, Vienna, and returning to the subject in 1783, he first planned to depict the condemned hero defended by his father.

page 30. Benjamin West, *Pylades and Orestes Brought as Victims Before Iphigenia,* dated 1766, Tate Gallery, London. Other precociously neo-classical works by West are *Agrippina with the Ashes of Germanicus* (Yale), *Departure of Regulus* (British Royal Collection), *Cleombrotus Banished* (Tate), all painted c. 1766–8.

page 31. David, *Lictors Bringing The Bodies of His Dead Sons to Brutus,* 1789, Louvre, Paris. Oil sketch, Wadsworth Atheneum, Hartford. See R. L. Herbert, *David, Voltaire, "Brutus," and the French Revolution: An Essay in Art and Politics,* Harmondsworth, 1972.

page 32. David, *The Tennis Court Oath,* pen and brown ink, brown wash, 1791, Musée National, Versailles. See entry in *The Age of Neoclassicism.*
 David's processions. A series of spontaneous fêtes of the Federation culminated on July 14, 1790. David first stage-managed Voltaire's transferral, July 11, 1791, followed by the Fête of Liberty, April 15, 1792, which was countered by a Fête of the Law mounted by constitutional monarchists. At this stage propaganda was openly competitive, but by the time of David's great festivals of 1793–4, the Fête of Unity and Indivisibility, the Victories of the Armies, and the Fête of the Supreme Being, there were no competing celebrations. See Dowd, *Pageant Master of the Republic,* for full accounts, including contemporary descriptions.

page 33. David, *The Death of Barra,* 1794, canvas, unfinished, Musée Calvet, Avignon. See *The Age of Neoclassicism* for recent discoveries about Robespierre's fabrication.
 David's efforts to change French dress continued over a number of years, 1792–4. His designs (preserved in the Louvre) were engraved in color and distributed. The five stages are those of the Festival of Unity and Indivisibility.

page 34. John Flaxman went to Rome in 1787 as a sculptor and began illustrations to the *Iliad* and *Odyssey* (using Pope's Homer) in evenings after daytime studies of the antique connected with sculpture. They were commissioned by an English lady, whose friend ordered further ones to Aeschylus in 1792. Seventy-three illustrations to Homer engraved by Piroli were published in 1793, thirty-one to Aeschylus in 1795, making Thomas Hope famous throughout Europe. Beckford got him to undertake illustrations of Dante on the pre-publication repute of the Homer pictures, but later plans for Bunyan, Swedenborg, and the Book of Enoch, expressing Flaxman's pietistic strain, fell through. The Homer illustrations are in a Dover reprint, 1977.

page 37. Johann Martin von Wagner of Würzburg, a painter, sculptor, and collector who painted *The Council of the Greeks Before Troy* in Rome, 1807, and left his collection, including many of his own works, to the University, Würzburg, where the painting is now exhibited.

page 38. David, *Intervention of the Sabine Women,* 1799, Louvre, Paris. See entry under preparatory drawing in *The Age of Neoclassicism.*

David, *Leonidas at Thermopylae,* 1814, Louvre, Paris.

David's Napoleonic pictures. Four large ones were planned, of which two were executed: *The Coronation of Josephine,* 1807, known as *Le Sacre* (Louvre, Paris), and *The Distribution of the Eagles,* 1809 (Museum, Versailles). *The Enthronement* and *Arrival of the Emperor* exist only in preparatory studies.

Various works of Guérin in the Louvre show him darkening then sweetening and inflaming earlier classicism: *Return of Marcus Sextus,* 1799; *Phaedra and Hippolytus,* 1802; *Aeneas Recounting Trojan Woes to Dido,* 1815; *Clytemnestra Hesitating Before Striking the Sleeping Agamemnon,* 1817.

Ingres, *Napoleon Enthroned,* Musée de l'Armée, Invalides, Paris. See entry in *French Painting: The Age of Revolution* for speculations about influence of Byzantine prototypes and the Ghent altar of Jan van Eyck.

page 40. Percier's and Fontaine's settings for Napoleon at the Tuileries of 1804 were destroyed in the fire of 1871. The series of three designs in the Le Fuel collection, Paris, shows progressive refinement of the engulfing effect. The Emperor is sitting on the final result in Ingres's portrait.

David, *Mars Disarmed by Venus and the Graces,* 1824. Musées Royaux des Beaux-Arts, Brussels. See entry in *French Painting: The Age of Revolution.*

William Blake, complete catalogue of Blake's works, ed. M. Butlin, London, forthcoming (paintings, drawings, and separate color prints). D. Erdman ed., *The Illuminated Blake,* Oxford, 1974 (Blake's poetical works decorated and engraved by himself).

Columnar Blake: *Gregory and the English Captives, Tiriel Supporting the Dying Myratana* (Yale).

page 41. Blake, *Body of Christ Borne to the Tomb,* tempera on canvas, Tate Gallery, London; *Christ in the Sepulchre, Guarded by Angels,* pencil, pen, and watercolor on paper, Victoria and Albert Museum, London.

page 43. Blake, *Satan in His Original Glory,* pen and watercolor, Tate Gallery, London.

Fuseli. See exhibition catalogue *Henry Fuseli,* Tate Gallery, 1975.

Blake, *David Delivered out of Many Waters,* pen and watercolor, Tate Gallery, London, an illustration to Psalm 18.

page 44. *Nebuchadnezzar,* color print finished in pen and watercolor, Tate Gallery, London, illustrating *Daniel* IV:31–3.

page 45. Runge. Completely illustrated catalogue (omitting the plant silhouettes): J. Traeger, *Philipp Otto Runge und sein Werk,* Munich, 1975. All the works discussed are in Kunsthalle, Hamburg.

page 46. Robert Adam. Damie Stillman, *Decorative Work of Robert Adam,* London, 1966, for reproduction of many drawings, all in black and white. For Adam's surprising use of color, G. Beard, *The Work of Robert Adam,* Edinburgh, 1978.

Fairy vogue. See the exhibition catalogue by P. Alleridge, *The Late Richard Dadd 1817–1886*, Tate Gallery, 1974.

page 49. For Runge's writings, consisting mostly of letters but including journals of foot journeys, two tales for children, and the work on color theory Goethe admired, see *Hinterlassene Schriften von Philipp Otto Runge*, ed. Daniel Runge, 2 vols., Hamburg, 1840–1. It includes Daniel's lengthy mystical commentary on many of his brother's works. Brief selections from the letters in L. Eitner, *Sources and Documents in the History of Art, Neoclassicism and Romanticism 1750–1850:* Volume 1, Englewood Cliffs, N.J., 1970.

page 51. Silhouettes. Lavater used silhouettes to support his theory that one could decipher human character from facial and cranial features. His *Essays on Physiognomy Designed to Promote the Knowledge and Love of Mankind*, 3 vols., 1789–99, perform a fascinating marriage between science and sensibility (chapter on silhouettes: fragment 11 of vol. 2). E. Biesalski, *Scherenschnitt und Schattenrisse: Kleine Geschichte der Silhouettenkunst*, Munich, 1964, jumps from cave paintings and Greek vases to the German eighteenth century, of which it has good illustrations, including silhouettes cut by Goethe, Chodowiecki, and Hans Andersen. R. L. Mégroz, *Profile Art Through the Ages*, London, 1948, has better English examples and a beautiful one by Goethe of Mme. St. Lambert tending a plant (cf. in Biesalski *Paul I of Russia's Children Digging Up a Seedling* by J. F. Anthing, a Rousseauist vision of a human family meeting a vegetable one in the form of a large tree shading its offspring and a father watching his children's education at a distance).

page 53. Böcklin, *Polyphemus*, Schack-galerie, Munich; *Hunt of Diana*, Louvre, Paris.

page 54. Friedrich. H. Börsch-Supan and K. Jähnig, *Caspar David Friedrich*, Munich, 1974. Catalogue of paintings, prints, and large finished drawings, anthology of comments by his contemporaries. *Caspar David Friedrich: Das gesamte graphische Werk*, Munich, 1974, drawings, achieving fusions of the specific and the typical even in fragmentary studies.

page 55. Friedrich, *Wanderer Above the Fog*, Kunsthalle, Hamburg; *Dolmen in the Snow*, Gemäldegalerie Neue Meister, Dresden; *The Abbey Graveyard Under Snow*, formerly Nationalgalerie, Berlin (destroyed in war); *The Cross in the Mountains*, Gemäldegalerie Neue Meister, Dresden.

pages 57–8. Friedrich, *Cross in the Forest*, Kunstmuseum, Düsseldorf; *Churchyard*, Kunsthalle, Bremen.

pages 58–9. For Danish neo-classicism, see three collections: Thorvaldsen Museum (Katalog, 1975), Statens Museum for Kunst (Aeldre Dansk Malerkunst, Katalog, 1970), Hirschsprung Collection (Handlist, 1977), all in Copenhagen. Books about Danish painting not readily available outside Denmark, see F. Novotny, *Painting and Sculpture in Europe 1780–1880*, Harmondsworth, 1960, 2nd ed. 1970. Bendz, *Interior in Amaliegade with the Painter's Brother*, Hirschsprung Collection.

pages 59–60. Købke, *Portrait of the Landscape Painter Sødring,* Hirschsprung Collection, Copenhagen; Eckersberg colors in *Starboard Battery and Deck of the Corvette "Najaden,"* Statens Museum for Kunst, Copenhagen.

page 60. Karl Friedrich Schinkel's buildings are exhaustively treated in P. O. Rave and others, *K. F. Schinkel Lebenswerke,* 11 vols. thus far, 1939–1968. Most of his buildings are in East Germany and many of the ones in Rave's three volumes on Berlin were destroyed or gutted by the war. Gothic Revival castles appear in H. Kania's *Mark Brandenburg* volume of 1960, and renovations of ruined medieval castles in E. Brües, *Die Rheinlande,* 1968.

page 61. Pen and black-ink drawing of *Staircase and Landing, Altes Museum,* Staatliche Museen zu Berlin (East Berlin); set of colored lithographs of Schinkel's designs for Royal Palace at Orianda in the Crimea, 1848; project for palace on the Acropolis, 1834, *View of State Hall,* pen, ink, and watercolor heightened in white, Staatliche Museen zu Berlin (East Berlin).
 View of Greece in Its Prime, formerly Schinkel-Museum, Berlin, last stored in Flakturm, Berlin-Zoo; M. Bernhard, *Verlorene Werke der Malerei,* Munich, 1965 (paintings lost in Germany in the war) and P. O. Rave, *Blick in Griechenlands Blüte,* Berlin (1946), which mentions a copy by C. Beckman.

page 63. Early "Romantic" gardens. *The Genius of the Place: The English Landscape Garden 1620–1820,* ed. J. D. Hunt and P. Willis, London, 1975, an anthology of contemporary sources, shows the ideas for them ripe twenty years before the gardens began to appear, which (and the importance of figures like Pope in the development) encourages the feeling they are very literary places.
 Chairbacks like window tracery. Examples, including one from Strawberry Hill, illustrated in exhibition catalogue *Gothick 1720–1840,* Brighton Art Gallery, 1975.

page 64. Richard Payne Knight began Downton Castle near Ludlow in Herefordshire in 1774. See N. Pevsner, "Richard Payne Knight," reprinted in *Studies in Art, Architecture and Design,* vol. 1, London, 1968. Other examples of Gothic outside, classic inside: R. Adam, Culzean Castle, Ayrshire; B. Rebecca, Castle Goring, Sussex; J. Nash, East Cowes Castle, Isle of Wight; and earlier, N. Hawksmoor, All Souls, Oxford, c. 1716–33, especially the library.
 Lee Priory, Kent, by Wyatt 1783–90, demolished 1953, one Gothick room of which preserved at Victoria and Albert Museum, London.

page 65. Fonthill Abbey. Contemporary guidebooks to Fonthill portray it as a marvel of tourism, jamming roads and pushing up prices for miles around. One of them describes separately three picturesque approaches, and all deploy the house's wonders for maximum effect on the spectator's mind, drawing a curtain behind him as he enters the oratory and forgets pomp, urging his eyes up the great octagon like the soul flying to heaven, jumping from family trees to little bits of sea-green china. Conceiving architecture as vista was part of Beckford's problem. The earlier "Convent" had to be dismantled because so shoddily built, but he went ahead even faster with the more substantial structure, bringing work on nearby farms to a standstill by his requisitions,

pursuing it at night by torchlight, and regarding a fire which destroyed part of the incomplete tower as a sublime spectacle.

J. Rutter, *Delineations of Fonthill and Its Abbey*, 1823, is the most sumptuous, best illustrated of the guides. The letters of Beckford which make up *Life at Fonthill 1807–22*, ed. B. Alexander, London, 1957, show him a willful and amusing letter-writer and lead one on to the subjective journals of his travels in Italy, Portugal, and Spain and his travesties of romantic fiction. The tower at Fonthill collapsed two years after Beckford left it and moved to Bath. The present fragmentary remains are catalogued in N. Pevsner, *Wiltshire* (*The Buildings of England*), Harmondsworth, 1963, revised B. Cherry, 1975.

Fountains Abbey, Studley Royal, Yorkshire, ruins and garden now in care of Department of Environment; one of William Burges's best small buildings adjoins (see chapter 4). See N. Pevsner, *Yorkshire: The West Riding* (*The Buildings of England*), Harmondsworth, 1959.

page 66. For full lists of Pugin's books and buildings see P. Stanton, *Pugin*, London, 1971.

Sadistic novels like Matthew Lewis, *The Monk*, 1800; pranks like those reported of F. Dashwood and the Hellfire Club in *Nocturnal Revels, by a Monk of the Order of St. Francis*, 2nd ed. 1779.

Shobden church, Herefordshire, built 1752–6 by a friend of Horace Walpole. Furnishings c. 1755 in painted wood.

Pugin's illuminated manuscripts, Victoria and Albert Museum Library.

page 68. *Contrasts; or, A Parallel Between the Noble Edifices of the Fourteenth and Fifteenth Centuries, and Similar Buildings of the Present Day; Shewing the Present Decay of Taste*, Salisbury, 1836, much enlarged 1841, facsimile of 2nd ed., Leicester, 1969.

page 71. Castellated grate in Pugin, *The True Principles of Pointed or Christian Architecture*, 1841, chapter on metalwork.

Essay on Spenser, by Thomas Warton, excerpt in P. Frankl ed., *The Gothic: Literary Sources and Interpretations Through Eight Centuries*, Princeton, 1960.

page 72. Modern a-historical style. See S. Giedion, *Space, Time and Architecture*, 1941, 5th ed. 1967, on European disgust with eclecticism beginning around 1890 and the influence of skyscraper construction pioneered in Chicago. For forceful expression of the superiority of engineers to present architects and denigration of styles of the past as no more integral to architecture than a feather on a woman's hat, see Le Corbusier, *Towards a New Architecture*, 1920, trans. 1927, repr. 1970.

Pugin, *Glossary of Ecclesiastical Ornament and Costume*, London, 1844, one of his most scholarly productions with excerpts from medieval Latin authorities.

Cambridge Camden Society. The physical requirements of high-church worship clearly and dogmatically laid out in a series of publications: *A Few Words to Church Builders*, 1841; *A Few Words to Churchwardens*, 1841. *A Handbook of English Ecclesiology*, 1847, was provided for traveling ecclesiologists and the working drawings for hinges, alms boxes, grave slabs, lecterns, and iron churches (for temporary use or colonial export) by the society's architects, Butterfield, Carpenter, and others, in *In-*

strumenta Ecclesiastica, 1847, vol. 2, 1850–6, were principally designed to return churches to their pre-Reformation condition.

page 73. Pugin, *Church of Our Fathers,* a projected book which exists only in twenty-three preliminary drawings at the Royal Institute of British Architects.

page 74. Centre Pompidou, Rue Beaubourg, Paris. Illustrated, with discussion of engineering as architecture and earlier stages of the design, in *A. D. Profiles No. 2,* London, 1977.

page 75. Dashwood. A copy of the famous portrait as St. Francis in his house, West Wycombe Park, Bucks, maintained by the National Trust. His only publication on religion was an *Abridgement of the Book of Common Prayer* in the interest of increasing attendance (on which B. Franklin collaborated), which expresses a coolly historical view of the Psalms and church ritual.

Ruskin Diaries. Most of them are owned by Bembridge Education Trust, Isle of Wight. A full selection published as *The Diaries of John Ruskin,* ed. J. Evans and J. H. Whitehouse, 3 vols., Oxford, 1956–9.

page 77. Proust translated Ruskin's *Bible of Amiens* (1904) and *Sesame and Lilies* (1906) with considerable help from Marie Nordlinger. His long Ruskinian pieces *Journées de pèlerinage: Ruskin à Notre-Dame d'Amiens, à Rouen, etc.* and *John Ruskin* are included along with shorter ones in *Contre Sainte-Beuve* (Pléiade), Paris, 1971.

Ruskin and Venice. He made eleven visits 1835–88. His first descriptions in *The Chronicles of St. Bernard,* his abortive attempt at a novel, written 1835–6, and a poem of 1835 (Library Edition, ed. E. Cook and A. Wedderburn, 1903–12, vols. 1 and 2). A more immediate version of its effect on him in a letter of May 16, 1841 (*Letters to a College Friend*). A later account of his first impression, *Praeterita* II, iii, interesting for the importance accorded Byron in Ruskin's idea of Venice.

page 82. Rose's death and blackness; feelings dictating sensations: Rose died in May 1875. Ruskin's obsession with black skies and plague wind (it can be followed in the *Diaries*) gathers force after this date, though with occasional intermission. He lectured on *Storm-Cloud of the Nineteenth Century* in 1884.

page 84. Ruskin's three great men, *Modern Painters* V, part ix, chapter 4. Dürer, Holbein, and Salvator.

page 86. Lamps in *Seven Lamps,* principles, laws, safeguards.

page 87. Names for topographical features around Brantwood with page references to *Diaries:* strawberry rock, 760; fern glen, 762; wishing gate, fir cottages, 776; fox-glove path, 977; "the Eaglet my own name for crag," 979; Theban cave, 1005; the Vecchio, 1009; St. George's Crag, 1010; Warder's Crag, 1066; Seneschal's Crag, 1071; oak glen, 1076; code names that cannot be untangled, 1078; Fir island, 1082; Queen's wood, 1090; Step-stream, 1093; Naboth ('s vineyard), 1098; Joanna's bay, 1101; Lambkin's Knoll, 1105; the tufted wood, 1112; Fairfield seat, 1127; my Stag's Horn Garden, 1135. Some of these names are short-lived and fade as they are uttered;

others occur repeatedly and probably enjoyed a common usage among Ruskin, his servants and friends.

Five climates, *Modern Painters* V, part vii, chapter 4, "The Angel of the Sea."

page 88. Ruskin's street-cleaning scheme in Church Lane, St. Giles. A letter of 1871 to *Pall Mall Gazette* proposing to employ three sweepers eight hours a day is quoted in introduction to Library Edition, ed. Cook and Wedderburn, vol 22. Account of the abandonment of this and "Mr. Ruskin's Tea Shop," Paddington, selling pure tea in small packets to the poor, in *Fors Clavigera,* letter 48 for December 1874.

Giotto's tower as most perfect of all buildings in *Seven Lamps of Architecture,* chapter 4, "The Lamp of Beauty."

page 91. Helpful for holy, *Modern Painters* V, part viii, chapter 1, "The Law of Help."

page 92. Proust, *Contre Sainte-Beuve* (Pléiade), pp. 95, 134.

page 93. Ruskin outside church. *Praeterita* III, chapter 1, records the first time Ruskin drew on Sunday, an orchis at Rheinfelden in 1858, and another Sunday the same year in a Turin museum with a military band outside the window when he put his Evangelical beliefs aside forever.

Ruskin and early Italian painting. See the Index volume of Library Edition, ed. E. Cook and A. Wedderburn, 1903–12, under Fra Angelico, Giotto, Carpaccio.

page 95. St. Giles', Cheadle, Staffordshire, built 1840–6, one of Pugin's most lavish churches complete with the large spire intended but not given to most of the others, painted inside with a medley of bright patterns like those in his *Floriated Ornament* of 1849 though not as carefully botanical, the doors illustrated in P. Stanton, *Pugin,* 1971.

Burges. If the long-expected book about Burges by J. M. Crook appears, it will fill a noticeable gap.

Bedroom stand exhibited at William Morris Gallery, Walthamstow, London, on loan from Victoria and Albert Museum.

Bottles, lumps of crystal. See R. Pullan, *The Designs of William Burges,* 1885, one of the volumes of photographs with flattering descriptions compiled by Burges's brother-in-law and including his strangest small objects, like the elephant inkstand, and a photograph of his office in the Strand with an ostrich egg suspended from the ceiling, "a common ornament of medieval rooms."

Fountains, towers. See the Vellum Sketchbook in the Royal Institute of British Architects Drawings Collection, rich india-ink versions of Burges's most bizarre ideas.

Lille organ case and other Lille designs for pictorial paving, stalls, font, as well as general elevations preserved in an album of drawings and contemporary photographs of drawings at the Royal Institute of British Architects. Burges's design won the competition for a new cathedral at Lille, but in the end money wasn't found to execute it. See exhibition catalogue, *The Second Empire,* Paris, Philadelphia, Detroit, 1979.

Decanter, Victoria and Albert Museum.

Faucets, hinges, doors. Many examples in Burges's rooms for the eccentric Catholic Marquess of Bute at Cardiff Castle, carried out 1865–81, open to the public from May to September.

page 96. Castle of Love chimneypiece in Banqueting Hall, Cardiff Castle; Tower of Babel in Library, Tower House, Melbury Road, illustrated in R. Pullan, *The House of William Burges,* 1885, whose dark photographs probably give a better idea of the effect Burges wanted than the rooms themselves. Tower House is privately owned and the present author has failed to obtain entry after numerous attempts.

page 100. Bute's bathroom, Cardiff Castle, with massive Roman marble bathtub is not at present shown to the public.

Castell Coch (red castle) at Taff's Well five miles north of Cardiff, designed 1872, begun 1875, in care of Department of the Environment, open year-round. See P. Floud, *Castell Coch,* Her Majesty's Stationery Office, 1954.

page 102. Simeon Stylites drawing, Victoria and Albert Museum, illustrated in Pullan, *Designs of William Burges,* where it is praised as "an excellent imitation of old wood engravings."

William Morris. The best short book is P. Thompson, *The Work of William Morris,* London, 1967, with separate chapters on different mediums Morris worked in, and good detail on how he learned and practiced each craft.

Butterfield finishes and exaggerations can be sampled at All Saints', Margaret Street, London (the Cambridge Camden Society's own purpose-built church), and Keble College, Oxford, especially the chapel (the most extensive Victorian university project).

page 103. Ruskin chapter, from *Stones of Venice,* is discussed on pp.84–6.

Ruskin on luxury, *Seven Lamps,* "The Lamp of Sacrifice."

Red House, Red House Lane, Bexleyheath, Kent, open two days a month, on written application to the owner.

page 104. Morris and Icelandic saga. He read translations in the 1860s, met an Icelander in 1868 and began studying the language. Their first joint translation appeared in 1869, then a translation of Volsunga saga (Sigurd story) in 1870. Morris visited Iceland twice, 1871, 1873, and wrote *Sigurd* in 1875–6 (vol. 12 of *Collected Works of William Morris,* with introductions by May Morris, 24 vols., 1910–15). See E. P. Thompson, *William Morris: Romantic to Revolutionary,* London, 1955, repr. 1977.

page 105. Medievalism and socialism. On this strain in English thought see R. Williams, *Culture and Society 1780–1950,* London, 1958. A German parallel in Heinrich Vogeler, who began as a Beardsley decadent and ended his life in Stalin's Moscow: H. Petzet, *Von Worpswede nach Moskau: Heinrich Vogeler, Ein Künstler zwischen den Zeiten,* Cologne, 1972. Worpswede near Bremen, an ideal craft village, is matched by Mathildenhöhe, Darmstadt; Chipping Campden, Gloucestershire; and others.

Gothic after the revolution. See the lecture "Gothic Architecture" of 1889, reprinted in Nonesuch Morris, ed. G. D. H. Cole, London, 1934.

For lifeless churches in Morris, see also *The Story of the Unknown Church* in Nonesuch Morris.

page 106. "The best Morris designs," like "Acanthus" wallpaper, 1875; "Honeysuckle" chintz, 1876; "Tulip and Willow" chintz, 1889 (designed 1873).

Walter Crane's nursery wallpaper "The Sleeping Beauty" c. 1875 is illustrated in *Victorian and Edwardian Decorative Arts,* Victoria and Albert Museum, 1952.

"Woodpecker" tapestry, 1885, William Morris Gallery, Walthamstow.

Pages of type. A good example is "Friends in Need Meet in the Wild Wood," drawing of border and lettering by William Morris for p. 286 of his romance *The Well at the World's End,* 1896, William Morris Gallery, Walthamstow.

page 108. Wagner outside the operas. See R. Gutman, *Richard Wagner: The Man, His Mind and His Music,* New York, 1968, repr. 1971.

Henry Wilson. See obituary by Beresford Pite, *The Times,* March 12, 1934. Typescripts of lectures by Wilson in Victoria and Albert Museum Library not available on short notice; grandiose architectural drawings in the Royal Institute of British Architects, two of which are illustrated in P. Howell, *Victorian Churches,* 1965; metalwork illustrated in *Victorian Church Art,* London, 1971.

Voysey. See Brighton exhibition catalogue by J. Brandon-Jones and others, *C. F. A. Voysey: Architect and Designer 1857–1941,* London, 1978.

page 109. Ealing, St. Peter, designed 1889, begun 1892. See N. Pevsner, *Middlesex* (*The Buildings of England*), Harmondsworth, 1951.

Wilson's leaf drawings are among five hundred of his drawings, many of them jewelry and metalwork designs, mounted in an album (E. 669–1955) now in Victoria and Albert Museum.

page 110. Alfred Gilbert, a prominent Victorian sculptor, represented in *Victorian and Edwardian Decorative Art: The Handley-Read Collection,* Royal Academy, 1972. The centerpiece now loaned by the Queen to the Victoria and Albert museum is illustrated in J. Hatton, *Special Easter Number of the Art Journal,* 1903.

Bainbridge Reynolds conglomerates including pulpit, lectern, clock, railings, screens, and other fittings, in St. Cuthbert, Philbeach Gardens, South Kensington.

page 112. Lethaby, *Architecture, Mysticism and Myth,* 1892, repr. 1974.

St. Bartholomew, Brighton. The project described by N. Taylor, "Byzantium in Brighton," *Architectural Review,* CXXXIX (1966), 274–7.

page 113. Mackintosh casket, Victoria and Albert Museum. For illustrations of his buildings, mostly in Scotland and more influential in Vienna than England, see R. Macleod, *Charles Rennie Mackintosh,* London, 1968.

Lethaby's phallic alcove, a rendition of the Beryl Shrine in D. G. Rossetti's poem "Rose Mary," was plate 137 of the Architectural Illustration Society, published by *The Architect,* January 20, 1888.

Helmet turrets prominent on Holy Trinity, Sloane Street, Chelsea.

Gaudí let gravity dictate the roof shapes of the Sagrada Familia church in Barcelona by his novel method of selecting arch shapes—adjusting small bags of sand hanging from a flexible wire model of the building. These "organic" forms were then photographed and the results inverted, thrusts became resistances, and a carbuncle on the ceiling was turned into a building on the ground. See César Martinell, *Gaudi: His Life, His Theories, His Work,* Barcelona, 1975.

page 114. Burges' hearts, and alembics were his private devices, frequent on objects made for his own use.

Lutyens's design is illustrated in A. Butler, *The Architecture of Sir Edwin Lutyens,* 3 vols., London, 1950. Only the crypt was built. For this and Scott's cathedral see N. Pevsner, *South Lancashire* (*The Buildings of England*), Harmondsworth, 1969.

page 115. Up to the time when James Macpherson, as private tutor in the house they were visiting, interested two literary men from Edinburgh by his recitation from ancient Highland poetry, he had attended university without taking a degree and written much but published little. John Home took the manuscripts and translations back to Edinburgh, where they excited Hugh Blair, and to London, where they aroused further interest. In 1760 these were published as *Fragments of Ancient Poetry Collected in the Highlands,* introduced by Blair. Though well received, they already provoked doubts of their authenticity, in the poet Gray among others. Macpherson seemed reluctant to go further but was persuaded and money raised for two journeys to the Highlands, where, with a copyist who knew the language better than he, he transcribed recitations and collected manuscripts, issuing the result in 1761, *Fingal* in six books, prefaced by his *Critical Dissertation Concerning the Aera of Ossian.* It enjoyed immediate success and appeared quickly in Continental translations. Two years later the appearance of *Temora* in eight books with the additional *Dissertation Concerning the Poems of Ossian* confirmed the suspicions of forgery. Macpherson refused to enter the controversy, and never published his sources, though they were said to be deposited with a printer waiting for subscriptions to support their publication. In the next year Macpherson got an appointment in Florida, then became a pamphleteer for the government, published a translation of Homer in 1773, sent a challenge to Dr. Johnson, who had impugned him vigorously in the *Journey to the Western Isles,* and ended rich as the agent of an Indian nabob.

The Highland Society's careful investigation of the Ossian question, undertaken in 1797 and published in 1805, is kinder to Macpherson than most later commentary. They found Ossianic poetry in great abundance, but no single poem, and concluded he had liberally edited the remains and inserted passages of his own. See *Dictionary of National Biography,* entry by T. B. S. Saunders, and D. Thomson, *Gaelic Sources of Macpherson's Ossian,* Aberdeen, 1952.

Blair, *A Critical Dissertation on the Poems of Ossian, the Son of Fingal,* which appeared separately in 1763, may be described as anthropological and comparative: "Gothic" (Scandinavian) poetry shown to be fiercer than Ossian, Druids and Celts confused, and Ossian preferred to Homer.

page 116. Homer. For other eighteenth-century criticism of epic poetry, see S. Elledge ed., *Eighteenth Century Critical Essays,* 2 vols., Ithaca, N.Y., 1961, especially

T. Blackwell, *Inquiry into the Life and Writings of Homer,* 1735, a surprisingly anthropologized view, which often reads like a recipe for Ossian. After Blair the next important critic of epic is Robert Wood, who traveled in Greece and Asia Minor and observed the primitive folk of North Africa as preparation for writing about Homer, a further crucial step in localizing him. See K. Simonsuuri, *Homer's Original Genius: Eighteenth Century Notions of the Early Greek Epic (1688–1798),* Cambridge, 1979.

page 117. Rousseau on solitude, historically considered, *A Discourse on the Origin and Foundations of Inequality Among Men,* Amsterdam, 1755; personally considered, *Rêveries d'un promeneur solitaire,* c. 1776–8, Geneva, 1782, in the form of nine "walks" and the beginning of a tenth (unfinished).

Nietzsche's history of solitude formed part of Book III in his unexecuted plan for a work called *The Will to Power: Attempt at a Revaluation of All Values.*

page 118. Runge's Ossian illustrations exist in twelve large finished drawings and a number of studies, all in Hamburg, Kunsthalle. Daniel interprets the poems cosmically (see similar interpretation of *Kalevala* on p. 143) in *Hinterlassene Schriften:* Fingal = Sun, giving; Oscar = Moon, bringing; Ossian = Earth, receiving.

page 120. Continental reception of Ossian. The poems were Napoleon's favorite reading in an Italian translation. Characters in Goethe's *Werther* cry over Selma's Song. Schiller, Coleridge, and Byron are among those who wrote imitations. See exhibition catalogue *Ossian,* Grand Palais, Paris, 1974, for pictorial representations and the connection with Chateaubriand; R. Tombo, *Ossian in Germany,* New York, 1901, for the most enthusiastic national response.

page 121. Sequence in Blake. *The Mental Traveller* makes sharp drama of the endless cycle. Later "epics" like *Vala, or the Four Zoas* seldom carry any feeling of necessity.

page 122. Blake's proverbs in "Proverbs of Hell" of *The Marriage of Heaven and Hell,* and *Auguries of Innocence,* which tries to make a narrative of nothing but proverbs.

Rousseau on language. He says in the *Essai sur l'origine des langues* (written 1754, published 1761) that, though bears, ants, and bees use natural languages (innate not acquired), only man has a conventional one, hence only he changes and progresses, be that good or bad. The word is the first social institution, anterior to customs, hence owing its form to natural causes. Passion not need dictates its invention —love, the desire to move a young heart. Rousseau supposes (as Vico earlier) that poet's language preceded geometer's, tropes came before the "proper sense," and language as it became exact grew heavier and colder.

page 123. Both *Atala* and *René* are short fragments of Chateaubriand's fiction about American savages which he detached for separate publication. *Atala, ou les Amours de deux Sauvages dans le Désert,* Chactas the Indian chief's story before the arrival of René the European, first appeared in 1801, and again a year later in vol. 3 of *Génie du christianisme. René,* the European's story before his arrival in America, was included in the *Génie* in 1805. *Les Natchez,* the larger armature of which they form part, wasn't published until 1826.

Chateaubriand had spent six months in America in 1791, reaching Niagara and the

Great Lakes but certainly not the southern scenes where much of *Les Natchez* is set, a story of the tribe's extermination he had heard before his trip. When he fled to England in 1793 he carried the manuscript with him in some form and in 1798 was reading parts of *Les Natchez* to a friend in London. Perhaps at this time he grafted on the Miltonic machinery which turns it into an epic and reverses the morality by allying the savage underdogs with infernal demons.

The fiction written later but published first, *Les Martyrs*, ranging through the Roman world from Brittany to Jerusalem in the time of Diocletian, bears an inverse relation to Chateaubriand's voyages. He began it in 1803 and traveled through Greece, Turkey, Palestine, and Egypt in 1806–7 seeking to authenticate the story's geography. It appeared in 1809. Chateaubriand, *Oeuvres romanesques et voyages,* 2 vols. (Pléiade), Paris, 1969, contains the two sets of parallel texts, and M. Butor untangles the history of the American texts in "Chateaubriand and Early America" in *Inventory: Essays by Michel Butor,* New York, 1968. For primitive peoples in English eighteenth- and early-nineteenth-century literature, see H. Fairchild, *The Noble Savage: A Study in Romantic Naturalism,* New York, 1928, repr. 1961.

page 124. The character who studies scripture is Eudore in *Les Martyrs,* posted to the fringes of Gaul, like Chateaubriand marooned in his family home. See G. Painter, *Chateaubriand: The Longed-for Tempests,* London, 1977.

page 125. Incest. The relation so tangled it feels like incest, as if interesting complexities always approximate that crime.

page 127. Lévi-Strauss excuses cannibals in *Tristes Tropiques,* 1955, retrans. 1973.

page 129. Smyrna in *Itinéraire de Paris à Jerusalem* (Pléiade, vol. 2, pp. 923–4), where its place on Chateaubriand's route, midway between his major destinations, determines its eternal character.

page 130. *Kinder- und Hausmärchen.* It took the Grimms six years to collect the tales which appeared in vol. 1 in 1812 but only three years, with more collaborators sending in materials, to assemble vol. 2, 1815. Vol. 3, 1822. The important prefaces to these volumes and the essay on child beliefs and customs added in the 1819 edition have not been included in English editions of the tales. The volumes of *Deutsche Sagen,* 1816, 1818, containing six hundred local legends and customs, were seen by the Grimms as complementary to the tales. Examples of earlier affected-naïve märchen collections: J. Musaeus, *Volksmährchen der Deutschen,* Gotha, 1782–7; L. Tieck, *Volksmährchen,* 2 vols., 1798. Ruskin and Andrew Lang wrote introductions to English translations, *German Popular Stories,* 1868, and *Household Tales,* 1884.

For evidence of conflations see J. Bolte and G. Polivka, *Anmerkungen zu den Kinder- und Hausmärchen der Brüder Grimm,* 5 vols., Leipzig, 1913–32.

page 131. Russian parallel from Afanasiev, *Sister Alyonuska and Brother Ivanuska,* Soviet reprint with Bilibin illustrations, 1977 (of *Skazki,* 1903).

Christianity killing belief. T. Croker, *Fairy Legends and Traditions of the South of Ireland,* part III, 1828, prints a translation of the Grimms' long essay on fairies

in Ireland and Scotland expressing this opinion which they had prefixed to a German translation of *Irische Elfenmärchen,* 1826.

page 132. E. Leach, *Genesis as Myth and Other Essays,* London, 1969.

page 133. Illustrators of Grimm. Moritz von Schwind, *Klassiker der Kunst* volume, 1906; *Das Ludwig Richter Album, Sämtliche Holzschnitte,* 2 vols., Munich, 1969; Cruikshank's illustrations to early English editions; and Maurice Sendak, *The Juniper Tree and Other Tales From Grimm,* 2 vols., New York, 1974.

page 134. Better roads in the eighteenth century. Besides Macpherson's complaints in his first *Dissertation,* see S. Piggott, *Ruins in a Landscape,* London, 1976, for this and other interesting material about early British antiquarianism.

page 135. B. Bettelheim, *The Uses of Enchantment: The Meaning and Importance of Fairy Tales,* New York, 1976, a child-psychiatrist's view.

page 136. This was the "fairy-tale wife," Frau Katharina Dorothea Viehmann, a tailor's wife with a remarkable memory who walked from her village to sell eggs and butter in Kassel, where the Grimms met her through parson's-daughter friends and heard twenty new tales besides variants of others in 1812–15. See R. Michaelis-Jena, *The Brothers Grimm,* London, 1970.

 Fragments. Their folk-nationalist periodical, *Altdeutsche Wälder,* which appeared three times between 1813 and 1816, is a curious farrago of history, lore, and outré learning. Jacob's independent productions like the *Teutonic Mythology,* 1835, trans. 1883–8, tend to unreadable patchworks of narrative and etymology.

page 137. Transformations. See A. Aarne and S. Thompson, *The Types of the Folktale,* Helsinki, 1961 (trans. and enlargement of German ed. 1910, 1928), the most important publication for understanding the tales, which collates dozens of variants in the closest proximity. Types 407, 652A, and 403.

 V. Propp, *A Morphology of the Folktale,* Leningrad, 1928 (English trans., Austin, Tex., 1968), often reads like Lévi-Strauss before Lévi-Strauss, though Lévi-Strauss takes exception to this in "Reflections on a Work by V. Propp" (original appearance, 1960), collected in *Structural Anthropology* II, New York, 1976. Propp objects to previous classifications of tales into mythological, pure fairy tale, animal fable, joke tale, moral tale, and says they all belong to one type if anatomized by functions. He settles on a series of thirty-one functions identified by such labels as (1) Absentation, (2) Interdiction, (4) Villain's Reconnaissance, and distributed into seven spheres, corresponding to the seven persons occurring in the tales: (1) villain, (2) donor, (3) helper, (4) princess (sought-after person), (5) dispatcher, (6) hero, (7) false hero. The teller has little freedom, can't rearrange functions, only choose which to omit. All tales can be morphologically deduced from that of the kidnap of a princess by a dragon. Propp's is the most sustained effort to reduce the multiplicity of tales to uniformity, to say all stories are one story, ceaselessly asking to be retold.

page 138. Organic conceptions of literature. Coleridge the most substantial thinker in English on the subject, see G. Rousseau ed., *Organic Form: The Life of an Idea,* London, 1972.

Wilhelm on utensils, in appendix to later editions of tales.

Impostor foiled by dragon's tongue. Aarne type 300, extremely common, see Gottfried von Strassburg's *Tristan,* where the tongue episode is found in proximity to its reverse, piecing together a slain or broken object like a puzzle to identify hero as killer but to punish not reward him. While Tristan is bathing, Isolde notices that the ragged edge of his sword corresponds to the fragment of sword tip extracted from her uncle Mordred's skull.

page 139. Gothic tongue. Progressive degeneration of languages in Preface, *Kinder- und Hausmärchen,* vol. 3, 1822.

page 140. Drinking customs, cakes in *Teutonic Mythology,* vol. 1.

Hesse is important to the whole fatherland as the oldest dwelling place of the folk, stuck fast in time (Preface, *Kinder- und Hausmärchen,* vol. 2).

National Museum, Helsinki, designed 1901, built 1905–12, Eliel Saarinen, Lindgren and Gesellius, their first building in national-Romantic style, granite facing, carved work in sandstone, brick spire roofed in copper. See J. M. Richards, *A Guide to Finnish Architecture,* London, 1966.

page 141. *Nachtwachen von Bonaventura,* c. 1803–4, a fictitious night-journal kept by the watchman in a sleepy provincial town when only poets, criminals and unruly thoughts are awake. Novalis, *Hymnen an die Nacht,* 1799. Wagner, *Tristan und Isolde,* 1867, Act 2, love duet.

E. Lönnrot, *Kalevala, or Poems of the Kaleva District,* trans. F. Magoun, Cambridge, Mass., 1963, and *The Old Kalevala and Certain Antecedents,* 1969, the versions of 1849 and 1835 respectively, containing data about Lönnrot and reprinting his prefaces. These better translations lack the Hiawatha feeling of the entomologist W. R. Kirby's Everyman version of 1907.

page 144. Wolfram von Eschenbach's *Parzival,* prose translation by H. Mustard and C. Passage, New York, 1961, preferable to Jessie Weston's Tennysonian verse translation of 1894, a curiosity whose goal is "to make Wagner better understood."

page 146. Gallen-Kallela (1865–1931). A fully illustrated monograph on this painter whose eccentric house near Helsinki is now a museum: O. Okkonen, *Akseli Gallen Kallelan Taidetta,* Porvoo, 1936 (Swedish version, 1948). His *Kalevala* murals in Atenaeum, Helsinki (moved from National Museum).

page 148. Ruskin's main writings on the Pre-Raphaelites, in vol. 12 of Library edition, four letters to the London *Times:* May 13, 1851 (especially Collins's *Convent Thoughts*); May 30, 1851; May 5, 1854 (Hunt's *Light of the World*); May 25, 1854 (Hunt's *Awakening Conscience*); and *Pre-Raphaelitism,* 1851.

Nazarenes, see exhibition catalogue *Die Nazarener,* Frankfurt, 1977.

page 149. J. E. Millais, *Christ in the House of His Parents (The Carpenter's Shop),* 1849–50, Tate Gallery, London. See similar subject by J. R. Herbert, *The Youth of Our Lord,* 1856, Guildhall Art Gallery (illustrated in C. M. Kauffmann, *The Bible in British Art,* Victoria and Albert Museum, 1977).

Millais, *Lorenzo and Isabella*, 1849, Walker Art Gallery, Liverpool, the subject from Keats's *Isabella, or the Pot of Basil*, who took it from Boccaccio.

Ophelia, 1851–2, Tate Gallery. The stream is the Hogsmill River, Kingston, Surrey.

William Dyce, *Titian's First Essay in Color*, Aberdeen Art Gallery, the most Nazarene of English painters, who had known Overbeck in Rome.

page 152. William Holman Hunt, *The Light of the World*, 1853, Keble College, Oxford; smaller version, City of Manchester Art Galleries; the life-size replica in St. Paul's, dated 1851–1900, was begun by Hunt after 1894 and finished by Edward Hughes. Thus the version in which the composition is generally known is not entirely Hunt's. See exhibition catalogue *William Holman Hunt*, Liverpool, 1969, for this and subsequent examples.

Charles Allston Collins, *Convent Thoughts*, 1850–1, Ashmolean Museum, Oxford.

Palace of Art. See Tennyson's poem of that name, *Poems*, 1842, whose title reverberates beyond the poem's boundaries.

Mariana, "of the moated grange," Angelo's shadowy fiancée in *Measure for Measure*, could be made mysterious by Tennyson in one of his earliest poems, *Mariana* (1830, illustrated by Millais in Moxon ed., 1857), because absent in Shakespeare.

page 153. *The Order of Release*, 1852–3, Tate Gallery.

Rossetti contributed five designs to the fifty-four illustrations in Moxon's Tennyson, 1857: *St. Cecilia, Arthur and the Weeping Queens, Sir Galahad,* and the two mentioned in the text. See exhibition catalogue *Dante Gabriel Rossetti*, Royal Academy, 1973, and V. Surtees, *The Paintings and Drawings of Dante Gabriel Rossetti: A Catalogue Raisonné*, 2 vols., Oxford, 1971.

page 154. Rossetti, *Galahad Receiving the Sanc Grael*, watercolor, Tate Gallery; ink drawing, British Museum.

On borrowings from Dürer and others, J. Christian, "Early German Sources for Pre-Raphaelite Designs," *Art Quarterly* XXXVI (1973), 1–2.

Rossetti and Dante. He finished a translation of the *Vita Nuova* in 1848 and planned a series of illustrations, of which studies or finished watercolors of six scenes survive. The two referred to in the text are *Dante's Dream at the Time of Beatrice's Death,* 1856, Tate Gallery, and *The First Anniversary of Beatrice's Death: Dante Draws an Angel,* 1853, Ashmolean Museum, Oxford. Two subjects from *Purgatorio* commissioned by Ruskin and several from *Inferno* also exist.

page 155. Rossetti, *The Tune of the Seven Towers,* 1857, and Ford Madox Brown, *Chaucer Reading at the Court of Edward the Third,* 1856–68, both Tate Gallery. *Work,* 1852–65, Manchester City Art Gallery. See *Ford Madox Brown*, Liverpool, 1964.

page 157. Brown, *Lear and Cordelia,* 1849–54, Tate Gallery. *Elijah with the Widow's Son,* 1868, Victoria and Albert Museum (engraved for Dalziel Bible, 1881). *The Coat of Many Colors,* 1867, Tate Gallery.

Hunt's trip to the Holy Land, in his own fatuous account, *Pre-Raphaelitism*

and the Pre-Raphaelite Brotherhood, 2 vols., 1905, where he says it fulfilled a childhood dream, also detail about his labors on *The Finding of the Saviour in the Temple,* 1854–60, City Museum and Art Gallery, Birmingham. The *Key* engraved by A. Blanchard, published by E. Gambart (the dealer who bought the picture), 1863. *The Awakening Conscience,* 1853–4, Tate Galler . *The Eve of St. Agnes,* 1848, Guildhall Art Gallery, London.

Osborne House, Isle of Wight, Italianate villa designed by Prince Albert in collaboration with Thomas Cubitt, 1845–9 (altered later), stuffed with the most revealing records of Victoria's domestic life. See *Catalogue of the Principal Items on View at Osborne House,* HMSO, 1965, and N. Pevsner and D. Lloyd, *Hampshire and the Isle of Wight (The Buildings of England),* Harmondsworth, 1967, repr. 1973.

page 160. Hunt, *The Triumph of the Innocents,* 1876–87, Walker Art Gallery, Liverpool (replica in Tate Gallery). *The Scapegoat,* 1854–5, Lady Lever Art Gallery, Port Sunlight (and sketch in Manchester with brown instead of white goat). For Richard Dadd, see *The Late Richard Dadd,* Tate Gallery, 1974.

page 161. *Burne-Jones: The Paintings, Graphic and Decorative Work of Sir Edward Burne-Jones 1833–98,* London, 1975 (exhibition catalogue), and M. Harrison and B. Waters, *Burne-Jones,* London, 1973 (well illustrated). Ruskin on Burne-Jones in *Three Colors of Pre-Raphaelitism,* 1878 (Library ed., vol. 34). *The Golden Stairs,* 1870, Tate Gallery.

J. E. Millais, *The Boyhood of Raleigh,* 1870, Tate Gallery.

Burne-Jones, *The Mill: Girls Dancing to Music by a River,* 1870, Victoria and Albert Museum.

page 162. Tennyson, in *Idylls of the King,* "Geraint and Enid," 1859.

Burne-Jones's fences in *The Secret Book of Designs,* album of about two hundred leaves of drawings, dated 1885 on cover, British Museum.

Kelmscott Chaucer, 1896, with eighty-seven illustrations (woodengravings) by Burne-Jones, the largest undertaking of Morris's Kelmscott Press. William Morris, *Ornamentation and Illustrations from the Kelmscott Chaucer,* Dover, 1973, reproduces all Burne-Jones's designs at three-quarters original size.

page 163. Burne-Jones, *Dorigen of Bretagne,* watercolor, 1871, Victoria and Albert Museum, from Chaucer, *Franklin's Tale.*

page 165. Burne-Jones, *Briar Rose* cycle, four large horizontal paintings, 1873–90, incorporated in dining-room walls at Buscot Park, Berkshire (National Trust, open to public), with connecting links to make frieze (smaller series of three in Puerto Rico).

Burne-Jones, *Love Leading the Pilgrim,* 1896–7, Tate Gallery (for architecture of briars); *The Sleep of King Arthur in Avalon,* c. 1890, National Museum of Wales, Cardiff (for figures as independent narcissi). *Arbor Tristis,* one of a series of watercolor roundels called *The Flower Book,* British Museum.

page 167. Burne-Jones, *Perseus* cycle, commissioned 1875 for music room of a London house, eight full-size gouache cartoons completed by 1885, now in Southampton Art Gallery. Only four final versions, now Staatsgalerie, Stuttgart; three sketches

of the whole decorative scheme in Tate Galley. *Car of Love, or Love's Wayfaring,* unfinished, Victoria and Albert Museum.

Literariness of nineteenth-century art, Nietzsche, *The Will to Power,* trans. W. Kauffmann and R. Hollingdale, New York, 1967, sections 828–9. Selection and rearrangement of Nietzsche's notebooks which first appeared in 1901.

page 168. Wagner's sources for *Tristan.* See R. Gutman, *Richard Wagner,* New York, 1968, for evidence that Wagner first intended to include the two Isoldes and the black and white flags at the end, and Gottfried von Strassburg, *Tristan,* the main German source, to appreciate how much Wagner leaves out and how idiosyncratic his way of unifying a story by obsessive reiteration of a few main elements (wound, potion) like a circulatory system running through the whole.

page 171. *Pelléas et Mélisande,* 1902. For Debussy's comment on the "grisaille" in which much of *Pelléas* is written, see C. Debussy, *Monsieur Croche et autres écrits,* Paris, 1971 (trans. as *Debussy on Music,* New York, 1977).

page 172. Robert Bresson, *Lancelot du Lac* (film), 1974. M. Proust, "Pastiche de *Pelléas et Mélisande,*" unpublished by Proust, in *Contre Sainte-Beuve* (Pléiade), 1971.

R. Strauss, *Elektra,* libretto by Hugo von Hofmannsthal (after his drama taken from Sophocles), 1908, the first of their collaborations, instigated by the poet. Their next, *Der Rosenkavalier,* 1909–10, the lighter subject Strauss had wanted after *Salome* of 1905, marks a great musical shift. It is usual to see this turn from the boldness and grisliness of the earlier operas to Mozartean lushness as a decadence, but the later works in some way saner and healthier. See C. Rosen, *Schoenberg,* London, 1975, chapter 1: "Expressionism," which puts the case clearly for Schoenberg against Strauss.

page 173. *Parsifal,* 1882, and Mozart's *Magic Flute,* fancifully linked, are the last dramatic works in careers significantly devoted to opera, quasi-sacred or temple dramas (Freemasonry the underlying creed in Mozart), in which simpletons (Parsifal and Papageno) and wise old men (Gurnemanz and Sarastro) figure prominently. But the comparison shows Mozart more childish and more mature, and to depict his last work as "old" is Romantic posturing. Nonetheless in Gurnemanz's explanations Wagner consciously harks back to Sarastro.

page 174. Nietzsche, *Ecce Homo,* the autobiography written in 1888 (first published 1908), is a reasonable place to begin a study of him, because it shows him at his best and reveals clearly the inseparability of his ideas from the drama of himself. Walter Kauffmann's introductions and notes to his translations of most of Nietzsche's important works concede nothing to Nietzsche's detractors, defend his mistakes, and rationalize his aberrations.

Nietzsche and discharging hostility. He is an argument against the fashionable idea that hostilities are cleared by giving them free expression.

page 175. Foul air of the New Testament. In *Twilight of the Idols, or How to Philosophize with a Hammer (Götzendämmerung,* 1889, twisted from Wagner's heroic title), Nietzsche comments on how bad the Christian text smells and draws a breath of

relief coming out of that hospital and dungeon into the healthier, higher world of Hindu caste doctrine.

page 176. Socrates and ugliness. *Twilight of the Idols,* "The Problem of Socrates." Strong races. *The Will to Power,* section 864.

Blond beast appears first in *On the Genealogy of Morals: A Polemic,* 1887, I, 11, where Kauffmann says it refers to the color of a lion.

page 177. Christianity responsible for the French Revolution, Jews lacking warrior and peasant, *The Will to Power,* section 184.

Gospels like a Russian novel, *The Antichrist,* 1888 (originally intended as first part of large work, *The Revaluation of all Values*), section 31.

Rudimentary memory, *On the Genealogy of Morals,* II, 1 ff; emergence from sea, *On the Genealogy of Morals,* II, 16.

page 178. Hitler in Florence, confessing himself to Speer, said he finally understood Böcklin. Speer's private name for the bunker in Berlin is taken from Böcklin, *The Island of the Dead.* A. Speer, *Inside the Third Reich: A Memoir,* trans. R. and C. Winston, New York, 1970 (from *Errinnerungen,* 1969).

page 179. Criminals in Nietzsche: as refuse not excreted, *The Will to Power,* section 50; as strong in weak world, *Twilight of the Idols,* "Expeditions of an Untimely Man," 45.

Camel, lion, child in *Thus Spake Zarathustra,* 1883–4, "Of the Three Metamorphoses," which follows the Prologue.

page 180. Bronislaw Malinowski, *A Diary in the Strict Sense of the Term,* trans. N. Guterman (from Polish), New York, 1967. Two diaries kept 1914–15 and 1917–18 while Malinowski was in Melanesia and New Guinea.

page 181. Malinowski on Frazer in *A Scientific Theory of Culture and Other Essays,* Chapel Hill, N.C., 1944.

page 182. Lévi-Strauss on missionaries, *Tristes Tropiques,* 1955, new trans. 1973.

Malinowski on myth and religion in "Magic, Science and Religion," 1925, and "Myth in Primitive Psychology," 1926, both reprinted in *Magic, Science and Religion and Other Essays,* Glencoe, Ill., 1948, repr. 1974.

page 184. For Lévi-Strauss in Brazil see E. Leach, *Lévi-Strauss,* London, 1970, and C. Lévi-Strauss, *Tristes Tropiques,* 1955, new trans. 1973.

page 186. Lévi-Strauss on Rousseau, "Jean-Jacques Rousseau, Founder of the Sciences of Man," originally delivered 1962, reprinted in *Structural Anthropology* II, New York, 1976.

page 188. Lévi-Strauss on Wagner in *Mythologiques,* vol. 1, *The Raw and the Cooked,* 1964, trans. 1969, "Overture"; on *Tristan,* end of "Chromatic Piece."

page 190. Vlaminck was the discoverer, and Derain, Matisse, and Picasso the ones he shared it with, but Matisse's and Picasso's interests were independent of the other's, and Picasso has denied he knew African things as early as this. R. Goldwater, *Primitiv-*

ism in Modern Painting, New York, 1938. J. Golding, *Cubism: A History and an Analysis 1907–1914,* London, 1959.

page 191. Roger Fry on African sculpture in *Vision and Design,* 1920.

The drastic metamorphosis of *Les Demoiselles* in the course of composition has often been charted. This monument of modern art was kept in the laboratory and shown mostly to other artists, was reproduced for the first time in 1925 and shown publicly first in 1937. Now in Museum of Modern Art, New York. The title not Picasso's, see A. Barr, *Picasso: Fifty Years of His Art,* New York, 1949.

page 192. Dada, see exhibition catalogue by D. Ades, *Dada and Surrealism Revisited,* London, 1978. B. Haussmann, *L'Esprit de nôtre temps,* c. 1921, Musée National d'Art Moderne, Paris.

M. Schamberg, *God* (photo of sink trap), Metropolitan Museum of Art, New York.

M. Duchamp, *Fountain,* 1917 (signed R. Mutt), replica 1951, Sidney Janis Gallery, New York.

S. Dali, *Buste de femme rétrospectif,* 1933, bread eaten by Picasso's dog, edition of six replicas, 1977, Galerie du Dragon, Paris.

page 193. Besides Lawrence himself, the most interesting observer of his life in Mexico, 1923–6, is Witter Bynner in reminiscences extracted in E. Nehls, *D. H. Lawrence: A Composite Biography,* vol. 2, Madison, Wisc., 1957. He recounts the two incidents referred to and lists Prescott, Diaz, Cortés, and recent Mexican history among Lawrence's reading. In a letter of June 10, 1925, Lawrence proclaims *The Plumed Serpent* the best of his novels, a judgment he did not change, *Collected Letters,* ed. H. T. Moore, vol. 2, London, 1962.

page 195. Nazi flag-raising formula in G. Mosse ed., *Nazi Culture: Intellectual, Cultural and Social Life in the Third Reich,* New York, 1966, an anthology of contemporary sources with commentary.

page 196. Nineteenth-century Colossi from M. Trachtenberg, *The Statue of Liberty (Art in Context),* Harmondsworth, 1976: Flaxman, *Britannia* proposed at Greenwich, 1799; Schwanthaler, *Bavaria,* Munich, 1837–48; E. von Bandel, *Arminius,* Teutoberger Wald, 1819–75; Schinkel, *Hermannsdenkmal* proposal; J. Schilling, *Germania,* Rüdesheim, 1876–83; B. Schmitz, *Kaiser-Wilhelm Denkmal,* Koblenz, 1897 (base only remains); B. Schmitz, *Völkerschlachtdenkmal,* Leipzig, 1898–1913. To which can be added: H. Lederer, *Bismarck Denkmal,* Hamburg, 1906, and 260-foot figure of Lenin projected atop Palace of Soviets, Moscow, begun 1930s, construction abandoned, 1941. See David's giant of the French people, p. 34.

page 197. The leader/god actually present. For evidence of Lawrence's interest in organic leadership and "living world union" embodied in English quasi-fascist organization Kibbo Kift Kindred, who combined devotion to leader and enthusiasm for forest lore, see E. Nehls, *D. H. Lawrence: A Composite Biography,* vol. 3, Madison, Wisc., 1959.

Ramón, binding Cipriano with fur strips in the following order, deprives him of the equated powers:

eyes and head = consciousness	loins = utterance
breast = heart	knees = consciousness
waist = mind, head	ankles = waking.

page 198. D'Annunzio. See M. Ledeen, *The First Duce: D'Annunzio at Fiume,* Baltimore, 1977 (trans. by author from Italian of 1975).

On Hitler's early life see the first part of *Mein Kampf,* trans. Ralph Manheim, Boston, 1943, London, 1969 (first published 1925–7; found as an unread ornament in Nazi homes, in G. Mosse ed., *Nazi Culture*), and to counteract Hitler's mythologizing, J. Fest, *Hitler,* 1973, trans. 1974, repr. 1977. Hitler's opinions not otherwise identified are taken from *Mein Kampf.*

The architecture of light, rows of antiaircraft searchlights used to make a classical building inside which the crowds hearing Hitler's speeches assembled. Speer's proudest achievement—he quotes comparisons to cathedrals—but in the daytime or when the lights were switched off there could be no worship, A. Speer, *Inside the Third Reich,* 1970. For fragmentary newsreel footage of Hitler as an orator and glimpses of the hypnotic monotony which surrounded the speeches, see *Hitler: A Career* (film), 1978.

page 199. The Will, the Task, History, in Hitler, "One Year of Socialism in Germany," Berlin, 1934 (speech in Reichstag). Versailles, etc., in Speer, *Inside the Third Reich,* 1970.

page 200. Hitler's favorite buildings, surviving Nazi buildings, in R. Taylor, *The Word in Stone: The Role of Architecture in the National Socialist Ideology,* Berkeley, Calif., 1974. Haus der Deutschen Kunst, Munich, 1933–7, by Paul Ludwig Troost, first of Hitler's classical buildings, now (with the *Deutschen* dropped from its title) houses the Neue Pinakothek temporarily.

page 201. Mountain pictures illustrated in B. Hinz, *Die Malerei im deutschen Faschismus, Kunst und Konterrevolution,* Munich, 1974, which includes a number of Hitler's speeches at the opening of the Grosse Deutsche Kunstausstellung held yearly in Munich, 1937–44, for which see the *Katalogs.*

Anti-exhibitions: "Art in the Service of Decomposition," Stuttgart, 1933; various "Degenerate Art" exhibitions, Dresden, 1933, traveling exhibition, 1937–8. On the Nazi destruction and prevention of art through confiscations and prohibitions ("Ausstellungsverbot," "Malverbot") including quantities of each artist's work removed from German museums, see artists' biographies in exhibition catalogue *Die Dreissiger Jahre, Schauplatz Deutschland,* Munich, 1977.

page 203. Alfred Rosenberg's main "philcsophical" work is *Der Mythus des 20. Jahrhunderts,* Munich, 1930, of which sizable extracts are included in R. Pois ed., *Alfred*

Rosenberg: Selected Writings, London, 1970 (also includes a speech of 1944 on Nietzsche).

Collective subjectivism. For an earlier occurrence of it, W. Laqueur, *Young Germany: A History of the German Youth Movement,* London, 1960.

page 204. Herder. His role in the creation of sophisticated localism in cultural analysis described by G. Iggers, "Historicism," *Dictionary of the History of Ideas: Studies of Selected Pivotal Ideas,* 5 vols., New York, 1973, which treats mainly professional historians in the later phases, and not, for example, Nietzsche.

page 205. For anti-Semitism in Germany before Hitler, F. Carsten, *The Rise of Fascism,* London, 1965.

Hitler's collapse and the inversion of his ideas are depicted in Speer, *Inside the Third Reich,* 1970.

page 206. On the since-obscured development of art in Russia before the Revolution, see C. Gray, *The Great Experiment: Russian Art 1863–1922,* London, 1962; retitled reprint, 1971.

Bilibin. The illustrations in S. Golynets, *Ivan Yakovlevich Bilibin,* Leningrad, 1970, show how quickly he tired of himself. His Pushkin of 1904–5 already shows mechanical hatching which was soon to make his pictures look like cheap engravings. In later years, after his return to the Soviet Union in 1936, he stole from his earlier work, six *Skazki* volumes of 1901–3 (all available in Soviet reprints, 1973–7), and re-rendered old designs in the new manner. The dynamics of this bear interesting resemblance to Kandinsky's more fertile progress.

page 207. Firwood rococo. Many Scandinavian examples of carved and painted substitutes for the stucco decoration found in the Bavarian origins of the style, such as Kahiluoto Manor in Seurasaari, the open-air museum on an island near Helsinki.

Kandinsky's medieval pictures. Many examples in Städtische Galerie, Lenbachhaus, Munich (see also E. Hanfstaengl, *Wassily Kandinsky, Zeichnungen und Aquarelle,* Munich, 1974). For his life the most important source is the *Rückblicke,* Berlin, 1913, trans. in R. Herbert, *Modern Artists on Art,* Englewood Cliffs, N.J., 1964. His main writing on art around the time of the shift to non-material painting is *Concerning the Spiritual in Art,* Munich, 1912, trans. New York, 1947, at least as obscure as his paintings, with interesting reference to his cultural heroes including Nietzsche and Maeterlinck. See also "On the Question of Form" in *Der Blaue Reiter,* Munich, 1912, trans. (*Documents of 20th Century Art*), London, 1974. The paintings are catalogued by W. Grohmann, *Wassily Kandinsky: Life and Work,* New York, 1958.

page 211. Votive paintings illustrated in *Blaue Reiter Almanac,* which also includes "On Stage Composition," mainly about Wagner's attempt to internalize opera, and one of Kandinsky's music dramas, "The Yellow Sound" (scored by T. von Hartmann). For Kandinsky's poems and his other dramas see Grohmann, *Kandinsky: Life and Work,* 1958.

page 212. Three stages in Kandinsky's paintings 1909–14 can be followed in Grohmann (though the stages overlap occasionally: First stage, blotchy: G nos. 66 to

100 (1909–10). Second, solid forms but darker geometry: G nos. 101 to 139 (1910–11). Third, speeded, weightless, colliding: G nos. 140 to 170 (1911–13) (more hectic coda to this phase: G nos. 171 to 183 [1913]). The opposition between Roman and darker geometry is based on the one Kandinsky found as a law student between Western and Russian law.

page 214. Malevich, fully illustrated including the eclipsed later years until his death in 1935, T. Andersen, *Malevich,* Stedelijk Museum, Amsterdam, 1970. His writings in *Malevich: Essays on Art 1915–33,* 2 vols., trans. X. Glowacki-Prus and A. McMillin, London, 1969 (from Danish ed. of 1968).

Categorization in early Soviet period. See N. Bukharin and E. Preobrazhensky, *The ABC of Communism,* Petersburg, 1920, trans. 1922, repr. 1969, an explanation of the first Party program for ordinary readers, and a vivid demonstration of the corrupting effects of popularization.

page 215. Pilot's house exists in two pencil drawings of 1924, Stedelijk Museum, Amsterdam, and Museum of Modern Art, New York.

page 216. E. Lissitsky, *Russia: An Architecture for World Revolution,* Cambridge, Mass., 1970 (originally published in German as *Russland: Die Rekonstruktion der Architektur in der Sowjetunion,* Vienna, 1930), a collection of short texts including reports by German architects visiting or working in Russia, 1928–33, with references to the proposals and visits of Le Corbusier and F. L. Wright, and descriptions of how Le Corbusier buildings were demodernized on the site during construction.

For Tatlin, painter turned sculptor and architect, see exhibition catalogue by T. Andersen, *Vladimir Tatlin,* Moderna Museet, Stockholm, 1968.

Trotsky, *Literature and Revolution,* 1923, trans. 1925, repr. Ann Arbor, Mich., 1960, written in Crimea on holiday in summer 1923 during an important crisis in his struggle with Stalin, and thus expensive to Trotsky. It shows the breadth of his reading, including émigré writers, to be enormous. Though his general position is that literature limps after politics, he has the insider's sense of how long it takes to create a culture and says proletarian dominance won't last long enough to form one. His treatment of individual writers is marked by daring wit which helps explain why he couldn't take Stalin seriously and never properly confronted him. His relation to ordinary Russian culture is revealed by the pieces in *Problems of Everyday Life,* written at the same time on such subjects as the prevalence of swearing and drunkenness. See I. Deutscher, *The Prophet Unarmed, Trotsky 1921–1929,* London, 1959 (middle volume of three-volume biography), and I. Howe, *Trotsky,* London, 1978.

page 217. Pilnyak, pseudonym of Boris Wogau, a dominant figure in Soviet literature 1921–3, cited till early 1930s as the first young writer to pick the Revolution as his main subject. He ran into trouble with *Mahogany,* 1929, which romanticized Trotskyism. A tale of heroic dam-building, *The Volga Flows into the Caspian Sea,* 1930, was to rectify his ideological errors but misfired. Nothing was heard of Pilnyak after 1937, though rumors circulated that he'd been arrested and shot in that year. See G. Struve, *Soviet Russian Literature 1917–50,* Norman, Okla., 1951 (a revision of *Soviet Russian*

Literature, London, 1935). The work referred to in text is B. Pilnyak, *The Naked Year,* 1922, trans. Ann Arbor, Mich., 1975. The year is 1919.

page 218. D. Vertov. Church vs. youth, *Enthusiasm,* 1931; woman waking, *Man with a Movie Camera,* 1928. See Rodchenko's ads for Vertov films, like a popularized form of non-objective painting, in exhibition catalogue *Alexander Rodchenko,* Oxford, 1979.

 Soviet posters in complete catalogue, B. Butnik-Siversky, *Sovietskii plakat epokhi grazhdanskoi voinui* [1918–21], Moscow, 1960; S. Raevsky, *Plakat A. Strakhova,* Moscow, 1936; and M. Guerman, *Art et Révolution: La Flamme d'Octobre,* Leningrad, 1977, for street decoration as propaganda.

page 219. Vera Mukhina. See R. Klimova, *V. I. Mukhina,* 3 vols., Leningrad, 1960. *Worker and Farm Woman* now mounted near Exhibition of Economic Achievement (a collection of bizarre Stalinist buildings) on the north edge of Moscow; *Zagorsky,* Tretyakov Gallery, Moscow.

page 220. Moscow University, Lenin Hills, 1948–53, by L. Rudnev, S. Chernishev, P. Avrosimov, A. Cryakov, praised by the contemporary Italian architect Aldo Rossi as reminding architecture of its true ends.

 See K. Berton, *Moscow: An Architectural History,* London, 1977. The freshest glimpse of Stalin's plans for a monumental Moscow comes in guidebooks of the 1930s like *Moscow: Past, Present, Future,* Intourist, 1934, which warns the visitor the city is being changed so fast that descriptions are instantly out of date. It enthuses over factory kitchens and complete days of organized rest, forecasts large ships in the straightened Moscow River, a single giant railroad station for the city, concentric zones of work and leisure with central government the exclusive occupier of the centermost. Best of all will be the Palace of the Soviets, the world's largest building, whose great feature will be absolute freedom of access for enormous masses of people. This project had begun with an international competition (proposals of Poelzig, Le Corbusier, and others) and ended by consuming 16 percent of the national cement output in the years before the war. The foundations were plagued by water seepage, but an immense skeleton rose, dismantled in the steel shortage of the war. Name of Palace of Soviets metro station (1935) changed in 1953, the foundations now re-used as a public swimming pool. See A. Kopp, *L'Architecture de la période stalinienne,* Grenoble, 1978, and *Mastera sovietskoy architekturi ob architekturey,* 2 vols., Moscow, 1975, fully illustrated.

 Soviet Writers' Congress 1934, London, 1935, (as *Problems of Soviet Literature*), repr. 1977, includes speeches by Gorky, Zhdanov, Bukharin, and Radek. On the general political situation in these years see I. Deutscher, *Stalin: A Political Biography,* London, 1949, 2nd ed. 1967, which makes a valiant effort to detect remnants of principle in his behavior, and R. Conquest, *The Great Terror,* London, 1968, revised ed. 1971. For a recent Marxist de-individualizing excuse for Stalinism see L. Althusser, *Essays in Self-Criticism,* London, 1977.

 Yuri Olesha, *Envy and Other Works,* trans. A. MacAndrew, Garden City, N.Y., 1967. Like Babel, Katayev, and Mandelstam, an Odessan, celebrated overnight for *Envy,* 1926(7?), attacked in the hardening which followed, mostly silent and mainly journalist after 1934, except for a few tedious political allegories, died 1960.

page 221. Osip Mandelstam's ordeal in his wife's memoirs, *Hope Against Hope,* New York, 1970, trans. 1971; *Hope Abandoned,* Paris, 1972, trans. 1974.

Mikhail Sholokov won the Nobel Prize in 1965 for a work it now appears he stole from the dying author who entrusted it to him, *Quiet Flows the Don,* 1928. He wrote the best account of forced collectivization in agriculture, *Virgin Soil Upturned,* 1932, trans. 1935, repr. 1977.

Alexei Tolstoy, an émigré from 1919, returned to Russia in 1923 partly for financial reasons, having changed sides the previous year. He recast his giant *Ordeal,* Russia in the First World War and first year of the Revolution, in line with his new political position (3 vols. completed 1941, trans. Moscow, 1953). Attacks on Tolstoy as bourgeois drove him into science fiction with a revolutionary message. His epic treatment of *Peter the Great,* 1929–45, is evidence of the changed attitude toward gigantic authoritarian figures from the Russian past.

Konstantin Simonov, *The Living and the Dead,* trans. Moscow, 1975, the first volume of his war trilogy, turns on the hero's loss of his Party card and shows the survival of patriotic fervor called up by the war.

page 222. Valentin Katayev, *Time, Forward!,* 1932, trans. 1933, repr. Bloomington, Ind., 1976. See foreword to this volume and Struve for his other books. Other novels of socialist reconstruction and the first Five-Year Plan (1928–32): Gladkov, *Cement,* 1925, and *Energy,* 1933; Pilnyak, *The Volga Flows to the Caspian Sea,* 1930; Leonov, *Soviet River,* 1931; Paustovsky, *Colchis,* 1934; Shagynin, *Hydrocentral,* 1934.

Vera Panova, *Looking Ahead,* Stalin Prize 1948, trans. Moscow, 1951 (also trans. as *Factory,* New York, 1951).

The Solzhenitsyn referred to is the one of *First Circle* and especially vol. 1 of *Gulag Archipelago.*

ABOUT THE AUTHOR

Robert Harbison was born in Baltimore in 1940 and studied English at Amherst College and Cornell University, from which he received a doctorate in 1969. He has taught at Cornell and Washington University, St. Louis, and has lived since 1971 in London, teaching for the University of Maryland and lecturing at the Architectural Association. He has held Guggenheim and National Endowment fellowships and is the author of *Eccentric Spaces* (1977).

A NOTE ON THE TYPE

This book was photocomposed in a film version of Janson. The original Janson face was recut directly from type cast from matrices long thought to have been made by the Dutchman Anton Janson, who was a practicing type founder in Leipzig during the years 1668–87. However, it has been conclusively demonstrated that these types are actually the work of Nicholas Kis (1650–1702), a Hungarian, who most probably learned his trade from the master Dutch type founder Dirk Voskens. The type is an excellent example of the influential and sturdy Dutch types that prevailed in England up to the time William Caslon developed his own incomparable designs from them.

Composed by Southern Graphic Arts, Inc.,
Fort Lauderdale, Florida
Printed and bound by The Murray Printing Company,
Westford, Massachusetts

Designed by Judith Henry